Steadfast Sisters
of the Silver State

ONE HUNDRED
BIOGRAPHICAL PROFILES
of NEVADA WOMEN IN HISTORY

EDITED BY JOAN BURKHART WHITELY

SNWHP

SOUTHERN NEVADA
WOMEN'S HISTORY PROJECT

STEPHENS PRESS ❖ LAS VEGAS, NEVADA

To standardize the names of women who are profiled, the Southern
Nevada Women's History Project chose to use each woman's first name,
followed by her maiden name, followed by the surname by which she is
most well known. Many of the subjects were married more than once, and
thus as adults had multiple surnames.

The authors of *Steadfast Sisters of the Silver State* did their work as
enthusiastic and dedicated volunteers. The Southern Nevada Women's
History Project is responsible for the accuracy and sourcing of the profiles
contained in this volume.

Project Coordinators: Mary Gafford, Joan LeMere, and Nancy Sansone
Editor: Joan Burkhart Whitely
Designer: Sue Campbell

ISBN: 9781935043942

STEPHENS PRESS
A Stephens Media Company

Post Office Box 1600
Las Vegas, NV 89125-1600
www.stephenspress.com

Printed in China

This book is dedicated to the women of Nevada who have built and nurtured communities throughout our state. These are women who encountered challenges and prevailed. In addition, we recognize all of our Southern Nevada Women's History Project members for their support and loyalty.

Contents

Ellen Finnerty Albright8
Joan LeMere

Ella Mary Marquat Anderson 10
Leola Anderson Tucker and Lisa Gioia-Acres

Kathy Alfano Augustine12
Fran Haraway

Dessie Lola Bassette Bailey.................... 14
Fran Haraway

Martha Gruss Barlow....................16
Fran Haraway

Marjorie Jacobson Barrick...................18
Joan LeMere

Adalene Spence Bartlett....................20
Mary Gafford

Selma F. Abdallah Bartlett22
Denise Gerdes

Billie Mitchell Bates24
Fran Haraway

Kathy Mackley Batterman26
Barbara Riiff Davis

Frances Pugh Beaupeurt28
Joyce O'Day

Isabelle Slavin Blackman....................30
Fran Haraway

Emma Lou Montgomery Brandt...................32
Betty Middleton and Jean Spiller

Hope Gaufin Broadbent....................34
Alice Bunker

Jane Hopkins Broadfoot....................36
Tish Campbell

Eileen Milstein Brookman....................38
Lois Evora

Lucille Koenig Brown....................40
Dorothy Bokelmann

Ruth Weston Brown42
Vera Knox

Lucile Spire Bruner....................44
Lois Evora

Lucile Whitehead Bunker....................46
Loretta Derrick

Florence Sandford Burge....................48
Fran Haraway

Helen Case Cannon50
Dorothy T. Bokelmann

Judy Edsall Carlos....................52
Denise Gerdes

Margaret Lehr Perkins Casey54
Mary Gafford

Marilyn Chambers....................56
Susan Houston

Leona Gudmundson Clark58
Jeanette Oxborrow Clark, Leona's daughter-in-law

Toni Gaglionese Clark60
Carolyn Lake

Dr. Angela Webb Clarke62
Fran Haraway

Margaret Phelan Coleman....................64
Norma Jean Harris Price

Margaret Jane Dailey Colton66
Dale Meyer, sister of Gale Colton

Mary Melita Smith Coombs....................68
Fran Haraway

Ethel Dolores "D.D." Cotton....................70
Claytee White

Marcia Smith deBraga72
Fran Haraway

Cherie DeCastro74
Barbara Riiff Davis

Joanne Cutten de Longchamps....................76
Susan Houston

Ruthe Goldsworthy Deskin78
Nancy Sansone

Dorothy Buchanan Dorothy80
Susan Houston

Gladys Keate Dula82
Mary Gafford

Lilly Hing Fong84
Dorothy Bokelmann and Jean Spiller

Louise Lorenzi Fountain....................86
Denise Gerdes

Estelle Kelsey Givens88
Kay O'Gorman

Alice Virginia Wood Goffstein....................90
Norma Price

Polly Gonzalez92
 Norma Jean Harris Price

Vera Eva Wittwer Hardy94
 Jean Spiller

Bunny Longbotham Harris96
 Barbara Riiff Davis

Edith Claire Posener Head98
 Mary Gafford

Lomie Gray Heard...............................100
 Mollie Murphy

Helen Kolb Herr102
 Lois Evora

Mabel Welch Hoggard104
 Mary Gafford

Jeanne Walsh Hood106
 Susan Houston

Barbara Joanne Thomas Hunter.............108
 Mary Gafford

June Calder Huntington.........................110
 Barbara Huntington White, daughter of June

Billie Jean Hickey James.........................112
 Norma Jean Harris Price

Velma Bronn Johnston............................114
 Fran Haraway

Mary Ka'aihue Kaye116
 Fran Haraway

Anna Dean Nohl Kepper..........................118
 Jo Ann Parochetti

Alice Marie Juliet Key.............................120
 Joan LeMere

Martha Pike King....................................122
 Fran Haraway

Bernie Kells Lenz....................................124
 Denise Gerdes

Celesta Lisle Lowe126
 Mary Gafford

Sister Rosemary Lynch128
 Judith Lachance

Mabel Clara Whitney Macfarlane.............130
 Joyce Cory, wife of Mabel's grandson

Mary Louise Hungerford Mackay.............132
 Janet Bremer

Florence Elberta Schilling McClure134
 Joan LeMere

Karla Bohac McComb136
 Mary Gafford

Elizabeth Hazel Penrose McKay138
 Elizabeth P. Lucas, granddaughter of Elizabeth

Ann Rittenhouse McNamee........................140
 Fran Haraway

Eve Wick Moss ...142
 Mary Gafford

Virginia Moreira Moura..............................144
 Fran Haraway

Leona Daoust Munk....................................146
 Fran Haraway

Colanthe Florence Jones Murphy148
 Fran Haraway

Dr. Rena Magno Nora150
 Fran Haraway

D'Vorre "Dee" Ober152
 Donna B. Gavac

Anna Nuhfer Parks154
 Joan LeMere

Edna Burke Patterson156
 Yvonne Kelly

Minnie A. Peters...158
 Donna Jo Harvey Andress

Anabelle Plunkett160
 Norma Jean Harris Price

Bertha Jane Mattson Purdy...........................162
 Carma Baker Watts, granddaughter of Bertha Jane

Bertha Berry Ragland164
 Joan LeMere

Agatha Lucy Pettinger Roberts166
 Fran Haraway and Nancy Sansone

Luciell Rohlman ..168
 Donna Gavac

Colleen Carroll Schroeder170
 Sally Wathan

Alice Lucretia Smith...................................172
 Joan LeMere

Janet Curtis Smith.......................................174
 Joan LeMere

Louise Aloys Smith.......................................176
Fran Haraway

Mary Evelyn Stuckey...................................178
Susan Houston

Sheila Tarr-Smith..180
Denise Gerdes

Doris Higginson Troy...................................182
Barbara Riif Davis

Alice Bacon Turner.......................................184
Rekaya Gibson

Nora Bloom Ullom..186
Mary Gafford

Kay Novak Wallerstein.................................188
Fran Haraway

Phyllis J. Walsh...190
Jo Ann Parochetti

Emilie Norma Wanderer..............................192
Vera Knox

Judith Mosier Warner...................................194
Kitty Warner Umbraco, daughter of Judith

Thelma Messick Weaver...............................196
Mary Branscomb, daughter of Thelma

Claudine Barbara Williams..........................198
Robyn Campbell-Ouchida

Helen Woolley Willis.....................................200
Joan LeMere

Pauline May Atterbury Wilson.....................202
Dorothy Bokelmann

Ethel Alice Bjornson Winternheimer...........204
Joyce Winternheimer, daughter of Ethel

Bertha Rosanna Sanford Woodard..............206
Nancy Sansone

A Message to Our Readers

From 2000 to 2006, the Southern Region of the Nevada Women's History Project worked on a project it was convinced fulfilled the mission statement of the state organization. Members felt it would enrich the lives of the children in our state. The project was a book of one hundred biographical profiles of women who lived in the state of Nevada, and contributed to its growth and development.

Source material for the biographies came from oral and written histories, interviews, and obituaries. After five years, the project was completed. *Skirts That Swept the Desert Floor* was placed free of charge in every public and private school library at the secondary level, and to public libraries throughout Nevada. It was well received by the public, and went into a second printing.

The book that you now read is a new effort by many of the same women who participated in *Skirts*, but who are now members of the Southern Nevada Women's History Project. This new identification is affiliated with the National Women's History Project, which is the organization's link to Washington, D.C. for women's issues.

We have many new members in our organization who participated in preparing this book. My heartfelt thanks goes to all of our faithful members who contributed to this new venture, as well those who contributed to *Skirts*.

Lastly, my gratitude goes to all of our loyal membership who believed in us, and kept on supporting us.

In friendship,

—*Joan LeMere*
President, Southern Nevada Women's History Project, 2013

Ellen Finnerty Albright

"My first impression of Las Vegas was a bit distorted," Ellen M. Finnerty admitted when she wrote of her arrival to the desert city in the dead of summer 1935 on a Greyhound bus that lacked air conditioning.

The bus pulled in at about two in the afternoon on July Fourth. Everyone aboard was tired, she wrote in her diary. "The temperature was approximately 109 degrees in deep shade, and we had an overlay of four hours. The exhausted, but kindly driver suggested the coolest spots might be the Overland Hotel or the White Spot Café."

The driver had a further suggestion, according to Ellen, who was twenty and single. Namely, that "passengers of the fairer sex stay off the streets because Las Vegas was literally swarming with men seeking employment on the Boulder Dam Project."

She had traveled through dusty Las Vegas from the "top of the Rockies," that is, Laramie, Wyoming, with its constant cool breezes. Their "road weary vehicle" had crossed the Red Desert of Wyoming, the Salt Flats of Utah, she wrote in her diary, and the endless arid miles from Salt Lake City to the little "oasis" of Las Vegas.

1915—UNKNOWN
MEMBER AND LEADER OF CIVIC GROUPS

Sometime after that trip, Finnerty went back to Las Vegas for work. She arrived in the good old days when the West was still being shaped by men and women of vision and vigor. It would remain her home till her death.

Ellen Finnerty was born in Sunrise-Platte County, Wyoming, on February 20, 1915, to Margaret Anne Behmaire and Thomas Edward Finnerty. She and her older brother George, born in 1909, attended elementary and high school in the county.

But Ellen went on to the University of Wyoming, at Laramie, which she attended for three years. Her parents had intended that she continue her education in Southern California; they did not anticipate that their daughter would, instead, assist about 1936 in opening an office for the International Mining and Milling Company in Las Vegas.

The company's office was near Main and Fremont streets in downtown Las Vegas, located in the landmark Beckley Building, which early Las Vegas merchant William Beckley had established in 1908. There Ellen met George "Bud" Albright, a young man who appeared at

> *Ellen arrived in Las Vegas in the good old days when the West was still being shaped by men and women of vision and vigor.*

her office door one day in 1936, to make an adjustment to her Underwood typewriter.

The next year, in February 1937, Ellen and Bud married. Together in Las Vegas they raised two sons, Karl and Kenneth. Horses were a part of the family lifestyle. Ellen regularly rode out in the desert with Bud and the boys.

For ten years she was a member of the Nevada Lariats Club, and served as its president. She and Bud also hunted each year with several local couples, who referred to their vehicles and trailers as their "hunting rigs."

As the Albright family matured, participating in community organizations became important. Ellen joined the Service League in 1947, not long after its founding, and belonged until 1958. The League—which is now known as the Junior League of Las Vegas—had started on February 26, 1946, to help meet the post-war needs of the rapidly growing valley.

The League's early activities were not much different than those of the present organization. In 1947, Ellen's first year as a member, the League made a donation to Child Haven, a service for impoverished children, which has evolved into a shelter operated by Clark County government for abused and neglected children, as part of its Department of Family Services.

That same year, the League assisted the county health department's baby clinic. It also helped finance surgeries for child burn victims.

But perhaps Ellen's greatest contribution came through her efforts in the Mesquite Club of Las Vegas, which began in 1911 and is the Las Vegas Valley's oldest women's service club. Today it is affiliated with the General Federation of Women's Clubs.

Ellen became president of the Mesquite Club in 1944. At that time, its headquarters was located on South Fifth Street, in a building with creaking floors and peeling paint. The job of repairing the place to restore the club's public image fell into Ellen's capable hands.

She started a year of fund-raising to pay for a facelift to the club's property. Other club projects also flourished under her leadership. She later said, "We had a wonderful time. Personally it was a most rewarding year. I gave so little in proportion to that which I received.

"Just learning to really know the women of Mesquite Club was an education, and instilled in me a respect for women the world over," she once wrote. "It was a year from which I gained immeasurably, and that I will always treasure." Ellen's date of death is unknown.

Joan LeMere

Ella Mary Marquat Anderson

Ella Mary Marquat was born into a ranching family on June 21, 1894, in Genoa, Nevada. Her parents, Henry Marquat and Marie—also known as Mary—Wennhold purchased their ranch from a Boyd family. Ella was the second daughter of six girls, one of whom died in infancy.

Ella attended the Genoa schoolhouse up until the eighth grade. Riding a horse to school one day, Ella was bucked off while crossing a bridge. She toppled into the swift-running river below. She managed to save herself by grabbing willow branches, and clinging to them until help arrived. This experience might have formed the foundation for the determination and fortitude with which she approached her life.

Ella met Charles Andersen, the son of Peter and Johanna Krumes Andersen. Upon their marriage on January 29, 1913, the name of Andersen was inexplicably changed to Anderson; and from that day forward, the couple and their offspring spelled the family name that way. Ella and Charles had five children, with the first three —Arlie, William, and Henry—born in Centerville, Nevada.

When her youngest child graduated high school, Ella, who was forty years old, discovered she was pregnant. Nine months later she delivered healthy twin boys in Reno, Nevada, naming them Harold and Harlan. In 1942, Ella opened her heart and home to her granddaughter, Leola, and raised her from infancy through high school graduation. Leola Anderson Tucker grew to admire her grandmother and carries the lessons and values she learned from this amazing woman.

Although Ella was busy raising children and helping to run a ranch, she made the time for work outside the home, cleaning the one-room Genoa schoolhouse for fifteen dollars per month. In addition, she became a civic activist in Douglas County and devoted time campaigning for women's right to vote. Although she spent nearly half a century parenting, Ella joined the ranks of the era's progressive-thinking women and made her voice heard in the little town she called home. She served many years on the Centerville Precinct Election Board, a job in which volunteers issued ballots during the day and worked late into the night counting and tallying the votes.

Although Ella gave much of herself to her

1894–1971
RANCHER, SUFFRAGETTE,
ELECTION OFFICIAL

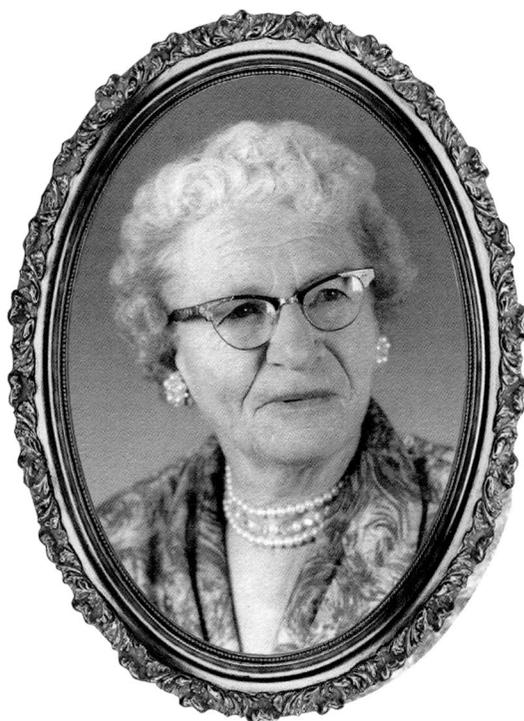

community, she always provided well for her family. Three times a day, using the family's wood stove, she cooked meals that consisted of homemade bread, meat, potatoes, vegetables picked fresh from her garden, and homemade desserts. Her domestic duties increased during haying season and the annual harvest, when extra help was hired. Ella not only fed the extra hands, but took on the responsibility of cleaning the bunkhouses. To ensure the men got to the fields promptly, Ella also cleaned the equipment once the morning milking had been done. If more help was needed in the fields, Ella had no qualms about picking up a tool and joining in.

Knowing the importance of self-sufficiency, Ella passed along domestic skills to her granddaughter, whom she taught the art of planting gardens, food processing and preservation, as well as how to darn socks and mend and patch well-worn work clothes. Ella's skill at food preservation is legendary; she was a master at peeling fruit quickly. The family pantry contained rows and rows of filled fruit jars that lasted until the next summer, when the process would start all over. Ella also was an expert in "snagging chickens" with a hook. Once they were caught, with axe in hand she took them to the chopping block, then prepared them for the cook pot. Her chickens also provided eggs that she sold to the Minden Cooperative Creamery and other customers.

As a lifetime member of the Trinity Lutheran Church and guided by the teachings of her faith, Ella held a staunch belief in doing "the right thing." She belonged to the church's Ladies Aid group, whose members devoted their lives to doing good works in their church and community. During a critical time in Ella's life, the church fellowship and her faith helped her cope with the loss of family members: her sister, Ada; Charles, her husband of thirty-eight years, and her daughter, Arlie, who succumbed to cancer at the age of forty-five.

By her death at the age of seventy-seven on February 2, 1971, Ella May Marquat Anderson had instilled in her granddaughter—and others whom she had also inspired—the belief that, "you can do anything you want, if you put your mind to it!"

Ella is buried in a family plot in the Garden Cemetery, located in Gardnerville, in Douglas County.

Leola Anderson Tucker and Lisa Gioia-Acres

Kathy Alfano Augustine

Some women achieve fame, and some, infamy. Kathy Alfano Voss Hohn Augustine Higgs was destined for both.

Her well-deserved fame came from the facts that she was the first woman elected state controller of Nevada, and her controller's office won seven awards in a row for financial reporting excellence.

Her notoriety came from being the only state official in Nevada history to suffer impeachment.

While Augustine was controller, her office managed to collect over five million dollars in delinquent payments from both companies and individuals. At the time of her death in 2006, Nevada Senate majority Leader Bill Raggio told the *Las Vegas Review-Journal*, "She should be remembered for her many years of public service as an assemblyman, a senator and two terms as state controller. Even her critics have to recognize that she had great talent, humor and was very dedicated to the state."

On the flip side, she was impeached in 2004 by the Nevada Assembly on three counts of ethics violations and convicted on one—using her office equipment for her 2001 reelection campaign—which clearly violated state election law. A few years earlier, Augustine was the defendant in a defamation suit by Lori Lippman-Brown, and Augustine had admitted that she lied in the hope of getting elected.

1956–2006
STATE CONTROLLER,
STATE LEGISLATOR

Augustine's news value, however, reached an all-time high when her fourth husband, Chaz Higggs, murdered her, and later attempted suicide. His act ended years of drama for a woman who, at the time of her death, was a candidate for Nevada state treasurer.

Kathy Alfano was born in Los Angeles in 1956. Her parents were conservative Republicans, and she adopted their political persuasion. She earned a degree in political science from Occidental College, and a degree in public administration from Long Beach State University. She had been accepted into law school when she was offered a job with Western Airlines.

For over a decade, Kathy worked for Western, scheduling pilot routes and work hours. During that period, she wed her first husband, flight controller Gary Voss, and had her daughter, Dallas. But the marriage lasted only two years.

Soon she married a U.S. Marine, but this union lasted just a few months. Finally she met Delta pilot Charles Augustine, who was fifteen years older than she. They married in 1988 and moved to Las Vegas, where Kathy taught math and science at a local Catholic school.

Author Glenn Puit, in his book *In Her Prime*, identifies Dr. Charles Vinnik as the person who led Kathy Augustine into politics when he suggested

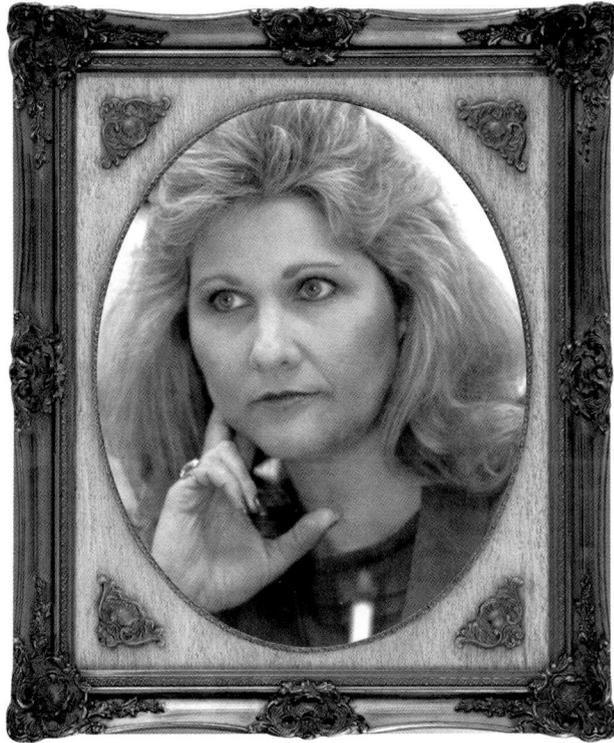

she run for the District 12 seat in the Nevada Assembly in 1992. After she won and served, Kathy decided to run for the Nevada Senate's District 7, and won that race, also. Finally in 1998 she was elected state controller, a position she held until her death.

As controller, Kathy was spending most of her time in Carson City. The Augustine's fourteen-year-old marriage began to falter. Chuck Augustine was not interested in moving north and Kathy, as a result, spent many weekends traveling between Carson City and Las Vegas. In 2002, Chuck and Kathy Augustine legally separated.

In July 2003, Chuck suffered a stroke and died a month later. One of his nurses was a man named Charles "Chaz" Higgs. The name is significant. A few weeks after Chuck Augustine's death, Higgs became Kathy Augustine's fourth husband.

Kathy's marriage to Chaz Higgs signaled the start of trouble for the state's chief financial officer. In summer 2004, the Nevada Commission on Ethics received a formal complaint that she was having her office workers do tasks related to her 2002 reelection campaign, and was also using state equipment for the same. In September, she was fined $15,000 for committing three ethics violations. She paid the fine in $500 installments.

Accepting the fine was not the end of her woes. In December 2004, she became the first state official in Nevada to be impeached. She was, however, allowed to remain in office.

Unable, by law, to serve a third term as state controller and undaunted by her setbacks, Kathy in 2006 began a campaign for state treasurer. But the Republican Party distanced itself from her candidacy and Governor Kenny Guinn, a Republican, called for her resignation.

Still, she pursued her plan, until tragedy intervened. On July 6, 2006, she was discovered unconscious in her Reno home. She died four days later without regaining consciousness. At first it was believed she had suffered a heart attack, but investigation led to the arrest of her husband. In 2007 a Reno jury convicted Higgs of her murder.

Although Kathy's last years were filled with trouble, her outstanding work is validated by the many honors she received. They include a Lyndon B. Johnson Internship Grant and an American Achievement Medallion.

Her awards and positions define Kathy Augustine as a hard-working politician whose service extended long beyond her office hours. She appears to have made certain poor choices, but left a positive mark on Nevada.

Fran Haraway

Dessie Lola Bassette Bailey

Dessie Lola Bailey gave a new meaning to the phrase, "working from home."

When her daughter could not go to school because the community had no facility for children with mental challenges, Dessie took up what today we would call networking. She found similar families, then located people who could help. Then she did more.

In 1954 Dessie co-founded the Clark County Association for Retarded Children, which grew into the Clark County Association for Retarded Citizens. She also co-founded Opportunity Village, a non-profit organization that provides job training, work and social outlets for Las Vegans with mental disabilities. And, she helped establish Variety School, a public school serving the same population.

Born in 1918 to Henry M. and Sarah Panzer Bassette, Dessie was born and spent her childhood in Bremerton, Colorado. She was one of eight children. Dessie graduated as valedictorian of her eighth-grade class. But during the Great Depression, the Bassettes' needs came before Dessie's education. To help, she hired herself out for housework and outdoor chores.

Always a hard worker, she found her life's purpose after moving to Las Vegas, where she married Elbert "Al" Bailey and had two children. First came son Patrick, then daughter Claudia, who had Down syndrome.

1918–1999
ADVOCATE FOR SPECIAL EDUCATION, FUNDRAISER, ACTIVIST

Dessie was an independent thinker, Patrick told the *Las Vegas Sun* in an April 17, 2000 article. "The conventional wisdom of that age was to immediately institutionalize the child without taking the time or trouble to bond with her. … My parents couldn't do that."

First Dessie and Al visited doctors and educators, "grasping at whatever straws they felt might help," Patrick recalled. When help did not come, the Baileys kept on. A group of parents formed the Clark County School for the Handicapped, and Dessie served on its first board.

The group publicized the need for community support of children with disabilities, which led to sponsorship by the Las Vegas chapter of the Variety Club.

In 1950, Las Vegas supporters held the first Night of Stars, to raise money for a school for handicapped children. The event collected $10,000, which enabled Dessie and others to buy land and break ground for a building, which they decided to name Variety School. The structure was built in part by volunteers, who often were fortified by large pots of Dessie's homemade chili. In 1951, a second Night of Stars raised $10,000 more, which bankrolled the school's completion.

Then came another setback. The Variety School board on which Dessie sat voted to enroll only children who were considered "educable," which meant

that Claudia and other severely handicapped children were again excluded.

For her own daughter, Dessie was back to square one. The stress caught up with her, and in 1953 she had a nervous breakdown.

Afterward, Dessie returned to her campaign to obtain an education for Claudia. In 1954, in the Baileys' living room, the Clark County Association for Retarded Children was created, with the aim of establishing a school for children with special needs who did not qualify for Variety School. This new organization eventually became Opportunity Village, which is still thriving in 2012.

With Dessie's encouragement, Peter Updike—who ran a similar institution in California—opened a school in Las Vegas. But it only lasted a year. Still, Claudia briefly had a chance to go to school.

Next the association opened another such school in Henderson's Carver Park, a segregated residential community designed to house blacks who were working at Basic Magnesium Inc., a plant that processed magnesium ore in World War II for U.S. aircraft and bombs. The school was a success, but after eighteen months, officials told the group that the school was operating illegally, and had to close.

Finally in 1957, Variety School opened four rooms dedicated to teaching children like Claudia Bailey. Then in 1958, Howard Marr—an educator who understood special-needs students—became principal at Variety. His commitment, plus an increase in funding, made Claudia's education a reality.

Then, to help intellectually handicapped students after they finished school, the Clark County Association for Retarded Children started the North Las Vegas Thrift Shop, a project that Dessie chaired. The shop lasted only two years, but it raised thousands of dollars for the after-graduation program to teach job skills, which eventually became the Opportunity Village Vocational Training Center. It provided training for Claudia Bailey and hundreds more.

In the early 1990s, Al Bailey, who had retired from the Union Pacific Railroad, began exhibiting symptoms of Alzheimer's disease, and he died in 1993. A few years later, Dessie also started showing signs of Alzheimer's. With Claudia, she moved to Bremerton, to be near her son, Patrick, and his family. Dessie died on November 28, 1999 and a year later, Claudia followed.

Dessie Lola Bailey will never be forgotten. Opportunity Village's Walters Family Campus has a Dessie Bailey Room, and Variety School has a wing named after this amazing Nevada woman. She fought for, and won, educational opportunities for children who had been so long denied.

Fran Haraway

Martha Gruss Barlow

Martha Gruss Barlow's family history is entwined with what made Nevada famous—the Comstock Lode. She had relatives who worked their lives in mining, although she herself moved into government and politics.

Martha was born in Silver City, Nevada. The town briefly made the news because of a silver strike, but later served as the link between the Comstock Lode mines near Virginia City and the processing mills at Dayton. Her schooling took place in Silver City, Dayton, and Simon, another Nevada town where silver ore was discovered.

Martha's father, Joseph Gruss, had come to Nevada by way of Michigan and Arizona; he was involved in milling and mining. Her mother, Lillian Harley, was the daughter of an Irishman who had sailed around the Horn—the southern tip of Chile—in the 1860s to reach the West Coast, and ended up in Virginia City, working in mines of the Comstock Lode. Lillian was born in Virginia City, which is where she married Joseph Gruss in 1912.

In 1920, when Martha was born, the census listed Joseph Gruss as a quartz miner. But by 1931 he was listed as one of four lessors of the Comstock

**1920–1993
COUNTY CLERK
AND TREASURER
ACTIVE MEMBER OF
POLITICAL PARTY**

Silver Mining Company, which resumed ore production that same year. Two years later, the local newspaper described him as "a prominent mining man."

Martha's mother, however, had interests that lay in a different direction. Having been a student at Virginia City's famed Fourth Ward School, Lillian became a teacher. For twenty-four years she taught in Virginia City and Silver City—at one point she simultaneously taught grades one through eight in an eighteen-pupil school.

Martha left Nevada for her higher education. She graduated from the commercial department of the Sisters Convent School in Grass Valley, California, and returned in 1939 to the family home in Silver City. By 1940 she was a state procurement officer for the federal Selective Service system, and lived in Carson City.

She also was active in the Young Ladies' Institute, a charity group composed of young women in the Catholic Church. She belonged to the organization for many years, and was also a charter member of the Soroptimists Club.

On June 30, 1946, Martha Gruss married Arthur R. Barlow of Mineral County; his family was prominent in ranching. Arthur had worked

with his father at the Dutch Creek Ranch. Arthur also had the distinction of being one of the first men called to military duty by the Selective Service.

Martha Barlow's entry into political life was recorded on February 12, 1954, in the *Reno Evening Gazette:* "A.J. Park who has served as Mineral County Clerk and Treasurer ... stated that he would not be a candidate for office this year and his deputy clerk and treasurer for the past seven years, Mrs. Martha G. Barlow, was the first to file to succeed him."

Martha, a Democrat, soundly won the 1954 election with more than a thousand votes. She began serving on January 1, 1955, and retained the post for thirty-five years.

Martha Barlow also served as a member of the Democratic Party Central Committee. And in 1956 and 1958, she was a delegate to the party's national convention.

The 1964 U.S. Senate race caused Martha to speak out. Republican Paul Laxalt ran against Democrat Howard Cannon, who won in Mineral County by two votes. The race was close, and vote totals in some counties were challenged, but Mineral County "held firm through the county commission canvas," according to the *Nevada State Journal.*

When the election investigator, a Mr. Duffy, announced that Mineral County might have had "possible irregularities," Martha was reported as saying Duffy should "enlighten the county clerk. ... I would have considered it courteous for him to have called me. I would have cooperated fully." But Duffy never did include Barlow in his investigation.

After Martha's husband, Arthur, retired from the civil service, he worked as a distributor for Standard Oil and a manager of the Mineral County airport. He died in 1964, but Martha carried on her work as an elected official.

Until her retirement in 1990, she continued to handle voting disputes and to educate Mineral County residents on practical topics such as voter registration and the issuance of marriage licenses. For more than three decades, she kept the office of the county clerk-treasurer running smoothly. She died on December 27, 1993.

Fran Haraway

Marjorie Jacobson Barrick

Marjorie Jacobson was born on October 9, 1917, in the small town of Harlan, Iowa, along the West Nishnabotna River. Her father, Clarence Jacobsen, was mayor of the small farming community of about 3,000 residents. Her mother 's maiden name was Mary Meta Faurschou.

From that modest Midwest start, Marjorie would progress in wealth and stature, eventually becoming a major financial supporter of the state university in the city of Las Vegas, which she and her husband made their home in the early 1950s.

Carol Harter, former president of the University of Nevada, Las Vegas, characterized Marjorie Barrick as a monumental figure in UNLV history. "She was iconoclastic," Harter said. "She was neither Republican nor Democrat, neither liberal nor conservative. There are very few people, I think, who are as well known in our community."

Marjorie had attended Creighton University in Omaha, Nebraska, receiving her bachelor's degree in 1940. There she met two men who would change her life.

1917–2007
PHILANTHROPIST,
SUPPORTER OF
EDUCATION AND CULTURE

The first was Edward Barrick, a businessman and widower who would become her life partner.

The second was Jackie Gaughan, a Creighton graduate who encouraged the Barricks to join him on a trip to Las Vegas. Gaughan went on to found a small family gaming empire in Las Vegas. Edward Barrick, too, saw potential in the town, and became a real estate developer. At various times, he was a part owner of the Flamingo hotel-casino on the Las Vegas Strip, and a part owner of the Horseshoe casino in downtown Las Vegas.

Marjorie did not end her education at Creighton. Once in Las Vegas, she started taking classes at the University of Nevada, Las Vegas. She said in a 1980 news article that she loved being around young students. She was known to read a book a day, as well as an array of newspapers and magazines to keep up with local and national news.

When Edward Barrick died in 1979, Marjorie made several decisions that continue to benefit UNLV students and Las Vegans in general. Her 1980 endowment to the university of more than $1 million underwrites several programs.

One of them, the university's Barrick Lecture series, is named after her husband. The series has attracted top names in academia and politics. Speakers have included former U.S. presidents Jimmy Carter and Gerald Ford, former Soviet Union President Mikhail Gorbachev, former South African President F.W. DeKlerk, chimpanzee researcher Jane Goodall, and film documentarian Ken Burns. The lectures are free and open to the public.

Other programs supported by the endowment include the Barrick Research Scholars Fund, the Barrick Faculty Development and Travel Fund, and Barrick graduate fellowships.

UNLV has thanked Marjorie Barrick in several ways. In 1985 it gave her an honorary doctorate in humane letters. In 1989, it named its on-campus natural history museum after her.

She served on many community boards and supported numerous organizations such as the City of Hope National Medical Center, Catholic Community Services, and Boys and Girls Clubs.

For her work, she received many awards, including Nevada Ballet Theatre's "Woman of the Year" award, and an appointment as member of Phi Kappa Phi, the academic honors society. In 1988, Nevada Governor Richard Bryan presented her a citation on behalf of the state.

Marjorie Barrick died at age eighty-nine on May 1, 2007. She was a wife, and the mother to a stepdaughter, as well as a businesswoman and philanthropist who came to a dusty desert town in Nevada, and left a lasting legacy.

Joan LeMere

Adalene Spence Bartlett

Horticultural maven Adalene Spence Bartlett shared her knowledge of gardening in the desert through many avenues. In the 1960s Nevada Governor Grant Sawyer selected her to lead the state's highway beautification program. But Las Vegans probably knew her best through a newspaper gardening column she wrote for a quarter-century, called the "Weeder's Digest."

Adalene was the oldest of three girls born to Frances Tuttle Spence and John Spence, an Irish immigrant who worked for the Union Pacific Railroad. Adalene was born in Pocatello, Idaho, on December 1, 1915. But the family uprooted her at age eight when they moved to Las Vegas.

Adalene enrolled at the now historic Fifth Street Grade School. Then in 1931, at age sixteen, she was part of the first graduating class of the Las Vegas High School. Friends called her "Ad."

She met Bob Bartlett, the love of her life, during her high school years. On December 24, 1934, she and Bob eloped to Pioche, Nevada, and married in a civil ceremony performed by Judge Roy Orr. They spent the first two years of their marriage in Pioche, where Bob worked for a lumber and hardware supplier while Ad worked for the local telephone company.

1915-1987
HORTICULTURIST, COLUMNIST, PARKS ADVOCATE

In 1938 the young couple moved back to Las Vegas. Ad used the secretarial skills she had learned in high school by working for the law firm of Ham and Taylor.

Bob initially worked at a hardware service, but then he and his brother, Bud, jointly purchased the Ullom Hardware Store on Fremont Street. They renamed it Bartlett Brothers Hardware and Sporting Goods. Ad then joined the family business, doing inventory and sales, but she also saved time to garden at the home she and Bob built near the intersection of Bonneville Avenue and Second Street.

Just before World War II erupted, Ad and Bob were blessed with the arrival of their first child, daughter Margo Ann, who arrived in September 1941. Their second child, Robert Bruce, was born in 1944.

Prior to his birth, the family relocated to a larger home in the recently opened Huntridge housing development south of downtown. There, Ad met the challenge of converting desert terrain via the planting of garden flowers and shade and fruit trees. Her prowess made the Bartletts' yard the envy of many neighbors.

As well, the Bartlett brothers moved their store to a larger building between Fifth and Sixth streets.

In the early 1940s Adalene joined the Mesquite Club, a ladies' civic organization, and the U-Ahn Study Club. A highlight of this period was her participation in the Mesquite Club's popular flower shows. She won many ribbons and trophies for her floral arrangements. In the late 1940s, Ad and Bob briefly lived in Reno, establishing a second Bartlett Hardware and Sporting Goods store.

Ad was an early member of the Nevada Federation of Women's Clubs, which is an affiliate of the General Federation of Women's Clubs. She served as president of the Mesquite Club in 1953 and 1954. During her tenure the club worked at establishing the first housing for the elderly.

The 1950s expanded both Ad's family and her professional reach. In 1955, she gave birth to their third child, Debra Frances. Bob bought out his brother, and converted the business from hardware into a china and gift shop. Also, the *Las Vegas Review-Journal* hired Ad to launch and write the "Weeder's Digest" column.

The twenty-five-year run of the column is testimony to its success. During that span, Ad made numerous television appearances to share her horticultural knowledge. She also hosted a local radio program on desert gardening.

Then she spread her interest beyond gardening, to the establishment of beautiful outdoor places for the public to enjoy. She helped the city of Las Vegas acquire the Twin Lakes Resort for a city park, now known as Lorenzi Park. She fought for the preservation of the Red Rock Canyon area west of the city, which today is federal property. She joined the movement to acquire land that became Ralph Lamb State Park, although this site has since become a city park.

In the 1960s, the governor named Ad Bartlett chair of a state beautification program, which was created in compliance with a national program created President Lyndon Johnson's wife, Lady Bird Johnson. Ad continued to serve in this capacity for the terms of two subsequent Nevada governors.

Then in the 1980s, Ad spearheaded numerous Mesquite Club fundraisers, whose proceeds went to the creation of the Lorenzi Park Rose Garden, located for many years at the park's northwest corner.

Adalene Bartlett's dedication to gardening lives on in the Adalene Bartlett Memorial Grove, a group of trees at Lorenzi Park, located near its garden club and the lovely rose garden. The grove's dedication took place in December 1988, exactly one year after her death in December 1987.

Mary Gafford

Selma F. Abdallah Bartlett

Selma F. Bartlett was a born into family that suffered severely from the stock market crash of 1929. As an adult, she became a military wife. Her husband's career led them to Southern Nevada, where Selma eventually became a bank officer who contributed to the growth of Henderson, Nevada.

Selma was born in 1927 to Amen and Louise Abdallah in New York City. She was the first of two daughters. After the 1929 financial crash—in which her father lost all his assets—the family moved to Oklahoma, where Louise's brother lived. They purchased a small farm with a one-room house, which was home for Selma in her early years.

She attended a one-room elementary school and a small country high school. For Selma, it was a time of little money, learning responsibility while the family lived off its farmland, and being active in school.

Selma met her husband-to-be, Troy Bartlett, in high school, where she watched him star in basketball and track. When World War II came,

alive on 9/1/14

1927-2011
BANKER, BUSINESS LEADER

Troy joined the U.S. Army Air Forces and Selma went to a business college in Oklahoma City. There she accepted her first job as a secretary.

When the war ended in Europe, Troy came home for a month, with orders to ship out to fight next in the Pacific. The couple seized the opportunity to marry. Not long after, the war ended.

Troy decided to stay in the military, with the aviation branch of service becoming the Air Force. His career took the couple to Albuquerque, New Mexico, and then to Nellis Air Force Base near Las Vegas. During the next ten years, Selma was often home alone for long periods while Troy travelled for his work.

In 1954 she landed a job at the Bank of Nevada. Around this time, Selma's mom Louise came for a visit, and fell in love with the town. She decided to stay, which pleased Selma and Troy.

In 1964, Troy retired from the military. The Bank of Nevada's president, Art Smith, offered

Troy a job at the same bank branch where Selma had been working the last decade.

Selma was one of the first women in Nevada to be appointed a bank officer. She excelled in her job. She once said that she concentrated her efforts, "first, on the community's growth and stability. And second, [on] my career as a banker." She said her philosophy was that "if Henderson was strong, the Henderson bank would be sound and would grow."

Back in the 1950s, Henderson was in its infancy. Its early business leaders, including Selma, formed a team to create a caring, family-oriented community. She became known as the banker who always spoke up for the community and its commerce. Her banking career spanned forty-five years, in which Bank of Nevada grew tremendously.

Selma spent a lot of time participating in civic and business organizations including the state's Nevada Economic Development Board, the Henderson Chamber of Commerce, the Henderson Development Association, and its Downtown Progress Association. She was a trustee of the James I. Gibson Library, the first facility in the Henderson public library system. She also served as regional vice president of the National Association of Bank Women, and taught for the American Institute of Banking at the Clark County Community College, which today is the College of Southern Nevada.

In 1989, Selma was honored with a National Jewish Humanitarian Award and received a commendation from the city of Henderson. The Henderson Chamber of Commerce also gave her an Outstanding Member Award.

Selma Bartlett ~~passed away on February 1, 2011, at age eighty-four. She~~ my will be remembered as a pioneering female banking officer who always put Henderson first.

Denise Gerdes

Billie Mitchell Bates

Billie was the lifelong nickname of Beulah Mitchell Bates, who was born on January 13, 1912, in Missouri, to Oliver and Flora Mitchell. She received a bachelor's degree in education from Southwest Missouri University, and in 1936, she wed Russell Bates in Aldrich, Missouri, the town of her birth.

Billie's Nevada connection began in 1942 when she, Russell, and their two daughters, Cornelia and Jeanne, moved to Boulder City from Bakersfield, California, where Russell had been working for the California Highway Department. They had visited friends in Boulder City, admired the town and decided to settle there.

Like many before her, Billie did not immediately fall in love with the desert. Russell, who was a heavy-equipment operator, was working on modifications to the Hoover Dam switchyard. The family could not find housing in the town proper, which was governed by the federal government, so they settled in a nearby area called McKeeversville. While the dam was under construction, McKeeversville sprung up as a tent city; over time, residents built makeshift houses there, too.

"This was the first desert country we had lived in," Billie later recalled. "Away from the town,

1912–2010
MEMBER OF CIVIC
GROUPS, INSTRUCTOR
OF PARLIAMENTARY
PROCEDURE

everything seemed so bare. It took us a while to see the beauty. Now we think the desert is wonderful, but it took a while."

Billie also eventually described Boulder City as "just the right size town. … I like to shop where I know the merchants by name."

The Bates daughters went through the local school system. Although both daughters moved out of state, they present Billie with a total of fourteen grandchildren and twenty-four great-grandchildren.

Billie had vivid memories of the World War II years in Boulder City. "Hoover Dam had to be protected," she explained. "The government established a military police camp here. The parade ground was right where this house is now," she said during an interview at her home.

She recalled that both entrances to the city were guarded. When travelers were escorted across the dam, their escorts carried machine guns.

After the war, some facilities changed. "The camp called Williston [which covered an area where Boulder City High School now stands] was closed," she explained. "The barracks were torn down. Near where Sixth Street is now, there was an army theater, which the Army donated to the city. The

Circle 8 Square Dance Group was started there. At that time they used live music, and I sometimes played the string bass violin with the band."

In spring 1942, Russell Bates was injured in an industrial accident at the dam and was unable to work for three years. Billie got a job as executive secretary to the project manager at Hoover Dam. Even after Russell recovered, she continued working at that job. She served under six managers until 1975, when she retired.

At that point she pursued several interests: parliamentary procedure and preservation of local history.

She joined a study group run by friends in Las Vegas, which taught her parliamentary procedure. After two years she became a registered parliamentarian, which allowed her to present programs according to Roberts Rules of Order, do consulting, and lead training workshops.

For her training of New Mexico state government employees, the state's governor gave her an award in 1973. In 1973 the U.S. Secretary of the Interior honored her with a Silver Medal for Meritorious Service for her training of federal employees.

Her interest in local history led her to participate in the Southern Nevada Museum Guild, the Clark County Museum, the Searchlight Museum, and the '31ers, a Boulder City group that celebrated people who were local residents during the town's early days.

On July 26, 1986, Billie and Russell Bates celebrated their fiftieth wedding anniversary at the Boulder Dam Hotel. Russell died in 1994, after fifty-one years of living in Boulder City. But widowhood and retirement did not slow Billie down.

Over the years, she accumulated numerous credits and honors. She belonged to the National Association of Parliamentarians, the American Institute of Parliamentarians, the Nevada State Association of Parliamentarians, the American Society for Training and Development, the International Toastmistress Club, the American Society of University Women, the League of Women Voters, Common Cause, St. Jude's Women's Auxiliary, the Friendship Force of Southern Nevada, the Daughters of the American Revolution, the Women's Democratic Club of Clark County, and the Clark County Democratic Central Committee. She was also an active member of the Church of Jesus Christ of Latter-day Saints.

Billie also served on the board of directors of the Frontier Girl Scouts Council and the board of the Boulder City Arts Council. Both the Girl Scouts of America and the American Association of University Women made her an honorary life member.

On May 17, 2010, Billie Bates died at age ninety-eight. She lived to her death in Boulder City, which she once called a "little piece of heaven."

Fran Haraway

Kathy Mackley Batterman

Thousands in Las Vegas owe their lives to the Flight for Life medical transport program—and to nurse Kathy Batterman, who gave her life in the course of duty, when a Flight for Life helicopter crashed at night in a sleet and snowstorm as it returned to its home base in Pahrump, Nevada.

"Fly high, make a difference," is the motto of a public elementary school named after this hero.

Batterman, who died at age forty-four on April 3, 1999, was one of the originators of Flight for Life, which began operating in 1980. The service flies helicopters staffed with nurses, paramedics, emergency medical technicians, and respiratory therapists, who scoop up the injured from ghastly accidents and try to stabilize them medically while transporting them to the nearest hospital.

Such flight nurses and paramedics usually perform for their critical patients procedures and treatments that are more advanced than what a traditional ground paramedic does during transport. This includes the placement and monitoring of chest tubes, use of aortic balloon pumps, as well as certain surgical procedures.

1955–1999
FLIGHT NURSE, EDUCATOR

At 11:15 p.m. on that April 3, Kathy and her crew had dropped a patient off at Valley Hospital Medical Center in central Las Vegas. The crew—which included the pilot and a second nurse—was headed back to its base at Hidden Hills Airport in Pahrump, in Nye County, which is sixty miles west of Las Vegas.

The weather was bad with sleet and snow. The pilot attempt to avoid the worst of it by flying a northerly route around the Spring Mountains and over Mount Charleston, which is a peak located between to Las Vegas and the helicopter's Pahrump base.

According to the National Transportation Safety Board's final report, the pilot probably suffered "spatial disorientation and subsequent loss of control" of the aircraft in weather that had reduced visibility to less than fifty yards. His reliance on "visual flight rules"—VFR for short—rather than navigation instruments probably caused the crash that killed all on board. Weather factors can significantly affect decisions made by the pilot, who is the final say on whether any flight is a "go or no go."

Surviving Kathy are her husband Kurt Batterman, also a critical-care and advanced-trauma nurse, and two children, Christopher and Jennifer.

Kathy was originally from Joliet, Illinois, where she was born Kathy Mackley on January 13, 1955. During her flight career, she flew over 3,000 rescue flights. Her mother-in-law, Harriet Batterman of Topeka, Kansas, said that although Kathy did at times worry about her safety, she felt her flight work accomplished good.

Kathy was not a formal educator, but she taught others the value of life and professional excellence through her pioneering of EMS (emergency medical services) education in Nevada. She led classes every year for emergency medical technicians, park rangers, scouts, and other health-care personnel.

She also assisted several local fire departments, ambulance services and community hospitals in their efforts to obtain various professional certifications. In particular, she helped obtain the certification for the first local course in trauma nursing for emergency-room nurses.

On October 8, 2002, three years after Kathy's death, the Clark County School District's naming committee submitted her name as one of five to be considered by the school district trustees for naming new elementary and middle schools.

"We are so proud to be opening the school in the name of such a remarkable woman," a spokesman eventually said about Batterman Elementary School, which is in the southwest quadrant of the Las Vegas Valley. "We will make sure the children know about her. Our motto is also a tribute to her: 'Fly high, make a difference.'"

Batterman Elementary opened for kindergarten through fifth grade on a year-round calendar, reflecting the growth of Las Vegas in the first decade of the new millennium. The Clark County School District, which has been the fifth largest school district in the nation, used a new prototype school design when it built Batterman's namesake school.

On April 25, 2006, U.S. Representative Jon C. Porter (R-Nevada) paid tribute to Batterman in his house of Congress. "Mr. Speaker, he said, "I am proud to honor Kathy A. Batterman for her dedication to providing emergency medical service to the Las Vegas and outlying community. Her death is a profound loss to the community and the medical profession."

In 2009, the National EMS Memorial Service released the names of ninety-one individuals from twenty-six states whom it was honoring for the loss of their lives in the line of duty. On that list was the name of Kathy Batterman.

Barbara Riiff Davis

Frances Pugh Beaupeurt

eno socialite Frances Beaupeurt was a "club woman," par excellence. Late in life she credited her civic activism to her husband, John, who "liked for me to be out and doing things."

She was born Frances Huntington Pugh on May 30, 1896, in Pueblo, Colorado. Her father, Ulysses Grant Pugh, was a steel mill crane worker who moved the family to Northern Nevada in 1911. Frances' mother, Mary Alice King Pugh Landt, was a member of the Nevada Sagebrush Chapter of the Daughters of the American Revolution, who inspired her children—Frances and her older sister, Gladys—to become socially active women as well.

Frances married John Edward Beaupeurt in 1917, and gave birth to their son Edward Francis Beaupeurt in 1918. At that point her social life really took off. John was a prominent banker, first in Yerington at the Mason Valley Bank, and later in Reno, where he was transferred in 1937 after his bank merged with the First National Bank of Nevada. John served as the secretary of the Nevada Bankers Association for 21 years—a position he held until his death in 1961.

His status in commerce coupled with Frances' energy and charm were a perfect combination

1896—1990
MEMBER AND LEADER OF CIVIC GROUPS

as the couple became active in numerous circles. John belonged to the Yerington Rotary Club, the Fraternal Order of Eagles, and the Hope Lodge of Masons in Yerington. Frances held a variety of positions in organizations including the Eastern Star and the Community Concerts Association. She also was state president of the American Voluntary Services, and Nevada regent for the Daughters of the American Revolution.

However, she made her greatest contributions to the Reno Women's Civic Club, the Twentieth Century Club, the Nevada Federation of Women's Clubs, and the Pythian Sisters.

When Frances was president of the Reno Women's Civic Club in 1952, the group made a high priority of assisting the elderly by advocating for better housing, housekeeping assistance, and a visiting nursing service. The club also advocated for better housing for families with low incomes.

While Frances was president of the Twentieth Century Club, its annual fashion show was a popular and anticipated event. The club was known for its philanthropy to advance social issues and education. It was also a forum for discussing current events and the arts.

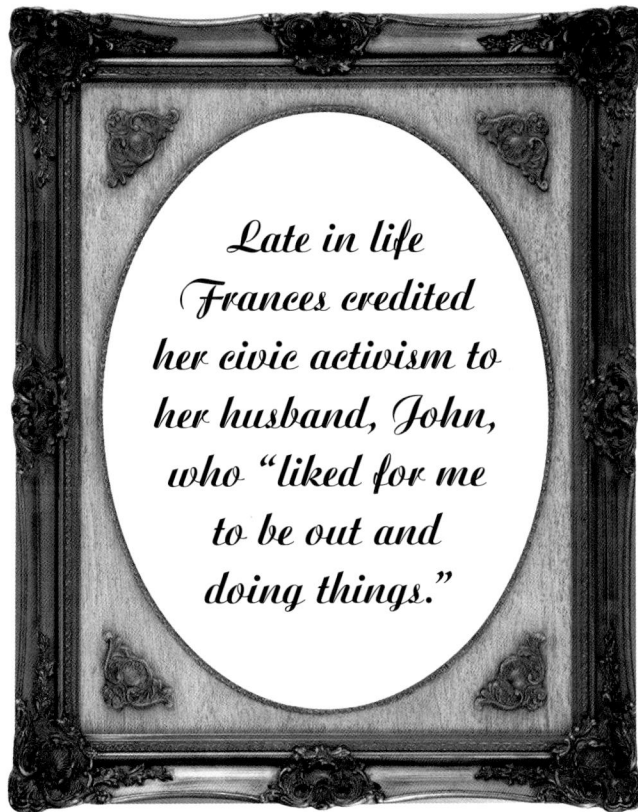

Frances also served as president of the Nevada Federation of Women's Clubs in 1956, when it lobbied the Nevada Legislature in support of Aid for Dependent Children. Lobbying the Nevada Legislature was of grave importance, as Nevada was the last state in the Union to pass this critical bill. That activism suited the Nevada Federation's heritage, as it was a state affiliate of the General Federation of Women's Clubs, which had formed in 1890 to allow women—who were then routinely denied access to all-male professional and social clubs—to promote social causes, starting with the reform of child labor.

In April 1958, Frances also presided over the Nevada Federation's golden anniversary, which was celebrated in Las Vegas.

Both Frances and John Beaupeurt were active in the Pythian Sisters, an auxiliary to the Knights of Pythias, a fraternal order founded in Washington, D.C., in 1864, to which U.S. congressmen and presidents have belonged. John served as chancellor commander of the Greenfield Temple of Pythian Sisters, and from 1933 to 1934, Frances served as grand chief of the Pythian Sisters at Yerington.

Within the Pythian Sisters, Frances went on to assume the national position of Supreme Guard, followed by the position of Supreme Press Correspondent of Canada, the United States, Alaska, and Hawaii. Her service culminated in

Late in life Frances credited her civic activism to her husband, John, who "liked for me to be out and doing things."

1970, when she became Supreme Chief of the Pythian Sisters, which was the highest national position a woman could hold. She was the first Nevadan to hold a national post in the organization.

Frances was proud of her son, Edward, who was attending the University of Nevada, Reno when he put his education on hold to enlist in the United State Army in 1940. He served in the Aleutians, France, and Germany, where he ultimately was in charge of 79,000 military prisoners. He had achieved the rank of captain when he was discharged in 1945, and returned to UNR to complete his studies for a business degree.

In 1988, at the age of eighty-seven, Frances proudly celebrated the sixtieth anniversary of the Nevada Sagebrush Chapter of the Daughters of the American Revolution by cutting the first slice of cake using her son's military dress sword. A staple of Nevada society pages for her charitable deeds and accomplishments, Frances also was listed in the first edition of *Who's Who of American Women*, and in the seventh edition of *Who's Who in the West*. She lived in Reno until her death in 1990.

In an interview for the January 3, 1971, *Nevada State Journal*, Frances Beaupeurt traced her activism back to her husband, John: "I think I owe my interest in club work to my husband. He always liked for me to be out and doing things."

Joyce O'Day

Isabelle Slavin Blackman

In Las Vegas, that town of ultimate chance-taking, two Las Vegas High teachers married in April 1932.

Isabelle Slavin Cuddy—the Catholic grand-daughter of a Union soldier who had served as a personal messenger to Abraham Lincoln—took a chance at remarriage by getting hitched to Alfred W. "Tex" Blackman, the Protestant grandson of a Southern plantation owner who had operated a cotton gin.

Tex taught business courses, and Isabelle—who had come to Las Vegas to teach under educator Maud Frazier, her "old and very dear friend"—taught biology. The wedding took place at the home of the bride's parents. Witnesses included Eugene Slavin, the bride's brother, and Ruby S. Thomas, whose eponymous elementary school has served special-needs children in Las Vegas for decades.

Taking a chance worked for the Blackmans. Describing their life together as good, Isabelle once wrote that their diverse backgrounds "make no difference where there is mutual respect and understanding.

The Blackmans resided at 2001 Goldring Avenue, where the University Medical Center Trauma Center stands today. They had a daughter,

and raised her along with Isabelle's two children from her prior marriage to W.T. Cuddy: Helen and W.T. Jr. According to Isabelle's younger daughter, Catherine Blackman Hammelrath, "My parents owned nine contiguous lots in the old Woodlawn subdivision. We had our own water well, horses, chickens, ducks, turkeys, and lots of cats."

Hammelrath, in a memoir she wrote for the Las Vegas centennial celebration in 2005, also remembered, "We had an alfalfa field where we played hide and seek. And the Tate fields across the street kept us supplied with crawdads and mosquitoes."

Tex was the "first CPA," or certified public accountant, in Las Vegas, according to Hammelrath. Isabelle was one of the founders of the local Beta Sigma Phi.

Isabelle was born to Charles L. and Frances Rose Geraghty Slavin in Canon City, Colorado, at the home of her maternal grandparents. She was the eldest of nine children. She described her childhood as "spent in two mining camps, Leadville and Cripple Creek, Colorado. These were wonderful years, years filled with freedom to run, climb, and investigate." Isabelle also described the joy of welcoming younger

1898–1995
TEACHER, MEMBER OF CIVIC GROUPS, WRITER

siblings—and the sorrow of losing several of them.

After living also for a time in Sonora, Mexico, the Slavins moved to the Nevada mining town of Goldfield, which Isabelle described as a "real boomer with crowded streets, hurrying people and rich miners. These people worked hard, played hard, and were most kind."

The Slavin family's final move was to Tonopah, where Isabelle's father—a blacksmith by trade—served as assistant police chief, deputy sheriff, deputy assessor and deputy county treasurer. He served two terms as Nye County clerk-treasurer, which was his last position. Frances Slavin succeeded him and served several years as county clerk-treasurer.

Isabelle once reminisced about the Slavins' Tonopah home, which was, "high on a hill overlooking the town below, and with a good view of the miners winding their way up the road to the Belmont Mill. Three shifts a day made that trip up and back. What a fairyland of lights that old mill was each night. And it is a shame that many living here will never know the feeling of a mining town—the horrors of the fires, the excitements of the strikes, and the wonderful friendliness."

After earning her degree from the University of Nevada, Reno, Isabelle enjoyed a year-long teaching fellowship at the University of Oregon, and a summer's further study at the University of California Berkeley. She taught in Tonopah for a year, and then married W.T. Cuddy, who was publicity manager for the *Milwaukee Journal*. They had two children. It is not clear whether Isabelle divorced or W.T. died.

In 1931, she and her children moved to Las Vegas, where she met Tex Blackman, and took a chance on remarriage. She died in March 1995.

Isabelle Blackman's primary contribution to Clark County history came through her involvement the Las Vegas Mesquite Club, which, at its birth, was a literary organization. But it quickly became a source of cultural stability in that rough railroad town, Las Vegas.

Mesquite Club members established the first community library, created and maintained the rose garden at Lorenzi Park, and started an endowment at the University of Nevada, Las Vegas to buy children's literature. It also supported many art-themed activities and organizations. Isabelle served as the Mesquite Club president in 1946 and 1947, and she was made an honorary member in 1951.

She also performed a valuable service by recording the activities of other women who molded Nevada, through her *History of the Mesquite Club*, which was published in 1966, and *Biographies of Past Presidents of the Mesquite Club 1911-1967*, which was published in 1967.

Fran Haraway

Emma Lou Montgomery Brandt

Emma Lou Montgomery—known as "Monty"—was born October 13, 1917, in Oswego, Kansas, to Madge and Clarence Montgomery. She earned an associate's degree from Christian College in Columbia, Missouri, and a bachelor's degree and teaching certificate from the University of Kansas, in Lawrence.

Monty taught history and economics in Stillwell, Kansas, but her main contribution to the Silver state did not come in the form of teaching. Rather, she was active in many Las Vegas civic organizations.

Her move westward began after she and Ted Brandt were wed in Oswego on April 7, 1941. One could say they literally started their marriage with a bang, thanks to an earthquake that hit Mexico City while they were honeymooning there.

The couple then settled in Denver, Colorado, where Ted worked as a pharmacist. Daughter Margaret Ann was born November 29, 1942, then son Robert, on October 16, 1945. In the fall of 1946, Ted accepted a job with the Mayfair Drug Store in Las Vegas.

They drove to Nevada in a Chevrolet coupe that had no second seat. Ted, Monty and four-year-old Peggy sat up front. Bob was so little he slept on a blanket in a box on the ledge by the back window. They drove straight through to Las Vegas, arriving on September 30.

On October 1, they moved into their first Las Vegas home, on Wengert Street, just a block from John S. Park Elementary School. The city had about 19,000 residents. There were only two casinos on the Strip—the Last Frontier and the El Rancho. Downtown was the bigger entertainment district, offering the Sal Sagev, the Las Vegas Club, the Fremont, Horseshoe, and Golden Nugget casinos.

On the Brandts' first Christmas in Las Vegas, Ted went to check the Mayfair and found the safe open, and empty. The owners lived in Utah, so he phoned the store's local attorney to ask what to do. The attorney told him to walk in and out of every casino until they found the perpetrator. The Brandts walked about a block, and found a man gambling, whom they believed was the culprit, according to an oral interview with Monty Brandt. She did not identify the culprit by name, but said he told them he had intended to return the money out of his winnings. The attorney had the man sign a paper to repay the money, and he agreed to leave town that night. According to Monty, the man did indeed pay

1917–2006
TEACHER, BUSINESS OWNER, COLUMNIST

everything back. This was Las Vegas justice, 1940s-style.

Ted Brandt managed the Mayfair for only a year, as the owners failed to live up to their contract.

Meanwhile, Monty started teaching again. First she did substitute teaching at the Biltmore Elementary School, third grade. The next year she taught full-time at a school with Harvey Dondero, a local legend, as principal.

But Ted claimed Monty's teaching cost him more than she earned, so he agreed to give her twelve dollars a month if she agreed to stay home. She accepted his offer.

Next Ted bought a half interest in the White Cross Drug Store, which was the business of early city father, W.E. Ferron, who had opened his first store in 1916. Later he relocated to a larger space at Second and Fremont, across from the Golden Nugget. It was this store that Ted bought into.

During this period, the city's biggest event was Helldorado, which lasted three days in May, highlighted by a big parade. The parade route started at Main Street, went down Fremont to Fifth, and then up Fifth to Cashman Field. Everybody brought blankets and chairs to save a spot on Fremont Street to watch.

One year, Ted let his cosmetics employee take everything out of the store's front window, so family and friends could put chairs in the window. This raised location gave the best parade view in town.

A short time later, a White Cross Drug opened on Oakey Boulevard. The town's first twenty-four-hour store, it attracted show people and tourists, too. It was there that Monty caught a glimpse of Christine Jorgensen, one of the first individuals to undergo a sex reassignment surgery. Regular customers included Red Skelton, the McGuire sisters, and an Arab with several wives.

After Ted's death, Monty hired a manager, but she oversaw the management and ordering, and maintained financial control until her retirement in 1980.

Monty was active in the city's first Presbyterian church, where she taught Sunday school for twenty-five years. It started in 1952 and moved about until eventually it located permanently at 1515 W. Charleston Boulevard. She was also active in the Service League, Junior League, Southern Nevada Museum, the American Field Service foreign exchange program, the Panhellenic Club, American Association of University Women, and the Daughters of the American Revolution.

In addition, she was second president of the Frontier Girl Scout Council and wrote "Scout About," a weekly column in the *Las Vegas Review-Journal* that covered local Girl Scout activities.

Emma "Monty" Brandt died on May 9, 2006.
Betty Middleton and Jean Spiller

Hope Gaufin Broadbent

Ely—which is the seat of White Pine County and the hub of mining activity in east central Nevada—was the destination of newlyweds Hope and Nevin Edward "Broadie" Broadbent in 1925. They had boarded the Nevada Northern Railway train in Salt Lake City on June 25, and were headed west to Ely with great anticipation.

They had married in the Salt Lake temple of the Church of Jesus Christ of Latter-day Saints, and much of Hope's adult service to her community of Ely would be through church programs.

Born on March 10, 1903 in West Jordan, Utah, Hope Gaufin once said, "I was told I weighed three pounds at birth, and the doctor put me in a shoebox, surrounded by cotton." She was the oldest of the seven children born to Ephraim Gaufin and Rhoda Ann Miller Gaufin.

"Amazing, all seven children had advanced education that prepared them for work, which was a marvel in that day," she also said.

Her father, who was a teacher, nurtured in Hope and her siblings a love of learning. As a result, Hope graduated from the University of Utah in 1923, with a degree in home economics. She was

1903–2002
TEACHER, CHURCH LEADER

a member of Phi Kappa Phi, an honor society that held the motto, "Let the love of learning rule humanity." She then taught high school in Sandy, Utah, for two years.

When Hope and Broadie married, he, too, was well prepared for life, with a degree in pharmacology. They intended to open a drug store, and Ely had been carefully selected for its growth potential.

When they first arrived, they stayed at Ely's Nevada Hotel. The location was convenient, as they acquired the property next door for their business.

"I was alone in our room when Broadie was working during the daytime,' Hope later recalled. "I would go out to walk, and I walked different parts of town. One day Broadie asked me where I had walked that day and when I told him, he explained that was the prostitution area, and I might want to visit other areas."

But while walking and getting acquainted with their new community, she discovered the site where they would one day make their own home.

"When we first came here, there were no street lights, no curb or gutter, many dirt roads. No

34

new homes were built, and no sense of community—because everyone was just taking everything out of the community and putting nothing back. However, there were many opportunities for service," Hope once said.

The Broadbents' first child, Robert, was born June 19, 1926, at the Steptoe Valley Hospital in Ely. Susan, their second child, was born September 1, 1928.

After the children were born, Hope became a substitute teacher in Ely. She taught seven years, including the years of World War II.

Besides owning Steptoe Drug in Ely, Broadie served as Ely's mayor for sixteen years. He also served on the state's Board of Pharmacy for thirty-seven years.

When the Broadbent children graduated from high school, Hope went to work full-time as co-manager of the drugstore, which she did for thirty-five years. "I loved working with the public," she told an interviewer. "I always liked to great the people by their names. … Many times I had the opportunity to help someone who really needed

service—not things I made public, but things that made me feel good."

As a member of the Latter-day Saints, Hope served as the Ely Ward Relief Society's president as well as president of the Nevada Stake Relief Society. She also taught professional tailoring.

Broadie died on April 4, 1979, after three years of illness. But before his death, they sold the store to their nephew, Art Olsen. Hope continued to work there for a while, but eventually moved to Boulder City to be near relatives.

"I lived most of my life in White Pine County and have loved the experience," she once said. Asked what enabled her to get along well with people, she answered, "Liking them. I used to be real judgmental. But now I see the good in all people. Enjoying them. Liking them."

Hope died at age ninety-eight in Boulder City on February 2, 2002. She was buried beside her husband in the Ely City Cemetery. In Ely they began their life together, and in Ely they finished their journey.

Alice Bunker

Jane Hopkins Broadfoot

Jane Hopkins Broadfoot has the distinction of being the world's first female boxing timekeeper. She officiated at bouts featuring some of the world's most famous boxers at renowned Las Vegas venues.

That was not her sole occupation, however. She also was a registered nurse who worked in general practice and pediatrics. She also did some work in television and radio.

Jane Elizabeth Hopkins was the only child of Thomas Jefferson Hopkins, a hospital administrator, and Jeanette James Hopkins, a poet. Jane was born in Meridian, Mississippi in 1924. When she was in her early teens, her parents divorced. Thomas was an avid sports fan, and it was by listening with him to sports on the radio that she developed her own interest in sports.

Jane attended the University of Mississippi in Oxford. There she met and married Jack Shaw, a businessman. They had one daughter, Jacqueline Jeannette, but divorced in 1948. Jane then married an Air Force man, Railton Sprake, with whom she had one son, John. The family traveled all around the United States with the Air Force, and also to St. John's in Newfoundland, Canada. They finally moved to Nellis Air Force Base in Las Vegas, in 1953.

In 1957 the couple divorced. The same year she met and married Dan Broadfoot, who worked in television for what was then Channel 2 (now Channel 3). Jane was an occasional co-host with Dan on a local show; together they also did a late-night movie segment. Jane also had a radio show, *Women's Side of the News*, during the 1970s, which was an exciting time for women's rights as the states were deciding whether to pass the Equal Rights Amendment.

In the 1970s, Nevada was a "small" state with less one million residents. The low population made networking easy. That was how Jane came to be asked to be a boxing timekeeper.

Jane loved boxing, and she loved that timekeeping was part-time work. It allowed her to continue working as a nurse, and also to do volunteer work.

1924—2011
NURSE, RADIO AND
TELEVISION CO-HOST,
SPORTS TIMEKEEPER

With her nursing background she assisted doctors with the physicals in the Golden Gloves program for amateur boxers.

She worked in professional boxing from the 1970s through 2006. Referees and timekeepers formed a pool, rotating the various jobs. Jane worked a lot of the big-name fights at the MGM Garden Arena, Mandalay Bay, and Caesars Palace for boxers including Roberto Duran, Sugar Ray Leonard, George Foreman, Larry Homes, Evander Holyfield, and Mike Tyson. She also worked a lot of fights with boxers from Mexico including Erik Isaac Morales, Marco Antonio Barrera—and from the Philippines, Manny Pacquio. In 1984 she worked some of the qualifying matches in Las Vegas for the summer Olympics held in Los Angeles in 1984. She also was a spectator at some of the Olympic boxing action.

Jane did not volunteer solely in the amateur boxing world. She also volunteered her time helping adults with learning disabilities. She helped one organization that raised money to purchase old motels and small apartment houses, to convert into supervised housing for individuals with disabilities.

She also supported Boys Clubs, which later become Boys and Girls Clubs.

Jane and Dan divorced in the 1980s but remained friends.

Over time, it became hard for Jane to carry or roll the bell equipment used at boxing events, so in 2006, the year she turned eighty-two, she retired from the sports world. In May 2011, she passed away.

Tish Campbell

Eileen Milstein Brookman

Eileen Milstein Brookman made her mark on Nevada mainly through politics, but also through participating in issue-based organizations including the Women's Democratic Club and the National Association for the Advancement of Colored People. She was a Nevada leader in support of the Equal Rights Amendment.

Eileen was born in Denver, Colorado, on October 25, 1921. Then her family moved to Los Angeles, where she attended Eagle Rock High School, and then the Los Angeles City College. In 1941 she married George Brookman, who at that time was in the U.S. Army. The couple had two children in California before their move to Las Vegas, which occurred sometime after 1948.

George became a general contractor in Las Vegas, and Eileen got involved in the community. She joined organizations including American Business Women's Association and Nike House.

**1921–2004
STATE LEGISLATOR,
MEMBER OF SEVERAL
STATE BOARDS, WOMEN'S
RIGHTS ACTIVIST**

Her entry into politics came in 1962 when Governor Grant Sawyer appointed her as the state's Indian commissioner. Then in 1965, she was elected to the Nevada State Assembly, where she served through 1977. In 1986 she ran again and was elected; then she was reelected in 1988.

Since she was only four feet ten inches tall, she decided she needed to make herself more noticeable. She started to wear the color orange everyday, and that color became her signature. From that point, all her campaign materials were produced with orange. And even after she left the Assembly, orange continued to be the identifying color for her district, Assembly District 9.

Eileen, who was called "Queenie" by friends, advocated with passion for those less fortunate. She worked for the rights of minorities, women, the disabled, the poor, and the elderly. During her time in the Assembly, she sponsored the Older Americans Act, which resulted in the

creation of the Nevada State Department of Aging Services and the Meals on Wheels program, which still serves food for seniors who are unable to prepare their own meals or leave their homes.

When Eileen recognized that "pay" toilets constituted unequal treatment for women—men always had the option to use a free urinal—she introduced an Assembly bill to eliminate pay toilets. Her rationale was that women were unfairly paying more for the upkeep of public facilities than men. Across the nation, state and cities began passing laws to do away with pay toilets.

In 1982 Eileen was appointed chair of the Nevada delegation to the White House for the Conference on Aging. Later, she was also appointed to the Nevada Commission on Aging. In this capacity, she worked on legislation to provide better transportation alternatives for seniors, which became the Older Americans Act. It guaranteed reduced transportation fare for seniors, and led to the creation of the state's Aging Services. That same year, she was appointed to the Nevada Taxi Cab Authority.

Among her many awards, Eileen was named Clark County's Humanitarian Mother of the Year. In 1982, she received a Distinguished Citizen Award from the University of Nevada's board of regents.

When Eileen completed her seventh term in the Nevada Assembly in 1990, she became the longest serving assemblywoman in Nevada history. But she ended her political career that year because her son was facing heart surgery, and she wanted to be near. Years later, on July 1, 2004, she died of cancer in her Las Vegas home. Survivors included her husband, George, and their daughter, Deborah.

Lois Evora

Lucille Koenig Brown

Lucille Koenig Brown Chain made her mark in California as a pioneering female sheriff, just across the state line from Gardnerville, Nevada, where she had attended high school. But Lucille died a Nevada woman—having moved to Reno in 1995, where she passed away after a short illness that same year.

Five feet eight inches tall, Lucille Brown became California's only woman sheriff in 1957. She won the Alpine County office that her husband, Orrin P. Brown had held for twenty-two years, until his death.

She served as sheriff for the two years that remained on her husband's term. She served legal papers, collected county taxes, arrested drunks, aided victims of traffic accidents, investigated cabin break-ins, located children who had gone astray, and sometimes combed the pinyon pines for escaped prisoners.

Lucille—who went by "Lu"—was born on June 4, 1906, to parents Nellie Mae Mayo and George Washington Koenig in the mountain community of Markleeville, California. She grew up with three brothers and one sister in the picturesque community, in a valley on the eastern slope of the Sierra Mountains, not far

from Gardnerville, Nevada. Some winters, heavy snowstorms would isolate the town. The one-room grammar school that all four children attended has since become part of the Alpine County Museum complex.

From 1919 to 1920 Lu attended the then-new Douglas County High School, which has since become a museum, too. In order for her family to afford her education, she "boarded out" in Gardnerville, with a family that had two small children. For her board, she did the family laundry, cleaned, and cooked dinner. Sometimes the family let dirty dishes and diapers accumulate all day, for her to wash when she came home from school. During this time she also worked as a telephone operator for Farmer's Telephone and Telegraph. The job also entailed clerking for Western Union, and activating the community siren at noon and six o'clock, as well as for fires and other emergencies.

Because of the unpleasant living conditions with the first family, Lu's mother made arrangements for her to board with another family. However, they also soon took advantage of Lu, so she returned home without finishing high school.

Lu remained in Markleeville until 1924,

1906–1995
SHERIFF, MEMBER OF
CIVIC GROUPS

She served legal papers, collected county taxes, arrested drunks, aided victims of traffic accidents, investigated cabin break-ins.

when she married Orrin. Two sons were born to the couple, who for a time lived in Reno and Gardnerville, before returning to Markleeville in 1935, when Orrin was elected county sheriff. During her early married years, Lu worked a variety of small jobs before getting hired as a bus driver for the Alpine County schools She traveled over the treacherous mountain roads in all types of inclement weather. Once, unaided, she had to extricate the bus from a snowdrift.

When Orrin died in 1957 after more than two decades as sheriff, Lu decided to run for the job, which paid $4,100 a year. She won. The sheriff's office was housed in a gray stone courthouse built in 1928. At the time, the county had no resident doctor, dentist, lawyer, minister, or priest. It had about three hundred residents—seventy-five of whom were Washoe Indians. Lu knew most Alpine County residents by name.

From her two-year stint as sheriff, she liked to tell the tale of how she once rounded up an inmate who had escaped from the Ione Boys School. In freezing weather, she was driving around looking for a campfire. Along the way she picked up a cold and tired hitchhiker who apparently had not noticed her government license plates. She soon suspected he was the escaped prisoner, and was probably carrying a gun.

So the intrepid sheriff told him she needed gas, and made her way to a gas station. When they arrived he stepped out of the car, which made it possible for her and several townspeople to apprehend him. She then drove him to the county jail, without a deputy or protective partition between the front and back seats.

After her term ended in 1959, she married Alfred O. Chain of Stockton, California. He and Lu became well known for their political and social endeavors. Lu served as president of the local historical society and was a member of the library board. As well, she was a trustee for the Alpine County Unified School District and the Alpine County Planning Commission. She also was a member of the California State Park Board.

She was proud of her involvement in a book mobile project for Markleeville, and the opening of the Alpine County Museum. About that time, she was named California Senior Citizen of the Year.

In 1979 Lu and Alfred moved to the farming town of Coleville to be near her younger son and his family. Once again she became an active member of her community, both through the Antelope Valley Women's Club and through her grandchildren's activities.

The couple lived in Coleville for sixteen years. After Alfred's death in February 1995, she moved to Reno, where she died in September after a short illness.

Dorothy Bokelmann

Ruth Weston Brown

Known as the "girl with the tear in her voice," Ruth Brown was one of the pioneering black female rhythm and blues artists of the 1950s. Her career spanned sixty years, and despite some lean years she proved to be an earthy, proud, and indomitable black woman.

Ruth first came to Las Vegas in 1955, to perform. Familiar with the discrimination directed at blacks in that era, she was nevertheless surprised by the degree of segregation she found in town. Although she was a headliner on the Strip, she was not allowed to stay in the hotels where she performed. Nor was she permitted to be in the audience when friends performed, including Pearl Bailey, Sammy Davis Jr., and Nat King Cole.

In that day, blacks referred to Las Vegas as the "Mississippi of the West." It didn't matter how famous you were. If you were black, you stayed on the so-called Westside of town.

A half century later, she was living well in a gated community in Henderson, Nevada, and found the contrast to the 1950s almost unbelievable.

Born Ruth Alston Weston in Portsmouth, Virginia, on January 12, 1928, she did not follow in the musical steps of her dad, a dockhand who sang

1928–2006
SINGER, RECORDING
ARTIST, ACTIVIST FOR
ROYALTY RIGHTS

and directed a local church choir. She found herself drawn to secular music, and idolized Billie Holiday and Ella Fitzgerald. Though her father forbade popular music in the house, she was able to sing at local USO—United Service Organizations—clubs during World War II. Her mother eventually reconciled herself to Ruth's style of music, but her father never did.

In 1945, Ruth ran from home to join trumpeter Jimmy Brown—whom she soon married—performing in bars and clubs. Unwelcome in her parents' home, she wound up with the Lucky Millinder Band in Detroit. The job ended a month later in Washington, D.C., when she was caught serving drinks to the musicians.

She stayed on in D.C., where she found important backers such as Blanche Calloway, the sister of Cab Calloway, and Willis Conover an influential disc jockey. They urged her to audition for Atlantic Records.

During a car trip to New York City in 1948, for an Atlantic recording session and an appearance at the Apollo Theater, Ruth was seriously injured in a wreck, and was hospitalized for months. Finally, on May 25, 1949, she showed

up, still on crutches, for her first session at the Apex Studios.

In the audition, she sang, "So Long," which ended up a huge hit. She followed up with "Mama He Treats Your Daughter Mean," "I'll Wait For You," and, in 1950, "Teardrops From My Eyes," which she recorded for Atlantic Records. The tune was on Billboard's list of U.S. hits for eleven weeks, and established her as an important figure in rhythm and blues. One of her nicknames was Miss Rhythm.

Her hits were so instrumental in Atlantic's success that some called the record company the "house that Ruth built." But the relationship with Atlantic ended in 1961, when her belting style fell out of favor. She later attributed the career slump and resulting poverty to Atlantic's low royalty system and her ignorance of business.

Her career bloomed again in the 1970s, after Redd Foxx, an old friend, funded her move to Los Angeles and helped her land roles in stage musicals, television shows, and film. She began recording again—blues and jazz for a variety of labels. She was inducted in to the Rock and Roll Hall of Fame in 1993. It is not clear when precisely she moved to Las Vegas, where Foxx also made his home.

Bob Bailey of Las Vegas, another longtime friend, remembers her as a "great singer and gorgeous woman." Blues artist Bonnie Raitt, who worked with Ruth to improve royalties for rhythm and blues performers, called her "one of the original divas," which Raitt defined as a "combination of sass and innocence. And the tone of her voice was mighty. She had a great heart and a fighting spirit."

Ruth once said of her offstage life, "I could pick a good song, but I sure couldn't pick a man." She was married three times, all ending in divorce. After Brown, she married Earl Swanson, and then, a police officer, Bill Blunt. She was the mother of two sons, Earl Swanson Jr. and Ronald Jackson.

Miss Rhythm was a persistent activist in the royalty reform movement of the 1980s, which brought belated payments from major music companies to aging, often ailing musicians.

She passed away on November 17, 2006 at a Las Vegas hospital from complications due to a heart attack and stroke she had suffered after surgery in October. A memorial concert for her was held on January 22, 2007, at the Abyssinian Baptist Church in Harlem, New York.

Vera Knox

Lucile Spire Bruner

An artist and educator, Lucile Spire Bruner was born on September 6, 1909, in Chautauqua County, Kansas. She spent her childhood years on the family's Kansas farm, and also in rural Oklahoma. It was in those places that her first inspiration came to create art.

As a youngster she expressed her desire to paint every tree she saw. She once wrote, "I felt, as I painted, an overwhelming sensation of ecstasy and joy as I was part of the whole natural process, with good earth under my feet, the movement of the wind, the heart of the sun, and the beauty of the Universe."

Lucile graduated from the University of Oklahoma with a degree in fine arts in 1932. When she married architect Elmo C. Bruner, her travels through the West began. She lived in Texas and also in Santa Fe, New Mexico, where the arts were abundant. In 1947, Elmo joined a Las Vegas firm that was designing and building schools.

To Lucile's disappointment, she found little art or culture in her new home, which in 1947 had only about 20,000 residents. In 1950 she joined the Mesquite Club, the oldest women's club in Nevada, which had started in 1911. In the club she found like-minded

1909—1998
PAINTER, ART EDUCATOR

women, and set out to spread the arts and culture in Las Vegas.

She started an art class for Mesquite Club members. Women would attend painting classes, bringing along their babies and playpens. Soon even men requested to join her painting classes. This led her to help establish the Las Vegas Arts League. Her interest in promoting art exhibits and art education led to the creation of the Las Vegas Art Museum in 1950, of which she was a co-founder.

In 1951 she established a local branch of the National League of Pen Women, a group of professional female artists, writers, and composers.

"I believe through education comes understanding and appreciation." That is how Lucile once articulated her philosophy about art education. Not only did she spearhead art appreciation for adults in Las Vegas, she also extended art education to children throughout the state when she adapted her own vehicle into an "art-mobile" in which she travelled to small towns such as Searchlight, Beatty, Jean, Pioche, and Indian Springs to teach art and art appreciation.

She explained her endeavor this way: "I teach art as a way to enhance or develop a legacy so that

when people in the future are looking back, they will know something about Nevada, about the United States, and about its people."

Lucile participated in the Suitcase Gallery, a program to bring art to youngsters in the public school district. She also was part of the continuing education program for the community at the University of Nevada, Las Vegas. In 1982, UNLV awarded her a Doctor of Humane Letters.

Her own art has hung in the Las Vegas Art Museum, branches of the Las Vegas-Clark County Library District, various banks, and in private collections, including that of former First Lady Nancy Reagan.

Lucile's "Heritage Collection" of twenty-five paintings depicting U.S. farm life in the early 1900s has become well known. The series is designed to convey a child's point of view.

She also belonged to the Nevada State Historical Society, the Nevada Alliance for the Arts and the Allied Arts Council. In 1994, the Clark County School District honored her by opening an elementary school that bears her name. It is located at 4289 Allen Lane in North Las Vegas.

In addition to being an artist, educator and wife, she was the mother of two sons—Jerry and Allen—and two daughters, Marilyn and Janice. Lucile died at age eighty-nine on November 18, 1998.

Lucile Spire Bruner was a mover, shaker, and pathfinder who once described her love of art as an instinctive "sharing" of treasures.

Lois Evora

Lucile Whitehead Bunker

Artist, youth leader, teacher, missionary, patriot, good friend, wife, mother, and grandmother: Lucile Whitehead Bunker earned each of these titles during a productive life that began when she was born in Overton, Nevada, in 1907.

Her mother, Gertie, raised eight children, instilling in them a balance between work and play. Gertie's husband, Stephen, taught them a love of music and education. Lucile spent her childhood in a rural setting, but the family moved to Las Vegas in time for Lucile to attend Las Vegas High School, where she became junior prom queen. After graduation she enrolled in the University of Nevada, Reno, where she completed a course of study in education, received her teaching certificate, which led her to take a teaching position in Beatty, where she lived in 1926 and 1927.

The Beatty job was a challenge. Lucile was the sole teacher in a one-room schoolhouse that required expertise in all levels of curriculum. Managing students was at times difficult since many were taller than she was. Eventually, she was invited to work at Las Vegas High School, which brought her back to Las Vegas, where she served as secretary to the superintendent of Las Vegas schools.

But she moved from that to a job recording documents at the Clark County offices, which tapped her considerable expertise in typing and shorthand. Las Vegas was known for its speedy divorces and weddings. Regularly she was called in to process licenses for film stars who were in town from Hollywood for a quick and quiet wedding.

In 1933 she married Berkeley Lloyd Bunker, a Las Vegas High classmate. Lucile had their first daughter, Loretta, in 1938. The family moved to Arlington, Virginia, close to the nation's capital, after Berkeley was appointed in late 1940 to the U.S. Senate seat for Nevada that came open with the unexpected death of Key Pittman. Berkeley then was elected to the United States House of Representatives in 1944.

The Bunkers' time in Washington, D.C. coincided with a critical moment in U.S. history, as the nation entered World War II a day after the Japanese attack on Pearl Harbor on December 7, 1941. Lucile worked on relief efforts by Senate wives, preparing bandages for the wounded. She attended a luncheon with Eleanor Roosevelt, and

1907–1988
TEACHER, CHURCH
LEADER

46

in 1942, had their second daughter, Ann. She escorted numerous Nevada constituents around the capital, and took her girls to view their father from the visitors' balcony when he addressed the Senate.

The family returned to Las Vegas when Berkeley's political career ended in 1946. He and his brother Brian operated the Bunker Brothers Mortuary and Chapel, which they had purchased from a prior owner in 1942. Berkeley was a prominent local figure, but his closest confidante was Lucile, whose opinion and uncanny business sense he relied upon.

They were a social couple, heading up the Las Vegas Dance Club, which met monthly. They also chaired the Knife and Fork Club, which took them to many restaurants. They entertained nationally acclaimed guest speakers who came to Nevada.

Lucile was a devoted member of the Church of Jesus Christ of Latter-day Saints. For many years she led the young women's program, taught classes, and directed camp sessions in Lee Canyon at Mount Charleston.

In 1955, Berkeley and Lucile accepted a church assignment to preside over its Southern States Mission, which covered the Deep South and was headquartered in Atlanta, Georgia. They moved south, and in that capacity, Lucile gained skill as a public speaker, despite her shy nature. On her free day each week, she also took a class from a master porcelain artist.

Upon the couple's return to Las Vegas, she began to teach women the art she had learned in the South. She also had musical talent. With a clear soprano voice and a perfect sense of pitch, she was asked to participate in a double quartet of women who sang inspirational songs and current favorites. They gained some acclaim performing all over Las Vegas.

Lucile Whitehead Bunker was given opportunities beyond the norms of her day. Whether it was studying at Manzanita Hall at UNR or leading a one-room schoolhouse in Beatty, listening in the U.S. Senate or telling stories at her church's Camp Chebwa, working in Atlanta or dancing in a Las Vegas ballroom, she always rose to the occasion. Lucile died April 22, 1988.

Loretta Derrick

Florence Sandford Burge

American history books are filled with the exploits and successes—and, sometimes, the failures—of men. But they are generally lacking when it comes to documenting the activities of women. One exception to that trend can be found in the archives of the *Reno Evening Gazette*, which preserves the work of one woman who attempted to pay due respect to the accomplishments of other women.

Newspaperwoman Florence "Flo" Burge crafted a career dedicated to highlighting women's activities, women's issues, and women's successes. From 1959 to 1966, Flo was the women's editor of the *Reno Evening Gazette*, a publication that has since evolved into the present *Reno Gazette-Journal*.

Her "Societies" and "Clubs" columns detailed social events in the Reno area, and her "Your Neighbor and Mine" columns put the spotlight on individual women of note, and their families. She also penned "Women You'd Like to Know," a series featuring women in various professions. She also authored many articles about

1912–1986
NEWSPAPER
REPORTER, SOCIETY
EDITOR, PUBLIC
RELATIONS EXECUTIVE

Nevada history, focusing on families who settled the Reno area.

Born in Rochester, New York, on April 3, 1912, Florence Sandford studied journalism at both the University of California, Los Angeles and the University of Nevada, Reno. Her husband, Lee Burge, worked for the state's agriculture department, and eventually became its supervisor of inspectors. She gave birth to twin daughters, Scheri and Suzette.

Florence's tenure with the Reno newspaper began at least three years before she was hired as its society editor. In 1956 she wrote a two-part series that was a short history of the Republican Party in Nevada. The project, titled "From a Log Cabin in Nevada to the Cow Palace," also covered national events in which Nevada Republicans played a part.

During her seven years as society editor, she won notable awards. In 1960 she won a Nevada State Press Association award in the women's features category. As the years went on, she won awards from the National Federation of Press women at the state

and national levels. In 1964 she was the recipient of a prestigious JC Penney-University of Missouri award for the best women's pages among newspapers with a circulation up to 25,000.

An unusual honor came her way in 1965 when Governor Grant Sawyer chose her to be one of Nevada's two official representatives for the California visit of Queen Elizabeth's sister, Princess Margaret, and the princess' husband, the Earl of Snowden.

Later in Florence's career at the *Gazette*, she wrote a column called "Round About," that allowed her to interview an assortment of individuals including Jerry Lewis, Harry Belafonte, the head of housekeeping at the El Cortez Hotel, and the first woman to swim the length of Lake Tahoe.

She was eclectic in her subject matter. Other articles included an analysis of the then-popular investment clubs, her experience with hosting diplomats from India, the challenges facing wives of hydroplane drivers, and the psychology of Christmas shopping.

Florence's connection to the Reno paper ended in 1966, marked by a surprise farewell party that her co-workers held at the Holiday Hotel. But that did not signal the end of her journalism career, as she went on to report on the *North Lake Tahoe Sierra Sun*, and then became editor of the *Incline Village News*. In Incline Village she eventually started her eponymous advertising and public relations company.

As usual, she kept winning writing awards. In 1971, she was the "sweepstakes winner" at the Nevada Press Women awards banquet for racking up the highest number of points in its award system. In the 1970s she also worked hard for Nevada Press Women, the National Federation of Press Women, and the National League of American Pen Women.

Florence did not only influence Nevada through her reporting. She also did volunteer work that benefitted the environment. A fishing and hunting enthusiast, she was a founder of the Sagehens Rod and Gun Club, and taught club-sponsored classes in hunter safety to girls. She also served on the Crystal Bay Public Information Committee of the Lake Tahoe Regional Planning Agency.

She also was a president of the board of directors of the Reno YWCA, and a member of the Reno Council of Parents and Teachers.

By bringing the stories of remarkable Nevadans to the attention of her readers, Florence made a career that brought her distinction, as well. She died in Reno in March 1986.

Fran Haraway

Helen Case Cannon

Early in adulthood, Helen Case Cannon achieved her wings as a private pilot. Later, through her two decades serving on the board of the Clark County School District, she helped numerous students spread their own wings, too.

Helen Case was born to Helena Reich Case and Walter Case in Cameron, Wisconsin, on May 16, 1916. Her father was a contractor and cranberry grower. She was one of the middle children of six, which included five girls and one boy. She attended elementary and high school in Cameron, and graduated in 1933 at age sixteen. She enjoyed growing up in a locale with four distinct seasons. During the summer, she picked strawberries, raspberries, and potatoes for neighbors.

In 1935, she enrolled in a teacher's college in River Falls, Wisconsin, to major in math and science. While Helen attended, her mother sent her fifty cents a day for spending money. Helen lived with a family, for whom she did babysitting and housecleaning.

Through her physical education classes, she became aware that a woman could have a career in athletics, which appealed to her. Consequently, in her sophomore year, she transferred to the University of Wisconsin in

**1916–2009
TEACHER, PILOT,
SCHOOL BOARD
MEMBER**

Madison, which offered physical education as a course of study. She received fifteen dollars a month from a student loan, and assisted one of her professors by running errands and typing memos. During the summer months she worked at a Campfire Girls camp, where she taught swimming, boating, archery, and canoeing.

In the middle of her senior year, Cannon accepted a job as a substitute physical education teacher in Oshkosh, Wisconsin. She finished her degree in the summer of 1938. The next year she became a regular teacher, earning one hundred dollars a month—but only for the nine months that school was in session.

Next, she taught in Two Rivers, Wisconsin, where she stayed for two years because there was an indoor pool in town. Then she taught in Rapid City, South Dakota, while living in a rented room. That summer she became the head lifeguard for a city pool at Canyon Lake.

The bombing of Pearl Harbor reignited Helen's desire to learn to fly. So on June 21, 1941, she used her saved earnings to start taking flight lessons in Madison, Wisconsin. In 1944 she was among the few selected from over 25,000 applicants—all with flight experience—to be trained for the Women

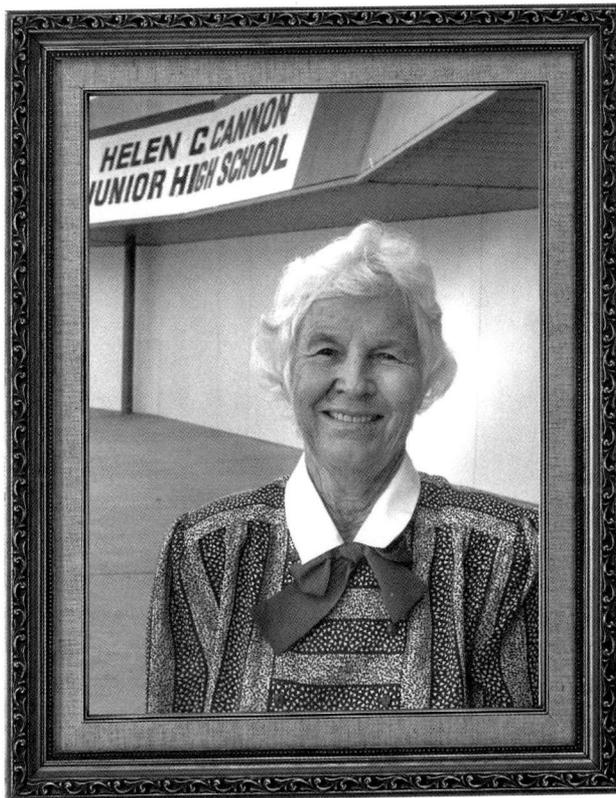

Airforce Service Pilots, also known by its WASP acronym. This involved "lots of jogging and marching," according to an account of the training.

After earning her wings, she was transferred to Luke Airfield in Phoenix, Arizona, where she met her future husband, Robert O. Cannon. Her duties there included ferrying planes, towing targets, and flying tracking missions. In December 1944, because male pilots were returning home from the war in great numbers, the WASP program was deactivated.

Helen kept a detailed log of her flying hours and earned commercial pilot and glider ratings in 1945. She was hired as a flight instructor at Stevens College in Columbia, Missouri.

In 1946 she married Bob Cannon—they started life together "with one suitcase each," according to one account. After living briefly in California, they moved to Las Vegas, where Bob entered the hotel business. Their son Robert was born in April 1947, and daughter Alice arrived in 1951.

When the Cannon children were small, Helen used the family's backyard pool to give swimming lessons—beginning and synchronized—to children of local families. In 1954, she was a volunteer swimming instructor at the Las Vegas municipal pool. Interested in girls' athletics, she also helped create opportunities for Las Vegas girls to play soccer. In 1992, in recognition of her efforts to include girls in the local athletic curriculum, Helen's name was entered into the Hall of Fame of the Nevada Interscholastic Activities Association.

Helen also took up golfing. She served as first state president of Nevada's Women's Golf Association, became its state champion in 1972 and later was elected to Nevada's Golf Hall of Fame. She also served as president of the Service League in 1956. She also continued her flying; in 1961 she participated in a powder puff derby as co-pilot.

When her children entered school, Helen resolved to become involved in their education. She ran for the district's school board in 1960, and was elected. She was on the board for twenty years, and twice held the office of board president.

She was known for being an independent thinker, and for making personal visits to schools to ascertain their needs firsthand. Besides advocating for improved reading materials, she supported construction of the Southern Nevada Vocational Technical Center in Henderson, which is now a magnet high school called the Southeast Career and Technical Academy. She also encouraged establishment of the community's public television station.

For her many contributions, the school district in 1976 named Helen Cannon Junior High School in her honor. Helen died in December 2009, at the age of ninety-three.

Dorothy T. Bokelmann

Judy Edsall Carlos

A series of unusual jobs prepared Judy Carlos for her career as a newspaperwoman. Long before she filed her first award-winning stories for the *Las Vegas Sun*, Judy sold sandwiches aboard a Mississippi river boat called the Delta Queen, sat at the reception desk in a convent library, and worked as a practical nurse in the ward for violent patients at the Illinois State Mental Hospital.

"Working at the mental hospital forever changed her life," said her husband of thirty-three years, Bill Carlos. "It made Judy determined to do whatever she could to help change the lives of the less fortunate."

She was born as Judy Edsall on April 6, 1936, in Alton, Illinois, the daughter of bookie Webster Edsall and his wife, Eleanor. Judy graduated from Alton High School in 1954, where she was class president and co-editor of the school newspaper. She graduated from the University of Missouri in 1958 with a bachelor's degree, taking a double major in journalism and English literature, and a minor in political science.

1936-2003
Newspaper
Reporter, Columnist

In 1959 Judy worked for the *Evansville Courier-Press* as a feature writer for what was then called the women's section. In 1960 she became women's editor for the *Lebanon Express*, a biweekly paper in Oregon. A year later she was promoted to news editor, a position she held until moving to Las Vegas.

In October 1963, Judy began working at the *Las Vegas Sun* as a general assignment reporter. Thirty days later, the newspaper's plant on Main Street was destroyed by fire. Judy, known for her self-deprecating humor, said she had attracted yet another disaster. When she had worked at the Evansville paper, the city was hit by the worst blizzard in thirty years. When she was in Oregon, Lebanon had its first hurricane.

Judy worked for twenty-four years at the *Sun*, covering the county and labor beats. She long penned the "File 13" column, which promoted community activities. Her earliest *Sun* bylines were under her maiden name of Edsall.

"Judy has a heart that has room for everybody," said former Nevada Governor Mike O'Callaghan, who was associated with the *Las Vegas Sun*. "The

"Her sources were unlimited, and her writing skills kept readers interested," said Mike O'Callaghan, a former Nevada governor

more downtrodden people always had more of her time than the powerful and the wealthy. Judy's column had the attention of Southern Nevadans seeking new information and good humor. Her sources were unlimited, and her writing skills kept readers interested. We were fortunate to know and work with Judy."

Judy won the Nevada Press Association's 1964 State Bar Award for her series on the first black attorneys admitted to practice in Nevada. She helped coordinate the Sun's coverage of the local racial turmoil following the assassination of Martin Luther King Jr., which earned the paper the state press association's Public Service Award. In the 1970s and '80s, she was the county reporter, and wrote several high-profile series. One detailed shoddy treatment of the elderly in senior care centers; another series covered the lack of employment opportunities for Southern Nevada blacks in the 1970s. She left the *Las Vegas Sun* in April 1987.

Judy married Bill Carlos, a Las Vegas probation officer in 1970, and had a son, Brian Carlos. She was a Las Vegas resident for forty years, always involved in efforts to help the less fortunate. She passed away in September 2003, at age sixty-seven.

Denise Gerdes

Margaret Lehr Perkins Casey

Margaret Lehr Perkins was born on August 12, 1920 into a wealthy family in Louisville, Kentucky. Who would ever have guessed she would end up living an exciting life in a desert town like Las Vegas, Nevada?

Margaret was the second daughter born to Margaret Zapp and Thomas Shannon Perkins. Her family lived with her maternal grandparents in their huge home including live-in servants. Of course, that prosperity fell with the Great Depression of the 1930s.

After graduating from the local girls' high school, Margaret, by that time known as Peggy, attended the University of Wisconsin, Madison. She received a degree in home economics in 1942. Sadly her mother, having died in 1940, did not live to see her daughter's graduation. Peggy joined the Pi Beta Phi sorority during her college days, where she made several lifelong friends. Peggy returned to Louisville after graduation to teach home economics. Upon declaration of World War II on December 7, 1941, Peggy decided to participate in the war effort. In February 1943, she began Curtiss-Wright training in aviation engineering at Rensselaer Polytechnic

1920—2012
AERONAUTICAL
ENGINEER

Institute, known as RPI, in New York City to study aeronautical engineering. Subsequently, she worked in the research division of the propeller plant at Caldwell, New Jersey. This job terminated with the end of World War II.

Next Peggy went to New York City and lived with Mary Joy Jameson. There Peggy met Walt Casey, Mary Joy's cousin. Both Peggy and Walt enjoyed playing golf. They seemed to "click," and Walt asked Peggy to marry him on their third date.

During World War II, Walt worked for Pan Am Airlines navigating a Pan Am China clipper "Flying Boat" over the South Pacific.

The summer of 1944 Peggy and her friend Mimi drove to California to meet Mary Joy and her family including Walt Casey. During their return trip to New York City, Peggy and Mimi stayed at the Bar BC, a dude ranch located in Wyoming. Peggy was hired as a cook and remained at the ranch from July through September.

Peggy and Walt Casey married on November 28, 1946 at the Mission Inn in Riverside, California. They resided in Portland, Oregon, where Walt worked for United Airlines. Their first son, Steven Shannon, was born there. A year later they moved to Glendora,

California where their second son, Michael Andrew, was born in 1949.

Due to Walt's health, the family moved to Las Vegas in 1951. They bought land on Topaz Street and built their home there. Life was rough. No phone service and other amenities were available. Yet, through it all, they gave birth to a daughter, Ann La Fetia, who was born in April 1954 in the Southern Nevada Memorial Hospital.

In 1959, Peggy joined Las Vegas' oldest women's civic organization, the Mesquite Club. She served on numerous committees throughout the years including serving as treasurer, financial secretary and third vice president. She and other Mesquite Club members wrote a book of sayings called the *Bright Blue Book*. Also, she became a master gardener and volunteered for many years at the Master Gardener Orchard Project.

In 1961, Walt founded the Boys Clubs, now known as the Boys and Girls Clubs. Both Peggy and Walt were Salvation Army board members working on numerous community projects. Peggy was a member of the Daughters of the American Revolution and PEO. She and Walt were both avid golfers. They were members of the First Presbyterian Church on West Charleston Boulevard.

Walt's water conditioning business was successful, and eventually, their son, Steve, took over the soft water company and ultimately sold it to Culligan. Their other son, Mike, owned Lamb Asphalt, and daughter, Ann, became a lawyer.

In the fall of 2006, even though there were many family memories there, Peggy and Walt decided to sell the large home they had built on Topaz Street in 1951. Peggy and Walt decided to purchase a home in Sun City Summerlin where they would be closer to their children.

That fall also heralded another grand event. The date November 28, 2006 marked their 60th wedding anniversary. Their children hosted an elegant luncheon for them and a number of their friends. A happy event it was!

As sure as all beautiful things must end, so it was for the Casey union. On the morning of November 20, 2007, Walt Casey passed away from a heart attack.

Peggy went ahead with her move to Sun City Summerlin. She finalized purchase of the home she and Walt had picked out. There Peggy was to have more years of being near her children and her other friends. She continued to enjoy her days of playing golf and other activities, such as, bridge and cribbage. Peggy was still active in the Mesquite Club. Also, she considered herself blessed that she had three wonderful grandchildren: Mike, Betty, and Scott. They visited her often along with her own three children and their spouses.

The full, rich life of Peggy (Margaret Lehr) Perkins Casey came to an end in June of 2012. As a lady devoted to golf, she should be happy to know she played the game of life well.

Mary Gafford

Marilyn Chambers

Ivory Snow's box-cover mom, U.S. vice presidential candidate, and ... porn star? Call it talent or luck, Marilyn Chambers chose to step "out of the box," from the mundane into the notorious.

The adult-film actress, who also ran twice for vice president, was born on the East Coast, died on the West Coast, but spent a decade living in Las Vegas.

Marilyn was born on April 22, 1952, as Marilyn Ann Briggs to an advertising executive dad and a mom who was a nurse, in Providence, Rhode Island. She grew up with three older siblings in Westport, Connecticut.

A five-foot seven-inch blonde who resembled actress Cybill Shepherd, Chambers managed to break into the film industry early, with a small role in a 1970 hit comedy that starred Barbra Streisand: *The Owl and the Pussycat.* For some reason, Marilyn was credited as "Evelyn Lang" for her acting role.

The advertising world also noticed her, hiring her for jobs with such high-profile corporations as Clairol and Pepsi-Cola. At age eighteen, she posed as a mother holding a baby on the cover of Ivory Snow's soap

1952–2009
Actress,
Businesswoman,
Political Candidate,
Author

box, with the slogan "99 and 44/100's pure." The slogan became an ironic footnote to her future endeavors.

After graduating from high school, Marilyn moved to California seeking work. First she went to Los Angeles, and then San Francisco. In 1972 she finally prevailed at a casting call for a lead character. A pair of controversial movie producers known as the Mitchell brothers liked her wholesome appearance, and offered her generous pay to appear in a pornographic production titled *Behind the Green Door.* The cash-starved Chambers accepted the role.

Coincidentally, the Ivory Snow box with her innocent-appearing face hit grocery store shelves at the same time *Behind the Green Door* hit the silver screen. Dubious headlines surfaced linking the two products.

Genuinely concerned, Ivory Snow management quickly revised its packaging to replace the winsome face of Marilyn Chambers. But notoriety followed, as nearly every adult film she made after "Green Door" featured a cameo appearance of her Ivory Snow box.

As for the movie, it became the first every widely released pornographic title in U.S. history.

Marilyn played an attractive and somewhat credible character in a plot more fully developed than was customary in adult films. It was an instant hit, bringing adult movies out of the sleazy dark room into the legitimate theater. Another of her well-known adult films was *Insatiable*.

Around this time, Chambers divorced her first husband Doug Chapin, and married Las Vegan Chuck Traynor in 1974. As producer-manager of her career, Traynor used his Las Vegas connections to get her local entertainment work, and they settled in as Las Vegans.

In October 1974, Marilyn starred in a dinner theater production at the Union Plaza in downtown Las Vegas. *Mind with a Dirty Man* ran for fifty-two weeks—the longest run for a Las Vegas play in the city's history to that point. She returned to the Union Plaza stage in 1978, performing in Neil Simon's production of *Last of the Red Hot Lovers*.

In 1979, Marilyn appeared in a one-woman show at the Jolly Trolley Casino, a minor casino, in Las Vegas. It made headlines for her full frontal nudity. The show had a short run.

In the early 1980s, the couple also co-owned with Bob Irwin The Survival Store, a gun and ammunition store on Spring Mountain Road in Las Vegas. They glamorized the weapons industry with an ad campaign featuring bikinis and a machine gun.

But Marilyn had talents beyond acting. She had a 1976 disco tune, "Benihana," which earned honors both on the Billboard Top 100 and rhythm and blues charts. She then formed her own country-western band and performed at venues in Las Vegas, before doing a national tour.

Marilyn also could write. For several years she wrote advice columns for *Club* and *Genesis* magazines, and she authored two autobiographies.

With her charming smile and ability to take on a challenge, Marilyn appeared in the 2004 ballot in Utah as the Personal Choice Party's vice president candidate, with Charles Jay running for the top slot. They won nine hundred forty-six votes. In 2008 she renewed her attempt for office; this time she was an alternate write-in candidate on the Boston Tea Party ticket.

Marilyn had one child by her third husband Tom Taylor, daughter McKenna Marie Taylor, who was born May 13, 1991. Marilyn and Tom divorced in 1994.

The groundbreaking actress died in Santa Clarita, California, on April 12, 2009—ten days before her fifty-seventh birthday.

Savvy and scintillating, Marilyn Chambers spanned the dark and light in the entertainment industry—and was accepted by both worlds. She received a key to the city in Las Vegas, and San Francisco declared July 28, 1999, to be Marilyn Chambers Day. Adult Video News named her as one of the top ten adult film stars. *Playboy* magazine rated her as one of the top hundred sex stars of all time.

Susan Houston

Leona Gudmundson Clark

Artist Leona Gudmundson Clark divided her life between Utah and Nevada, moving several times to each state.

She was born May 25, 1904, in Springville, Utah, to Erma Adella Crandall and Moses Samuel Gudmundson. She was the oldest of ten children. Her parents married the same day as her mother's brother, Myron Edgar Crandall Jr., who wed the daughter of Brigham Young University's founder Karl G. Maeser. Their double wedding reception on June 25, 1902, was a large affair.

Leona's father went to New York City to study violin but contracted typhoid fever and returned home. The family then moved to Provo, Utah, where he worked at BYU as a professor of violin and orchestra.

Through eighth grade, Leona attended the BYU Training School, whose teachers were BYU professors.

One of her favorite teachers was "B.F. Larsen, a famous artist, and he taught me so much," she once told an interviewer. There she also learned woodworking, ceramics and jewelry making. One of her grandmothers taught her to sew.

In 1925 Leona graduated from the two-year BYU Normal School with an elementary teaching certificate. She next taught for ninety dollars a month in Cedar City, Utah. There she met Daniel Brown Clark. Dan, who also had attended BYU, worked in the sheep and livestock business. They married May 10, 1927, in the St. George temple of the Church of Jesus Christ of Latter-day Saints.

In about 1930, Leona ordered a "house kit" from Aladdin Redi-Cut Company and then, while her husband was in Ely developing a livestock business, she and several relatives built the couple's first house. It came from Michigan via rail. The lumber was cut and each piece numbered, with directions enclosed. It was a small house—twenty-five feet by twenty—with a living room, kitchen, bathroom and two bedrooms.

In about 1929 or 1930, Dan acquired a sheep ranch in Nevada, with the financial help of Gronway Perry. When Dan paid off the loan, he became its sole owner.

Four sons were born to Leona and Dan in Cedar City: Donald D. born on December 28, 1928, John Calvert on August 22, 1932, Howard Dexter on August 22, 1932, and Malcolm G. on July 30, 1936.

Leona and the children first stayed in Cedar City, where the children attended school. Leona,

1904–2000
TEACHER, ARTIST,
CHURCH MISSIONARY

who took ballet in high school, taught ballet in Cedar City. She loved dancing, and later earned an "A" in a dance class at the University of Nevada, Las Vegas, when she was past sixty.

She and the children spent summers at the family's ranch, near Ely and the Success Mine. Dan spent time daily with the children so that Leona could paint.

In May 1943, the family moved permanently to Ely. Leona's piano playing was always in demand for church and school events. She also taught sewing and tailoring. She was recruited to teach a "Make It Yourself with Wool" course after she and Dan—a member of the Wool Growers Association—happened to meet Mary North, the head of the national "Make it Yourself with Wool" contest. Leona supervised the Nevada contest for two years.

When Dan and Leona divorced in 1956, she bought a house in Orem, Utah, and returned to school. She graduated from BYU in 1957 with a teaching degree and an emphasis on kindergarten. With a grade-point average of 3.75, she was elected to Phi Kappa Phi.

She taught in Ely, then moved to Las Vegas in 1960 to be near son Malcolm and his wife, Jeanette. Leona taught there until retirement at age 65.

In 1972 she went to Norway to locate relatives on her father's side. She grew close to her Norwegian cousins, who came to visit the States several times.

Then in 1975 Leona served a Latter-day Saints mission in Tallahassee, Florida, where she also did some nice watercolors of local shrimp boats.

In 1976, a Leona Clark painting of the Ely sheep camp was selected as one of twelve painting featured in the official U.S. Bicentennial art calendar. She also studied watercolors under Nevada artist Cliff Segerblom.

Leona adjusted well to city life. Once, when she and daughter-in-law Jeanette went to a concert at the Las Vegas High School. Jeanette had to leave early. So when Leona later left alone, a purse-snatcher attacked her. But the criminal didn't know Leona Clark.

She screamed and started chasing her assailant. She told bystanders to phone the police. A police helicopter was overhead in minutes. The criminal threw the purse in the bushes, but got arrested. And Leona got her purse back.

In 1985 Leona moved back to Springville, where her brothers and sister had retired. She took up the hobby of making and dressing porcelain dolls. Each granddaughter received a doll custom-matched to the recipient's eye color, hair and other physical features.

Leona remained a thirsty student her entire life. At age ninety-three, her memory was still able to retain names, dates, and places. She died in St. George, Utah on November 29, 2000, at age ninety-six.

Jeanette Oxborrow Clark, Leona's daughter-in-law

Toni Gaglionese Clark

When Lena Gaglionese was growing up in Seattle, in a large Italian family from Naples, it's unlikely she envisioned becoming the glamorous wife of a Las Vegas casino owner.

Lena was three when she lost her mother in 1918, but was raised by a caring stepmother and her father, Salvatore, who was a street cleaner. She quit high school without graduating, then headed to San Diego to visit a friend. She ended up staying. For several years she worked as a nanny for the family of a high-profile lawyer.

But one day Lena met a Mr. Clark, who suggested she apply for a job at a dinner club his son was opening. The man introduced her to his son, Wilbur, who promptly hired her. Wilbur Clark then owned four clubs in the area.

When Wilbur asked Lena out for their first date, he ended up having to interrupt the evening to handle a business emergency. A bartender had shown up drunk, so Wilbur had to scramble for a replacement. The couple's relationship did not begin auspiciously. However, something clicked.

**1915–2006
Casino Owner,
Philanthropist**

First Wilbur changed Lena's first name, thinking "Toni" suited her better. In 1944 he changed her last name to Clark, when they married in the office of Nevada Governor Howard Carville, who was a strong supporter of Wilbur Clark.

Wilbur bought the El Rancho Hotel in Las Vegas in 1950, and then sold it to build his dream hotel-casino, the fabulous Desert Inn on the Las Vegas Strip. Toni was not involved in the business end, but was a great asset as a hostess. She planned events for the wives of high-stake gamblers, including fashion shows.

Wilbur and Toni Clark were prominent, so an invitation to their home on the Desert Inn golf course was highly prized. They lavishly entertained high rollers at the home, which featured a central fireplace in the living room. The home also boasted an indoor swimming pool resembling the famed pool at the Hearst estate in San Simeon, California.

Toni was sometimes called the "first lady of Las Vegas," and made Mr. Blackwell's Best Dressed List for 1954.

Whenever Wilbur and Toni traveled, they promoted the Desert Inn and Las Vegas. The hotel, with 300 guest rooms, was then the city's largest resort. Frank Sinatra, Sammy Davis Jr. and Nat King Cole all headlined there. Its championship golf course attracted professional tournaments.

But a 2001 article in the *Las Vegas Sun* about the Desert Inn's implosion described a darker side to Wilbur Clark's resort: "When construction funds ran out in 1948, Clark traded away 74 percent interest in the property to the Cleveland mob, led by Moe Dalitz. Although Clark remained as figurehead, Dalitz and his partners were in control."

Residential real estate development was another of Wilbur Clark's interests. He named streets in his Las Vegas developments after relatives. There is, for example, a Wilbur Street and a Toni Street. When he ran out of family names, Wilbur named one street Katie, after his executive secretary. Years later, when Katie Street became a through street, Toni kidded Katie, who had become a friend, by saying, "If I knew at the time that Katie would became a through street, I would have put my name on that one."

Toni and Wilbur Clark were married for twenty years when he died in 1965. After his death, the Desert Inn changed hands several times. Other illustrious owners of the Desert Inn included Howard Hughes, Kirk Kerkorian, and Steve Wynn, who imploded the original hotel to make way for his Wynn and Encore properties.

In later years, Toni found companionship with Larry Finuf, who had leased a men's store at the Desert Inn. Their relationship and marriage spanned thirty-two years.

When the Desert Inn was demolished to make way for the Wynn Las Vegas, Toni accepted it as progress. She had more difficulty accepting the loss of the golf course home she had once occupied with Wilbur.

Years before, she and Wilbur had donated the land for the Catholic Guardian Angel Cathedral, just off the Strip near the Desert Inn. One day Toni and Larry Finuf were driving by, and she suggested they stop to visit the cathedral. Sadly, that day she caught a glimpse of bulldozers flattening her former home, on the ninth hole of the course.

Toni eventually was confined to a wheelchair due to a disease called progressive supranuclear palsy. When she needed end-of-life care, she moved into the Nathan Adelson Hospice in Las Vegas. During her stay, one of her closest friends—Phyllis McGuire of the famed McGuire Sisters, another Las Vegan—would visit and sing her gospel songs, a cappella. It was a musical genre that both Finufs enjoyed.

On October 4, 2006, at the age of ninety-one, Toni died in hospice. Larry Finuf summed up her spirit when he said, "Toni was a very sweet lady."

Carolyn Lake

Dr. Angela Webb Clarke

Music and medicine are two arenas in which Angela Webb Clarke excelled. To understand her energy and her dedication to causes, one needs only to look at Angela's mother, Cora Mayfield Webb.

Cora and her husband, Luke E. Webb, had ten children, with Angela, who was born November 11, 1932, among the youngest. Although the Baltimore family was poor, education was emphsized. Cora would not tolerate anything but the best effort from her children. In fact, B grades often resulted in corporal punishment. Angela once proudly told interviewer Marc David, "I didn't have a mark on me."

Cora's commitment paid off. Nine of the ten children graduated from college. Between them they earned twenty-seven advanced degrees. According to David's interview, when Angela graduated summa cum laude from the University of Maryland School of Medicine in 1961, she asked her mother, "Can I stop school now?" Cora's reply was to send Angela the sum of money that would have paid for Cora's airfare to attend the graduation ceremony. Cora's thinking was that

1932–2010
PHYSICIAN, MILITARY OFFICER, PROFESSOR, PIANIST

Angela needed the cash more than she needed her mother's presence.

Angela had decided to be a medical doctor when she was only five. She graduated from Morgan State University, in Baltimore, before pursuing her medical degree. The epitome of an educated woman, she was also proficient in languages: Latin, French, Spanish, German and Hebrew. She used the Hebrew for her studies of the Torah.

She served in the United States Air Force during the Korean War and the first Gulf War. During the Korean conflict she worked in Tokyo air-to-ground communications, which made her eligible for government assistance with her college tuition. She rose to the rank of lieutenant colonel.

Angela loved playing the piano, singing and dancing. She entertained at military bases in both the United States and Japan.

After receiving her medical degree, Angela practiced in the Beverly Hills section of Los Angeles for ten years before moving to Las Vegas. She travelled for a time as the personal physician to bandleader Harry James. Ever the entertainer, she appeared on *The Dating Game* and *Let's Make a Deal*, and

also made commercials. Much later she was an extra in *3000 Miles to Graceland*, a film with Kurt Russell and Kevin Costner that had Las Vegas as its setting.

In 1975, Angela moved her medical practice to Las Vegas. Soon known and admired for her diagnostic skills, she became an associate professor of medicine at the University of Nevada, Reno—as she had also been at the University of California, Los Angeles. In 1984 and 1985, she served as president of the Clark County Medical Society. She also was a diplomate of the American Board of Family Practice. A diplomate is a doctor who has passed additional written and oral exams in his or her specialty.

In the late 1980s, Angela decided to retire from medicine. She had her own health issues, which also led her to relinquish her active status in the Air Force Reserves.

But it soon was apparent that when Angela Clarke retired, she didn't necessarily slow down. She moved to Sun City Summerlin, and refocused on her musical skills. She became a member of the Lynette Jazz Dancers, the Sun City Folk Dancers, and the Sun City Sun Cats. She also participated in the Veterans of Foreign Wars Post 8250 and the American Legion Post 76.

Diagnosed with cancer in 2002, Angela turned to the practice of tai chi, a stress-reducing art developed in ancient China. She did not, however, stop dancing.

She also told interviewer David that, "the secret to retiring is to make sure you are as busy as you were when you were working, and that you enjoy what you are doing. The more I do, the happier I am, the less pain or aches I feel."

Dr. Angela Clarke's energy and dedication can be documented not only in the articles she authored for medical journals, but also in various volumes that mention her, including the *Directory of Medical Specialists*, "Personalities of the West and Midwest," "Two Thousand Women of Achievement," *Who's Who in the West*, and *Who's Who of American Women*.

Angela, who died on June 17, 2010, was once married to Shirlee Khurlsingh Clarke. She left behind three children: Wuan A. Clarke, Indranee K. Clarke, and Tarita K. Clarke. The good doctor was buried in the Southern Nevada Veterans Memorial Cemetery in Boulder City.

Fran Haraway

Margaret Phelan Coleman

Margaret Phelan Coleman was a singer, actress, war widow, and community volunteer. She came to Las Vegas in 1948 to sing comedy and risqué songs. But meeting U.S. Air Force Colonel Clark Coleman changed her plans, and her life. In 1972 she became the first woman appointed to the Clark County Planning Commission.

Mary Margaret Coleman was born in Chicago, Illinois, on June 2, 1914, to Arthur "Dugan" T. Phelan and Alma Altman. Margaret's ancestors were Irish and German immigrants who settled in Canada, and then spread to the Chicago area. Her father played third base for the Chicago Cubs from 1910 until 1915. When he developed arthritis in his legs, his sports career ended. The Cubs helped him move his family to Florida, where the warmer climate seemed to help his physical condition.

A sister, Betty Joyce Phelan, was born in Florida, where Margaret began her schooling in a backwoods one-room schoolhouse. Alma objected to the quality of the education, and induced Arthur to move the family to Arcadia, Florida.

1914—1995
SINGER, REAL-ESTATE
BUSINESS OWNER,
MEMBER OF STATE
BOARDS

When Margaret was in third grade, Arthur took a job as a baseball club manager in Fort Worth, Texas, where Alma gave birth to a third child, Arthur T. Phelan Jr.

Arthur organized and managed several Class D baseball clubs throughout the south. Eventually he purchased a team in Alexandria, Louisiana, which became a family operation. Called the Evangeline League, the club required Alma and the children to run a concession stand during the summer. Arthur Jr. was the team batboy. Margaret later called that family effort the "zenith of my life."

After graduating from high school, she was offered scholarships by several Texas colleges, but chose to work as a legal stenographer for the Fort Worth Chamber of Commerce and its convention authority, until her financial goal was met. Two years later, she auditioned and was accepted into the Lazar Samoiloff Opera Academy in Los Angeles.

In October 1941, at age twenty-seven, she married John Charles Hunter, an Annapolis graduate and a Navy pilot. He left for duty in

Hawaii soon after their wedding, and she followed him there on December 3, 1941. They were together two days when he received orders to go to Midway Island. Pearl Harbor was bombed on December 7; John was lost at sea on December 8.

Margaret was in the first convoy of military families to leave Oahu, on December 25. "After this shock," she later wrote, "I returned to Fort Worth with the firm conviction that my life was over." The description came from an autobiography she wrote for the Mesquite Club.

The young widow dealt with her grief and loss by studying music at home in Fort Worth. Her friends and family encouraged her to return to Los Angeles to renew her plan to be an opera singer. She did.

In summer 1942, she was chosen the Outstanding Young Female Professional Singer of Southern California. After a concert with Jerome Hines at the Hollywood Bowl, she traveled to New York City and auditioned for the Metropolitan Opera. The trip left her financially strapped.

She became the lead soloist at an Episcopal church in New Rochelle, New York, and also began to sign in nightclubs and hotels. Then she found a full-time position at the Episcopal Church headquarters in New York. In her job she helped relocate Japanese Nisei—second-generation immigrants who were U.S. citizens—into schools throughout the United States.

After World War II, the Army airfield near Las Vegas—which eventually became Nellis Air Force Base—closed, even though it had contributed substantially to the local economy. When it reopened in 1948 as the Las Vegas Air Force Base, Colonel Clark Coleman was appointed its commander. The community's future seemed promising, and the Las Vegas Strip was flourishing again.

After playing a lead role in a Broadway show, Maggie traveled to Las Vegas to perform at the El Rancho Las Vegas—where she met Clark after one of her performances. It was love at first sight. They were married one month later.

After Clark retired from the military in 1954, they started Coleman Realty. They also raised a son, Clark Jr., from his prior marriage. A grandson was born in Las Vegas.

In Maggie's later years, she suffered from Parkinson's disease and arthritis. She died at age eighty-one on December 26, 1995.

She helped to establish the Clark County Committee for the Aging, and several senior housing communities, including Levy Gardens. She was a member of the Nevada Centennial Commission and the state's Land Use Planning Board. She also belonged to the Mesquite Club for more than forty years, serving as its president from 1962 to 1963.

In 1988, the Colemans were honored when a small Las Vegas municipal park was named after them. Coleman Park, which is located on the corner of Carmen Boulevard and Daybreak Drive, is a tribute to Clark and Maggie, who once told friends that in her public life, "I was just trying to be myself."

Norma Jean Harris Price

Margaret Jane Dailey Colton

Margaret Jane "Gale" Dailey Colton contributed to Southern Nevada in several distinct ways. She ran a detective service, and was according to some accounts the first woman in the world to be certified in operating a polygraph, or lie-detector machine. She helped the town of Searchlight train its first ambulance team, and she was a founder of the Searchlight Community Church.

Gale was her nickname—she was born Margaret Jane Dailey, on March 23, 1917, in Pittsburgh, Pennsylvania. Blond and green-eyed, she appeared on one of its radio stations at age eight.

She once told of a childhood experience in which her family was able to feed stew to a vagrant because Maggie had told her mom not to discard the leftover food. On a simple level, the incident foreshadowed Maggie's lifelong interest in community service.

She played lead roles in high school plays, and was also valedictorian of her class. Before leaving the city, she became president of the Pittsburgh Modeling Club, and also owned her own real estate.

She was also active there in the Red Cross and other volunteer agencies—a pattern that she continued when she moved west.

On her first trip to Las Vegas, Gale fell in love with the desert. At about age thirty-eight, in the 1950s, she became a resident, and purchased the Nevada Detective Service. In her determination to succeed, she attended a college in New York and became certified on the polygraph. This skill attracted some interesting clients to her agency, which included local casinos, police departments and the Federal Bureau of Investigation.

Then Gordon Colton entered Maggie's life. He was a member of a prominent family that had founded the town of Searchlight and established the area's first gold mine, called the Duplex. Gordon's grandfather, George F. Colton, had named the town after of a box of Searchlight brand matches, which he had

1917–2000
PRIVATE INVESTIGATOR, MINE AND STORE OWNER, CHURCH FOUNDER

used to light a flame, which then caused some gold flecks in nearby rock to glitter. In its prime, Searchlight was bigger than Las Vegas.

Gale and Gordon were married and began working together. In 1962, they attempted to restart mining in the Duplex, by hiring a group of unemployed miners from Chicago. The effort came to be called the Chicago Miners' March.

While the miners worked, the couple was building Coltons' General Store, which included a gas station and lounge. The two were known for giving food and gasoline to the needy.

With this going on, Gale still felt an emptiness in Searchlight, which led her to gather the influential people in town to do fund-raising to build a church. Due in part to her diligence and hard work, the Searchlight Community Church was debt-free the day it opened.

After Gordon's death in 1975, Gale relocated to Las Vegas. When the MGM Grand Hotel and Casino was devastated in 1980 by an immense fire, Gale went to the scene to assist. At the time, she was on the board of the local Red Cross.

She also was a proud member of the Mesquite Club of Las Vegas, which is affiliated with the General Federation of Women's Clubs. She served as state vice president of the charitable March of Dimes campaign, and also helped when Southern Nevada joined the Children's Miracle Network, a charity that supports children's hospitals.

In 1994 Gale received an outstanding citizen's award from American ORT Federation, which supports education and immigration services. She was a lifetime member of Hadassah—a women's organization that supports Jewish causes—and worked thousands of hours as a volunteer at Southern Nevada Memorial Hospital, which is now called University Medical Center.

"She was truly a Nevada pioneer in the same spirit as my great-grandfather," said her son Stanton.

On May 20, 2000, a bright light went out when Gale Dailey Colton passed away. She rests beside her Gordon, her loving husband, in the Searchlight Cemetery.

Dale Meyer, sister of Gale Colton

Mary Melita Smith Coombs

Melita Smith Coombs spent her adult years as an artist and supporter of the arts. She spent her childhood that way, too.

From the time that Melita could hold a pencil or paintbrush, she translated what she saw into drawings. Born on January 12, 1916, and raised in Salt Lake City, Utah, she had both family and teachers who encouraged her talent.

In elementary school, she was allowed to embellish classroom blackboards, charts and maps. In high school she spent hours on her art. After she married and had children, she took art classes at night and, before long, her training began to pay off in the form of art commissions and requests for her to teach.

She solidified her reputation as an artist in San Francisco, where she and first husband Paul C. Strong had moved after their wedding in 1933. There she learned from such gifted instructors as Ray Strong, Marque Reitzel, Leonard Richmond, Don Ricks, and Margery Stocking Hart.

One of her most prestigious commissions was a portrait of Mary Sherwood Hopkins, the wife of railroad magnate and eponymous San Francisco hotel founder, Mark Hopkins. She painted it as part of the Gold Spike celebration to commemorate the joining of the Union and Central Pacific railroads at Promontory Point, Utah.

Melita also painted portraits of Howard Hughes for the "Men of Achievement" series and of Buster Wilson, an Indian artist and member of the James Wilson family, whose ranch has become Spring Mountain Ranch State Park near Las Vegas. Today her painting, which was commissioned by the park, hangs above the fireplace in the ranch house. She also took a commission to paint presidents of the Church of Jesus Christ of Latter-day Saints' genealogy library in Las Vegas.

She may be most well-known for her rendering of the old Las Vegas Mormon Fort as it appeared in 1855, when it was built. The fort was home to the first non-native settlers in the Las Vegas Valley. The

1916—2008
ARTIST, ART GALLERY OWNER, ARTS ACTIVIST

"I try to express the realism and idealism in life," Mary once said.

painting was included in the Las Vegas calendar created for the nation's Bicentennial in 1976.

Melita also was a gallery owner, having had galleries in the California cities of San Francisco, Sacramento, Mill Valley, and Tiburon. She also had a study and art gallery on Oakey Boulevard in Las Vegas.

Paul and Melita had two sons, Ronald Paul and Gary Payson, but the couple eventually divorced. She later married Carl Steed Coombs. They also had two sons, Dennis George and Christopher Carl. The family made its home in Las Vegas where Carl owned and operated Paradise pools and Spas. He died in 1994.

When Melita moved to Las Vegas she joined its art community. The Nevada Watercolor Society was founded about the same time that the Coombs family arrived. The Allied Arts Council—which is now called the Metro Arts Council—soon followed, and Melita was involved in both groups.

She was chair of the Bicentennial Calendar Art Show and was a project coordinator for the Las Vegas Artists Cooperative. She also became active in the local branch of the National League of American Pen Women, and served for a time as its president—as she had also done for the Berkeley, California, branch of Pen Women.

At the time of her death on November 26, 2008, Melita had ten grandchildren and eighteen great grandchildren. The Nevada Watercolor Society newsletter, *Desert Wash*, described her once as a "moving force in the art community."

She once said of her own art, "I try to express the realism and idealism in life." And she succeeded.

Fran Haraway

Ethel Dolores "D.D." Cotton

Ethel Dolores Cotton, affectionately known to her friends as D. D., was a pioneer in the entertainment industry as well as in the hotel-casino business of Las Vegas, where she resided fifty-two years.

D.D. was born August 15, 1935, to Mabel Moses and Locksley Thompson. She migrated from New York City to the bright lights of the Las Vegas in 1957. But her life journey began in the Manhattan neighborhood of Sugar Hill, surrounded by highly motivated neighbors who included Willie Mays, Leslie Uggams, Diahann Carroll, Joe Louis, and Frankie Lymon. All enjoyed successful careers in sports or the arts.

At age five, D. D. started dance lessons. Dancing allowed her to escape a stepfather who abused her mother. D.D.'s professional career blossomed with the support of performer Eartha Kitt and the Katherine Dunham School of Dance. The love of dance served as the foundation for D.D.'s professional career. Her most staunch advocate was her mother, who supported the years of dance lessons by working as a housekeeper.

1935–2009
DANCER, CASINO DEALER, FLOOR MANAGER, CIVIL RIGHTS ACTIVIST

During high school, D.D. performed at small neighborhood affairs, which led to dancing in nightclubs and eventually to an audition for the chorus line at the famed Apollo Theater. However, the work was not as financially rewarding as she wanted. But it led to great exposure that included an introduction to Cab Calloway, who gave her the opportunity to dance and travel with *Calloway's Cotton Club Revue.*

Dancing in a chorus line behind the great headliner, singer, bandleader, arranger, and songwriter Calloway, D. D. opened with the show in Miami in 1957. Thus started her entertainment career. Though prior chorus line dancing had taken her to stages in New York, Michigan, Florida, and Canada, Las Vegas, to which she moved with the *Cotton Club Revue,* proved to be the place of her dreams. Opportunities seemed infinite in work and society.

She found Las Vegas exciting and felt that her life really began there. The *Cotton Club Revue* opened at the Royal Nevada Hotel, which later became the convention center for the Stardust Hotel. The semi-permanent nature

of the show allowed D.D. to form lasting friendships with community members and entertainers.

In Las Vegas, D. D. met and married Elmer Cotton. She quit show business only to be thrust into exciting positions in the gaming industry, becoming a keno writer at both the Town Tavern Casino and the Louisiana Club on the Westside, a segregated black neighborhood. Happily, she discovered a short-lived opportunity to dance in a show at the Carver House and was privileged to work with the world famous Treniers, a rhythm and blues singing duo of twin brothers.

However, her most important introduction was to Ash Resnick, whom the *Los Angeles Times* described as the inventor of the casino junket. Resnick was affiliated with Caesars Palace, but had worked with many casinos. Resnick was also, according to book author Anthony Summers, a "high-level mob courier."

During the 1960s integration of the Las Vegas Strip and downtown gaming establishments, the Culinary Union Local 226 began sending skilled blacks out to secure jobs in various gaming locales. After being turned away at several places, D. D. was hired downtown at the Nevada Club as a cocktail waitress. Several other blacks were also hired at Fremont Street casinos during that push for a better standard of living. These young people endured some name-calling indicative of the period, but eventually they and the town settled into the new social order.

In 1966, D. D. moved to Caesars, along with Peggy Walker, as the first two black cocktail waitresses on the Strip. After four years, she decided to become a dealer and learned the craft by working at the Rainbow Club in Henderson, the Silver Nugget in North Las Vegas, and then back to the Strip at the Tropicana, where she worked for twenty years. She eventually became a floor manager supervising all games.

A dancer, cocktail waitress, dealer, and manager, D. D. was instrumental in helping integrate workplaces in Las Vegas. The Nevada Club was the training ground, and D.D. never forgot those first months.

"At the time, Richard Walker and I were the only two black people working in a white establishment anywhere in town. People would just come and look at us like we were people from outer space. White dealers would come from all over Fremont Street to watch Richard deal craps. Cocktail waitresses would come and look at me. The owner of the Nevada Club, Van Satton, started something; within three to four months, every place on Fremont Street had at least [one] black dealer."

Ethel Dolores Cotton, better known as D.D., passed away on April 24, 2009. In her own words, she believed her "life really began" in 1957 when she moved to Las Vegas. And she breathed that life into the city, making it more just, more equal, and a better place to live—for all residents.

Claytee White

Marcia Smith deBraga

Marcia Smith deBraga "made" history as a Nevada legislator. She also wrote Nevada history, as an author. She skillfully represented rural Nevada in all her endeavors.

Marcia served five terms in the Nevada State Assembly, from 1993 to 2001, representing Churchill and White Pine counties plus parts of Eureka and Lander counties. She helped pass bills that compensated people for the loss of water rights, and she also encouraged negotiations between parties on this sensitive issue.

She became an advocate for the children of Nevada, when she supported legislation to investigate the cluster of childhood leukemia cases in and around Fallon. As head of the Assembly's Natural Resources Committee, Marcia scheduled hearings that resulted in the dissemination of current easy-to-access information about the disease. Another of her child-based concerns was protecting youngsters

1937–2010
State Legislator,
Author, Columnist

whose legal custody was given to a parent who had abused the other parent.

Marcia's history writing came in the form of "Dig No Graves for Us," which was a hundred-year history of Churchill County, which was published in conjunction with Nevada's celebration of the U.S. Bicentennial. Her book recounts the problems of the area's first settlers, and details the heyday of Churchill's mining towns.

Born in 1937 in Los Angeles to Eldon and Zona Smith, Marcia and her family moved to Idaho when she was about eleven. When she was thirteen, they moved to Fallon. She graduated from Churchill County High School, took some community college courses and then, in 1955, married rancher Lyle deBraga.

They made their home in Stillwater, in Churchill County, where they raised four children. Marcia once wrote that on the ranch, her husband was boss. "He said 'The Boss' should be able to tell the difference between hay fields and grain fields. Since the only thing on the farm

I could possibly identify was dirt, I was never in the running."

Marcia wrote a newspaper column for the *Lahontan Valley News* and was a correspondent to the *Reno Evening Gazette* and the *Nevada State Journal*. Her "Solemn Column," which was not solemn at all, dealt with the challenges of family life. One of her admirers wrote, "Marcia wielded a pen with more power than a high-powered weapon."

She also was active in the Nevada Cattlemen's Association. For twenty-one years, she was a secretary for the National High School Rodeo in Nevada. She, Lyle and a friend, Rich Lee, also started the Silver State International Rodeo in 1985 as a rodeo venue for youngsters who did not qualify for the National High School Rodeo, with some missing the cut-off by a fraction of a second. The Silver State International Rodeo began as a three-day event, but today it lasts five days and attracts more than five hundred participants.

In politics, Marcia served as chair of the Churchill County Democratic Party and headed the Rural Nevada Democratic Caucus. In the state assembly, she chaired the Committee on Natural Resources, Agriculture and Mining. In 2000 she cosponsored a land-use summit. And in 2001, she earned the gratitude of the Nevada Women's History Project by introducing a bill to make Sarah Winnemucca, a legendary Paiute tribe member, the second of two statues representing Nevada in the United States Capitol in Washington, D.C.

The Soroptimists honored Marcia as its Woman of the Year. She was selected Community Woman of the Year by the American Association of University Women, and Community Woman of the Year by an organization called Business and Professional Women. The Nevada Women's Lobby voted her Outstanding Woman Legislator. She received the Nevada Farm Bureau's Silver Plow Award and the Truckee Meadows Tomorrow Silver Star Award.

Marcia died on March 24, 2010. At the time of her death, Nevada politician Rory Reid —who was running for governor at the time—said, "Nevada has never had a more dedicated and passionate public servant."

Fran Haraway

Cherie DeCastro

The DeCastro Sisters—a singing act patterned as a Cuban version of the Andrews sisters—made several marks on Nevada. They performed regularly at Las Vegas resorts. And Cherie DeCastro, the only sister who was part of every single performance and recording by the group, became a Nevadan in 1967.

Until her death in 2010, Cherie—who resembled Elizabeth Taylor—was treated like a celebrity in her Huntridge Las Vegas neighborhood, which is an older area near Charleston Boulevard and Maryland Parkway.

The sisters were the offspring of Juan Fernandez DeCastro, a Cuban aristocrat, and his wife, Babette Buchanan, who had been a showgirl with the Ziegfeld Follies. In the 1920s Juan bought out Babette's contract from Florenz Ziegfeld, to marry her and take her to Havana. He owned real estate and radio and television stations there, in partnership with David Sarnoff, an American mogul. Juan also owned a sugar plantation in the Dominican Republic.

Sarnoff and writer Ernest Hemingway were regular guests at the DeCastro home in Havana, where Cherie and her sisters, Babette and Peggy, grew up. Cherie, however, was a U.S. citizen by birth, born in New York in 1922, after her dad bought an apartment at the famed Dakota building.

The DeCastro Sisters began performing as young girls. They emulated the Andrews Sisters, who had come on the American scene in the 1930s, and were popular during World War II. Ironically, the DeCastros' first appearance in public was at the U.S. embassy in Havana, for an audience of wealthy Americans. The occasion was George Washington's birthday in the pre-Castro era.

The sisters returned to the United States as adults in 1942, determined to perform. "At that time there was no audience for Latin acts," their manager, Allan Eichler, once said. "They were ahead of their time."

The DeCastros got a chance to sing at a Miami club. An agent heard them, and then booked them into the Copacabana in New York with the Will Mastin Trio, which featured singer Sammy Davis, Jr.

As the DeCastros gained popularity, their act became more flamboyant. They added comedy, but kept their exotic Latin identity. The trio worked its way across the country, including an engagement at the Palladium in Hollywood, where they sang with Tito Puente's band. They made their first recordings in 1946.

1922–2010
SINGER, RECORDING
ARTIST

The sisters appeared in the 1947 film *Copacabana* with Carmen Miranda and Groucho Marx. The same year, the sisters joined Bob Hope and Cecil B. DeMille in a live special broadcast that launched television station KTLA in Los Angeles. It was the first U.S. telecast west of the Mississippi. Bob Hope introduced the DeCastros, who sang "Babalu."

The sisters also sang in Walt Disney's animated *Song of the South*. They provided bird and animal voices, and also contributed to its hit song, "Zip-a-Dee-Doo-Dah," which won an Academy Award for best song.

The sisters continued to perform in both the United States and Cuba until 1959, when dictator Fulgencia Batista fled Cuba and Castro took power.

American mobsters ran many of the Cuban clubs where the sisters sang. Of that era, Cherie later recalled that while the sisters were performing in 1958 at Capri, a Havana club where actor George Raft was the host, "Fidel's men were already shooting in the streets, and people stopped going out at nights." She returned to Miami, and never revisited Cuba. About that time, her father, died from cancer at age sixty-seven.

Six months later, American mobster Sam Giancano, who had known Juan DeCastro, helped get his widow on a plane just minutes after she had witnessed Castro supporters shoot four former Batista aides. The only possession she was able to take was a pocketbook holding jewelry from Juan.

By then the DeCastro Sisters had recorded "Teach Me Tonight," which is considered their greatest hit. Though considered a "throwaway" recording, it caught on at once. Listeners loved its risqué lyrics, and bought more than five million copies. The sisters recorded numerous songs, but nothing else of the magnitude of "Teach Me Tonight."

Their stage act remained popular. They performed with Noel Coward in Las Vegas when he made his debut at the Desert Inn in 1954. They also appeared in Las Vegas with George Burns and Bobby Darin.

Cherie's mom Babette died in Las Vegas in 1985. Daughter Cherie had always hoped to take her mom's remains back to Cuba, to reunite with her father, "who was all alone." Cherie's two sisters also predeceased her.

In 2000, the DeCastro Sisters were inducted into the Casino Legends Hall of Fame as Las Vegas stars, in the Tropicana Hotel on the Las Vegas Strip, although the museum was dismantled several years ago.

Cherie's two marriages—one of them to cowboy actor Monte Hale—ended in divorce. She adored her many cats, and was known for taking in strays. She had been in a long and happy but unofficial relationship when she died of pneumonia on March 14, 2010.

Barbara Riiff Davis

Joanne Cutten de Longchamps

When Galen DeLongchamps of Reno visited Los Angeles, he spotted a magazine cover and said he'd like to meet the pretty face on that cover.

That girl was Joan Cutten, the daughter of Ruth Avery Cutten, who saw to it that Joan attended private schools in Los Angeles and Paris before embarking on a modeling career. Mother Ruth, a former dancer with Isadora Duncan, owned a Los Angeles dance studio and was also a drama coach. So it was natural that she encouraged young Joan in those arts.

A meeting was arranged, and it wasn't long before there was a marriage. On January 21, 1941, in Pasadena, eighteen-year-old Joan wed Galen, who was not much older.

Joanne Cutten de Longchamps, who then made Reno her home, went on to distinguish herself in art, letters, acting, modeling, and music.

Galen was the adopted child of the prominent Reno family of architect Frederick DeLongchamps, who was renowned for designing public buildings,

ABOUT 1923–1983
MODEL, POET, ARTIST,
PHILANTHROPIST

including the courthouses in Minden, Pershing, Humboldt, and Douglas counties.

Upon her marriage, Joan changed her name to Joanne de Longchamps, spelling her new last name slightly different from her husband's last name. The newlyweds enrolled at the University of Nevada, Reno. Galen became an engineer, and though Joanne never graduated, she audited every fine arts course she could. She studied with Wilbur Van Tilburg Clark, Robert Hartman, and artist Robert Caples, among others. She later became a lecturer and teacher of fine arts at UNR.

DeLongchamps was captivated by the art of poetry. Her third book of poems, *The Hungry Lions*, was published in 1963 when she was forty. Her poetry appeared in more than three hundred magazines, and she published seven poetry volumes. For her poetry, she won the Reynold's Lyric Award and the Carolina Quarterly Award. In 1973, she was appointed UNR's first Walter Van Tilburg Clark chair in creative writing.

In the decades between 1960 and 1980,

Joanne was considered Nevada's foremost poet. She contributed regularly to the *West Coast Poetry Review*. She, along with other poets, formed the Reno Poetry Workshop.

Another of Joanne's artistic interests was collage. She would painstakingly shred paper of every texture and color, and reapply those pieces in designs that mimicked forms in nature. Desert flora and fauna were her dominant themes. She often exhibited in local galleries and sometimes managed to have pictures of her visual art published in her poetry books.

A 1971 trip to Africa and Greece inspired to create drawings that were later translated into a series of poems and collages.

Tragedy invaded the deLongchamps' lives when their only son, Dare, took his life in an old schoolhouse near Galena, a town that had supplied timber to the mines in Virginia City. The couple had purchased the property for historic purposes, and Joanne had composed poetry inspired by it entitled, "The Schoolhouse Poems." But after their son's suicide, she never visited the site again.

Joanne was also an accomplished musician. In 1973 she collaborated on an effort to create a theme song for the city of Reno, using the words "Reno, Fantastic Reno." The Reno Philharmonic performed the composition, though it never became Reno's official song.

In the last decade of her life, Joanne was stricken with cancer and multiple sclerosis. Her last year of life, 1983, marked many turning points. The community held a respective exhibit of her art. She divorced her husband. UNR awarded her an honorary Doctor of Letters. She received the Nevada Governor's Arts Award for Literature.

Posthumously, in 1989 she was inducted into the Nevada Writers Hall of Fame. She was also listed in *Who's Who in Poetry, The World Who's Who of Women, Who's Who of American Women*, the *Directory of American Poets*, the *Dictionary of International Biography*, and *Contemporary Authors*.

Joanne styled herself as an elegant lady wearing mink draped over a shoulder who often gesticulated with her elongated cigarette holder. Sadly she died in relative isolation. After four decades of artistic endeavors, she was said to have remarked, "Nevada hardly knows me as a poet."

She willed her beloved 1895 Victorian home at 821 North Center Street in Reno to UNR, for use as a guest residence for visiting dignitaries and professors.

Susan Houston

Ruthe Goldsworthy Deskin

Ruthe Goldsworthy Deskin improved life for Southern Nevada seniors, abused or neglected children, and individuals fighting addictions. She called Las Vegas home, but her birthplace, Yerington, remained the place of her heart.

Born February 20, 1916, she often called Yerington by its original name, Pizen Switch. Her father, Jim Goldsworthy, was a mining engineer and owned a feed store. Her mother, Viola West, came from a Mason Valley pioneer family.

Ruthe, the oldest of three children, delivered newspapers as a youngster, which perhaps foreshadowed her career in news. In 1937 she graduated from the University of Nevada, Reno, where she had worked on the school newspaper. She then became the *Reno Evening Gazette's* women's editor.

Ruthe married Jim Deskin, who worked for the Nevada Employment Security Department. When Jim got transferred in 1940, the couple and their two children moved to Las Vegas. Housing was scarce for families, so they spent their first months in a motel room with a kitchenette. Next

1916–2004
NEWSPAPER
REPORTER, EDITOR,
COMMUNITY ACTIVIST

they rented a two-bedroom house on Tenth Street. Ruthe's initial impression of Las Vegas: small and hot. Since the Deskins lacked air conditioning, they created a temporary "swamp cooler" by rigging a wet blanket with an electric fan running behind it. Shortly after, Jim went into the Navy and Ruthe moved back to Reno to stay with family.

By 1950, the Deskins moved back across the state, settling in Henderson. Ruthe's first job was at the *Las Vegas Review-Journal* as its Henderson reporter.

For better money, she moved into radio. At first she wrote on-air advertisements. She became the announcer for "Women in the News" on the KENO station after an unfortunate incident. When the show's young male announcer read one of Ruthe's commercials on air—about a corset with a removable crotch—he and the engineer had a laughing fit. The station went off the air until the two recovered. After, the corset salon that had paid for the commercial requested a female announcer.

Radio was a new format for Ruthe, who had studied print journalism.

In 1954 she went to work at the *Las Vegas Sun*. She worked closely with Hank Greenspun, the editor and publisher, and also grew close to his wife, Barbara. Ruthe even travelled with the couple when Hank ran unsuccessfully for governor in 1962. Through Hank, Ruthe became involved in many humanitarian projects.

She worked with community leaders in the mid-1950s to create the Sun Youth Forum, an event in which high school students discuss issues of the day and write columns that run in the *Sun*. Greenspun then assigned Ruthe to work with Charlotte Hill to launch the charitable *Las Vegas Sun* summer camp for children, which began in 1970.

In 1959 Ruthe won the Nevada State Press Association's award for best story by a woman reporter. In 1966 she became the association's second woman president. She also served a term as president of the Las Vegas Press Club.

Through her *Sun* column, which ran for half a century, Ruthe championed the rights of the downtrodden. She supported anti-addiction programs, quality hospice care for the elderly, community arts, and placing abandoned pets into loving homes.

Two Las Vegas buildings bear her name. Ruthe Deskin Elementary School was dedicated in 1989, and in 1994 the activities center at Child Haven was named after her. Child Haven, which Ruthe had helped found in the early 1960s, is Clark County's residence for displaced children. She also served as a director of the first Spring Mountain Youth Camp, which is a secure correctional facility for male teens. She served on both the Child Welfare Advisory Board and the Juvenile Probation Committee, which are connected with county and state agencies.

Jim and Ruthe were avid bowlers. She held various posts in the Las Vegas Women's Bowling Association and played into her eighties. At one tournament in Elko, her team's hotel reservations fell through, but she talked a brothel owner into letting her team lodge at the brothel.

In 1980, the Nevada State Board of Regents named Ruthe a Distinguished Nevadan. Jim Deskin, who became executive director of the Nevada State Athletic Commission, died in 1983.

Through her decades in the media, Ruthe rubbed elbows with politicians and celebrities.

Ruthe belonged to numerous groups including the Las Vegas Arts Museum, the Clark County Law Library advisory committee, the Animal Rescue Foundation board, and the Silver State Kennel Club. She also served on the American Cancer Society's crusade committee, the state Tourism Advisory Council, and Nathan Adelson Hospice's board.

Ruthe Deskin died on February 14, 2004, survived by two daughters—Nancy Cummings and Terry Gialketsis—and Jack Deskin, her stepson.

Sun official Brian Greenspun, Hank's oldest son, said, "Ruthe Deskin represented not only the conscience of the *Las Vegas Sun*, but for fifty years the conscience of Las Vegas."

Thalia Dondero, a Clark County commissioner for many years, said of Ruthe, "She never wavered in her friendship with people. If you were her friend, you stayed her friend. She was true blue."

Nancy Sansone

Dorothy Buchanan Dorothy

Dorothy Buchanan Dorothy first chanced on Las Vegas in 1945, when she and her husband touched their private plane down for a brief rest, en route from California to Mexico. But when they moved permanently to Southern Nevada, she did her best to improve her surroundings—both in Las Vegas and Pahrump.

Dorothy, who gave her birth date approximately—as February 17, "in the early nineteen hundreds"—was born to Lucile and James "Buck" Buchanan, who homesteaded a ranch of more than a thousand acres near the town of Yreka in Siskiyou County, California.

She received a diploma from San Francisco College, but didn't limit her learning to academia. She also studied creative writing, radio technique, and use of the comptometer, a form of early adding machine. She also learned to fly an airplane, and in the process forged a friendship with early aviatrix Amelia Earhart. Dorothy joined the "99ers," Earhart's flying club, and was one of the few present when Earhart and Fred Noonan departed San Francisco on their fatal 1937 attempt to fly around the globe.

**UNKNOWN—1982
PILOT, STAGE
PERFORMER, RANCHER,
COMMUNITY ACTIVIST**

Dorothy also exhibited musical talent, and sang under the stage name of Dorothy Varnum. She and her sister both performed original songs on local and national radio programs. Eddie Cantor and the Tom Oakley Band included some of her songs in their repertoire.

A bout of ill health in 1936 sent Dorothy to the Palm Springs area to recover. There her writing ability surfaced. She wrote a weekly "chatter" column for the newspaper. "Doing the Town with Dottie" was one of her slug lines. She also wrote press releases for resorts in the area.

When World War II started, more talents emerged. Dorothy volunteered at the Northrop installation in Los Angeles, operating a comptometer. She also "adopted" several hospital wards treating injured veterans by supplying typewriters, wheelchairs, and other rehab equipment.

In 1943 she married John MacAdam, a wealthy Los Angeles man whose grandfather had invented a form of asphalt road surface known as "macadam." It was a short marriage that ended when MacAdam died, but it introduced Dorothy to high society.

After his death, she returned to Palm Springs, where she met Dale B. Dorothy, a fellow aviator who became her husband. After their 1945 pit stop in Las Vegas, they soon returned, settling first into a bungalow on North Fourth Street in Las Vegas. They next purchased a motel in Henderson's Whitney Ranch area, along the Boulder Highway leading to Hoover Dam and Boulder City.

Then the *Las Vegas Review-Journal* approached Dorothy to write a column. F.F. Garside was then the editor. She was prolific, and for the next decade also wrote columns for the *Las Vegas Sun*, the *Henderson News,* and the *Tonopah Times.*

In 1948, she and Dale purchased the Bickell Ranch near Pahrump. The site is now the Calvada subdivision The Dorothys named their ranch The Lazy 88, with "88" being ham radio talk for "love." They farmed mostly cotton and alfalfa there for nearly eight years, when Pahrump had only one road to connect it to Las Vegas. By 1955, the Lazy 88 was producing 40,000 pounds of cotton per truckload.

"For a whole year I tried to awaken people to the potential of the Pahrump valley," Dorothy once said. "There were no roads electricity, no telephones. And Dale's ham radio was the only communication in the valley, which was used to advantage to direct emergencies and lost planes."

In the early 1950s Dorothy took on the challenge of having the Blue Diamond Road to Pahrump developed and paved.

She also helped form several Democratic clubs in Pahrump, Blue Diamond, Whitney, and Boulder City. She was a founding member of the Las Vegas Valley Business and Professional Women's Club. A rockhound group she was part of blossomed into the Y'smanettes Club in 1946, which then eventually evolved in the Las Vegas YMCA. She also had a role in developing the Lee Canyon campground at Mount Charleston and the adjoining roads.

Dorothy worked tirelessly from 1958 through 1963 to raise funds for a United Nations Peace Grove in Lorenzi Park in central Las Vegas, but only three trees were planted. Eleanor Roosevelt noticed Dorothy's non-partisan efforts, and invited the Dorothys to her home in Hyde Park, New York City. She also showed them around the United Nations building.

The list of organizations to which Dorothy contributed is lengthy. Some of them are: the Mesquite Club, Las Vegas Press Club, Nevada State Parole Board, Soroptimists Club, local chapter of the Humane Society, the Las Vegas March of Dimes, the St. Rose de Lima Auxiliary, the Weimaraner Dog Club, and the Silver Gavel Parliamentarian Society. In a nod to her unusual "Dorothy Dorothy" name, she also belonged to the Identical Names Club.

She passed away October 31, 1982, but her legacy remains throughout the Las Vegas Valley. Of her life, she once said, "I own shares in these United States of America, Inc., and I want to do my part in keeping it the wonderful country it is."

Susan Houston

Gladys Keate Dula

The year 1900 was five years before Las Vegas officially became a townsite. But that year marked the birth in Caliente of Gladys Inez Keate, who would affect the destiny of Las Vegas.

Gladys was born to Ernest and Emma Conaway Keate, in the home of her grandparents, who owned one of the largest cattle ranches in that end of the state. Her grandfather, Joseph Conaway, had served in the Nevada Legislature for two terms and was known in political circles.

The Keates prospered as Ernest ranched and mined. Gladys' brother Henry was born in 1903, and another brother, Walter, in 1905. But their mother and a third baby boy both died from diphtheria during an epidemic that swept Northern Nevada in 1910. At that point, Gladys and her two brothers moved in with their Conaway grandparents.

When Gladys was twelve, her father bought a ranch adjacent to the sprawling Conaway Ranch. She moved in with her father, taking over household duties in addition to attending school.

At the tender age of fourteen—on August 10, 1914—Gladys took a huge step. She married the senior locomotive engineer of the Union Pacific

<div style="text-align:center">

1900–1975
Newspaper
Correspondent,
Community Activist,
Member of Civic
Groups

</div>

Railroad Company. His name was Robert Flaik Dula. They lived in Caliente.

She became an informal one-woman welfare agency. Records show she served as a midwife fourteen times. Since there were no public agencies to serve the needs of the community's penniless and aged miners and prospectors, she began to personally offer them care.

Even though Gladys had a limited formal education, she served as a newspaper correspondent in Caliente. Eventually she became the circulation director in Caliente for several out-of-town newspapers.

Then in the 1930s, when friends of President Franklin Roosevelt set up the "President's Ball" to raise funds to fight polio, she organized fund-raising events in Caliente. Later, in the 1940s and 1950s, she planned similar events in Las Vegas.

In 1939, she was appointed the Nevada delegate to the Institute of Government, a Washington, D.C. event that Roosevelt had set up.

The Nevada Association of the Blind attributes its inception to Gladys and other founders who had befriended various blind individuals. This

organization preceded the Blind Center of Nevada in Las Vegas, which currently serves Clark County.

A Democrat all her life, Gladys worked as campaign chair for numerous office seekers. From 1924 to 1944 she was vice-chair of the Democratic State Central Committee.

In 1944, during World War II, Gladys, Robert and their children moved to Las Vegas. While continuing her polio fund-raising efforts, she served four years on the board of the Clark County chapter of the National Foundation of Infantile Paralysis. She was also active in local branches of the Easter Seals organization and the American Cancer Society. A member of Rebekah Lodge, she served from 1939 to 1940 as state president of the Rebekah Asssembly of Nevada.

Upon the Dulas' move to Clark County, their social life abounded. She joined the Mesquite Club in 1944, and was elected its president for 1949 to 1950. She cofounded Homesite Baptist Church in Las Vegas, and served as its treasurer for several years. She also organized the Women's Democratic Discussion Group in 1948. Gladys was listed in *Who's Who in America* (1944-1945) and in *Women Only* in 1958.

She and Robert belonged to the Brotherhood of Locomotive Engineers and the Union Pacific Old Timers Club. Gladys also joined the Ladies Auxiliary to the Brotherhood of Railroad Trainmen.

The family consisted of two boys, Edwin and Robert Jr., and daughter Glade. Their younger son, who became a Las Vegas policeman, was killed on duty on April 9, 1955. Known for his work with community youth, the deceased officer's name was given to the Dula Center, a recreation building designed specifically for Clark County youth.

In 1960 Gladys served as state chair for John F. Kennedy's presidential campaign. In 1964 the Lincoln County Democratic Party honored her at a testimonial dinner.

Gladys and Robert celebrated their fiftieth wedding anniversary on August 14, 1964. Robert retired from the railroad in 1965 and died in 1971. Gladys Keate Dula passed away on June 7, 1975, and is buried at Memory Garden Mortuary & Cemetery.

Mary Gafford

Lilly Hing Fong

Lilly Hing Fong, who received her early education in China, helped raise the profile of the University of Nevada, Las Vegas by funding the expansion of its programs and buildings.

The Claes Oldenburg flashlight sculpture, which may be UNLV'S most distinctive landmark, owes its existence to Lilly's hard work. She also was the first Asian-American teacher in the Clark County School District.

Lilly was the oldest of the ten children of Helen and Ong Chun Hing. She was born in Superior, Arizona, in 1925.

Her mother was born in Pennsylvania, but in 1903 returned to China, where she lived until she became a "picture bride" in an arranged marriage to Ong. He emigrated from China in 1912; he and his family had opened several restaurants in Phoenix. In 1921, before meeting in person, Ong and Helen wed in a Buddhist ceremony. In Superior, they lived next to their American Kitchen Restaurant, which also sold groceries.

In 1930, Lilly's mother took her and three siblings to China for seven years, to care for their ailing grandmother. According to Lilly, Chinese children had fun playing marbles, checkers, and hopscotch, but in school they rigorously studied Sun Yat-Sen as well as the ancient dynasties. They mastered the ethical and moral teachings of Confucius. Lilly learned to use an abacus and do calligraphy.

In 1937 when the war with Japan began, Lilly's father brought the family back to Arizona. He firmly believed in education. Lilly said he told her, "Confucius said education is the equalizer of all. It knows no distinction in class. If I give you money, you would spend it. So I am going to give you an education that is going to last for life." As a result of her parents' sacrifice, all ten Hing children earned college degrees.

Lilly said her parents treated her as well as their first-born son, who was younger. She also said she did not experience anti-Chinese discrimination until she left Superior.

She earned a degree from Arizona State University in Tempe. She met her future husband, Wing Fong, while he was attending Woodbury College in California. Married in 1950, they made their home in Las Vegas, where Wing

1925–2002
TEACHER, EDUCATION
SUPPORTER,
PHILANTHROPIST

began as a manager for the Las Vegas Bottling Co. He later opened the popular Fong's Gardens Restaurant. He also became active in banking and real estate.

Lilly was the first Asian-American teacher in the Clark County School District, which honored her in 1952 as an outstanding teacher. She taught for five years at the Fifth Street Elementary and West Charleston Elementary schools. In 1955 the Fongs' son Kenneth was born, followed in 1957 by daughter Susan.

West Charleston Elementary, which her children attended, gave Lilly a lifetime membership to the parent-teacher association to thank her for being involved.

In 1957 she and Wing donated two days' worth of business proceeds to the UNLV library. Then she persuaded major donors such as Judy Bayley and Artemus Ham, Jr. to support construction of a performing-arts center for the university. When the venues opened in 1970, they bore the names of Bayley and Ham.

During the 1970s the Fongs began making annual donations to UNLV for scholarships. In 1974, Lilly was elected a regent of Nevada's system of higher education, and served for ten years.

She then established an endowment fund for a Chinese language program at UNLV, donating her per diem regent stipends. She also initiated a program in the College of Education to honor excellence in student teaching. The UNLV Outstanding Professor of the Year award came about, in part, at her urging. She also helped save a building called the Tonopah dorm, which was turned into offices and classrooms for the College of Business and Hotel Administration.

In 1980, at age 55, Lilly earned her master's degree in education at UNLV. In 1982 she was named its Alumnus of the Year. Between 1982 and 1984, she helped raise three million dollars to build Beam Hall, and to support the engineering and computer science programs. The Nevada Society of Professional Engineers honored her for that role. Subsequently, UNLV renamed its geoscience building after her.

With Lilly's influence, private contributions were collected to install the Oldenberg sculpture and Rita Abbey murals in a concert space. She also raised money to build Alta Ham Hall. In 1984, she and Wing donated a quarter-million dollars apiece, to UNLV and the Clark County community college system, now known as the College of Southern Nevada.

In addition, she was a state president of the American Association of University Women and an education vice chair on the Governor's Commission on the Status of Women. She belonged to the U.S. Small Business Advisory Council and joined the boards of Opportunity Village and the Las Vegas Symphony.

The school district in 1990 honored Lilly and Wing for their years of service by naming an elementary school after the couple. Lilly died at age seventy-six on March 20, 2002, after decades spent promoting her father's vision of education.

Dorothy Bokelmann and Jean Spiller

Louise Lorenzi Fountain

Louise Lorenzi Fountain was born in Las Vegas into the family for whom Lorenzi Park in central Las Vegas is named. Though her father started out as a farmer, Louise and her husband helped install up-to-the-minute communication systems for a Las Vegas television station and various local law-enforcement agencies.

Louise was born in a small frame house in the 500 block of South First Street in Las Vegas, on November 14, 1913. She was the first-born of David Gerald Lorenzi and Julia Traverse Moore.

Her father, born in France, moved with his wife to Las Vegas in 1911 to farm, after reading literature published by the Las Vegas Chamber of Commerce that touted the locale's agricultural possibilities.

David Lorenzi bought eighty acres just off the Tonopah Highway—which is now Rancho Drive—which he had spotted from the window his train. But farming didn't pay well, so he converted the property to a recreational park. He spent years financing and developing the park.

1913–2006
BUSINESS OWNER,
MEMBER OF CIVIC
GROUPS

To raise money, he first opened an ice cream and candy parlor that served light meals. He also catered banquets and private parties that were held in the local Elks club. Since sugar was tightly rationed during World War I, David Lorenzi gradually converted it into the town's first cash and carry grocery store.

He spent five years readying his park, which opened in May 1926. Its focal point was a pair of lakes he had dug using a team of mules—hence its name, Lorenzi Lake Park. A dance pavilion was built overhanging one lake. The other was used for baiting, with an island used for fireworks displays and concerts. He also built a fresh water swimming pool, the city's largest at that time.

As Louise was growing up, her father strived to entertain the public with events at the park, such as rodeos and horse racing. He sponsored bathing beauty parades, which went down Fremont Street, with judging held at the park. Louise learned to swim, row a boat, and dance. She also helped out at the park, which her family sold in

1938 to a business that renamed it Twin Lakes.

Louise was in the second graduating class of the Las Vegas High School, which relocated to Seventh Street after the prior school on South Fifth Street burned down. Originally she intended to become a nurse, but switched plans after graduating high school, when she enrolled at the Marienello Beauty College in Los Angeles. She worked for two years as a beauty operator, and then married Edgar Fountain, an engineer.

They moved to Coulee Dam in Washington, where Edgar worked on the dam. In 1940 they moved to San Francisco, where he worked for six months in shipyards. Then they moved back to Coulee Dam, where their first child, Julia Ann, was born in 1941. When she was four years old, the family moved to Las Vegas.

Edgar wanted to go into business for himself, so the couple bought the Nevada Amusement Company, which consisted of 35 coin-operated phonograph machines stationed in various locations. Then they sold it to open the Frontier Radio and Appliance Company with a partner named Ben Sharpe. The company operated a message center for a two-way car phone system they installed in municipal police and county sheriff vehicles.

Frontier helped install equipment for Channel 8, the city's first television station, of which the Fountains were original part owners. At that time, the Fountains lived at 1200 Chapman Drive, where they welcomed their second daughter, Mary Belle, who was born in 1950.

From there, the Fountains branched out into bottling of soft drinks, restaurant ownership, land investments, and rental properties.

In 1955, Edgar was elected a city commissioner of Las Vegas, and held the office for three terms. He also was a Mason, Shriner, and an Elk.

Louise was active her whole life in church work. Originally she belonged to the First Methodist Church, where she was baptized as a child and later, when her children were young, taught church school. She also held several offices in its Women's Society. The Fountains then transferred to become charter members of Griffith Methodist Church. Louise was the first president of its Women's Society of Christian Service, to which she belonged for many years.

She also cherished her term as Mesquite Club president in 1956 and 1957. The club redecorated its clubhouse that year. Louise introduced the club's tradition of opening meetings with prayer. That year marked the first time the club sent its president-elect to a meeting of the National Convention of Federated Women's Clubs.

Louise belonged to the Daughters of the American Revolution, and was a charter member and regent of its Valley of Fire chapter. Her hobbies included bridge and "gold," likely a reference to amateur prospecting. She also enjoyed most aspects of being a homemaker. Louise Lorenzi Fountain died on January 29, 2006.

Denise Gerdes

Estelle Kelsey Givens

Estelle "Esther" Kelsey Givens was the first president of the Mesquite Club of Las Vegas. She was the originator of the city's early tree planting plan, which relied on youngsters carrying buckets of water and pulling hoses to water the saplings, which were needed to provide shade in the harsh summer climate.

Estelle came to Las Vegas in 1909 from Kentucky with her husband, James. The town was new, with the town site that forms present downtown Las Vegas only five years old. Colonel Givens, as James was called, was elected first president of the local chamber of commerce.

After Estelle gave her speech at the new club's first meeting, members voted unanimously that their club would work in diverse ways to benefit their community.

Estelle's tree program involved dividing the town into districts with a woman "forester" to lead each district. On "tag day," the foresters—who were Mesquite Club members—"sold" tags in exchange for tree-planting donations. Donors pinned their tags to their clothing, to show their support. It was said there was a great fluttering of tags everywhere. The year was 1912.

In January the Mesquite Club held a public meeting to discuss the tree project, to which the city leaders, the school commission and the chamber of commerce were invited. The community decided to plant trees on February 14, which the mayor proclaimed as "arbor day." A newspaper article declared the meeting a success, noting, "There was splendid public attendance, with hearty approval for the ladies' proposition."

The club dedicated trees to prominent individuals including the state's U.S. senators, Francis Newlands and George Nixon, Governor Tasker Oddie and a state senator whose last name was Bergman. One tree was dedicated to A.S. Henderson, who was the principal of local schools. Another was dedicated to Harry Brisley, who didn't live in Las Vegas but generously donated.

When volunteers lost their enthusiasm for watering the trees, the Mesquite Club went to

1856–Unknown
Member and Leader of Civic Groups, Advocate for Library and Shade Trees

> *Estelle was not a young woman when she and her husband moved to Las Vegas. But she brought a willingness to dig in and work hard.*

the city commissioners to lobby for funds to pay for workers to do regular watering. The ladies also lobbied for an order to prevent livestock from wandering the streets, as they were nibbling and damaging the young trees' bark.

But the squad of children who had helped nurture the trees were rewarded when they became the Mesquite Club's guests at the opening of the Majestic Theatre on May 17, 1912.

With the tree project underway, Estelle looked for another task for the club to embrace. She wrote to a legislator and pleaded for a library for Las Vegas. During her time in the town, a library was established.

When she left Las Vegas in 1913, Estelle donated her books—which included literature and opera—to the new library. She also compiled a scrapbook into which she pasted newspaper clippings about club activities and news items from Las Vegas and elsewhere in Nevada.

Estelle was not a young woman when she and James moved to Las Vegas. Many newcomers were younger than the Givens couple, but Estelle brought a willingness to dig in and work hard. She also brought properness, dignity and poise to the new, freewheeling community. Records suggest that she had a profound impact on the young women who joined the Mesquite Club.

Estelle was born on May 14, 1856, in Kentucky, to Carlos Kelsey and Sara Ann Kelsey. James Givens, an attorney, became Estelle's second husband, after her first husband died after five years of marriage.

After James' death, Estelle moved to the Seattle area, where she taught school. There is no readily available record of her date of death.

Kay O'Gorman

Alice Virginia Wood Goffstein

Dubbed the mother of the Four Queens Hotel, chorus dancer Dottie Wood Goffstein came to Las Vegas in 1951 with no cash or contacts, but perhaps a wild card in her back pocket.

She soon learned that glitzy Las Vegas had a dark side. But she was an optimist who did what she could to alleviate suffering.

Born January 30, 1924, near Covington, Kentucky, Dottie got her nickname from her dad, who said that at birth she was no bigger than a dot. Shortly after, the Woods moved to Cincinnati, Ohio, where her father soon died.

Dottie's mother scrimped for dance lessons for Dottie, who had shown promise. By age fifteen, she had dropped out of school to perform in chorus lines in Boston, Buffalo, Chicago, Detroit, Louisville, Miami, and Toronto.

At age nineteen, Dottie married, but divorced not long after the birth of her first daughter, Michele. She returned to Cincinnati with no job or child support. Her mother took care of Michele so Dottie could resume dancing.

**1924–2005
DANCER, CASINO
OWNER, PLANNER OF
CHARITABLE EVENTS**

In 1951, Dottie and a dancer friend took stage jobs at the El Rancho Vegas Hotel. They soon learned they were expected to engage in unsavory "extracurricular" activities. They refused, were fired, and hitchhiked back to Ohio with plans to never visit Las Vegas again.

But a year later the two did return, for a short run at the Flamingo Hotel with the Lindsay Sapphire Dancers. Dottie caught the eye and heart of Ben Goffstein, the hotel's vice president of operations. Ben asked the two young women to join him at a horse race. The brief date was enough to convince Ben he wanted to marry Dottie. She was indifferent so Ben began a two-year, long-distance courtship.

They married on New Year's Eve 1954, a serious step since each had a young daughter and a failed marriage. Together they had two more daughters. One day their parents would name a Fremont Street casino after the four girls: the Four Queens Hotel and Casino.

One of Dottie's many entertainment friends was actress Joan Crawford, whose fiancé was Al

Steele, the president and chief executive officer of Pepsi Cola—who, in turn, was one of Ben's business associates. When Crawford and Steele wed on May 10, 1955, in a Las Vegas chapel, Dottie helped out. As Crawford wrote in her memoirs, the couple forgot the bride's ring, so Dottie loaned her own for the ceremony.

Dottie and Ben dominated the Las Vegas social scene into the late 1960s with lavish themed charity benefits. On March 9, 1968, the newspaper noted, the Goffsteins hosted a Hawaiian Night. She also held a Ziegfeld Night and an Arabian Night.

Most proceeds went to the Variety Club, a children's charity with a circus theme, which called its chapters "tents." Ben Goffstein was one of the founders of Las Vegas Tent 39. In 1950 he was elected its "chief barker." In 1954, Dottie joined the cause, which funded medical care and other services for disadvantaged children. Sunrise Variety School for the handicapped was one of the tent's first beneficiaries. The school's daycare for children of working mothers eventually spun off into a separate program called Home of the Good Shepherd.

Dottie became a devoted volunteer. In 1970, she was elected its "chief barker-ette," an honor she received at least three times. In 1975 the club presented her with its highest honor, the Heart Award.

She worked for other charities, too, including the Nathan Adelson Hospice, Child Haven, St. Jude's of Boulder City, Bishop Gorman High School, the American Cancer Society, and a pet rescue shelter called Heaven Can Wait.

Dottie also started an entertainment "guild" in Las Vegas. Individuals who contributed their singing or dancing talents included Betty Aultman, Toni Clark, Elma Dean, Mabel Elwell, Elsie Goldring, Evelyn Goot, Alta Ham, Doris Ham, Eugenia Howell, Ruth Irwin, Okabelle Jones, Dale Linnette, Billie Long, Bess Rosenberg, and Alice White.

The Four Queens was Ben Goffstein's lifelong dream. It opened in 1966, at a construction cost of five million dollars. Ben, the builder-owner, named it after their daughters. Michele was the queen of spades, Benita the queen of clubs, Faith the queen of hearts, and Hope the queen of diamonds. Dottie called herself the joker. She took the duty of chief decorator, but sometimes helped out in the hotel's housekeeping department. But Ben died of cancer at age fifty-nine, one year after the hotel's opening.

Ben had served as "crew chief" of the auxiliary that supported the U.S. Air Force Thunderbirds demonstration team. Dottie decided to throw a holiday party in 1968 for Thunderbird team members who were away from home. There she met Bob Bingham, who would become her companion for thirty-five years. Bob then served in Viet Nam for two years, but the two corresponded and eventually became close.

Dottie Goffstein died of cancer at the age of eighty-one on July 18, 2005 at St. Rose Siena Hospital in Henderson.

Norma Price

Polly Gonzalez

In the north end of Las Vegas, at the intersection of Bradley Road and Corbett Street, a visitor will encounter the lovely Polly Gonzalez Memorial Park.

Near its picnic area is a colorful wall of individually designed tiles that pay tribute to Polly.

"Who was she?" the visitor may ask. The park was dedicated in 2006 to Polly, who died in a vehicle rollover in Death Valley in 2005, but remains an icon in the Las Vegas Hispanic community.

She was Nevada's first Latina television news anchor. Also an investigative reporter, she is remembered fondly as a pioneer who improved the status of Nevada Hispanics.

Born on July 23, 1961, in San Jose, California, Polly came to Las Vegas in October 1994 to report for television station KLAS, Channel 8. She soon became the anchor of the noon newscast and co-anchor of the station's 4:30 pm. edition. She covered notable stories including the 1996 Oklahoma City bombing and the 1994 Northridge earthquake.

1961–2005
TELEVISION REPORTER AND ANCHOR, ADVOCATE FOR HISPANICS

In 1996, Polly also anchored *Ventanas*, a community affairs program on KLVX Channel 10, the public television station in Las Vegas. The show, whose title translates to English as "Windows," discussed why some Hispanics have not achieved their potential, including the lack of an adequate education or poor access to jobs that pay a decent wage.

Polly used her position and life experience to uplift Las Vegas' Latino community. She joined the Latino Chamber of Commerce, where she worked with Thomas Rodriguez, a chamber member who is executive manager of the Clark County School District's diversity and affirmative action programs. He reported that, thanks to Polly's enthusiastic promotion of the Latino Youth Leadership Conference, the event reached a wider audience.

In 1996, she was a motivational speaker at a series of conferences held at the University of Nevada, Las Vegas. In 2000 she also started a program, *Portraits of Success*, which aired on KLAS during Hispanic Awareness Month to recognize the achievements of local Hispanic leaders.

Polly was one of five children raised by their single mom, Virginia Gonzalez, who is now Virginia Garcia. The family had to rely on public assistance, and their mother sometimes sold drugs to make money—a former lifestyle that Gonzalez Garcia has acknowledged, but has also overcome.

Life was tough for Polly and her siblings. But she determined to be a good student. In 1986 she graduated from San Jose State University, and got her first news job in the Monterey-Salinas area of California. The region's agribusiness and food processing relies on cheap labor, which influenced Polly's views on social justice and personal drive.

As a child she was also influenced by an older San Jose resident—civil rights leader and union organizer Cesar Chavez, who had moved to San Jose from Yuma, Arizona, to be a community organizer. But Chavez gave up community organizing during a grape workers strike in the 1960s. Intended to expose the workers' low wage and deplorable work conditions, the strike led Chavez to launch a movement now known as the United Farm Workers.

At an early age, Polly learned the power of the phrase popularized by Chavez and his sister, Dolores Huerta: "Si se puede," which is often translated as "Yes, we can." In her public speaking, Polly often quoted from books written about Cesar Chavez. She told young listeners that she refused to acquire what she called a "loser's limp," and urged them to not be limited by prejudices based on skin color or language background.

She was involved in KLAS' charitable project to "adopt" K.O. Knudsen Middle School, a magnet school in a modest neighborhood that focuses on the performing arts and language. Polly did not only contribute monetarily to the Knudsen cause. She also regularly visited, and sometimes read to sixth-graders from *Harvesting Hope*, a biography of Chavez by Kathleen Krull.

According to Sylvia Tagano, the Knudsen principal, "Polly had a powerful spirit. But she was also empowered by the children, who gave her enthusiastic support."

Polly and her family were devout Catholics. In Las Vegas, she and her daughters, Gabriella and Sabrina, belonged to the Elizabeth Anne Seyton Catholic Church in Summerlin. But she never forgot where she came from, and made frequent trips back to San Jose.

On March 28, 2005, on the return leg of a trip to San Jose, Polly and her daughters were driving through Death Valley to look at the wildflowers. In high wind conditions, her Ford Explorer left the roadway and rolled. It took Polly's life, but her daughters were not seriously injured.

The girls went to live with their father, from whom Polly was divorced early in their marriage. However, their father, Allan Moto, died five years later, after a long-term illness, the *Las Vegas Review-Journal* reported in 2009.

Some of the tiles on the memorial wall at Gonzales Memorial Park symbolize sorrow and loss. But Polly herself was charismatic and inspiring, say those who knew her. "Don't acquire a 'loser's limp'" she often exhorted. "You have to get up and walk."

Norma Jean Harris Price

Vera Eva Wittwer Hardy

Vera Eva Wittwer Hardy, who was widowed with four young children, conquered adversity by becoming a teacher. She spent thirty-one years teaching rural youth in Southern Nevada—including in St. Thomas, a community that was vacated so the forming Lake Mead could cover the site.

The daughter of Samuel and Bertha Tobler Wittwer, Vera was born on August 21, 1904, and grew up in Bunkerville, Nevada. After completing high school, she taught school on a so-called county Normal Certificate, which allowed an individual to teach elementary grades.

First she taught in Bunkerville for a year, then for two years in St. Thomas. Then, on June 4, 1926, she and Dudley Hardy married in the St. George temple of the Church of Jesus Christ of Latter-day Saints. They lived in Bunkerville, where Dudley worked for the Nevada Highway Department. He also owned and worked his own farm. They had four children: two sons and two daughters.

1904–2002
TEACHER, CHURCH
GENEALOGY VOLUNTEER

But at age forty-one, Dudley suffered a fatal heart attack. Vera was alone with four children, the youngest just two months old. After deciding she would not accept welfare payments, she moved with her children to Reno, to attend the University of Nevada—whose name became the University of Nevada, Reno in 1968. She graduated from teacher training with a university-based Normal Certificate, good for five years.

Vera then moved her family to Logandale, where she taught third and fourth grades. At the end of the five-year period, she applied for a Life Certificate and received one of the last such teaching certificates issued by the state of Nevada.

But after achieving this, she decided to earn a full bachelor's degree in education. She did so by going to summer school and taking correspondence courses from the University of Nevada.

She then taught in Logandale until the school was moved to Overton, where she taught until

94

her retirement in 1968, after thirty-one years in education.

In a 1984 article in *Desert Echoes*, Effie S. Davenport quoted Vera as once saying modern education is a "whole different ballgame." She preferred her era in education. "You could be a more effective teacher with smaller groups, and one-to-one help. I'm glad I taught school then instead of now. There's more problems today."

Vera's interest in her students didn't end with the regular classroom. For Christmas and holidays, the teachers planned social events, programs and operettas for students. They held May Day celebrations and held math and spelling contests. Vera would stay up nights making costumes and planning events. She felt that if children kept busy learning and participating, they would not have time to get into "mischief." She worried whether her grandchildren, and all children today, are challenged enough in school.

"It was a joy to teach in those days," Vera also told Davenport. "The kids were good. Their parents took interest, had more time to spend with their children, and supported teachers better."

When she retired, she stayed busy. She devoted more time to her church, her gardening, her arts and crafts. She made gorgeous quilts, afghans, embroidery, and crewel work.

She also spent time at the Logandale Genealogical Library, working on its name extraction program, which involves transcribing data on individual ancestors from government documents such as birth and death records. She was an active member of the Latter-day Saints church and belonged to the Daughters of Utah Pioneers.

Her daughter Elaine once said, "Vera was a people person. She had more best friends than anyone I knew."

Vera died at age ninety-seven on June 3, 2002. She was survived by sixteen grandchildren and her four children: Elaine Whipple, Glen Hardy and Maurice Hardy, all of Logandale; and Bertha Smith, of Cedar City, Utah.

Jean Spiller

Bunny Longbotham Harris

Bertha and William Longbotham liked the name Bunny and that's what they named their daughter, who was born November 26, 1916, in Texas, and then lived in New Mexico. Many of her friends remember calling her "Bunny Honey," which suited her sweet disposition.

Bunny grew up in the Great Depression. Then after high school, she joined her oldest brother in Southern California, where she attended business school. Wherever she lived, she joined local organizations and helped her community.

On Easter Sunday, 1938, Bunny married Robert Harris. World War II soon came along. She immediately joined the Women's Ambulance and Defense Corps. Members' duties included patrolling residential streets along the Southern California coast, making sure residents had blacked out their windows. The night blackout was to keep offshore enemies from observing light sources to determine locations.

By 1944, Bunny and Bob moved to Las Vegas, where they owned and operated Harris Auto Service. They joined the local chamber of commerce. Bunny worked alongside Bob as the office manager and bookkeeper, until he died on a hunting trip in 1967. They never had children.

Bunny had grown up loving horses and all things Western. She was a fixture at local rodeos, which attracted the attention of the Miss Rodeo America pageant committee. She was invited to become a member of the committee, and served on it for thirty years.

In 1946, Bunny helped establish an Elks-sponsored group, the Las Vegas Emblem Club No. 114, which promotes patriotism, respect for the flag and fellowship. The original Emblem Club began in 1917, when a group of Elks ladies began meeting to prepare bandages for soldiers injured in World War I. Bunny served as the local club's president, but in 1960 was elected national president of the club, whose motto is "truth, justice and charity." She was the first Nevada woman to serve in the post, which required traveled throughout the nation.

In 1959 she became a member of the Elks-sponsored local Miss Helldorado Rodeo pageant committee, and served several times as its chair. She also volunteered as a chaperone and co-coordinator for local

**1916—2005
BUSINESS OWNER,
RODEO SUPPORTER,
MEMBER OF CIVIC
GROUPS**

and national rodeo contest. In addition, she acted as a judge at numerous contests in the neighboring states of Utah and Idaho.

Bunny also was director of the Nevada Heart Association for six years. She also served as a president of the Desert Winds Chapter of the American Business Women's Association, and in 1978 was its national program chair.

Sometime around 1962, she earned a real-estate license and practiced as a real-estate agent for many years. She also worked as a preparer of federal income tax returns. She also found time to work as a travel coordinator for the Las Vegas Metropolitan Police Department, which she did for fifteen years.

In 1966 Bunny decided it was her civic duty to try politics. She belonged to the Clark County Women's Democratic Club, and ran for Assembly District 4, which had been reapportioned. There were nine seats, and fifty-three candidates. A longtime supporter of diversifying Las Vegas gambling- and tourism-based economy, she made diversification her platform. She campaigned to expand the state's Department of Economic Development, "so that we can do a real job of trying to bring new industry (to Las Vegas) and create more jobs."

Bunny finished sixteenth—better than most of the 53 candidates fared, but not high enough to win a seat—and never ran for public office again.

She was on the board of the Las Vegas YMCA for more than thirty years, and became its first woman president. She also held offices in: South Gate Chapter 18, Order of the Eastern Star; El Giza Temple No. 139, Daughters of the Nile; and Starlight Shrine No. 1, White Shrine of Jerusalem.

Bunny also became a registered parliamentarian with the National Association of Parliamentarians. She was president of the organization's Silver Mace Unit in 1981 and 1982. She served as president of the state association from 1988 to 1990.

In June 2005, Bunny Harris, the inveterate volunteer, died at age eighty-eight.

Barbara Riiff Davis

Edith Claire Posener Head

The renowned clothing designer Edith Posener Head was known in adulthood for her heavy, tinted horn-rimmed eyeglasses and her pageboy haircut. But on October 28, 1897, she made her debut as a tiny, unexpected arrival in Searchlight, Nevada, to a mining engineer named Max Posener, and his girlfriend Anna E. Levy.

In 1901 Edith's young mother married Frank Spare. The family moved to San Bernardino, California, where they passed off Edith as Frank's own child. A good student in high school, Edith went to the University of California at Berkeley, where she received a bachelor's degree in French. Then in 1920 she earned a master's degree in Romance languages from Stanford University.

Edith's first job was teaching French at Bishop's School, which is located in La Jolla, California. A year later, she took a job at the Hollywood School for Girls, teaching both language and art. To improve her art skills, she also enrolled for night classes at the Chouinard Art College. Through a classmate, she met Charles Head, and married him on July 25, 1923.

Their marriage did not appear to be happy, as they lived apart for many years until their divorce in 1936.

1897–1981
FASHION DESIGNER FOR ACTORS AND AIRLINES, AUTHOR

Meanwhile, in 1924 Edith won a position at Paramount Pictures as a costume designer. Later in life, she admitted that for the Paramount interview she had shown costume sketches done by another student.

One of her first big assignments was to create a wardrobe for Clara Bow, the silent film star, for the picture *Wings*, which premiered in 1927.

By 1930, her distinctive artistry was well established. She was credited for her design of the famous "sarong" dress that Dorothy Lamour wore in *The Hurricane* (1937), and costumes that Ginger Rogers wore in *The Lady in the Dark* (1944).

The Emperor Waltz, a musical that came out in 1948, was the first movie for which Edith was nominated for an Oscar. Every year from 1948 through 1966, she was nominated for one or more Academy Awards, for a total of thirty-five nominations. She won eight Oscars.

Many leading ladies sought out Edith to let her know how much they admired her work. One of her greatest fans, Elizabeth Taylor, is said as a young actress to have lived for a time in Edith's home, where the designer had an inscription attached to the bottom of the stairway reading, "Elizabeth Taylor sleeps here."

During the 1940s and 1950s, Edith became a favorite clothing designer of such stars as Ann Baxter, Betty Davis, Audrey Hepburn, Grace Kelly, Shirley MacLaine, Ginger Rogers, and Barbara Stanwyck.

One of the highlights of her life came when she was asked to design uniforms for women in the U.S. Coast Guard. She also designed uniforms for Pan American airlines personnel.

During the 1950s, she often appeared on the Art Linkletter television show. Edith also wrote numerous books about fashion design. In 1959, she collaborated with Jane Ardmore on *The Dress Doctor*. In 1967 with Joe Hyams she wrote *How to Dress for Success*. In 1983, Paddy Calistro authored *Edith Head's Hollywood*, which compiles a number of magazine articles that Edith had written.

Edith worked continually to separate her personal life from her professional life. She retained the surname Head through her career even though on September 8, 1940, she had married Paramount Pictures set designer Wiard Ihnen, and they remained married until his death in 1979. She was known for being a warm hostess at the soirees at their home in Coldwater Canyon.

Later in life Edith said she was Catholic, though both her birth parents were of Jewish descent. But she never traded her trademark glasses or hairdo. It's said that she initially adopted the tinted lenses to view how fabrics would contrast when shot in black and white. Her never-changing hairstyle—bangs and short cut—depict the clean and simple lines she advocated through her life.

On October 24, 1981 at age eighty-three, Edith Head breathed her last, in Los Angeles, California.

Mary Gafford

Lomie Gray Heard

Educator Lomie Gray Heard had a foot in both Las Vegas worlds—the Las Vegas of her home state of New Mexico, as well as Las Vegas, Nevada.

She was born in Carlsbad, in the territory of New Mexico, on January 22, 1906. Her parents, A.J. and Mariel Gray Heard, were ranchers. Her grandfather had owned the first house in the town of Eddy, which was later renamed Carlsbad.

Lomie spent her young school years in Knowles, New Mexico, and in Midland, Texas. She became friends with Georgia Lusk, who was superintendent of schools in Lea County, New Mexico, and also the state's U.S. congresswoman. On occasion, Lusk took Lomie along on visits to rural schools, to show her how an excellent teacher should instruct and discipline.

Then in May 1925, Lomie went with Lusk to Las Vegas, New Mexico, to go to summer school to obtain a second-grade teaching certificate. To pay her way, Lomie had borrowed one hundred fifty dollars from her maternal grandmother. Lomie also went to the state capitol to meet Isabelle Echols, who was the state superintendent of public instruction. Echols hired Lomie for a teaching position in Los Luceros.

After Lomie got to Santa Fe, a family friend drove her to Los Luceros, where she paid fifteen dollars a month for a room with board out of her monthly teaching salary of seventy-five dollars a month, which was a lot in those days.

On the first day of school, she unlocked her classroom door and was surprised to find the room had a dirt floor, one window, no teaching supplies, and no American flag. The worst was the lack of even an outdoor toilet—the pupils had to relieve themselves by some nearby adobe ruins.

At the end of the first day, Lomie walked to the school trustees' homes, and demanded a floor and an outhouse. A floor was installed, but not the outhouse.

Lomie loved the rural countryside. She would go to the Rio Grande and visit the dude ranch at Alcalde, or the Spanish fort near Los Luceros.

1906–2009
TEACHER, PRINCIPAL

In 1927 and 1928, Lomie taught in rural Negra, New Mexico, and then in 1928 she taught in Lovington, New Mexico. The year 1933 took Lomie to Hobbs, New Mexico, and in 1942 she moved to teach on a Navajo reservation.

Finally in 1944, Lomie moved to Nevada to teach kindergarten at Jefferson School in Las Vegas. After she served five years in that role, the school district's superintendent, Walter Johnson, appointed her to a combination teaching-principal position at a school on Nellis Air Force Base. When Lomie retired from that school, she was surprised and flattered that the district changed the school's name to Lomie Gray Heard Elementary School.

Lomie died of natural causes on February 9, 2009 at the age of 103.

Mollie Murphy

Helen Kolb Herr

In 1966 Helen Herr—a businesswoman and educator—became the first woman elected to the Nevada State Senate. Earlier she had served five consecutive terms in the Nevada Assembly, where she had been the second woman to hold office.

A feminist, Helen supported the gender-neutral concept of equal pay for equal work. She did not, however, support the Equal Rights Amendment (ERA) because she felt it did not adequately support women in the workplace. She became the spokeswoman and chair of Nevada's Stop ERA campaign. When she ran in 1976 for reelection to the state Senate and lost, she attributed her defeat to reaction against her anti-ERA stance. But she never relinquished her interest and involvement in her community.

Helen was born on August 3, 1907, in Fargo, North Dakota. She graduated from Plaza High School in Plaza, North Dakota and earned her elementary teaching certificate in 1925 at a state teachers college in Valley City, North Dakota.

Eventually she relocated to California, where she founded and ran a real-estate agency in Los Angeles in the late 1940s. For health reasons, she moved to the drier climate of Las Vegas, where in 1949 she opened her own real-estate firm, the Helen Herr Realty Company, on Las Vegas Boulevard. She also became a community activist.

Subsequently she was appointed to the East Las Vegas Town Board, where she served for ten years, including a stint as its chairman. While chairing it, she opposed a state plan to turn the Boulder Highway—a seventeen-mile link between Henderson and Las Vegas—into a freeway.

In 1956, Helen ran for the Nevada State Assembly and was elected. A Democrat, she served five terms. Then in 1966 she won a seat in the state Senate, where she again served for ten years. She worked to improve mental health facilities,

1907–1999
BUSINESS OWNER, TOWN BOARD MEMBER, STATE LEGISLATOR

strengthen the state's welfare and Medicaid programs, and secure equal rights for women.

In 1973 Helen sponsored and introduced a bill that would have guaranteed equal pay for equal work. She also sought to improve conditions in the state prison system. But she opposed the Equal Rights Amendment, because she felt it would create more problems than it would solve.

That stand may have been why she lost the Democratic primary to retain her seat. Despite the personal setback, Nevada voters joined her in opposing the federal amendment, which was defeated in a state referendum.

After leaving office, Helen remained in the thick of public policy and programming. She helped establish facilities for trouble youth: the Caliente School for Girls, which is now called the Caliente Youth Center; Spring Mountain Youth Camp; and Regina Hall, which today provides emergency housing for teen girls.

Helen received numerous honors such as the 1983 local Catholic Welfare Woman of the Year Award and inclusion on a list of the Ten Most Outstanding Women of Nevada. In 1993, she became the first woman elected to the Nevada Senate Hall of Fame. Helen Herr Elementary School on Eighth Creek Lane in Las Vegas bears her name. She died from heart failure in California on June 23, 1999, survived by her daughter, Derri Bauer.

Lois Evora

Mabel Welch Hoggard

From early childhood, Mabel Welch Hoggard wanted only to be a teacher. She fulfilled that ambition, but along the way she helped Las Vegas black teachers, and the community at large, develop racial parity.

Born in Pueblo, Colorado, in March 10, 1905, to Marshall and Maybelle Welch, Mabel spent her school years in Iowa with her grandparents, in Des Moines and Colfax. Every summer she returned to Colorado to help her parents in the store they ran. When she completed high school at age seventeen, her parents sent her to Bluefield State Teachers College in West Virginia, where she majored in education.

After graduating cum laude, Mabel used her teaching degree to teach in Jenkins, Kentucky. She and other black teachers were pressured to relinquish a portion of their pay to support the election campaigns of local politicians. She refused to participate and left Kentucky for West Virginia.

Eventually she accepted the principal's post at Delbarton School in Williamson, West Virginia. She also married Irwin Wims, a World War II veteran. Their son, Charles Wims, was born on June 13, 1925. During this time, Mabel's mother also moved to West Virginia and opened a bakery where Mabel sometimes helped out. When or why Mabel's first marriage ended is unknown.

After World War II, Mabel wanted to better herself, so she took a federal exam to become a government interviewer. She scored in the second highest percentile and was offered a position in California. While en route to the new job, she stopped off in Nevada to visit relatives who lived in Carver Park, a segregated housing tract near Henderson. During her visit, she was offered—and accepted—a secretarial position with the USO, the United Service Organizations, which was affiliated with Nellis Air Force Base.

She worked for the USO but applied to teach in the Clark County School District. In September 1946 the district hired Mabel, who became the first licensed black teacher in Nevada. For twenty-four years she taught first and second grades at the all-black Westside School, which was located just northwest of downtown Las Vegas in a segregated neighborhood.

1905–1989
TEACHER, PRINCIPAL, CIVIL RIGHTS ACTIVIST

J. David Hoggard, a widower with two sons, courted Mabel, and they married. For years they resided at 711 Morgan Street and worked to better their community. Both were members of the National Association for the Advancement of Colored People, and served on its executive board. Mabel is credited with helping organize the Westside Council, which was a group of teachers and school administrators who worked on socio-economic problems in the Westside.

Mabel and David also helped set up a program at the Westside Federal Credit Union that was designed to encourage students to save money for their educations. One of David's sons, J. David Hoggard Jr., eventually became a longtime administrator at the Clark County Community College, which is now known as the College of Southern Nevada.

From the 1930s to the mid-1970s, Las Vegas held a reputation as the "Mississippi of the West" for its discriminatory practices in housing, the workplace, hotels, and the schools. One year, for example, the National Education Association came to Las Vegas for its annual meeting. But the then-prominent hotel that hosted the event did not allow blacks in its casino. So local black teachers were barred from this professional meeting, which led to unrest. Mabel and other black leaders worked to calm the animosity, averting a violent response.

Mabel retired from teaching in 1970, but kept active as volunteer. Because of her endless hours donated to the local branch of the Red Cross, the NAACP, the Zion Methodist Church, and the Clark County Classroom Teachers Association, Mabel received a Distinguished Nevadan Service Award at the University of Nevada, Las Vegas in 1977.

On May 31, 1989, Mabel passed away at age eighty-four, after several years of poor health following a stroke. In June 1989 she was honored in the U.S. Senate for her teaching skills, her service to church and community, and her dedicated humanistic approach.

Posthumously—thanks to the support of Nevada Congresswoman Shelley Berkley—Mabel was named a Black Pioneer of Nevada. Nevada Governor Kenny Guinn presented the award to Mabel's family on February 3, 2001.

Mary Gafford

Jeanne Walsh Hood

"I'm here," Jeanne Walsh Hood once said, "because I'm qualified." The claim is bold, but Jeanne was telling the truth when she spoke to the *Las Vegas Review-Journal* in 2009. She was one of the few women at the highest level of hotel management in Nevada in the 1970s.

Jeanne's innovations in the hospitality industry touched the Hyatt hotels, IHOP restaurants, the Four Queens Hotel and Casino, Playboy Enterprises, and the Fremont Street Experience.

Born Jeanne Walsh on May 21, 1926, in Minnesota, she grew up with two sisters in a quiet St. Paul suburb.

In 1946 while in college, she worked a summer at the Old Faithful Inn in Yellowstone National Park. There she met David Hood, who announced he intended to marry her. Two years later, they did just that, in Reno where Dave had accepted a job with the Golden Hotel.

When their first-born was three months old, Dave took a job in Los Angeles at the famed Garden of Allah Hotel. The couple lived on the premises, rubbing elbows with the Hollywood celebrities who came in. Jeanne learned accounting by keeping the hotel's books.

A few years later, the couple teamed up with builder Joe Almarosa to develop "motor hotels," or motels, in high-traffic areas near airports and highway junctions. One day, two young entrepreneurs named Don Pritzker and Skip Friend recruited the Hoods and Almarosa to help build a hotel chain. Pritzker was the son of A.N. Pritzker, who had launched the Hyatt hotel chain with a lodge near the Los Angeles airport.

In 1961 the Hoods were in a group that formed the Hyatt Chalet Motels, a division of Hyatt Lodges. With a one-million-dollar investment, it developed sixty lodges and thirty coffee shops over the next decade. The twenty-four-hour coffee shops with a distinctive A-frame building, always located near hotels, were so successful that the International House of Pancakes Restaurant Corp. purchased all but one of the restaurants in 1970, for $5 million.

Then in 1972, David Hood was appointed head of the growing hotel group's new Elsinore Corp., the parent to several Nevada gaming properties, including the Hyatt Lake Tahoe and the Four Queens Hotel and Casino in Las Vegas.

David died suddenly in 1970 at age sixty. Jeanne, who knew daily hotel operations and her husband's management style, succeeded him as president of the Four Queens and Elsinore director. Downtown Las Vegas was in flux. The Union

1926–2009
DEVELOPER OF MOTELS,
CASINO OWNER, MEMBER
OF CORPORATE BOARDS

Plaza was under construction. The Golden Nugget was a small casino with no hotel rooms yet.

Jeanne's careful but ambitious supervision of the Four Queens produced high revenues for Hyatt. She added a guest-room tower and enlarged the casino. She also installed downtown Las Vegas' first high-tech video surveillance system. As well, she created downtown's first upscale restaurant, famous today as Hugo's Cellar. She also launched the hotel's French Quarter, which became a national known jazz spot that broadcast radio shows hosted by Alan Grant.

Jeanne advanced gaming by introducing the first one-dollar slot machines. She also organized the Reel Winners Club, one of the first loyalty clubs for slot players. Slot tournaments were her next innovation. In 1979 she promoted a "fly in and play" concept for day players from Southern California. She was particularly proud of the ninety-nine-cent shrimp cocktail she devised.

In 1981 the Hyatt group voted to partner with Playboy Enterprises in Atlantic City, New Jersey, where Playboy built a lavish but over-budget casino hotel. The project started to siphon funds from the lucrative Four Queens. Hood once said, "I am not awed by what they are doing as much as I am awed by their expense account."

New Jersey gaming officials next denied Playboy Enterprise a gaming license, and stipulated that Elsinore had to buy Playboy's share of the venture. Elsinore was left with $150 million in debt at a high interest rate, which resulted in its Chapter 11 bankruptcy.

Elsinore turned to Jeanne Hood to rebrand the hotel and make it profitable. The renamed Atlantis Hotel and Casino was her home for the next five years. She creatively cut costs and streamlined operations. She had to erase the Playboy logo from every cranny.

Despite a 1987 union strike that crippled Atlantic City hotels, Jeanne persevered. She helped persuade the court to release the Atlantis from bankruptcy, and sold it to Donald Trump after rebuffing an offer from Steve Wynn.

Jeanne returned to Las Vegas in 1990 to update the neglected Four Queens. To boost sagging tourism, she pushed for a collaborative effort by downtown casinos, which led to the Fremont Street Experience, which has become a primary downtown attraction.

As her role in active management declined, Jeanne accepted positions on corporate boards and banks, including American Casino Enterprises, Pioneer Citizens Bank, Opportunity Village, and Nevada Dance Theatre, which named her its 1998 Woman of the Year.

Jeanne passed away on August 2, 2009. She left behind four daughters—Barbara, Jennifer, Patty, and Joyce—as well as seven grandchildren and three great-grandchildren.

Susan Houston

Barbara Joanne Thomas Hunter

**1932–2011
TEACHER, RANCHER,
ARTIST**

The precious baby girl born to Velma Bennett and Clair C. Thomas on a sunny June 17, 1932, grew up to be a Las Vegas teacher, rancher, artist, wife, and mother.

Born in Greeley, Colorado, Barbara Joanne Thomas enjoyed her early studies. She completed high school by age seventeen.

Barbara next attended Colorado Agricultural & Mechanical College. From there she enrolled at Colorado State University, where she earned an associate's degree. There she met her first love, Dr. Lester C. Burgwardt. The couple married on September 4, 1951.

After their honeymoon, the newlyweds headed straight for Sandpoint Naval Air Station, located near Seattle, Washington. While Lester served in the military during the Korean War, Barbara worked for the Department of the Navy.

After Lester's military discharge, the Burgwardts moved to Clark County, Nevada. They arrived in Henderson on a windy August day in 1954. Lester worked at the Basic Magnesium Plant, while Barbara spent time sprucing up the plant-owned bungalow in which they first lived.

In 1960 the Burgwardts were blessed with a son, Craig Thomas. Two years later, they had fraternal twins, daughter Connie and son Kent. From 1960 to 1970 the family owned and lived on a local ranch, which they sold in 1970 at a substantial profit.

In addition to planning for a family, Barbara attended the University of Nevada, Las Vegas, where she received a bachelor's degree. In later years she completed a master's degree in counseling.

In 1970 the family moved back into Las Vegas, where Barbara and Lester divorced. At that point Barbara took a job with the Clark County School

District teaching science to elementary pupils. She won accolades for her work as a science specialist.

Along the way, she met a teacher named Leon Hunter. Together they perfected a system of team teaching, which the school district implemented. Other schools districts across the country also adopted the couple's model program. In 1975 Barbara and Leon married.

In the early 1980s Barbara became interested in art. She joined the Las Vegas Watercolor Society. Although she did not narrowly confine her subject matter, she enjoyed painting scenes of the Southwest and of Native Americans. Her work hung in many art shows and one-woman exhibits.

According to Carl Partridge, a fellow artist, "The artwork of this extremely talented lady was meticulous, quite detailed. Truly everyone who saw her paintings was taken aback by how tediously she worked on each painting. Barbara was a recognized artist."

Barbara had an interest in genealogy, too. She traced her own ancestry back to Mayflower passenger Stephen Hopkins, who also had sailed previously to Jamestown. Thus Barbara was eligible to join both the Jamestown Society and the Descendants of the Mayflower.

As another of her ancestors, George Younts of Pennsylvania, had fought in the American Revolution, Barbara also was active in the local Old Spanish Trail Chapter of the Daughters of the American Revolution. She served on numerous committees and was a vice-regent from 2002 to 2004, and regent from 2004 to 2006.

In 1983 Barbara was invited to join the Mesquite Club, one of Las Vegas' oldest civic organizations for women. She lent her skilled educator's mind and artistic talents toward many Mesquite projects.

Other organizations in which this vivacious woman participated include the National League of Women Voters, Nevada Women's History Project, Clark County Museum Guild, Retired National Education Association, Retired Professional Employees of Nevada, Desert Willows Writers, and the Sun City - McDonald Ranch Library Guild.

After fifty-seven years in Nevada, Barbara Thomas Burgwardt Hunter passed away in her Henderson, Nevada, home on October 11, 2011. In addition to her two sons, a daughter, and their spouses, she left behind fifteen grandchildren. Hers is a heritage of education, the arts, and plain old caring.

Mary Gafford

June Calder Huntington

June Calder Huntington, my wonderful mother, contributed to the development and fabric of our beloved hometown of Las Vegas. She was a businesswoman, a seamstress, and a perpetual volunteer in church and community activities.

My family arrived in Southern Nevada from Southern California in 1936. The family consisted of my father, Clifford H. Huntington, my mother, my fifteen-year-old sister Berniece, my ten-year-old brother Jack, and me, Barbara. I was two years old. The state of Nevada was only seventy-two years old, having been brought into the Union in 1864. The population of Las Vegas was around 5,000. When I graduated from Las Vegas High school in 1952, the city had grown to about 25,000 people.

June was born in Garden City, Utah, on June 14, 1903, the fifth of six living children. When June was four years old, her mother died in another childbirth. The loss of her mother shaped her personality and actions through life. She was generous to friends, neighbors, and newcomers. Christmas wasn't Christmas if we didn't take boxes of food,

1903—1961
STORE OWNER,
MERCHANDISE BUYER,
CHURCH LEADER

new clothes, and toys to those who otherwise would have a "skimpy" Christmas. My mother made "Christmas" also happen through the year.

June and Clifford married in 1920. He was born in Utah, attended college, and then became a merchant. He was with the JC Penney Company in Alabama, and then in California, both in Pasadena and Santa Monica. In 1938, Clifford advanced to manager of the Penney's store in Caliente, Nevada, where the family resided until 1945. Then in 1946, the company transferred him to Las Vegas to be an assistant manager.

That year, Ronzone's—the finest department store in Las Vegas at the time—hired him as manager. Two or three years later, Clifford and June bought their own store, which became Huntington's Children's Shop. It was located at 810 South Fifth Street, which is now Las Vegas Boulevard. For several years, Huntington's was "the" children's store in town.

June was the heart and soul of the shop. She served as the customers' sounding board. An

excellent seamstress, she sewed specialty dresses for the store and took custom orders. She also assisted Clifford in expeditions to Los Angeles to purchase inventory. Her good taste ensured the quality of the store's clothing, accessories, furniture, and toys. She also served as the store's decorator, advertiser, and organizer of special events, such as for Easter or birthdays. She also did hiring and event clean-up.

Some wonderful Las Vegas women worked at the store, including Myrtle George, who was the mother of U.S. District Judge Lloyd D. George; Lena Oxborrow, who was Alice Bunker's mother; and Vinnie Stewart, who was Ron Stewart's wife. I was one of the Huntington children who helped out at the store, starting when I was twelve.

The Church of Jesus Christ of Latter-day Saints was a large part of June and Clifford's life. She served as Relief Society president, temple worker, and president of a church group called the Mutual Improvement Association. Clifford served as a bishop, stake president, and temple worker. Since Las Vegas had not yet built a temple, the couple traveled regularly to St. George, Utah, for their temple work.

Both were involved in community affairs, too. They helped at election time, were members of the Rotary Club International and volunteered for the Boy Scouts, the March of Dimes, and other worthwhile causes.

June grew to love Las Vegas and its people. Although she described herself as a "simple, ordinary human" who never did much, more than 1,600 people came to her funeral. Beatrice June Calder Huntington died of cancer on May 6, 1961, at the age of fifty-seven.

Barbara Huntington White, daughter of June Huntington

Billie Jean Hickey James

Nevada woman Billie Jean Hickey James devoted her life to the power of words, a love of the Earth, and the quest for peace. A poet and English instructor at the University of Nevada Las Vegas, Billie Jean was rarely silent on the social issues of diversity, justice, and empowering women.

She loved the writings of James Joyce, Virginia Woolf and Emily Dickinson. To reach her university students, she sometimes celebrated the birthday of Dickinson at her home. She represented Dickinson's poetic voice by dressing in a white Victorian dress to host tea to students at her home. Sometime she dressed in an American flag theme to protest as the "peace lady" in front of Las Vegas' federal courthouse against various wars.

Called a frontier poet, Billie knew the Wyoming prairie and the Nevada desert. She was born to Eugene and Juanita Hickey in McLeansboro, Illinois, on December 2, 1942. But she was raised in Laramie. Her mother, a hairdresser, was only fourteen when she gave birth to Billie Jean, who was the oldest of three children. Her father served in World War II and later was a carpenter.

Billie Jean graduated in 1964 from the University of Wyoming with a bachelor's degree in English, and then taught English at a Laramie high school. Divorced after a brief marriage, she had a son to raise. To start over she joined her parents and siblings, who had moved to the desert south of Las Vegas.

There she met Bill James, an engineer, who shared her love of hiking and the environment. They were married in the Red Rock National Conservation Area on December 7, 1971, and built their own home. Adept at backpacking and camping, Billie Jean often dressed like a pioneer woman in hiking boots, long skirt and a big floppy sun hat. An amateur naturalist, she knew the habitats of animals and the botanical names of many plants. On her last field trip in April 2010, she accurately identified fifty-two varieties of desert plants without using a reference manual.

In 1974, she completed her master's degree in English at UNLV, and joined its English faculty.

1942–2010
POET, COLLEGE INSTRUCTOR, PEACE ACTIVIST, SUPPORT OF ARTS AND ENVIRONMENT

For two years, she was Nevada poet in residence, selected by the Nevada State Council on the Arts. She also taught poetry for the Artists in Schools program in Clark County. In 1977 she was one of seven Western poets chosen to read at the Rocky Mountain Modern Language Association's convention. She also taught a poetry workshop for three summers at the University of Nebraska.

Billie Jean's work appears in a 1991 collection of poems, *Desert Wood, An Anthology of Nevada Poets*, published by the University of Nevada Press. She authored *Sandset and Other Poems*, which was a finalist for the Walt Whitman Award in 1978 and 1980. She contributed to numerous anthologies and literary reviews.

In 1983, Bill James went to work in Riyadh, Saudi Arabia, on a three-year contract to an oil company, Billie Jean left her teaching to join him. In respect to the culture, and perhaps out of fear, she covered her body with long garments, and her hair with a scarf. She taught writing and poetry to Saudi women. But not long after the Jameses arrived, her son was killed in a car accident in California. A period of mourning followed his funeral, in which Billie Jean stopped writing. While on vacation, she visited the Jung Institute in Zurich, Switzerland, which inspired her to write about her emotions and dreams.

In 1986, the couple left Riyadh. Their extended road trip led them to London, where they donated their vehicle to the non-profit Oxfam International before returning to Las Vegas.

To deal with her continuing grief, Billie Jean supported Bryn Well, a women's counseling group. She attended lectures at Pacifica College in Santa Barbara, California. She continued to hike. She and Bill traveled to participate in clean-up projects sponsored by the Sierra Club in national parks, the Virgin Islands, and Guyana. In 1999, Billie Jean made a trip to Australia's southwest coast with a longtime friend, Linda Cayot, who is a scientist and consultant with the Giant Land Tortoise Conservancy at the Charles Darwin research station in the Galapagos lslands.

Billie Jean left us on Earth Day, April 22, 2010. She went missing for several months, but her body was eventually found in August, amidst clutter in a storage room of the Jameses' expansive desert home.

She will be remembered for her poetry and support of the arts and the environment. The College of Southern Nevada's dance department issued a T-shirt in her honor. The Sierra Club placed a stone at Red Rock that commemorates her. More than three hundred friends attended a memorial service for her, which Bill held at the Winchester Center in Las Vegas.

The first Joshua near Goldfield
stands like an old miner's ghost
welcoming me back to dust.
Drier and wider now this night
asks me to remove my sweater and stay.
The desert is home.
　　　— Billie Jean James
Norma Jean Harris Price

Velma Bronn Johnston

1912—1977
RANCHER, ANIMAL
RIGHTS ACTIVIST

Velma Bronn Johnston was not called "Wild Horse Annie" as a compliment. It was quite the opposite. The epithet came from Dante Solari, a Bureau of Land Management range manager who had opposed Velma's early efforts to protect Nevada's mustang population.

The enmity between the two began when Solari, mistaking Velma for the wife of a rancher who considered the wild horses a nuisance, assured her that a large group of mustangs was to be sent soon to a rendering plant in Canada.

Ironically something good came out of the 1955 incident. When Velma recounted it to her husband, Charlie, he indicated for the first time that he would help Velma with her cause of protecting wild mustangs.

Velma was used to overcoming tough situations, as she had contracted polio at age eleven.

She was born on March 6, 1912, in Reno, to Joe Bronn, a drover and mustang trainer, and his wife, Trudy. Velma's illness occurred after medical treatment for her younger brother Jack's hip, which had eaten up much of the family's finances. Velma was sent to a San Francisco hospital that helped the poor, where she was put into a painful body cast. Her parents couldn't afford to stay in the city near her, so she weathered her stay alone.

When the cast was removed, Velma had a drooping left shoulder, a displaced jaw, misaligned teeth, and scoliosis. Shunned by many children after she returned home, her main friend was a neighbor boy, Walter Baring. After her brother Jack died of meningitis, Velma's broken-hearted father paid more attention to Velma's two younger sisters than he did his disfigured older daughter. But Velma learned to cope.

When she graduated from high school and started working at the Farmers and Merchants Bank—which later became First National Bank—Velma realized she could do well conducting business by telephone. Customers could not stare at her physical defects. So she joined the Reno chapter of Executive Secretaries Inc. and immersed herself in work.

Then she met Charlie Johnston, a World War I veteran who was a horseman and tracker. The two eloped. To keep her job, she didn't disclose their marriage. Charlie lived in a rooming house, and she lived at home. They pretended they were just courting.

Later Charlie became a deputy sheriff in Gabbs, Nevada, where Velma was allowed to

disclose her married status and work outside the home. First they lived in a shack, but later were thrilled to buy the Double Lazy Heart Ranch outside of Sparks. There Velma learned to love the mustangs she saw as she roamed their ranch and the environs.

> *Outside Sparks, Velma learned to love the mustangs she saw as she roamed their ranch and the environs.*

But one morning, she was on the road behind a truck filled with mutilated and dying mustangs, on their way to a slaughterhouse. It changed her life. She wanted to act on behalf of the horses, but there was no advocacy group to join. She started learning everything she could about mustangs.

At one Bureau of Land Management meeting, she got up the nerve to oppose a rancher who favored a horse roundup. Though she discounted her own expertise, the meeting chair told her, "I'm sure there's nothing at all simple about you, Ma'am. And from what I've seen here tonight, anyone who thought that would be making a serious mistake."

First Velma enlisted the support of Charles Richards, a former Nevada congressman. Then state Senator James Slattery offered to sponsor a bill outlawing roundups by aircraft, which passed in 1955. Velma had helped protect Storey County's horses, but she had a higher goal: protecting all wild horses.

Her efforts to get federal legislation banning aircraft roundups of horses and burros caught the attention of a *Denver Post* reporter, Robert O'Brien, who had read about the Nevada situation in the *New York Times*. He wrote an article for *Reader's Digest*, which brought nationwide publicity to Velma's cause. Then her old playmate, Walter Baring, who had been elected to a Nevada seat in the U.S. House of Representatives, took up her cause. Nevada politician Howard Cannon, who sometimes opposed Baring, also supported Velma.

While the public debate went on, Velma still worked as a secretary but also took care of Charlie, who was terminally ill. After his death in 1964, she threw herself into her work and became president of the Reno branch of Executive Secretaries.

Somewhat distanced from the horse protection movement, Velma renewed efforts when she struck up a friendship with Marguerite Henry, the author of widely read children's books about horses. Henry wrote a 1966 book, *Mustang, Wild Spirit of the West*, which popularized the topic among children.

In 1971, an improved Wild Horse Annie bill passed in Congress. President Richard Nixon signed Baring's Wild and Free-Roaming Horses and Burros Act into law late that year.

Velma, who also helped found the Animal Welfare League of Nevada, died of cancer on June 27, 1977. Her life shows that one person *can* make a difference.

Fran Haraway

Mary Ka'aihue Kaye

When Mary Kaye was twelve years old, she already showed signs she could make music of high entertainment value. She did go on to revolutionize Las Vegas nightlife by making hotel lounges a gathering place for music lovers through her music group, Mary Kaye Trio.

"I've been working since I was nine," Mary once told *Las Vegas Review-Journal* reporter Mike Weatherford. "I was my father's favorite guitar player." She was born on January 9, 1924 in Detroit, Michigan. Her father was Johnny "Ukulele" Ka'aihue, a vaudeville favorite and son of Hawaiian Queen Lili'uokalani's younger brother, Prince Kuhio.

Mary told interviewer Tim Brooks that she gravitated early to the guitar. "So I used to sneak Daddy's guitar out and play it. One day he caught me, so I said, 'I'm sorry, Dad. I'm tired of playing the uke.'"

Johnny owned the Royal Hawaiian School of Music in St. Louis, Missouri, and often played concert dates with his children—Norman, who had an operatic voice and played the bass guitar, and Mary, who also sang well and, by age 10, could play any song on the guitar by ear. It was no surprise that Johnny's children won most amateur talent contests in the St. Louis area.

Mary and Norman's mother was Maude Van Patten, a socialite from Detroit. This unlikely marriage happened as a result of Johnny's visiting Detroit with Duke Kahanamoku's swim team. Mary once joked during an interview with *Vintage Guitar Magazine* that she was "originally from the island of Detroit."

At first Mary and Norman played at their father's music school by entertaining parents who stopped by to sign up their children for lessons. Later, the siblings became featured players in her father's group, Johnny Ukulele and the Royal Hawaiians. For two years, they served as the house band at St. Louis' Jefferson Hotel.

That experience led to the formation of the Mary Kaye Trio—since "Kaye" was easier to pronounce than Ka'aihue. Mary and Norman teamed up with comedian-impressionist Frank Ross, who also played accordion. When Norman went off to World War II, Jules Pursley temporarily replaced him on the bass. Eventually Mary and Pursley married. When Norman returned, Pursley

1924–2007
GUITAR MUSICIAN,
RECORDING ARTIST,
INVENTOR OF THE
LOUNGE ACT

became the trio's road manager.

The Mary Kaye Trio first played Vegas in 1947. In 1952 they played at the El Rancho Vegas, and the following year at the Last Frontier, where they were so well received that management wanted to hold them over. But another act—film star Ronald Reagan—was already booked for the space in which they'd been performing.

With a thought that later turned out to be genius, Mary suggested the trio move to the Last Frontier's bar. Weatherford reported that Mary said, "We'll put a stage and big heavy drape around the stage, so that the music won't interfere with the gamblers." In another brilliant stroke, she added, "We won't call it a bar. We'll call it a lounge."

The trio quickly built up a following among stars that were performing on the Strip—who couldn't attend an early show—and the stars' musicians. Frank Sinatra and Elvis Presley were big fans. And Mary called Sammy Davis Jr. "the fourth member of the trio," because he liked to sit in and play conga drums.

"We never did the same act twice," she told Weatherford. "We could put any song anywhere. They came back night after night, because they never knew what we were going to do. And we didn't, either."

Mary's "simple idea," Weatherford wrote, "turned Las Vegas from a gambling oasis in the middle of the desert to a twenty-four-hour party town. The Mary Kay Trio was the first musical group to play all-night casino lounges." Today, Mary and musician Louis Prima are considered the inventors of the Las Vegas lounge phenomenon. Her trio was voted the best jazz act in 1957 and 1962, in the Playboy All-Star Jazz Poll. In 1959, Mary was the first female artist to show up on U.S. Billboard charts.

Throughout the years the Mary Kaye Trio took many publicity photos, but the most famous was not connected to their appearances in Las Vegas. It was a 1956 photo of them with a Fender Stratocaster electric guitar. That guitar—of white ash with a neck made of maple, and gold fittings—later became known as the "Mary Kaye Strat," the ideal rock guitar. Ironically, Mary didn't play a Fender—she normally played a d'Angelico. But the photograph brought fame to both Mary and Fender.

In 1966, when the trio was making a million dollars a year, its members decided to disband. One reason was that Norman wanted to devote time to his growing real-estate business. The trio's last gig was at the Tropicana Hotel before an audience of celebrity well-wishers.

Mary died from pulmonary disease in 2007 at Mountain View Hospital in Las Vegas. A diabetic herself, she supported the American Diabetes Association and worked to improve the access of diabetic children to care.

Fran Haraway

Anna Dean Nohl Kepper

Anna Dean Kepper understood that history is never just a collection of dry facts, but a vibrant mélange of people, stories, and places. Preservationist, archivist, and oral historian, Anna marshaled the Southern Nevada community to collect historical accounts from its older residents and save its historical sites. Remarkably, Anna accomplished this in her ten years in Las Vegas.

Born Anna Dean Nohl in Seattle, Washington, on May 12, 1938, Anna earned two master's degrees from the State University of New York in Oneonta—in museum science and American folk culture. In 1973, when she was 35, Anna moved to Las Vegas with her husband, Jack Kepper, a geology professor at the University of Nevada, Las Vegas. When the couple divorced, Anna's father-in-law, retired photographer John Kepper, remained a close ally in her preservation activities.

Anna began the Las Vegas phase of her career at the UNLV Library. From 1975 until her death in 1983, she was its curator of Special Collections, the central repository for materials documenting the history of Southern Nevada. She recruited and organized volunteers, including UNLV students, to collect historical documents and photographs. Imbued with her passion, these workers were called Anna's "missionaries."

Trained as an oral historian, Anna knew the value of collecting stories from people, as told in their own voices. She was tireless in persuading early settlers to donate their photos and papers. In the process she became friends with such venerables as the Lake sisters—Olive, Alice, Ada, and Emily—who had arrived in Las Vegas in a covered wagon in 1905, before the railroad came through.

Another coup was Anna's acquisition of materials about the last days of Prohibition and the city's first legalized casinos, which came from Harold Stocker, a former bootlegger. Anna was the impetus that brought another professional oral historian to the library staff.

Anna's enthusiasm spread beyond her university work. She is largely credited for saving the Las Vegas Mormon Fort, in today's downtown Las Vegas. Built in 1855 to house church members on a mission to reach the Las Vegas Paiutes, the fort also sheltered travelers on the wagon road between Utah and the Pacific Coast. In 1973, Anna helped establish the Association for the

1938–1983
LIBRARIAN, HISTORIAN, PRESERVATIONIST, MEMBER OF CIVIC GROUPS

Preservation of the Las Vegas Mormon Fort. With funding from the National Bicentennial Commission and the city, the association restored the fort and opened it to visitors. The project culminated in 1990, when the fort site joined the Nevada park system as Old Las Vegas Fort State Park.

Anna served as the association's president from 1974 to 1979, when it held events such as a one-day Las Vegas Auto Tour, designed to acquaint community leaders with local buildings of historical significance. The association also created an itinerary for self-guided tours, which was distributed for years. The association later became the Preservation Association of Clark County, which is still active.

Anna also was responsible for helping preserve and relocate several historic Las Vegas homes, owned by some of early Las Vegas' most prominent citizens. One example is the 1930s Tudor Revival home of attorney Harley Harmon, which was sold to J.K. Houssels, a lawyer and casino owner. In 1983, the house was moved from its original site to the UNLV campus, where, until recently, it housed the architecture department.

Also, Anna played a role when two other historical local homes were moved to the grounds of the Clark County Museum in Henderson. One is the 1920s California bungalow home of early businessman Will Beckley. The other is a 1930s Tudor Revival owned by P.J. Goumond, an early casino operator.

Anna was active in many professional organizations and historical groups. She played a role in the Southern Nevada Historical Society, the Boulder City Museum and Historical Society, and the Nevada Historical Society. She belonged to the Nevada State Library Association, the American Association for State and Local History, and the Society of California Archivists. She was the Nevada representative to the National Trust for Historical Preservation.

Anna received numerous awards for her contribution to preserving the region's history. In 1980 the Nevada Historical Preservation Conference gave her a Distinguished Service Award. In 1982 the Southern Nevada Historical Society presented her with a certificate of merit. The Boulder City Museum and Historical Association honored her for helping that city be entered in 1984 on the National Register of Historic Places. Confirming the importance of her work, she was profiled in, *The First 100: Portraits of the Men and Women Who Shaped Las Vegas*, a book published by the Las Vegas Review-Journal in 1999.

Her life ended early, at the age of forty-five. She died in Las Vegas on December 23, 1983, of breast cancer. Only eighteen days before her death, she completed the final examination for her master's degree in public administration at UNLV.

The university conferred her degree posthumously. At her memorial service, Hal Erickson, who directed the UNLV library during Kepper's tenure, said, "I don't think there was anybody that Anna Dean didn't think had something to contribute."

Jo Ann Parochetti

Alice Marie Juliet Key

Dancing was the vehicle that carried Alice Key into the political activism that would be the hallmark of her life.

Her grandfather had planted the seeds of black pride when they lived next door to each other in her childhood in Henderson, in western Kentucky, along the Ohio River. Alice Marie Juliet Key was born on March 18, 1911, when the town's population was a little over 11,000. It was also home to famed ornithologist, naturalist, and painter John James Audubon. A museum to honor the great Audubon was not built until 1934—and by then, Alice was long gone.

She had moved with her mother and the family of an aunt to Riverside, California, where she finished high school and then sought higher education. Her mother managed a coffee shop when Alice began attending the University of California, Los Angeles, where she studied journalism.

While at UCLA, she met a young woman who convinced her that the theater stage would be more appealing and fun than the classroom. The woman worked at the famous West Coast branch of Harlem's Cotton Club, Culver City. The show's producer talked Alice's mother into letting Alice dance.

Alice left her books behind, and began working at the club. It wasn't long before she realized there were inequities in the dance clubs. The Cotton Club, with its black performers and clientele, was rated a "B" club while similar clubs with all white dancers were rated "A" clubs. Dancers were paid according to the rating of their club.

Remembering her grandfather's teaching, it wasn't long before Alice organized her fellow dancers, and went directly to her union to protest. After winning that fight, it wasn't long before she and friends picketed a drugstore on Central Avenue that refused to hire blacks.

Her dancing ability must have been better than average because over the years Alice danced at the Cotton Club in Harlem, the Moulin Rouge in Paris, and the Palladium in London.

In 1943, Alice retired from dancing and began her second career. She became a writer for a

1911—2010
DANCER, LABOR ORGANIZER, CIVIL RIGHTS ACTIVIST, REPORTER

newspaper called the *Los Angeles Tribune*. One of her biggest scoops was discovering that the blood plasma of black soldiers was being separated from that of white soldiers. She learned this on a visit to Fort Huachuca in Arizona, and wrote about it.

Her next news job took her to Las Vegas, where she became the editor in chief of the *Las Vegas Voice*. She also co-hosted the first local black television show, *Talk of the Town*, which aired on the KLAS station.

In the late 1960s, Alice immersed herself in public service. She spent several years as executive director of the Las Vegas branch of the National Association for the Advancement of Colored People. She also led the Clark County Economic Opportunity Board. She spent a memorable year working with the Nevada Committee for the Rights of Women, which educated women about birth control and campaigned for reform of Nevada abortion laws.

In 1983 Governor Richard Bryan appointed her as a deputy labor commissioner for the state. She held the position for ten years, which entailed handling labor complaints filed in Clark, Lincoln, and Nye counties.

Alice also helped establish two organizations, the Barbara Jordan Democratic Club, whose goal was to increase political awareness, and Ladies Who Danced, a group that raised funds for cultural causes.

Alice Key began her life knowing the joy of dance. She never forgot her grandfather's advice. She believed in contributing to her community. The Silver State was fortunate to have had Alice, who died at age ninety-nine on September 11, 2010.

Joan LeMere

Martha Pike King

In the 1920s, Martha Agnes Pike—fresh from a year's teaching in Cleveland, Ohio—decided to repeat what Zebulon Pike, her ancestral uncle, had done. She, too, went west. Uncle Zebulon's choice led to the naming of a Colorado peak after him. Martha's parallel choice led to an elementary school in Southern Nevada bearing her name.

Wanderlust and bravery both seemed to run in her family. Her father, Emory Jenison Pike, posthumously received the Congressional Medal of Honor for service in the Army's 82nd Division in France in World War II. He was the division's first soldier so honored; its second honoree, Sergeant Alvin York, was memorialized in a Hollywood war film.

Martha's maternal grandparents were both immigrants, her grandfather George Trigg from England, and grandmother Marian Newhouse, from Germany.

Martha's education was unconventional, due to her father's military career. She was born in Fort Meyer, Virginia, on February 22, 1902, to Lieutenant Colonel Pike and his wife, Agnes.

1902–1994
TEACHER, CIVIC GROUP MEMBER

Due to all the moving, Martha did not enter high school until she was sixteen, but graduated in record time at age eighteen in 1920. She entered Drake University, but graduated in 1924 from Ohio University.

After teaching a year in Cleveland, Martha headed for Clifton, Arizona. She taught for a year, and then met and married Ralph Amos King. The wedding led to Martha's dismissal from her job. At that time many school districts prohibited married women from teaching.

She did not teach again until World War II, when a shortage of teachers led to a relaxing of the old rule. At the onset of the war, Ralph King took a chemist job for the federal Bureau of Mines.

Martha resumed teaching when she and Ralph moved from Jerome, Arizona, to Boulder City, Nevada. She got a job at the Boulder City High School. Her first mention in *Aquila*, the school yearbook, comes in its 1946 edition, where her teaching load is listed as "commercial." She also was the advisor for *Pebbles*,

the school's newspaper and did bookkeeping for the school.

According to an online biography, her chores were considerably more than what the yearbook highlighted. "Her first year, she taught six classes a day, kept the school accounts, manned the ticket booth at all school events, handled the correspondence for the tenth anniversary of Boulder Dam and taught adult education classes two nights a week."

Martha taught at Boulder City High School for more than two decades, and helped organize the Boulder City Classroom Teachers Association. She received a Clark County Classroom Teachers Distinguished Service Award, which required her principal's nomination. In 1967 she was named the Outstanding Clark County Teacher.

That same year she retired from teaching, so yearbook staff dedicated that *Aquila* edition to her. "The 24-year reign of 'Our King'" has come to an end," the dedication reads. "Boulder City High School says farewell and 'Long live the King.'"

The 1967 yearbook also said, "Mrs. Martha King is a person of great wisdom, a keen sense of humor, deep faith, and a strong conviction of the power of education to lift mankind." It listed her responsibilities as sociology, economics, bookkeeping, and school banking.

Martha's outside activities were arduous. She cared for a sick husband and her mother, as well as her son and daughter. Through the years she participated in a group called PEO, a women's philanthropic and educational organization that gave out school scholarships.

In 1991 the Clark County School District honored Martha by naming Boulder City's new second elementary school Martha P. King Elementary. The school's website describes Martha: "Her legacy will remain forever as our benchmark for honor, success and inspiration to all who walk these halls."

Martha, who died on January 8, 1994, would have been proud. Given her family's military history she would have enjoyed the elementary school's April tradition of reenacting the Civil War, using water balloons for ammunition.

Fran Haraway

Bernie Kells Lenz

Brunetta Mae Kells Lenz, who went by the name "Bernie," did fashion modeling in young adulthood. She then went into business for herself. Some of her ventures enabled young girls to train as models. She also offered training for Las Vegas students interested in retail careers.

In the 1960s and 1970s, Bernie visited Southern Nevada's public junior and senior high schools to talk to girls about a career in the fashion industry. But drumming up business for her modeling school at Fifteenth Street and Charleston Boulevard was not her only goal.

"She taught by example," Bernie's daughter, Two Lenz, said. "When Mother walked into a classroom, she was poise and beauty personified." Two also said her mom "taught a lot of free classes, just to set the girls straight on what they would need to do to make it in the modeling industry."

Bernie was born in Colorado Springs, Colorado, in 1921. She was the daughter of John Kells and

1921–2010
MODEL, BUSINESS FOUNDER, TEXTBOOK AUTHOR

Florence Sluterbeck. Her father died when she was three. She grew up in a meager but loving home. The family moved to Long Beach, California, in the 1930s, where Bernie graduated from Long Beach Polytechnic High School.

Her beauty was recognized early. So shortly after high school graduation she began modeling. She signed with the Ford Studio in New York, and modeled for leading designers including Dior, Chanel, Adrian, Irene, Trigere, and Wragge.

During World War II she served as a dental assistant in Guam, where she treated soldiers who were stationed in the Pacific. After the war, she moved to Las Vegas with her husband, Richard Lenz. They settled into a home on Thelma Lane, where she lived for more than forty years.

During the late 1940s, Bernie founded the Nevada Academy of Art and Technology for students interested in retail. Then in the 1950s, she began to teach modeling. In 1960, she opened the Lenz Academy of Modeling and Finishing School, which remained

until her retirement nearly thirty years later. Five times, the school won the "best school of the year" designation of the Models Association of America.

Bernie wrote *The Complete Book of Fashion Modeling and Modeling Curriculum* and *The International Method of Modeling Training*, which went to schools in forty-four cities through a franchise system.

Right in Las Vegas, she worked with Wilhelmina Cooper to stage fashion shows using models from New York at the downtown El Cortez Hotel. She appeared before the state legislature to allow schools such as her Lenz Academy of Modeling and Fashion Merchandising—which had evolved from her earlier academy—to gain accreditation.

She served as president of the Models Association of America International, and was a board member of the International Talent and Modeling School Association, which met annually in New York City to upgrade model training and to introduce new talent to major agencies. Her pupils won more than seventy-five awards in multiple categories in competitions. Her graduates have worked in the fashion centers of the world, including New York, California, France, Italy, Japan, and Germany.

As president of the World Model Association, she championed legislation to restrict advertising that presented models as prostitutes.

Bernie's achievements weren't limited to fashion. She also served on the Governor's Board of Post-Secondary Education.

Her fashion legacy continues. In 1979, Richard Weber and Tena Houser purchased the Lenz Talent Agency, which has expanded to include Screen Actors Guild and Equity franchises, and a side venture, Destination Vegas, which produces events.

Bernie Lenz passed away on July 1, 2010. She was survived by her daughter, Two, and her son Richard Lenz, as well as two grandchildren and two great-grandchildren.

Denise Gerdes

Celesta Lisle Lowe

Celesta Lisle Lowe was a child nomad. She and her siblings moved about as her dad opened mom-and-pop diners and gas stations in various California and Nevada towns. But she believed in the permanent value of education, which she advanced through her library work in the 1960s and 1970s for the institution that has grown to become the University of Nevada, Las Vegas.

Celesta was born in Ludlow, California, on October 26, 1917. She was the youngest of the five children of John Quincey Lowe and Celesta Fairbanks Lowe, both Mormons. Her father also worked for the railroad and did some mining.

Celesta's senior year of high school, she was sent to board with friends in San Bernardino, California. The Depression then hit, but it did not deter her from graduating and going on to attend Redlands College in the fall.

Romance entered Celesta's life in the form of a young man she had met while residing in Tecopa, California. Her suitor was David Walker "Deke" Lowe, Jr., a telegraph operator for the Tonopah and Tidewater Railroad. He, too, came from a Mormon family, his parents being Frances Kinkaid Lowe and David Walker Lowe, Sr.

1917–2004
Hotel Operator,
Librarian, Columnist

Celesta and Deke married in Las Vegas on April 25, 1935, which was the day of the town's first Helldorado Day Parade. The two walked in the parade, which commenced at Fremont and Main streets in front of the old Union Pacific train station, and ended at the Helldorado Village on Sixth Street. There the two made their marriage vows. Celesta was 18.

Deke was working for the railroad at Silver Lake, near Baker, California. When Celesta became pregnant with David, their first son, she went to stay with her sister-in-law Exa Jones in Las Vegas, to be near a doctor. Lisle, their second son, was born in Las Vegas under the same circumstances. Their third child, Janet, was born in an empty box car that the family lived in temporarily while Deke was working in Santa Rosa, California, for the Northwestern Pacific Railroad. They next moved to San Bernardino, California, where their fourth child Dale was born while Deke worked for the Santa Fe Railroad.

Then Deke decided to trade the equity the family had in their San Bernardino home to purchase the twenty-six-room Goodsprings Hotel in Goodsprings, Nevada. It was 1945, World

War II was on, and the mines in Goodsprings were active. Prosperity seemed imminent.

But when the war ended, the Goodsprings mines began closing. Desperate to take care of his brood, Deke took a job as the central train control dispatcher for the Union Pacific Railroad in Las Vegas. At first Deke and oldest son David—who had entered Las Vegas High School—lived in a mobile home on Tenth Street while Celesta and the younger children stayed in Goodsprings. But Celesta didn't want to limit their education to the town's one-room schoolhouse.

The family made plans to transition to Las Vegas. Deke and Celesta filed for a "Jack Rabbit" homestead of five acres next to the land owned by Celesta's parents. In 1952 their homestead was approved, but it took them until 1956 to meet all the requirements, which included building a livable dwelling, drilling a well for water, and installing a septic tank.

Celesta was proud that all four children graduated from Las Vegas High School. As for the Goodsprings Hotel, the Lowes rented it out from 1953 until it burned down in 1964.

To add to the family's income, Celesta first took a position as secretary at the Von Tobel Hardware Store on Main Street. Her pay was one dollar an hour. She passed the state's civil service test and began looking for better work.

She read in the newspaper that the soon-to-open Southern Nevada University—now UNLV—was hiring. She filed her application at the old Las Vegas high school, where the college had set up a temporary office. Jerry Dye hired Celesta as a library technician, where she worked for twenty-one years.

In the mid-1960s, Celesta also began writing a column for the *Las Vegas Review-Journal*, "Echoes from Archives," which ran in *The Nevadan*, the paper's Sunday magazine. For fourteen years she wrote, under both Bill Vincent and editor Bill Wright.

After both the Lowes retired, they stayed busy. Deke did prospecting. Celesta took up gardening and contributed to the Nevada Women's History Project. Deke died in 1992 after fifty-seven years of marriage. Celesta died in Henderson at age eighty-seven in 2004.

She once said that she believed in husbands and wives staying together "through thick and thin. One must work at keeping one's children on the right track of morality and integrity. My theory is you have to sacrifice your own personal feelings for the others that you love."

Mary Gafford

Sister Rosemary Lynch

Franciscan Sister Rosemary Lynch's mission in life was to strive for social justice and peace. One adjective sums her up—dedicated.

Rosemary was born in Phoenix, Arizona, in 1917, and grew up loving the calm beauty of the surrounding desert. She also loved the rituals and traditions of the Franciscan Catholic parish she belonged to. When her brother left home to attend a Franciscan seminary and become a friar, she also felt the call to enter religious life.

In 1932 she joined the Community of the Sisters of St. Francis of Penance and Christian Charity. She took her final vows at the Stella Niagara convent in Niagara Falls, New York, in 1934.

Rosemary returned to the West to teach and be an administrator at Catholic schools For eighteen years, she taught Spanish and headed the foreign-language department at Conaty High School in Los Angeles. Then she moved to Montana, where she served eight years as the principal of Havre Central High School.

In 1960 her order sent her to Rome to attend its general chapter, which is a periodic meeting of

1917–2011
NUN, TEACHER, PRINCIPAL, ADMINISTRATOR, PEACE ACTIVIST

representatives from all its worldwide communities. She was then chosen to be part of the order's central leadership team, which was headquartered in Rome, where she stayed for fifteen years. The Second Vatican Council took place while she was there, which instituted major changes in the Catholic Church, and within its religious orders, too. Rosemary assisted her order in changing its rules and constitution. She became so knowledgeable in church law that she began helping other orders that desired to update.

As part of her Franciscan duties, Rosemary had many opportunities to travel. She visited her order's sites in Africa, Indonesia, and Mexico. After working in U.S. schools she was already aware of the social inequalities faced by poor and minority children. Her international traveling heightened her awareness of poverty and injustice, especially among women and children. This reinforced her determination to work for non-violent social change.

Rosemary returned to the United States in 1977, and came to Las Vegas to join the staff of the Franciscan Center for Social Justice. That summer President Carter asked Congress to

fund development of a neutron bomb, also called an enhanced-radiation bomb. Shortly after, word leaked out that the bomb was being tested at the Nevada Test Site. Rosemary researched, and learned that the last organized protest at the Test Site had taken place in 1957, twenty years earlier.

She and a group of friends decided to organize a demonstration at the Test Site's entrance to mark the anniversary of the earlier protest, protest production of the neutron bomb, and remember the 1945 bombing of Hiroshima. For several years she continued to go alone to the site, or with a friend, to sit quietly and pray.

1981 was the 800th anniversary of the birth of St. Francis of Assisi. The Franciscan Center made plans to honor the anniversary with a forty-day period of prayer at the Test Site during Lent 1982, beginning on Ash Wednesday. The event was called the Lenten Desert Experience, which eventually became the present-day Nevada Desert Experience. Rosemary participated in many of these protests. While she was sometimes arrested and underwent court appearances, she respected the guards and police officers involved, though she opposed their roles to support the Test Site. Many of them also respected her.

In 1989, Rosemary was among a group of Franciscans who with others founded an organization called Pace e Bene—Italian for "peace and good"—to promote world peace through education about non-violence. According to its web site, the organization is now international, and has trained more than 25,000 people in workshops around the world. When Rosemary retired in 2004, she became Pace e Bene's first elder. She remained an active advocate for peace and justice until she died.

On January 5, 2011, Sister Rosemary was on her regular morning with her friend and companion Sister Klaryta Antoszewska when she was struck by a car that was backing out of a driveway. Rosemary died four days later from her injuries.

When the news of her death came out, many Las Vegans probably did not recognize her name. But most of them are aware of the Nevada Test Site protests that have become a part of the Easter season in Southern Nevada. Regardless of one's stand on nuclear weapons, most people also understand Rosemary's desire for social justice and peace. The Nevada Desert Experience and Pace e Bene ensure that Rosemary's work goes on.

Judith Lachance

Mabel Clara Whitney Macfarlane

Restaurateur Mabel Whitney Macfarlane is another unsung heroine who contributed to Las Vegas in the 1930s, before the city made it big in the hospitality industry.

Born December 18, 1887, in Panaca, Nevada, Mabel moved with her seven children to Las Vegas in the throes of the Great Depression to help support the family. Her husband, Isaac C. "Chauncey" Macfarlane remained on the family farm outside of St. George, Utah. For years he raised and delivered produce and poultry for Mabel to use in the several restaurants she owned and operated in Las Vegas between 1931 and 1938.

Mabel never learned to drive an automobile, so Chauncey made at least two trips in their Ford Model A to move Mabel and the children from Utah, along dirt and gravel roads, to Las Vegas. At first she made their household in a small home near the intersection of Carson and Second—now Commerce—streets in downtown Las Vegas. Next door she opened her first café, the Cozy Nook.

1887-UNKNOWN
RESTAURANT COOK,
OWNER, OPERATOR

Although the construction of Boulder Dam created work in the area, times were still hard. Hungry men would sometimes show up at the Cozy Nook asking if they could work to earn a meal. It was soon common knowledge that a fellow who was hard up could still eat at Mabel's.

Mabel was probably attracted to Las Vegas because three of her brothers—Stowell, Burt, and Ralph Whitney—had established the Whitney Ranch, which is now known as East Las Vegas. The family objected vociferously, but futilely, to the name change. Mabel also helped a nephew, Don Whitney of Logandale, Nevada. As a young child with a severe case of pneumonia, he was so thin that Mabel told him to show up daily to the café for food. He regained his strength and was able to run cattle on the "Mormon mesa" into his 80s.

In time Mabel moved her café to the Boulder Hotel on Fremont Street, which allowed her to expand the business. The diner had a U-shaped counter in the middle, with booths on both sides. Eventually Mabel took over the

restaurant in the Overland Hotel, also on Fremont, which was even larger.

All of Mabel's children helped out in the eateries. Her five teenage daughters waited and bussed tables. The two youngest—June Jeffers and Howard—washed dishes. Daughter Beth Corey Garside later acknowledged that the cafés were not only a way for the children to help support the family, but also a way for Mabel to keep her children close and safe in a town with a wild reputation.

The kids left in the morning for school, and went straight to the restaurant after school, where they remained until the dinner period was over. At one point, local police noticed the girls were taking shortcuts in the dark, through downtown alleys, on their way home. Officers told Mabel this was dangerous for attractive girls such as her daughters, so the practice ended.

Mabel's eateries had reasonable prices—a full meal cost less than a dollar. She served all three meals, and made everything from scratch. She offered a daily feature, such as short ribs, veal, lamb, or pork. She made fresh pies and cakes daily, with strawberry shortcake among her customers' favorites.

In 1937 all five of Mabel's daughters—Glenna, Donna, Georgia, Beth and Anne—got married. As the economy was improving, Mabel and the two youngest children eventually returned to St. George to live with Chauncey.

An unassuming, woman, Mabel showed true grit during a time of crisis. Daughter Beth's husband, Calvin M. Cory, once summed up Mabel. Shortly after his proposal, he told Beth, "I really wanted to marry your mother. But she was already taken."

Joyce Cory, wife of Macfarlane's grandson

Mary Louise Hungerford Mackay

Mary Louise Hungerford Mackay knew both deprivation and extreme prosperity. After her first marriage, she made ends meet as a seamstress. But a friendship with one of her wealthy clients led to an invitation for dinner, at which she met the Comstock Lode "Silver King" she would one day marry: John Mackay.

Born in about 1844, Louise grew up in New York City, where her father Daniel was a barber, until he went to fight in the U.S. Mexican War. Her mother Eveline sewed fine handiwork for rich ladies. Louise would tag along when her mother made deliveries. She enjoyed the opulence she witnessed.

In Downieville, California, her father—called Captain Hungerford after he fought in Mexico—had an apothecary and barbershop called "At the Sign of the Pestle and Mortar." At age ten, Louise had the great adventure of moving to California to join him. She, her mother, and aunt went by ship to Panama, crossed the isthmus, and then boarded another ship. They arrived in Downieville by mule train.

1844–1928
SEAMSTRESS,
MINE OWNER,
PHILANTHROPIST

In January 1857 Louise enrolled at St. Catherine's Female Academy in Benicia, California. Most of the students were affluent residents from the Bay Area. The next year, the family lacked the funds for Louise to return to school.

Just after her sixteenth birthday, she married Dr. Edmund Bryant, a Downieville physician. By 1863 they had moved to Virginia City, where a second daughter was born in their boarding-house room. The baby died of smallpox at eight months old and is buried in a hillside Catholic cemetery. The death drove Edmund to drink and drugs. In his addiction, he abandoned his family. Louise found work doing sewing for Rosner Brothers Dry Good Store and private clients. She also taught piano and French. Edmund died in June 1866.

One of ladies for whom Louise sewed was Theresa Fair, the wife of Jim Fair, superintendent of a successful mine. The two women would share tea before a dress fitting. After Edmund's death, Theresa Fair started inviting Louise for supper. On Christmas dinner 1866, the Fairs invited Louise and her daughter, Eva. They also invited bachelor John Mackay, who was one of Jim

Fair's mining partners. The two were married on November 25, 1867, at the Fairs' home by Father Patrick Manogue.

The Mackays' first home together was at the corner of Howard and Taylor streets in Virginia City. To give birth to their first child, Louise went to San Francisco, where they felt medical care was better. John William Mackay Jr. was born at the Grand Hotel on August 12, 1870. When second son Clarence was born in April 1874, the Mackays were living in San Francisco on O'Farrell Street.

For the next two years, Louise, the children, her mother and aunt lived in France, seeking surgery to cure the limp of Eva, who had been injured in a fall at age four. At least once a year John visited the comfortable home they purchased in Paris. But he felt more comfortable back in Nevada. On one of his Paris trips, he said the firm had struck the Big Bonanza, the world's largest and richest silver ore body. It made all four partners—Mackay, Fair, Flood, and O'Brien—millionaires.

Louise asked to be taken to the place that was called the richest spot on earth. She went to the lifting works of the Consolidated Virginia Mine. A mist hovered over the shaft, created by hot air from below meeting with the outside air. She and John rode in a cage down to a timbered tunnel. They walked into a ten-foot-square space where miners were working. Each had a lit candle that made the quartz crystals on the bluish walls shine and sparkle. Iron and copper pyrites also reflected the light. The Mackays were walking inside a "river" of silver.

Louise asked for a souvenir—enough silver to mint a set of dinner service for the family. Eventually the family sent a half-ton of silver to the Tiffany Company. Its craftsmen worked two years to fashion the Mackay silver set, comprised of more than 1,350 pieces. Each had the Mackay family crest, the Hungerford crest, and Louise's initials, M.L.M.

The family went to live in Paris but shuttered the house there after son Willie died at age twenty-five in a riding accident. When the mines played out in the 1880s, John Mackay went into business laying undersea communication lines between North America and Europe. John died in their London home in 1902, and Louise went to live with son Clarence on Long Island, New York, where she died on September 4, 1928.

The family chose to return to Nevada in 1908 to dedicate a statue of John Mackay in front of the Mackay School of Mines building, which they gifted to the University of Nevada. Over the years many thousands of dollars have come from the Mackay endowment to fund projects such as the university's athletic field, stadium, track, science building, and salary enhancements for faculty.

Janet Bremer

Florence Elberta Schilling McClure

Hurricane Florence was the nickname that Florence Schilling McClure earned from the Nevada politicians she lobbied, and the reporters who covered the stories she generated. A hurricane is a tropical storm with high winds, accompanied by thunder. The term fit Florence, who worked vigorously to right social wrongs.

Florence was a "ground breaker," according to her daughter Carolyn McClure Dunn. "She was a highly educated, highly charged individual."

Florence Elberta Schilling was born September 26, 1921, oldest child of Louis Arthur Schilling and Grace Marie Marshall Schilling. They were farming folk who settled on a piece of inherited land in Centralia, Illinois. Louis was a hard worker, gentle soul, and good provider. Before Florence's arrival, her father Louis had served during World War I in Europe, where he experienced extreme hand-to-hand combat. He suffered from shell shock—now termed post-traumatic stress disorder—for the rest of his life.

When Florence was about two, she gained a sister, Rilla Marie Schilling. Sometime after, their father was placed in a veterans' hospital, which changed Florence forever. Her maternal grandmother, also named Florence, took the younger Florence under her wing, introducing her to reading and discussions of current events. Florence's mother arranged with the town library for her daughter to check out books on her own, which was unusual in that era.

With her father gone, Florence took on heavy chores, such as hauling coal to the furnace. She was proud of her strength and her near-photographic memory. Florence entered high school at age thirteen and graduated just after turning seventeen. In 1941 she graduated with a two-year degree from MacMurray College for Women in Jacksonville, Illinois.

Florence had upper respiratory problems, so she moved to Florida to see if the warmer climate would help her health. There she met her future husband, veteran James Edwin McClure. During World War II he had escaped from Davao, a Japanese prisoner of war camp in the Philippines.

When James went to visit his parents in Oklahoma, he wrote her, suggesting they marry. On October 5, 1945, they did, in Coconut Grove,

1921—2009
ADVOCATE FOR RAPE VICTIMS, CO-FOUNDER AND DIRECTOR OF SOCIAL-SERVICES NON-PROFIT

Florida. They had two children, a boy and a girl. Burton Cohen lured the McClures to Las Vegas in 1966 by offering Florence a spot on his team to build and run the Frontier Hotel. The two had worked together at the International Hotel in Los Angeles.

She joined the League of Women Voters and other women's groups. Then she returned to school, earning a bachelor's degree in sociology from the University of Nevada, Las Vegas in 1971.

About this time she met Jean Ford and Sandi Petta, two women committed to the community. In 1973 Florence and Petta founded a non-profit group, Community Action Against Rape, which Florence directed for twelve years. Under her leadership, the organization changed the way that law enforcement treated rape victims. Now called the Rape Crisis Center, it trained police and medical workers on the victim's viewpoints and needs. It also arranged for hospital to stock rape kits, to gather legal evidence during medical treatment.

Florence also petitioned the state legislature to update Nevada's outdated rape laws. Her work led to a law that made it illegal to admit the sexual history of a rape victim as evidence in court, unless directly related to the case at trial. The legislature also reclassified the crime of rape from a battery to an assault. Florence also attended court so victims would not have to go alone.

Florence was appointed to the National Institute of Mental Health's advisory committee on rape prevention. She was a member of the Citizens Committee on Victims Rights, the Nevada Women's Lobby, and the Nevada Women's History Project. She also was a state president of Soroptimists International and a member of the American Association of University Women.

When Florence retired from directing Community Action Against Rape, Nevada Governor Richard Bryan proclaimed December 8, 1984 as Florence McClure Day. In 1988, the local chapter of the National Organization for Women honored her. In 1990 she received the Western Society of Criminology's Morrison-Gitchoff Award. In 1992 Maxwell House named her one of its 100 Real Heroes. She was Humanitarian of the Year for Women's American ORT in 1993. On April 15, 1995 she received a regional award from Women Helping Women. The Citizens Committee on Victims Rights recognized her on April 28, 1995. In 1998 the National Honor Society gave her an Honorable Member Golden Key. The Women's Research Institute of Nevada, housed at UNLV, honored her in 2001. In 2002 she was honored as a significant influence on Safe Nest, a Southern Nevada shelter for victims of domestic violence.

At age eighty, Florence began writing a book about a half-breed Indian, Cherokee Chief Will Shorey—born in 1753 near Knoxville, Tennessee—who was left out of his tribe's history because he looked like a white.

Florence McClure didn't just intellectually analyze crime and victimization. She also sought services and new laws to benefit society at large. She died on November 5, 2009.

Joan LeMere

Karla Bohac McComb

On the balmy morning of June 19, 2006, a full house at the Las Vegas Palm Mortuary on Jones Boulevard celebrated the life of Karla Bohac McComb. Her family, friends and many co-workers from the Clark County School District came to remember Karla, who had been the district's director of Education Services, as well as a wife, mother, teacher, and musician.

Born on July 23, 1937, Karla was the only child of John F. and Lorraine Winters Bohac. They resided in Tacoma, Washington, where Karla was encouraged to excel in music and academics. After graduating from high school, she spent two years studying in Europe. Then she enrolled at California State University, Sacramento, which awarded her a bachelor's degree with a double major in English and French, which she spoke fluently.

In 1961 Karla took her first teaching job. Yet she never forgot her love of music. She played flute for the Idaho Falls Civic Symphony, the Idaho State Symphony Orchestra, the Tahama County Band, the Chico Symphony Orchestra, and the Shasta Symphony Orchestra.

1937–2006
TEACHER, CURRICULUM SPECIALIST, DEVELOPER OF SCHOOL PROGRAMS

In 1971 Karla moved her family to Las Vegas, where she was hired by the school district to teach English and French. Some years later, she became its coordinator of curriculum services. From 1989 to 1991, she was in charge of the district's collection of books, pamphlets, and videos relating to ethnicity. Recognizing the vast ethnic diversity among district students, Karla helped the district's teachers and librarians make good use of the materials.

Eventually her title changed to curriculum specialist. Her office and specialized library were then located at the district's old Ninth Street School.

In the 1970s, Karla developed rheumatoid arthritis. As the disease progressed, she grew more dependent on a wheelchair for mobility. Yet she never allowed her physical condition to deter her.

Karla attended Nova Southeastern University and earned a master's degree in educational administration while writing numerous academic papers. In 1982 she published a creative work, *A Cultural Celebration*, and in 1984, *Out of Many—One*. From 1978 to 1989 she was a consultant to the University of Utah. She also

became an adjunct professor at Nova University's local campus.

In 1990 she served as a member of the Nevada Governor's Council on Holocaust Education, and was named chair of its Holocaust education conferences in 1994 and 1995. For thirty-three years, she directed the Clark County School District's program to keep schools safe and drug-free. For many of those years, she also was a member of the Nevada Commission for National and Community Service. She also chaired a school district initiative called Z Squared, which aims to keep guns and violence out of schools.

Numerous honors came her way. In 1991, Phi Delta Kappa, an education group, gave her its Leader in Education Award. In 1994 she was a finalist for the annual Las Vegas Women of Achievement program.

Karla served as vice president and president of Easter Seals of Southern Nevada. She was a member of the Nevada Humanities Committee. For a time she chaired the local Vocational Rehabilitation Council. She belonged to a range of organizations, including the American Association of University Women, the Association of Supervision and Curriculum Development, Phi Delta Kappa, Alpha Delta Kappa, the Volunteer Center of Southern Nevada, and the YMCA's northeast advisory committee. From 1981 to 1986 she was president of the Las Vegas Valley Dog Obedience Club.

From 1986 until her death, Karla was included in *Who's Who in the West*. She also appeared in *Who's Who in American Education* and *Who's Who in American Women*.

A baseball lover, Karla was a season ticket holder to games of the Las Vegas Stars, later called the Las Vegas 51s. She retired in 2002 from the school district but stayed busy with her family and her dogs. Her family included daughter Kammy Bridge and granddaughter Karly, as well as daughter Martha Hayes, son-in-law Michael Hayes, and granddaughter Brianna Hayes.

Mary Gafford

Elizabeth Hazel Penrose McKay

Elizabeth Hazel Penrose Davis McKay was born in Meriden, Connecticut, on May 16, 1869. She received a delayed affidavit of birth in Storey County, Nevada, where her family arrived in time for the state's 1875 census.

Elizabeth, who went by "Bessie," remembered riding to Nevada in a covered wagon, fearing Indian attacks. Her parents, John and Mary Ann Kinsman Penrose, were born in Redruth, England. Initially the couple stayed in Pennsylvania, where two sisters were born, Cordelia and Katherine.

An 1880 census record of Storey County shows that another Penrose, Mabel, was born in Gold Hill. But the July 13, 1894 issue of the *Daily Territorial Enterprise* reported that a sixth daughter, Gladys Vera Penrose, died at age three. There is no further record of miner John Penrose.

Bessie graduated from high school in about 1886, at age seventeen. She became a teacher. Her schools were often one room, with a closet for storing coats, lunchboxes, and sometimes an unruly student. Sitting close to the wood-burning stove was too warm, and sitting far was too cold. Teachers had to get wood chopped, and clean out the stove's ashes. Drinking water was kept in a bucket, with a big dipper that everyone used. How would modern health officials react to that?

The teacher was responsible for all eight grades. Younger students sat up front. The grades took turns reciting lessons, getting assignments, and showing completed work to the teacher. Sometimes older students helped the younger ones.

Bessie told her grandchildren, including Elizabeth David Lucas, that the pupils were not her only challenge. She also had to manage night-shift miners who either wanted to learn to read or just wanted to "get to know" the new teacher.

Bessie taught her grandchildren to read with funny rhythms and stories. An example would be "geography," whose spelling was indicated by the line, "George Elliot's old grandfather rode a pig home yesterday."

Her granddaughter Lucas used Nevada Department of Education records to identify the school districts where Bessie taught: Plumers School District from 1887 to 1888; Sanders School District from 1889 to 1890; and Gold Hill School District, 1891 to 1896.

1869—1952
TEACHER

On November 17, 1897, Bessie married Henry Clay Davis. Henry "Harry" Penrose Davis was born January 25, 1899, in Nevada. Reese Ernest Davis was born May 25, 1901, in Redding, California. Stanley John "Mickey" Davis also was born in Redding, on April 29, 1905.

On May 19, when their youngest was less than a month old, Bessie was suddenly widowed. The *Shasta Weekly* newspaper reported, "Mrs. H.C. Davis and her three bright little boys left Friday for her old home in Mason Valley, Nevada, after having settled matters connected with the life insurance of her late husband. Mr. Davis carried a $2,000 policy. Many friends, deeply sympathizing with Mrs. Davis over the sorrow that came into her life, will regret to see her leave this community." It showed a 1904 picture of Bessie at the Creamery School.

Nevada education directories list Bessie as teaching at Sanders in Yerington County in 1906, at Yerington in 1910, and at Gallagher in Yerington County in 1914. The family sometimes joked that the youngest son, Mickey, grew up in the classroom because during his first months, he slept in a box under Bessie's desk at school.

On June 10, 1912, Bessie married again, to Joseph F. McKay. Her older boys told little Stanley that since their mother had changed her name to McKay, he would have to change his, too. From then on, they called him "Mickey."

Education directories indicate that Bessie subsequently taught at a Mason school from 1915 to 1917. Then she taught, again, at the Gallagher School in Yerington County from 1918 to 1919. In 1921 she taught at Missner School in the same county. Then from 1922 to 1925, she taught at Churchill Consolidated in Fallon County.

It appears that Bessie taught about thirty-eight years. By 1928 she and Joseph had moved to Santa Cruz, California.

Female teachers in that era had to keep their hair long and demonstrate other virtues such as never swimming in mixed company and never smoking, dancing, or drinking alcohol at all. As soon as Bessie retired, she cut her hair and had Joseph teach her to swim.

Every good day she swam in the Monterey Bay, until 1952, when she died on August 24. Lucas also remembers watching the dance floor clear whenever Joseph and Bessie stepped up to waltz. Bessie also learned to close her day with a drink of Four Roses bourbon over ice.

Bessie's son Mickey recalls that in his youth she used to play the piano for silent movies at a local theater. He was glad, because he got in free to watch the movies. At her funeral, Mickey chose songs that he remember her singing when she played at other funerals.

Bessie Davis McKay always loved Nevada, and kept an oil painting of mountains with sagebrush, to remind her of Gold Hill. I wish you could have known her.

Elizabeth P. Lucas, granddaughter of Elizabeth McKay

Ann Rittenhouse McNamee

Ann Rittenhouse McNamee of Las Vegas came from a prominent family, married into a prominent family, and within her upper-crust milieu helped the community by working in service organizations.

Her father, George Flint Rittenhouse was the first city engineer of Las Vegas, whose projects included designing a section of Woodlawn Cemetery, which is now on the U.S. Register of Historic Places.

Her brother, Franklin "Pete" Rittenhouse was a partner in one of Las Vegas' earliest law firms, McNamee, McNamee & Rittenhouse, established in 1913. He also served as the U.S. Attorney for Nevada during the Eisenhower administration.

Her husband, John Rittenhouse, a native Nevadan, was a partner in the same firm and a descendent of Eureka-born attorney Leo McNamee, who had represented the powerful Union Pacific Railroad. John and his brother, Frank Rittenhouse, became lawyers for the Six Companies, a consortium of six companies that built Hoover Dam. Frank's son, Frank Rittenhouse Jr., also a lawyer, became known when he represented Ria Gable in her divorce from actor Clark Gable, who was splitting after eighteen years to marry actress Carole Lombard.

Another brother-in-law, Joe McNamee, earned his local fame as a state assemblyman and the owner of the Silk Purse Ranch, a 110-acre spread north of town, purchased from the Gilcrease family.

Ann's mother, Pauline Ross Irwin, was the granddaughter of Irish immigrant Thomas Irwin, who settled in Pennsylvania. The Pennsylvania Rittenhouses built the first recycling mill in the nation, which made paper out of rags. Another famous relative was astronomer David Rittenhouse.

Ann was born in 1922 in West Virginia. She graduated from Waynesburg University in Pennsylvania in 1943, and became an airline passenger agent. But soon she decided to join her parents, George and Pauline, in Las Vegas. There she met her brother's partner, John

1922–2007
CIVIC GROUP MEMBER

McNamee, whom she married in 1946. They had two children, Chris and Ross Ann.

Not a lawyer herself, Ann once was selected to be foreman of a federal grand jury.

Ann worked in the 1950s as secretary to the vice president of the Southwest Gas Corporation but filled her off-hours with volunteerism. She joined the Service League, a women's club founded in 1946, which designed projects to meet community needs. The League later became the Junior League, and Ann became a sustaining member.

She was loyal to her alma mater and supported it financially. She was a member of Waynesburg University's Charter Society and its Paul R. Stewart Society.

Ann helped found an organization called the Clark County Attorneys' Wives. She came up with the idea for its most popular fundraiser, which was a home tour. She also served several years on the board of Planned Parenthood of Southern Nevada.

She also served sixteen years on the advisory board of the local Salvation Army, which came to Las Vegas in 1947. Ann Rittenhouse was so dedicated to the Salvation Army that when she died in 2007, her family asked those who wished to honor her memory should, in lieu of flowers, donate to the Army's local chapter.

Fran Haraway

Eve Wick Moss

Eve Wick Moss took pride in serving her country as a nurse throughout World War II. That experience prepared her to contribute after the war to her civilian community, Clark County.

Eve's parents—Benjamin Edward Wick and Gerda Lundstrom Wick—both immigrated to the United States. Benjamin, then seventeen, left Norway to join his brother Siebert in Montana. Gerda—the youngest of nine children—left Sweden for Redfield, South Dakota. Benjamin and Gerda met and married in South Dakota when she was twenty.

Eve was born November 2, 1916, in Meadow View, an Oregon town later absorbed by Eugene. Eve's father taught grades one through eight in a small schoolhouse. In 1919, a year after her older sister, Elizabeth, had died of typhoid fever, Eve's family moved to Roseberg, Oregon. It was a fresh start, but Eve wasn't entirely happy. Each summer her father would go to Corvallis, Oregon, to take classes in bookkeeping and shorthand. The family would live in a tent for the season, earning extra money by picking fruit.

Eve began first grade in Yakima, Washington, proud that she already knew English. When Eve was in secondary school, her mom again gave birth. The baby died and Eve's mom became sickly. These events introduced Eve to the field of nursing.

After graduating from Yakima High School in 1934, she attended the University of Washington in Seattle. Next she enrolled for nurse's training at Swedish Hospital in Seattle. After completing a three-year nursing course, she graduated in 1939 and commenced her career.

While working at Swedish Hospital in 1940, Eve signed up to be an Army Red Cross nurse. She reported to Fort Lewis, Washington, on January 1, 1941. She was there when the United States entered the war late that year, after the Japanese attack on Pearl Harbor on December 7.

She became a regular Army nurse at the ranks of second lieutenant, working for seventy dollars a month. At the time, Fort Lewis had about 60,000 in personnel. There at Fort Lewis, she met Bob Moss, who was captain of the mess hall. After four months of courting, they married on June 28, 1942. They traveled by the Victoria Ferry to Canada, where they honeymooned in Vancover, British Columbia. The

**1916—2009
Nurse, Member of
Military, Member of
Civic Groups**

honeymoon lasted only four days, as these were war times.

Both Eve and Bob were assigned to the 203rd Hospital Unit. After a ten-day trek by train across the nation, they arrived at Camp Kilmer, New Jersey, by December 22, 1942. On December 29, Eve, Bob, and other servicemen boarded the S.S. Brazil. It docked in Guroch, Scotland, on the morning of January 7, 1943. Their ultimate destination was Burford, England, where the 203rd ran a hospital for the war-injured. The work was grueling but rewarding. As time passed, the Mosses' military assignments split them to different locations.

In August 1943, the 203rd moved to a medical center near Paris, France, in the town of Garches, which had been occupied by the Germans. The 203rd got there not long after the D-Day invasion. Eve recalled that the center treated wounded German soldiers as well as wounded French and American soldiers.

The German army surrendered on May 7, 1945. Eve decided to view Flanders Field, a reminder of World War I, before returning to the States. In fall 1945, she boarded a so-called "liberty ship" with one hundred nineteen other Army nurses to cross the Atlantic. After a short stay at Camp Kilmer, she reunited with Bob in California.

There Eve became the head nurse in the emergency room at St. Elizabeth's Hospital, while Bob acquired a position with Northwest Airlines. In

> *She had a special place in her heart for the Retired Officers' Wives organization, in which she served in every position except treasurer.*

1946, their first son, Bob Jay, Jr., was born. Then Bob reenlisted in the U.S. Air Force Medical Corps, which moved them to Seguin, Texas. They were still there in 1949 when Rick, their second son, was born. Then they moved to Montgomery, Alabama.

From there the family made its longest move, to Germany, where Bob was assigned for four years. Eve gained a deeper respect for the downtrodden, as Europe was still rebuilding from the war. She learned two hobbies there, tole painting and oil painting. Also, their third son, Skip, was born in Wiesbaden, Germany.

In the final ten years of Bob's military career, the Mosses lived at bases in California, in Newfoundland, Canada, and near Washington, D.C. When he retired in 1976, he and Eve selected Las Vegas to be their home, and became members of the First Presbyterian Church.

Bob was a thirty-third degree Mason and an active Shriner. Eve was active in the auxiliary for St. Jude's Ranch for Children, the Mesquite Club, and the women's auxiliary of the local Salvation Army. She had a special place in her heart for the Retired Officers' Wives organization, in which she served in every position except treasurer.

"I have had a wonderful life. I would not trade it for the world," Eve once said. She died February 11, 2009, and is buried with her husband at Arlington National Cemetery.

Mary Gafford

Virginia Moreira Moura

In the 1800s, many families from the Azores—an island group west of Portugal—immigrated to America to further their fortunes. Those who were fisherman settled mostly on the Atlantic Coast. Those who were farmers pushed west, often in search of gold and silver.

Many from the Azores settled in the farmlands of Pershing County. As a result, Lovelock, Nevada had a sizeable number of Portuguese immigrants. Among them were the parents of Virginia Moreira Moura.

Manuel Moreira came to Lovelock to establish a foothold, and then returned to the Azores to marry Maria Soares. In 1910, he and Maria moved to the Upper Valley—a rich farming area about two miles from Lovelock—where they became ranchers. Their daughter, Virginia, grew up here. It is where she contributed both her work and her volunteerism to benefit Lovelock and Pershing County.

Virginia, who was born in 1910, also married into a Portuguese farming family. In 1942 she wed Manual Moura, whose parents came from the same

**1910–1994
RANCHER, DEPUTY
COUNTY RECORDER AND
AUDITOR, COMMUNITY
VOLUNTEER**

spot in the Azores, Santa Maria, as her own parents. She had met Manuel when he came to work for her parents in the early 1920s.

The Mouras eventually took over Virginia's father's ranch, where they raised Herefords, a breed of beef cattle. They also grew alfalfa and grain.

Virginia and Manuel had one child, Tommy, who attended the small Fairview Elementary Schools in Upper Valley that his mother had attended. He, too, received his communion at St. John's Catholic Church, to which his mother devoted so much of her talent and energy.

In her early adulthood, she was historian of the Pershing County High School Alumni Club. She also worked with the local 4-H Club.

Virginia's day job was serving as deputy county recorder and auditor—and, later, as an employee of the Pershing County Water District. That was in addition to her roles as ranch wife and community volunteer.

Virginia also was very involved in the local Business and Professional Women's Club. Over time, she headed its legislation committee and

> *Because she was bilingual, the Pershing County Farm Bureau hired her to present the Portuguese version of its regular radio program.*

served as vice president as well as, in 1944, its president. She was a charter member of her Soroptimist Club and an active member of the Fraternal Order of Eagles Ladies Auxiliary, in which she served as inside guard, chaplain, secretary, and president.

Proud of her heritage, Virginia visited the Azores as a youngster with her parents. She also was secretary treasurer of a fraternal Portuguese organization, I.D.E.S., which stands for Irmandade do Divino Espirito Santo—in English, Brotherhood of the Divine Holy Spirit. Because she was bilingual, the Pershing County Farm Bureau hired her in 1932 to present the Portuguese version of its regular radio program, which was broadcast in four languages.

She also volunteered at the Fairview Community Center and at her local credit union, as a member of its supervisory committee.

Her church work remained a constant in her life. She was active in St. John's St. Agenes Altar Society, serving twice in the 1940s as its president. She also was part of the Children of Mary Sodality—a sodality being a Catholic organization for non-clergy. In 1958 she was president of the Bishop Keane Deaner, an organization that included parishes in Battle Mountain and Winnemucca.

For several decades the *Nevada State Journal* and the *Reno Evening Gazette* chronicled Virginia's willingness to open her parents' home—and later her own home—for organizations to hold meetings and social events.

According to the Reno newspapers, Virginia moved to San Jose, California in 1945, to be with her husband, who was temporarily farming there. She was back in the Upper Valley by the end of the year, soon rejoined by Manuel.

Over the years, she suffered setbacks that are typical for most people. In 1943, not long after she and Manuel married, he was badly hurt when a load of hay slipped its bindings. It hit him in the head, knocking out several teeth and causing other injuries. In 1944 she contracted double pneumonia, which led her to recuperate for a month in San Jose, where her parents often spent their winters.

Virginia Moreira Moura exemplifies the Nevada woman. An expert at multi-tasking, Virginia assisted her church and her community while upholding the honor of her ethnic group and her family. She died on March 30, 1994.

Fran Haraway

Leona Daoust Munk

The life of Leona Daoust Munk is chronicled in the pages of the *Reno Evening Gazette* and the *Nevada State Journal*. She was noted first for her social activities, then for her volunteerism, and finally, for her political involvement.

From her birth on October 18, 1911, in Tonopah, Nevada, Leona Daoust had direct connections to American history. Her grandfather, Samuel Charter Peek, stopped off in Illinois on his way west, where he worked for his uncle, John Deere. Then he settled in Calaveras County, California at the same time that an unsuccessful pocket miner named Samuel Clemens—better known as author Mark Twain—was developing a profound interest in the area's jumping frogs.

In 1930s, Leona often appeared in print as a guest at dances, card parties—she was a member of the What Not Card Club—picnics, holiday gatherings, and functions of the Garden City Rebekahs and Professional Women's Club. Another frequent name on those guest lists was Robert Munk.

In January 1932, Leona helped Robert plan a surprise party for his sister. Eight months later, the

**1911–2003
FOUNDER, LEADER OF
CIVIC GROUPS, POLITICAL
PARTY ACTIVIST**

following article appeared in the November 7, 1932 *Evening Gazette*:

"Robert Munk, youngest son of Mr. and Mrs. Chris Munk, was married on Saturday to Miss Leona Daoust at the parsonage of Grace Methodist Episcopal Church. … Mrs. Munk is the youngest Daughter of Mr. and Mrs. W.L. Daoust of Lovelock and was educated in the Stockton schools. She has been engaged as a clerk in the Lovelock post office for three years. The bridgroom was born in the Big Meadows District of the Lovelock Valley, and is a graduate of the Pershing high school. He has followed mining at Tungsten since graduation and later become connected with the Western Utilities Power Company at Winnemucca."

Leona's in-laws Niels Christian and Ellen Olson Munk—both from Denmark—were part of the Lovelock farming community. Robert Munk continued the farming tradition by co-founding Munk Brothers Ranching and Trucking, a company that the *Evening Gazette* described as a "farm contracting and hauling firm." Leona became the company bookkeeper. Later she

146

also went into partnership with Kathryn Landa in Kay Lee's Drive In.

After her wedding, Leona remained socially active. In 1933 she was still involved in Rainbow Girls, Beta Sigma Phi, American Legion, and 4-H Club events. Then, on September 16, 1933, Leona and Robert accepted another responsibility. "Mr. and Mrs. Robert Munk of Winnemucca are the parents of a son born at the Lovelock hospital," the *Evening Gazette* announced. "He will be called Ronald Robert Munk." Their family was complete when a daughter, Deanne, also joined them.

Having children and a family business did now slow Leona down. Throughout the 1940s she was active in her sorority and, in 1950, she co-founded the Lovelock Girl Scouts, with her daughter as a founding member. In the 1950s Leona became a mother advisor to the Rainbow Girls, with Deanne as a worthy advisor. Leona also served as a Parent-Teacher Association program chair.

But her service didn't stop with organizations related to her children. She also was in charge of Shriner Hospital activities for Eastern Star, and helped found the Lovelock Soroptimists Club.

But Leona's life was rocked by tragedy. On November 9, 1959, the *Evening Gazette* reported, "On Friday night, two Lovelock men, J.W. Fundis and Bob Munk, were killed when their pickup collided with a huge semi trailer on U.S. 40 west of Winnemucca."

Robert's death ushered a new era for Leona. She entered politics. In 1960, she was named an attaché to the Nevada State Legislature, a position she held for several years. Her job was to help

She was noted first for her social activities, then for her volunteerism, and finally, for her political involvement.

organize and process bills that came before the body. That same year, she also served as an assistant secretary in the Nevada Senate, and was elected a delegate to the Republican National Convention held that summer in Chicago. She was Pershing County's first delegate in more than thirty years.

In 1962 Leona was vice chair for women of the Pershing County Republican Party. She was still serving as an assistant secretary to the state senate, and a legislative attaché.

In 1966, the *Nevada State Journal* announced the next step in Leona's evolution: "Leona Munk filed for the state Assembly for the newly created legislative district comprising Eureka, Lander and Pershing counties."

The article also included her statement on why she was filing. "I like politics," she told the reporter. "The exposure (through her legislative jobs) has taken." She affirmed her desire to aid her state, "with special emphasis on my counties."

Although Leona lost the election to a long-time legislator, William Swackhammer, she was not finished with public service. In 1967 she was appointed to the Columbia Basin Interstate Compact Commission. And in 1972 she became the first woman to serve on the Pershing County Draft Board.

During the 1960s, Leona also kept busy as president and director of the Pink Ladies at the Pershing County Hospital, and as a president of the Soroptimists Club.

Leona Munk died on Valentine's Day 2003, at age ninety-one after a life of service.

Fran Haraway

147

Colanthe Florence Jones Murphy

**1911–2006
PILOT, AIRLINE
MANAGER, AIRPORT
CO-FOUNDER AND
OPERATOR**

Florence Jones Murphy was the first woman in America to establish, co-own, and operate a commercial airport. Her facility evolved into the present North Las Vegas Airport.

A Native American, Florence also helped run the first Las Vegas-based commercial airline. In her honor, a Las Vegas street bears her name: Colanthe Avenue, near the intersection of Rancho Drive and Oakey Boulevard.

Florence was born Colanthe Jones on December 13, 1911, in Fernley, Nevada, to Benjamin F. and Lola Blair Jones. Her father worked for the Southern Pacific Railroad, but he moved the family to Winnemucca, where Florence—who took the nickname from a favorite aunt—was one of seven children. Determined to do anything her five brothers did, Florence started taking chances early in life.

After attending the University of Nevada in Reno for two years, she married John M. Murphy, a Nevada State Highway Department engineer. Six years later, in 1936, they moved to Las Vegas where John was a division engineer for the department, and Florence became a legal secretary.

The same year, Florence rode in a Piper Cub small aircraft, and the rest is history. "One of my favorite things to do, once I became a proficient pilot," she told an interviewer, "was to fly out at dawn over Sunrise Mountain and go back and forth across it, looking out at the panorama. It looked like a great big Indian blanket, … and as the sun moved, the colors would become more subdued or more brilliant."

By 1938 both Florence and John had their pilot licenses, and were flying out of what was then called McCarran Field, but is now Nellis Air Force Base. When the U.S. Army took over the airfield in 1941, it left the Murphys without a landing spot. So they and a friend, Bud Barrett, bought two hundred acres off the old Tonopah Highway (now Rancho Drive) With borrowed highway equipment, they created two runways. They added a bit of landscaping, bathrooms,

and reassembled a used hangar—and Sky Haven Airport was born.

For Sky Haven's grand opening, they held contests, entertainment, and air stunts. About one hundred and fifty airplanes flew in. A crowd of spectators from Nevada and California also showed up. The celebration was going fine until an Army pilot came and halted it. The grand opening date was December 7, 1941, and the Japanese attack on Pearl Harbor caused the government to ground all civilian aircraft. It took a couple of weeks for the out-of-towners to get home. The small field was popular in the late 1940s, and one of its regular patrons was Howard Hughes.

In 1945 Florence went to work for a friend, June Simon, who with Charlie Keen and Ed Converse owned a small commercial air service called Bonanza Air. Florence ordered supplies, licensed the lanes, did scheduling, and managed the maintenance department. Bonanza Air started out with two Cessna twin-engine places seating five passengers each. Then it expanded by buying surplus C-47's, and ended up with a fleet of nine craft.

By that time Florence was vice president of the airline—the only woman in the nation at that time to hold such a position—but she also managed personnel and labor relations. In addition she sometimes piloted the Bonanza Air's scheduled Reno run. Several years, and many changes later, Bonanza Air was bought by Hughes, who promptly renamed it Hughes Air West.

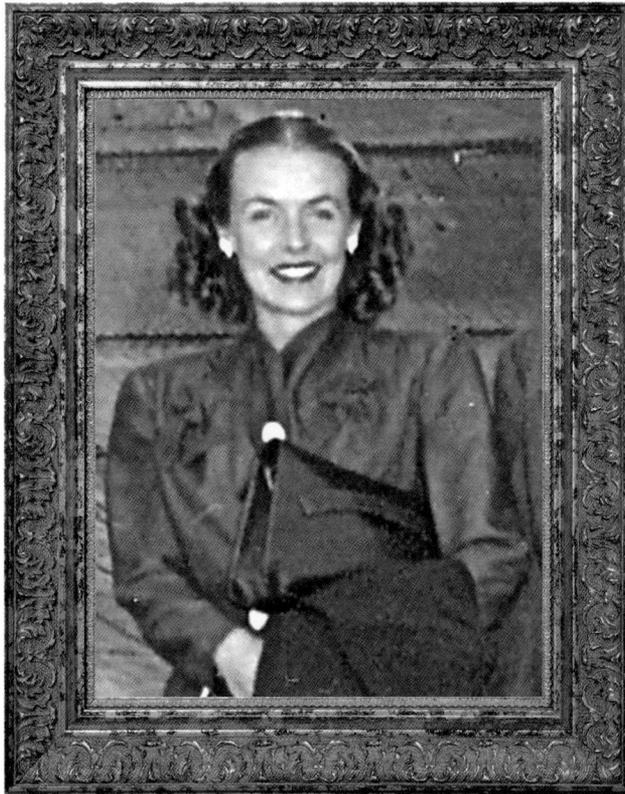

In 1958 Florence reinvented herself by leaving aviation and entering real estate. But she never forgot her flying days. One of her most precious possession dating from that time was a drawing by her then nine-year-old daughter, Margaret. It depicted Ed Converse, who was labeled as "the man with the money" and Florence, labeled "the lady with the brains."

In 1960, John died, but Florence and her friend, Larry McNeal, continued to run Murphy McNeal Realty. At one point he was naming streets near new developments and wanted to name one after her. She agreed, on the condition that he use Colanthe, her first name. He also named a street after himself, using his middle name. Thus Colanthe and Gilmary avenues were created, running side by side.

In an article about Florence, *Las Vegas Sun* reporter Ed Koch quoted a spokesman for the Howard W. Cannon Aviation Museum, which is located at McCarran International Airport. According to Mark Hall-Patton, "Florence was a pioneer in so many areas of aviation. She broke down so many barriers for women."

Florence died on January 27, 2006. Her granddaughter Darcy Wellington described her as "a woman ahead of her time, a trailblazer." Florence's obituary, written by a relative, called her "truly, The Lady With The Brains."

Fran Haraway

Dr. Rena Magno Nora

Psychiatrist Rena Nora did it all. She was an outstanding medical doctor, researcher, author, community leader, and champion of Las Vegans in crisis as well as Las Vegas Filipinos in general.

Rena's area of interest and expertise was veteran affairs. Having served in the U.S. Army Medical Corps, in which she attained the rank of colonel, she was chief of psychiatry services in the Veterans Administration's health care system, with offices in Lyons, New Jersey and Las Vegas. She researched and wrote about veterans' post-traumatic stress disorder and related issues of suicide and gambling.

Another focus of her work was gambling addictions. She was medical director of the VA's local Intensive Outpatient Program for Problem Gamblers, was co-chair of the National Certification Board for Gambling Counselors and a medical advisor to the Nevada Council on Problem Gambling. Nevada Governor Kenny Guinn appointed her to serve on the Nevada Advisory Board on Problem Gambling.

For her pioneering work with problem gamblers and their families, she received in 2005 the Herman Goldman Award for Lifetime Achievement. It is the National Council on Problem Gambling's highest honor, and rarely given because the qualifications of earning it are so stringent. Posthumously, in 2009, she received the Foundation for Recovery's Robert Rehmar additional Professional Award, which is named for the group's founder.

Rena did not limit her expertise and care to veterans. She was appointed to the Governor's Commission on Mental Health and Developmental Services. She also served on the state Board of Examiners for Alcohol, Drug and Gambling Counselors.

She was born to the Magno family in Kalibo, Aklan, in the Philippines on March 9, 1940. On March 19, 1940, she received her high school

1940–2008
PHYSICIAN, RESEARCHER, PROFESSOR

> *Having flourished in two cultures, she became interested in "trans-cultural" psychiatry, which studies the effect of culture on mental illness.*

diploma in 1956 from La Consolacion College in Manila, which includes a high school. She earned her medical degree from the University of Santo Tomas, the Catholic University of the Philippines. She did her psychiatric residency in Paramus, New Jersey, at the Bergen Pines County Hospital, and at Columbia University's Psychiatric Institute in New York City.

The psychiatrist, herself having flourished in two cultures, became interested later in her career in "trans-cultural" psychiatry, which studies the effects of culture on mental illness. She also wrote articles on the topic. Rena was a board-certified psychiatrist and a Distinguished Fellow of the American Psychiatric Association. She also was a clinical professor of psychiatry at the University of Nevada School of Medicine, and also at the Robert Wood Johnson Medical School in New Jersey.

Rena also joined and worked in Filipino-American organizations. In 1999 she received the Banaag Award for her contributions to medicine in Las Vegas. The award goes to Filipinos who advance the standing of Filipino communities outside the Philippines. That same year she received an Outstanding Community Service Award from the Asian Chamber of Commerce.

Not only was she an outstanding medical professional and humanitarian, Rena was a wife and mother. She was married to radiologist Demetrio T. Nora, who was born in the Philippine province of Batangas, who also worked in the VA health care system. He died on October 27, 2008, eleven days before his wife's death on November 8, 2008.

The couple had three children: Yvette Nora Whitley, a director at Elsevier, a publisher of science and health information; Cheryl Nora Moss, a district court judge in Las Vegas; and Dean T. Nora, a California oncologist and surgeon.

Rena Nora's military funeral included a twenty-one-gun salute and presentation of a memorial American flag. Balita.com, a web site devoted to the Filipino-American lifestyle, praised Rena not only for her medical career, but also for her "passion to serve others based on her belief in the beauty and dignity of the human spirit."

Fran Haraway

D'Vorre "Dee" Ober

D'Vorre Ober was a wife, mother of five, teacher, artist, and practicing member of Southern Nevada's Jewish community. D'Vorre acted on the basis that each child needs to understand his or her special talents. Her interest in and contributions on behalf of special-needs children began at home, after one of her son's eyesight was damaged at birth by improper administration of oxygen.

There's no greater tribute to D'Vorre than the fact that her son who has impaired vision is now a successful attorney with a supportive wife and family, despite his legal blindness. But D'Vorre did not limit her insights and dedication to her immediate family. She changed countless lives by encouraging the ambitions of others through her education, art, and deep religious faith. She also designed the Clark County School District's first special-education program.

One might assume that a woman so effective in a wide range of endeavors would have had an exceptional mother. But this was not the case with D'Vorre, whose mother died quite young. D'Vorre's teachers and religious leaders helped guide her from youth into adulthood.

1932–2008
TEACHER, ADVOCATE FOR STUDENTS WITH DISABILITIES

D'Vorre was born on February 17, 1932, in Pittsburgh, Pennsylvania, and attended the Pennsylvania College for Women in Chatham, Pennsylvania. She wed Harold "Hal" Ober, to whom she was married for fifty-five years.

She earned her bachelor's degree in education from the University of Arizona, while raising the children. Then she earned her master's degree in special education from the University of Arizona, while teaching at the Arizona State School for the Deaf and Blind in Tucson. The university's graduate program in education was one of the few at the time that emphasized curriculum for students who are intellectually or physically challenged.

When the Obers arrived in Las Vegas, the boomtown was "running to keep up" with the basic education needs of its mainstream students. It had virtually no official programs for students with learning difficulties. These students were placed in the mainstream, to sink or swim as best they could. Most classroom teachers at the time had little training or curriculum for learners with special challenges.

D'Vorre joined the Clark County School District as a teacher in 1977. She did not accept

She changed countless lives by encouraging the ambitions of others through her education, art, and deep religious faith.

this profund neglect of special-needs students.

As a parent and teacher, D'Vorre began informing leaders of the necessity of serving all young people, whatever their abilities. Her view included the notion that special-needs programs have long-term benefits beyond the benefit to the special-needs student and his or her family. Such educational programs also enhance the attractiveness and reputation of Nevada, which is important when drawing the businesses that are essential for the state's economic development and prosperity.

In 1980, she asked the state legislature to fund the state's first program for infants and preschoolers with vision impairments. For her advocacy, D'Vorre was charged with developing guidelines for the Clark County School District, and serving as the program's teacher.

Her husband, Hal, also assisted the district. With his background in construction and land management as a developer of residential projects such as Desert Shores, he scouted the Las Vegas Valley for sites to locate new schools, in response to the district's rapid growth in the 1980s. He helped lead the district's campaign to encourage voters to support the bonds that paid for the new schools.

Eventually, the district recognized the Obers' talents and efforts by naming a new elementary school in the affluent Summerlin area after them. Their son, Scott Ober, served as the first principal when the school opened in 2000, and set the tone for its reputation as a welcoming and well-managed school.

After retiring from the school district Scott Ober went on to head the Solomon Schechter Day School, a private school developed by the Las Vegas Jewish community in conjunction with Temple Beth Sholom. Both D'Vorre and Hal Elementary School and the Schechter Day School stand at the edge of the scenic Red Rock hills to the west of Las Vegas.

But education is not the only arena in which D'Vorre's influence lives on. Her artwork is on permanent display. Her sculpture of a young girl, whichs stands at the entrance to Ober Elementary, first took shape in clay in the Obers' kitchen, and then was carefully transported for its casting in bronze. Some Ober pupils like to rub their hand across the sculpture's head, for "help in learning my lessons," as one pupil once put it.

Another example of D'Vorre's artistic influence greets visitors to Las Vegas, daily. Wall tiles at McCarran International Airport's D gates, depicting famous cities, came from art created by Ober Elementary students in a project to which D'Vorre volunteered her time.

D'Vorre, who was preceded in death by Hal, died on May 20, 2008. She left behind five children, fourteen grandchildren and one great-grandson.

Donna B. Gavac

Anna Nuhfer Parks

When twenty-two year-old Anna Parks and her husband stepped from the train at the new depot in Las Vegas, it was 1911 and the town was just six years old. The sand that swirled around her ankles was a new sensation, as she had been born and raised in Pennsylvania. But she had just spent several years in California, where she had met and married William Roberts, who was three decades older than she.

Of Pennsylvania Dutch descent, Anna Nuhfer was born on July 2, 1898, on a farm near Venus, Pennsylvania. The seventh of eleven children, she was her father's favorite. She once proudly recalled that one summer she kept the books for her father's farm, for which he had paid her ten cents.

In 1909 Anna traveled to California, where she stayed with two of her sisters and their husbands. She got a job at a boarding house, where William swept her off her feet. He was fifty-five, but was good-looking and very charming, energetic and a hard worker. They made plans to move to Las

1899–1962
MINE OWNER, STORE
OWNER, MORTICIAN,
MUSEUM FOUNDER

Vegas to follow his dream of opening a store in the boomtown.

So in 1911, Anna and William opened the People's Store at 128 Fremont Street. The store was stocked with textiles sold by the yard, trinkets, toys, women's clothing and baskets made by Indians. In addition to the store, the couple, not yet married, had a share of a limestone-mining claim at Sloan, Nevada.

Anna helped raise funds for the claim by traveling by train back to Pennsylvania, where she sold stock in the claim to her relatives. She returned with about $64,000, which was more than 90 percent of the capital for a new company, the Nevada Lime and Rock Company. In June 1914, the two finally married, after three years as business partners.

In the winter of 1914, a scandal rocked the small city. A dead baby's body was found in the desert. The man who had taken care of the remains from an infant death was charged with improper disposition of remains. The public was outraged and a trial was held. However, the man's lawyers made good arguments, which resulted in

154

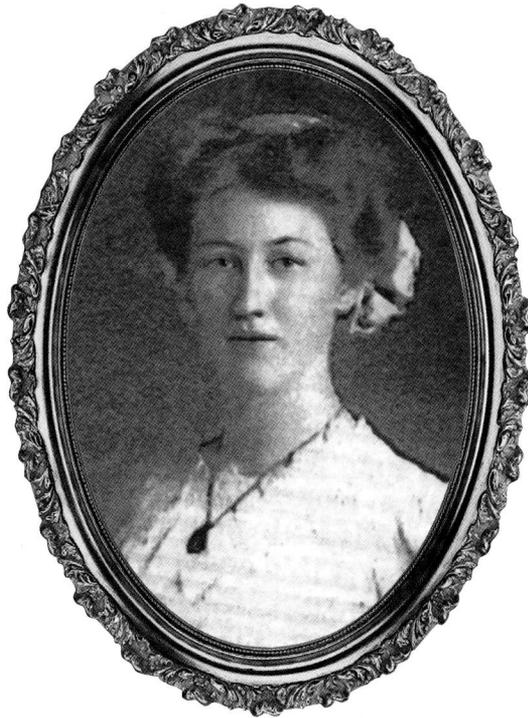

the charges being dropped, and the man's swift but quiet departure from Las Vegas.

William, who had been a mortician for ten years near Fresno, California, seized the business opportunity and opened the Las Vegas Undertaking Company. It served not only those who died in Las Vegas, but also the deceased from mining camps in Searchlight, Eldorado Canyon, Sloan, and Goodsprings. Anna accompanied William on these morbid trips to collect bodies, and began to learn the trade of embalming.

In August 1920, Anna gave birth to a baby girl they named Edith. Against her husband's wishes she then gathered her baby and widowed mom to travel to Los Angeles, where she enrolled in mortuary school. The only female student in the class, she passed her exam and in 1925 had her mortician's license.

When she returned to Las Vegas, she found her husband living with another woman. After their divorce was final in 1926, Roberts left town. Anna stayed in the mortuary business, and opened her Palm Funeral Home in 1927 at the corner of First Street and Carson Avenue. In 1928 she married S. Gene Parks, who worked for her at the business.

During the years of the Depression, she kept meticulous records of the men who died in the construction of Hoover Dam, whose remains she handled. She also provided occasional food and shelter to the unemployed who flocked to Southern Nevada for jobs on the dam. She often provided them with employment.

Although Anna defined what the true pioneer spirit embodies, she is not often written of in Las Vegas history books. That is largely due to her gender. But she started businesses with partners, and then on her own built up Palm Mortuary business in several locations.

She also gave Las Vegas its first museum in the 1940s, when she opened her own small museum venue. Later, Anna's daughter gave the collection—of baskets, rocks, fossils, and other artifacts—to the Henderson Chamber of Commerce. Anna's collection was the core of the present collection of the Clark County Museum on Boulder Highway.

Anna Nuhfer Roberts Parks died in 1962 at the age of seventy-three in an automobile accident. Her life was cut short by the wheels of progress.

Joan LeMere

Edna Burke Patterson

A surprise snowstorm that blew into New York City was not the only force of nature to touch down on May 18, 1907. That day, Edna Burke Patterson was born in Salina, Kansas, to Effie Craig and Charles Howard Burke. Unlike the freak storm, Edna exerted influence on her patch of earth for more than ninety years.

Edna went on to lay strong roots in Elko County, Nevada, where she became a teacher, rancher, prolific author, recorder of local history, and political activist. She helped lead the Nevada Republican Party and the Nevada State Board of Education. She also cofounded a museum.

When Edna was three years old, she contracted polio. It paralyzed her right arm, but the handicap never impeded her. "If I could, I preferred to do it myself," she once said. But when she needed help, she was not averse to asking.

The Burkes relocated to Colorado, where Edna graduated from South Denver High School with a four-year scholarship to a teachers college in Greeley. Doubting her career choice, she left after two years. To see if the profession suited her, she applied to teach in Lamoille, Nevada. John Malcolm Patterson, a young rancher who was the school board clerk, hired her.

According to Edna, "John and I had a liking for each other from the start." After she taught a year

1907–2002
RANCHER, TEACHER, AUTHOR, MEMBER OF STATE BOARD OF EDUCATION

in a two-teacher schoolhouse, she and John married. They were together for fifty-four years until John's death in 1982.

Edna's unpublished autobiography describes her early ranch work as tough and physical. The couple lived with their two children—Marilyn and John—and John's father, Webster, in a six-room building moved to the ranch from a military base. The old building lacked plumbing and central heating.

Undeterred, Edna daily hauled water in buckets from a well, and used coal oil lamps for lighting. The Great Depression made ranch life harsh. "It was a skimpy living," Edna later said, but "we survived."

She found time to join the Lamoille Women's Homemakers Club, serving several terms as president. She helped lead a successful drive to acquire a permanent clubhouse.

In 1941 she and John rented an apartment in Elko, where their son attended high school. With some extra time, she went to the courthouse, read newspapers, and interviewed the older inhabitants. Four years later she was back in Lamoille, "feeling a responsibility," she once said, to do something with the interesting material she had gathered. Her first book was *Who Named It*, a place-name study.

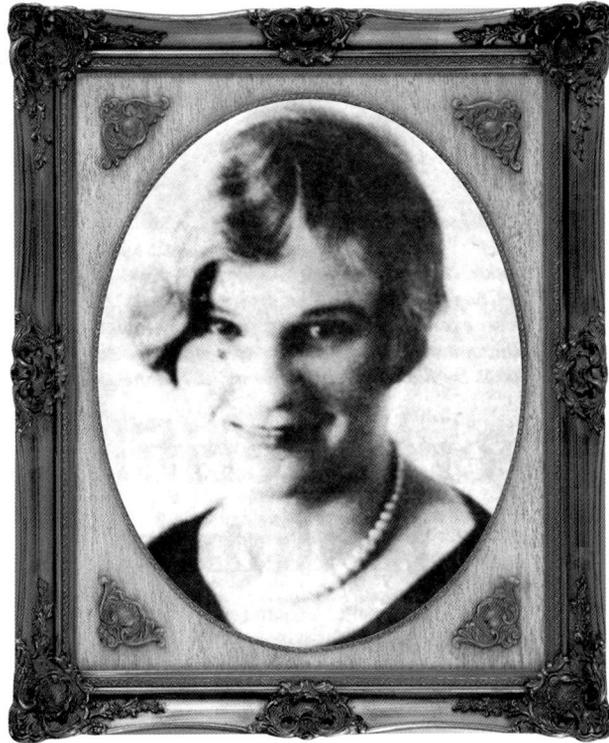

Her next book, *Nevada's Northeast Frontier*, is a sweeping history, coauthored with Louise Ulph Beebe and Victor Goodwin. Many books and papers followed, on Native American tribal cultures and the history of Northeastern Nevada. Her books are in many university libraries. A tape recording and transcript of her life story, "Women of the West," is archived in a women's oral history project at Washington State University.

Edna also grew interested in politics, and participated on the Republican Party's State Central Committee. Republican Governor Charles Russell appointed her to the State Board of Education, and she became its first woman president. She delivered what she considered one of the best speeches of her life to help thwart a plan by the next governor, Grant Sawyer, to merge the state's education department with its department of health and welfare. According to Edna, Sawyer was furious when his bill failed. She believed that her opposition to his plan contributed to her defeat in the next board of education election.

In 1957, Edna and two doctors—Tom Gallagher and a Dr. Morris—established the Northeastern Nevada Historical Society. After hard work to raise funds, their project came to fruition with a generous donation from the Fleischman Foundation. The museum was built in Elko in 1992, and has gained national accreditation. Edna served eleven years on its board, until 1986. After she retired, the museum named her a trustee emeritus.

Edna developed enduring friendships with the Western Shoshone and Northern Paiute women who had worked on the ranch, and desired to advance education for under-served minorities. With the help of the Lamoille Women's Club, Edna organized a Council for Promotion of Indian Education in Northeastern Nevada, which provided scholarships to deserving high school students.

Edna remained active in state and community affairs until the end of her life. In a 1990 interview with an Elko newspaper reporter, she confided that, along with securing a clubhouse for the women's group and founding the museum, her greatest achievement was, "the books I have written—for they not only serve the present generation, but leave a heritage to those who follow me."

Edna, who lived to be ninety-four, died on April 6, 2002, in Denver, Colorado, where she had moved to be near her son. "What a Beautiful Life I Have Had," is how her autobiography concludes. "The Lord had his arms around me the day I came to Elko County in 1928."

Yvonne Kelly

Minnie A. Peters

Born in Kansas in 1871, Minnie A. Peters and her husband Benjamin Peters, a mining engineer, were living by 1917 at the Rand Mine in Southern Nevada's Eldorado Canyon. At every mining camp they settled in, Minnie made sure each bachelor miner had a hot meal—and nursing care if he became ill. She was the equivalent of a social worker for the miners, who lived in out of the way places with no doctors or nurses.

From about 1925 to 1929, the Peters family lived in Searchlight, Nevada, in a home they had bought from Dr. Allen L. Haenszel and his wife, Arda. C. Haenszel, who were moving away. The house had a corrugated roof and a wood-frame body sheathed on all sides with asbestos that made it fireproof and also provided wonderful insulation from the heat of summer and cold of winter.

Minnie—who also went by "Petie"—would organize the local ladies wherever she and Ben lived.

So in Searchlight, Minnie gathered the ladies, including Fran Colton Roller—whose first husband George Colton was credited with naming Searchlight—to hold card parties and baby showers, and prepare hot meals for old "batches," meaning single miners.

The Peters family lived near the Cashmans—Jim Cashman Sr. had an auto dealership in Searchlight—and the Gusewells, whose homes were larger than most in Searchlight. Here Petie became a schoolteacher, and taught eight grades—and one four-year-old girl.

I, Donna Harvey, was that four-year-old. Another student was Bill Nellis, who became a soldier, died in World War II, and was honored when Nellis Air Force Base took his name.

Petie wore her hair marcelled, with never a hair out of place. She wore dresses, hosiery, and shoes with practical heels. She taught courtesy and fairness along with the ABCs.

Each month, for example, Petie issued the students a pencil. When she gave a yellow pencil to the four-year-old, the girl broke it in two because she had wanted a red one. Without a word, the teacher sharpened the short halves, and made the child use those stubs the entire month.

1871—UNKNOWN
TEACHER, COMMUNITY
ACTIVIST

Petie also taught poetry, made good books available, and produced student performances and plays for the town. At recess she played "Dare Base" and "Run Sheep, Run" with her pupils. She also organized picnics.

Petie was a crack shot with a rifle. She once shot a diamondback rattler directly in its triangular head when it threatened a group of people visiting the nearby M & M Mine. She hunted rabbits and quail for her dinner table, but loved her family pets.

Young Arda M. Haenszel, daughter of the family that sold their Searchlight house to the couple, described Petie as "crusty" and "abrupt." Petie was that, but beneath the crust beat a heart of gold. Indian Mary, an aged local dweller, was one of many recipients of Petie's kindness. Whenever Mary dropped out of sight for an extended period, Petie looked her up to provide food, supplies, or nursing.

After teaching in Searchlight, Petie taught for a while in Nipton, California. Then Ben died and Petie moved to Boulder City. At age ninety in 1960, she drove twice to Nelson, Nevada, to visit her friend Bertha Gresh. In 1961 Petie received her seventy-year pin from the Rebekah Lodge.

Minnie A. Peters—who signed everything, including reports, as "MAP"—never lost her sharp wit, though she lived to be almost 100. She lived alone, did her own housework, and taught her parakeet to play cards. She was truly a unique Nevada woman. Her death date is unknown.

Donna Jo Harvey Andress

Anabelle Plunkett

History shows that talented women pave the way whenever they enter a professional field that has traditionally been male. Southern Nevadan Annabelle Plunkett—along with Lorraine Painter and Sue Morris—serve as examples of policewomen who overcame obstacles to be respected as equal partners in law enforcement.

Early obstacles in Southern Nevada included women's ineligibility for certain types of police work and lower pay.

Mystery and controversy surround the identity of the first woman police officer in Southern Nevada. Several women who worked for the Las Vegas Police Department in the mid-1940s each said she was the first officer, and all had a measure of proof to substantiate their claims. But all have died, and the interviews they granted to newspaper reporters do not tell enough to determine the first female officer.

The Las Vegas Metropolitan Police Department's web site cites Annabelle Plunkett as the first career policewoman in Las Vegas. She was hired later than Lorraine, but Lorraine may have been ignored because of her brief time with the department. The present Metro Police structure was created on July 1, 1973 with the merger of two separate agencies, the Clark County Sheriff's Office and the Las Vegas Police Department.

World War II brought non-traditional job opportunities to women because there was a shortage of men. Previously women were limited to support duties in police work. Annabelle, Lorraine, and Sue managed to break the glass ceiling with their feistiness and willingness to work hard. They were hired as police clerks and secretaries, but as times changed, the lines between job descriptions grew blurred.

Lorraine was hired as a clerk by the Las Vegas Police Department on November 14, 1944, to replace Sue Morris, who also claimed to be the department's first policewoman. Lorraine was issued a badge and a gun, and said that as of March 10, she started receiving a patrolman's wage of $150 per month. A graduate of Las Vegas High School, she completed an FBI training course on March 6, 1945, but never received formal police training. Lorraine resigned less than two years later to be a secretary at a law firm.

Annabelle was hired as a clerk to take Lorraine Painter's place in 1945. Born in 1925 in Elko, Nevada, Annabelle and her family moved to Las Vegas in 1935. She was twenty when she took

1925—1989
POLICE CLERK, POLICE OFFICER

the job with the police. Soon she was promoted from clerk, with some law enforcement duties, to personal secretary to Deputy Police Chief Robert Malburg.

In January 1948, Annabelle was appointed to a fulltime police officer position, but also continued as secretary to Malburg, who became police chief in 1949 after the death of Chief Luther Horner.

Annabelle did not receive formal police training until 1955, but before then she was first on the scene of many serious incidents, including Chief Horner's suicide in his home, on December 11, 1949. Horner had been complaining of extreme job pressures.

Officer Plunkett was described as possessing firearm skill, a nasty right cross, and a cool head. She remained on the force for twenty-six years, retiring in 1973.

The *Las Vegas Sun* published an interview with Annabelle on September 26, 1971. At that time she said she had two children, but the article gave no other details about her marriage or family life. The *Sun* reported that she started out as a part-time officer, and then began full duties in 1955, when

the department's juvenile division was established. At that time, female officers could work only in communications or the juvenile division. Women officers were not assigned patrol duty on the streets until 1971.

Annabelle complained that the system did not encourage women officers to advance. In her era, only male officers could take the exams that led to promotion to higher ranks. However in 1968 the Breakfast Exchange Club of Las Vegas named her Police Officer of the Year for her "striving for the betterment of all police officers."

Annabelle died in Nevada on July 27, 1989, at age sixty-three. After retirement, she became virtually invisible to the public. Her family information still remains unavailable.

Norma Jean Harris Price

Bertha Jane Mattson Purdy

The stalwart wife of a Southern Pacific Railroad man, Bertha Jane Mattson Purdy accompanied her husband in all his transfers in Utah and Nevada. She was active in church circles, but also contributed in education and civic affairs.

Bertha was born February 18, 1884, in West Weber, Utah, in her maternal grandmother's log cabin home. Her parents, Peter and Margaret Mattson, lived on a sixty-five-acre farm in a two-room house. Bertha and her siblings enjoyed playing with the baby farm animals.

Because her mother was in poor health between 1888 and 1894, Bertha lived much of the time with her Grandmother Mattson.

When Bertha was thirteen, their mother died giving birth to Margaret. Her father moved with his five children to Ogden, Utah, where Bertha graduated from the eighth grade in June 1898. She attended Ogden High School one year. Then in 1900 she went to Logan, Utah, to take a business course at Brigham Young College, which Young had founded in 1877. Bertha studied two years, and then transferred her credits to the agricultural college in Logan.

But the failure of her father's sheep business caused him to call Bertha home, to keep house. She also taught Sunday school.

At a mission farewell dance held by the Church of Jesus Christ of Latter-day Saints in 1904, Bertha met Oliver George "O.G." Purdy. They were married at the Salt Lake City temple on June 28, 1905. One month after their wedding, the Southern Pacific Railroad sent O.G. to Imlay, Nevada.

In November 1908 the rest of the family moved to Ogden, Utah, to take care of O.G.'s mother. Then in 1909, Bertha and the family moved to Imlay to join O.G. The Purdys had five children: Norman (born 1906) Margaret (1908), Paul (1911), Harlon (1913), and Donald (1917).

Bertha learned to act with authority when O.G. was away. When the two were having a new home built in Sparks, Nevada, Bertha learned it would be possible to purchase half of the lot next door, too. Since O.G. was out on a railroad run, Bertha made the decision to buy the

1884–1968
CHURCH LEADER, CIVIC GROUP MEMBER

land and widen the home by several feet. In 1916, the Purdys moved into the home with only a blanket over the front doorway. She lived in that home until her death.

At church Bertha served as president of the Young Women's Organization, which had been started by church founder Joseph Smith in February 1843. The group's motto is "stand for truth and righteousness." Bertha also taught Sunday school for twenty-five years.

Bertha also participated in the local parent-teacher association, or PTA, at school. In 1926 she helped start the Jack's Carnival, which became an annual school fundraiser. She also served as president of the Sparks PTA Council, which included all Sparks schools.

Bertha was the first woman to serve on a grand jury in Washoe County. In the Nevada Federation of Women's Clubs, she held offices including state president from 1937 to 1940. She traveled to its national conventions. At one, Eleanor Roosevelt singled Bertha out to learn more about Reno, as one of Eleanor's children had lived there six weeks to obtain a Nevada divorce.

In 1941, Bertha became the first president of her church's Reno Stake Relief Society. When the society elected her, she was out of town at a convention. People didn't make many long-distance phone calls, so Bertha didn't learn the news till she returned home.

Bertha entertained many dignitaries in their home, including judges, the mayor, superintendent

Bertha was appointed inspector of elections for a Sparks precinct, and voting took place in the Purdy parlor.

of schools, and Heber J. Grant, who was a president of the LDS church.

Bertha also was active in the Brotherhood of Locomotive Engineers. The Purdys were instrumental in developing the lodge's Engineer Hall at Ninth and C streets in Sparks. The brotherhood advocated for railroad widows and orphans; it also strived for better work conditions, insurance, and pensions.

At the seventieth anniversary of the Engineers Auxiliary, Bertha received a forty-year pin from Emily Denny of Atlanta, Georgia who was grand president of the international organization. A Reno newspaper reported, "Mrs. O.G. Purdy was truly the grand lady of the lodge."

Bertha was appointed inspector of elections by the Washoe Board of County Commissioners for Sparks Election Precinct 5. Voting took place in the Purdy home at 916 F Street, where carpets in the front room and parlor were rolled up to make way for the voting equipment.

Three of the Purdys' sons served in World War II—Harlon, Norman, and Don, the youngest. Don was serving in an Army Air Corps training mission when his B-25 was lost at sea. He was listed as missing in action on March 26, 1943. His gold star hung for many years in the family's home.

Bertha served in the American Legion Auxiliary, the USO, and on the board of the American Red Cross. O.G., who also had served on the Sparks school board, preceded her in death on October 28, 1950. Bertha died on January 13, 1968, just short of her eighty-fourth birthday.

Carma Baker Watts, granddaughter of Bertha Jane Mattson Purdy

Bertha Berry Ragland

Eight-year-old Bertha Berry rearranged her dollhouse furniture once again. She stepped back and looked it over. Perhaps she thought, "Well, that will do for now."

Fast forward twenty years, and Bertha Berry Beggs Ragland has become a retailer. Her Bertha's Gifts and Home Furnishings served Southern Nevada shoppers for half a century.

Bertha was born on March 19, 1911, in Chino, California, to Clark and Jessie Berry. She had planned to study art after high school, but along came the Depression. It forced her, and many in her generation, immediately into the workforce. The days were dark, so everyone in a family pitched in to help.

Bertha took a position with a department store in San Bernardino, California, which began her lifelong career in merchandising. At the store she was a sponge, absorbing knowledge about how to display and sell china, jewelry, and furniture. It was the best education for her future role in Las Vegas.

"My family was very much against me coming out here, and my friends thought I lost a marble or two,' Bertha said in a May 22, 1989, *Las Vegas Sun* story. "I came here with a steamer trunk, a borrowed coat, and sixty dollars in my pocket." She arrived in Las Vegas in 1943, and for four years managed the N.W. Davis Merchandise Mart on Fremont Street. In 1947 she opened her first Bertha's location at 126 South Fourth Street, on an initial investment of $26,000.

Six years later, she moved the shop to Fifth Street, which today is Las Vegas Boulevard. Then in 1953 she began a bridal registry, a service that had not been available in Las Vegas. It was well received and utilized.

In 1963, the store moved near Maryland Parkway to a 19,000-square-foot facility at 896 San Francisco Street, which is now known as Sahara Avenue. Bertha worked long days—sometimes ten to fifteen hours a day—building her business with her husband at the time, Jack Beggs. "There really wasn't anyone selling the better lines of that type of merchandise," she later recalled. "There was a need among local people who wanted to purchase fine, quality items."

In the 1980s, Bertha's employed about thirty-five people, and had expanded to 35,000 square feet. Its annual gross sales were between three and four million dollars. Bertha remarried, to George Ragland, who died in 2002.

With Bertha, the customer came first. Many Las Vegans remember meeting the ever-gracious Bertha when they shopped there. She received

1911–2005
Store Founder and Operator

the 1985 Golden Apple Award, which goes to the merchant of the year, from the Southern Nevada Better Business Bureau. In thirty-eight years of operation, her store had only three minor complaints filed against it.

The store was closed on Sundays so she could change its window display, and her son Bob McConnell could do cleaning. She often spent part of her Sunday preparing and delivering a full week of meals for people who were incapacitated or in financial need.

Bertha was a member of the Daughters of the Nile, and served as president of Altrusa, a women's civic group that was established in 1917. She also served on the Las Vegas Chamber of Commerce and the Salvation Army's advisory board. For her community commitment, she received numerous awards.

Her exclusive store also occupies a spot in Las Vegas' notorious Mob-related folklore. In July 1981, members of mobster Tony "the Ant" Spilotro's Hole in the Wall Gang were arrested while attempting to break into the shop. The gang, which was run by Spilotro enforcer Frank Culotta, earned the nickname due to its methodology. To gain access for heists, it punched holes in walls or ceilings.

The gang timed its attempt when the sound of traffic and fireworks would mask the sound of members using sledge hammers and cutting torches to break in. The shop was targeted for its high-priced valuables. Fortunately, an informant tipped off authorities. So police and FBI agents were on hand to foil the gang's plan. The resulting arrests helped law enforcement turn the tide against the high-profile gang.

When Bertha retired in 1997 she closed her namesake store. "It was like a funeral in here," Bertha said, as customers came to say affectionate and emotional good-byes.

"My living room is from Bertha's," one patron said. "Nearly every piece of furniture I've ever bought has been from Bertha's."

Bertha clearly loved her work. "My business is my hobby," she always said. A woman of exceptional charm, she died at age ninety-four on September 23, 2005.

Joan LeMere

Agatha Lucy Pettinger Roberts

Aggie Roberts was notoriously close-mouthed when asked about her family, personal life or past. But she could hardly stop talking when people in the Las Vegas Valley asked her how to create or improve their gardens.

Agatha Lucy was born January 2, 1919, on a farm in Steinauer, Nebraska, to Anne and Michael Pettinger. She was the fifth of seven children, and attended Barnes Business College in Denver. There she met Reese Roberts on a blind date. They married and arrived in Las Vegas when he was stationed in 1942 at a military installation that has become Nellis Air Force Base.

Aggie's horticultural knowledge, hands-on experience, and her non-stop enthusiasm were community resources. She worked for twenty-nine years at the University of Nevada Cooperative Extension Service, which recruited her after hearing of her gardening successes. Aggie also served on the executive board of the Metropolitan Beautification Committee for twenty-one years. She taught

**1919–2006
HORTICULTURIST,
BROADCASTER,
COLUMNIST**

gardening classes and helped form many gardening clubs in Southern Nevada. She gladly took on informal speaking engagements at schools, recreation centers, churches, and nursing homes. She also wrote a newspaper column on gardening in the desert.

Lee Heenan, who worked with Aggie at the local Rose Society, said Aggie helped design a landscape beautification project for San Francisco Boulevard, now called Sahara Avenue. Aggie also helped the school district develop a landscape plan for the Helen J. Stewart School. She served on the original beautification committee for the Las Vegas Strip.

Beginning in 1950, Aggie served sixteen times as PTA president at her children's schools. She served on the Nevada PTA Board of Managers, and received a National PTA lifetime membership for her service. Starting in 1974, she also was a longtime superintendent of the youth division at the Jaycee State Fair, for which she received the prestigious Western Fairs Association Award. She taught Sunday school for

> *The horticulturist brought beauty to Las Vegas and enriched the lives of the children she met, according to Joyce Woodhouse, a Nevada state senator.*

decades at St. Anne's Catholic church, and was involved in Boy and Girl Scouting.

In her honor, Aggie Roberts Elementary School in Henderson bears her name.

When the school was dedicated, Aggie turned the honor into a responsibility. She read to the children during Nevada Reading Week, and appeared at the school's Arbor Day celebrations. She sometimes dressed as a bumblebee or ladybug at open houses or PTA events. For all this, she earned the affectionate title of the "Plant Lady." Her positive outlook and patience made her a natural to work with children.

She also appeared on local television and radio. After her death, she was entered in the Nevada Broadcasters Hall of Fame.

Linn Mills, a well-known local horticulturist who works at the Springs Preserve in central Las Vegas, knew Aggie well and was interviewed extensively at the time of her death. According to Mills, two of her endearing characteristics were that she was always on time, and worked far more hours than she was assigned.

An incident that demonstrates both her dedication and her reticence was the time her house burned down, and she lost everything. Yet, Mills said, she did not divulge details of her emergency. She only told him she had "a few things to do," but still planned to teach her class the next morning.

Aggie's husband, Reese, died in a 1974 car accident. They had three children: Pam Levins, Betty Roberts, and Bill Roberts.

Joyce Woodhouse, a Nevada state senator and great admirer of Aggie, said the horticulturist brought beauty to Las Vegas and enriched the lives of the children she met.

Daughter Pam described Aggie as a "matriarch" who loved everybody. "Despite her numerous public appearances, my mother still acted 'giddy' when she appeared in the news or on a television segment about gardening."

Aggie also played a mean game of Trivial Pursuits or Pictionary, and was "the life of the party," Pam added. A grandmother of seven, Aggie died on May 16, 2006, of an infection that resulted from a perforated colon. One of her favorite sayings was, "From what we get, we can make a living. What we give, however, makes a life."

Fran Haraway and Nancy Sansone

Luciell Rohlman

Luciell Rohlman was a dynamic Nevada senior who, suddenly widowed, nonetheless had a great impact on those around her.

Luciell could not have known that fifty-seven years of marriage to her husband, Harold, would end abruptly. And when the unthinkable happened, she hadn't a clue that she would live another quarter-century without Harold. What she did know was that three choices stretched out before her, and she examined each one carefully.

The least demanding future would be a return from Nevada back to Detroit, where supportive friends and relatives lived. Luciell also considered a period of travel, to look around for a new environment in which to settle. But she chose the third option, to remain near her son in the expanding Las Vegas community, upon which she lavished her energy and concern.

Luciell Rohlman, whose maiden name is unknown, was born August 4, 1895, in Detroit. There she was educated, met and married Harold,

**1895—1999
COMMUNITY
VOLUNTEER, SENIOR
RIGHTS ACTIVIST**

and gave birth to their three sons and daughter. The family of six made its way through the troubled years of the Great Depression. Much later, her son Bob Rohlman said his mother not only always had food on the table for the family, but enough to share with needy neighbors or family friends.

In 1976, Luciell and Harold packed for an extended visit with their son, Bob, a Las Vegas real-estate agent. They did not seriously contemplate leaving the Midwest, but the Nevada desert did appeal to them. They also were looking forward to doing the sightseeing of typical tourists.

Scarcely had their visit begun, when Harold suddenly became seriously ill. He was rushed to Desert Springs Hospital. But despite the best efforts of the talented medical staff, his health worsened and he died four months after their arrival in Las Vegas.

Because of the hospital staff's dedication, Luciell felt a special bond with Desert Springs for the rest of her life. She regularly volunteered there, where many benefited from her first-hand

understanding of medical crises, including the resulting confusion and grief.

After consulting with her three sons and one daughter, all of them settled in their own lives, Luciell decided to throw in her lot with the energetic, self-directed citizens of Southern Nevada, whom she described as "my kind of people."

Practically everyone in Nevada was from somewhere else. But Luciell easily made friends, both in the hospital and around the bustling town.

Luciell, who was in her early eighties when widowed, realized that senior centers and transportation for older adults and the disabled were critical for quality of life in her age group. She went to work building support to maintain bus service for the elderly and to expand centers that serve seniors. Three days a week she served as hostess at the Las Vegas Senior Center downtown. She also attended its popular Saturday night dances. "She was the hostess with the most-est," her son Bob told the *Las Vegas Review-Journal* in 1999.

It would have been easy to presume Luciell was always a mild-mannered senior. But when the occasion called for it, she knew how to be confrontational and make her argument.

Several times, the center named her Queen of the Day. But at one such event, the emcee misjudged Luciell in a way that caused many to smile. "I suppose you like to knit and sew," the emcee said to her, according to her son Bob. "'No,' Luciell replied, 'I like to go out with men and dance.'"

In 1995, Las Vegas Mayor Jan Jones recognized Luciell's contributions by proclaiming August 23 to be Luciell Rohlman Day. At that point, she had put in more than seven thousand volunteer hours. Some insisted that without her campaigning, seniors might have lost a specialized bus service whose budget had been threatened.

Luciell's extraordinary service ended at age 104, when she died in August 1999. She was survived by four children, fifteen grandchildren, and twenty-four great-grandchildren.

Donna Gavac

Colleen Carroll Schroeder

Colleen Carroll Schroeder was sometimes called Las Vegas' first lady of fashion. She started as a model in 1969 for Bernie Lenz Models, a local agency. But she went on to teach modeling and serve as a regional fashion coordinator for Broadway department stores.

Colleen Sylvia Carroll was born on March 4, 1928, in Hollywood, where her father was a stunt rider in movies. He had won the World Championship Bronco Riding Award and later was inducted in the Cowboy Hall of Fame. But the family moved back to Laramie, Wyoming, where Colleen grew up.

She graduated from the University of Wyoming in 1949 and met Don Schroeder, an officer in ROTC, the Reserve Officer Training Corps. They became engaged before she left Wyoming to pursue an acting career. She attended the Pasadena Drama School in California, and received a summer scholarship to the Cleveland Playhouse in Ohio. She spent summers working in summer stock, including a play, *Western Anxiety*, which was directed by William Saroyan.

1928–1999
MODEL, FASHION COORDINATOR, PLANNER OF CHARITY EVENTS, POLITICAL FUNDRAISER

He recommended she further pursue her acting in New York City.

But instead Colleen and Don married in October 1951.

She continued to act in various theater productions at Don's military posts. In 1966 Lt. Col. Schroeder was assigned to Nellis Air Force Base as its tactical weapons strategist and Army liaison officer. In 1969 he started his second tour in Vietnam, but was killed in action on February 13, 1969. He had earned more than twenty medals. Colleen, who became the single parent of four children, never remarried.

Her first work in Las Vegas was as a substitute teacher. She started modeling in 1969 for Lenz at a "tea room" fashion show at the Showboat Hotel and Casino on Boulder Highway. Soon she was teaching modeling at the Lenz agency. In 1970 she began a new career, as regional fashion coordinator for Broadway stores' southwest division. She traveled regularly to both coasts to attend designer runway shows and modeling competitions. She also worked with New

York and Los Angeles fashion buyers.

Colleen's goal was to bring a distinct, world-class fashion presence to Las Vegas. On Broadway's behalf, she worked with such figures as model Lauren Hutton and designer Diane Von Furstenberg. She also taught charm classes at local Broadway stores and arranged in-store fashion shows.

Then Colleen began producing shows outside the store as well. The Las Vegas Community and Charity Fashion Show, sponsored by the Broadway, became her trademark. She would choose the clothing and accessories, recruit the models—who included some of the celebrity wives in Las Vegas—write the script for the show, which included live music and singing. From the 1970s into the 1990s, Colleen also produced many fashion shows for trade groups and conventions. Some took place in major Las Vegas hotels.

Colleen received many awards for her fashion work from the numerous charities and community groups she worked with. They included Lighthouse Compassionate Care, Opportunity Village, Hadassah, St. Jude's Ranch, St. Rose Dominican Hospital, and nationwide associations devoted to the fights against heart disease, cancer, and diabetes.

As well, Colleen judged beauty pageants, did public speaking, appeared on local television and radio, and worked with the Broadway's youth council. In 1984 she opened a boutique, Ravishing Rags, with partner Curt Johnson. But she enjoyed collaborating with pianist Liberace, in events held at his Tivoli Gardens restaurant on East Tropicana Avenue.

From 1983 to 1984, Colleen also wrote about fashion and high society in "Fashion Front," a column in the *Las Vegas Review-Journal* newspaper.

She also got into fund-raising for local Democratic political candidates. Former Nevada governor and former U.S. senator Richard Bryan recalled at Colleen's memorial service that, "Colleen could get certain powerful people to take her calls, that other people in Las Vegas could wait a lifetime to speak to."

But Colleen's forte was working on behalf of the arts in Nevada. She joined the Las Vegas Symphony in 1982, helped start the symphony's guild in 1984, and served on the guild's board of directors. She helped launch popular symphony events including its Picnic Pops and concerts for children, the latter held at Artemus Ham Hall on the campus of the University of Nevada, Las Vegas. She served on the board of the Arts Alliance, and lobbied state legislators for cultural funding.

In addition, she served a term as president of the Officers' Wives Club and was a member of Christ Church Episcopal. She also belonged the Mesquite Club, the League of Women Voters, Opportunity Village Vanguards, St. Jude's Ranch, and Friends of the Library. And, she was a published author of poetry.

Colleen died of cancer on June 19, 1999. Her four children are Shelly, Steve, Scott, and Sandy.
Sally Wathan

Alice Lucretia Smith

Alice Lucretia Smith was born in the Deep South, but helped promote racial equality in Northern Nevada. Today an elementary school in Golden Valley, Nevada, bears her name.

Mississippi was ranked as one of the poorest states in the early 1900s, when Alice was born in Bay St. Louis, on November 4, 1902. Her birth shortly followed the building of a levee system there by the Mississippi River Commission, which failed and resulted in the return of local flooding.

The descendant of slaves, Alice helped raise her brothers and sisters after their mother died. Life was difficult for Alice, as it was for most of the people she knew. From her mother, she inherited her spiritual faith and an interest in education. Alice earned a teaching license from the Mississippi State Normal School in Hattiesburg, and then taught in the rural Mississippi communities of Waveland and Kiln. She then attended Alcorn College for a year.

In 1935 Alice made a gigantic leap by moving to Oakland, California. There she met and married

1902–1990
CIVIL RIGHTS ORGANIZER, MEMBER OF CIVIC GROUPS, STATE APPOINTEE

Alfred O. Smith that same year. In 1938 they moved to Reno, where they worked several jobs. At the same time, the couple organized the Reno-Sparks branch of the National Association for the Advancement of Colored People.

The NAACP's first meeting took place in 1945, in the Smiths' living room. Alfred was its first president, and Alice its first secretary.

In December 1946, Alice lost her beloved Alfred. She pledged to "devote the rest of my life to help my fellow man, without pay or thanks," and this she did. She was in the branch's leadership for many years, serving as its president from 1955 to 1957.

Alice had noticed problems when they had arrived in the Reno-Sparks area. Some restaurants and businesses posted signs in the window reading, "No Negroes allowed," "No colored trade solicited," and "No Indians, dogs, or Negroes." She did not become bitter, but energized.

The Reno veterans' hospital initially denied admission to her husband in his final illness, but Alice refused to dwell on injustice. She told a

newsman of the day that she wanted to be constructive, instead of wasting time with foolishness.

Her religious roots also revived, and she joined the Bethel African Methodist-Episcopal (AME) Church in Sparks, which is the oldest continuing African-American church in the state. Then in 1961 she joined the Sparks American United Methodist Church. She served as a leader of Church Women United for several years.

In 1971, Alice said that, "race relations, and the attitudes about race relations, have made wonderful strides." She believed in strong families and placed high value on education, religion, and what she described as "getting out into the community and assisting there—because I think it's going to take all of us to make the world go round."

For twenty-five years she volunteered for the local Red Cross, as a Gray Lady and as a board director. She was active in the League of Women Voters and the Washoe County Economic Opportunity Board, including as chair of the latter group's board of directors. The same community services agency established its annual Alice Smith Award in her honor, to thank board members for their service.

In 1972, Governor Mike O'Callaghan appointed Alice to the White House Conference on Aging. She also was appointed to the Nevada State Welfare Board, and the advisory committee of the Nevada Division of Aging Services.

Where Alice saw a need, she saw *to* that need. She died on August 6, 1990.

Joan LeMere

Janet Curtis Smith

Janet Curtis Smith was justice of the peace in the small Southern Nevada town of Goodsprings, but she gained national attention for her handling of the initial court appearance related to a sensational criminal case: the 1997 killing of a seven-year-old girl by a teenage boy at the Primm Valley Casino near the state line between Nevada and California.

Janet, who never earned a law degree, rose up through the ranks of power by proving her worth as a support staffer to a Nevada judge and then the state's governor, Mike O'Callaghan. She served as the justice of the peace of Goodsprings for twelve years. Her normal work consisted of cases involving drunken driving, car accidents or financial crimes involving the casinos in Jean, Nevada, according to her 2005 obituary in the *Las Vegas Sun*.

Janet aroused controversy after the death of Sherrice Iverson, who was playing alone at the Primm Valley while an adult relative gambled, when she was accosted by Jeremy Strohmeyer, eighteen, of Long Beach, California, whose traveling party had stopped at the casino. Strohmeyer followed the seven-year-old into a women's restroom, where he sexually assaulted and strangled her in a stall. In 1998,

1928–2005
JUDGE'S SECRETARY, GOVERNOR'S ASSISTANT, JUSTICE OF PEACE

he pleaded guilty in a last-minute plea bargain before trial, to counts of first-degree kidnapping, first-degree murder, and sexual assault on a minor, according to a *New York Times* account of the case. Myron Leavitt, a Nevada District Court judge, sentenced Strohmeyer to three life terms in prison, without the possibility of parole.

The Strohmeyer case was controversial on multi levels. The *Los Angeles Times* described it as a case that "spurred nationwide debate about Good Samaritan laws, tougher parental supervision and better security in casinos."

Janet, whose role in the legal process was confined to Strohmeyer's first court appearance, imposed a gag order banning discussion of the murder investigation, or related legal proceedings, by any involved parties. Her move drove local news editors ballistic. She did so at the request of Strohmeyer's two attorneys. *Las Vegas Review-Journal* editor Thomas Mitchell editorialized against Janet's order. "It is based," he wrote, "on the premise that somehow knowledgeable people can't make fair jurors. It is ludicrous and psychobabble." The *Review-Journal* entered the case, claiming the gag was unconstitutional.

Janet stuck to her guns, though she did modify her order to allow authorities to release procedural facts, such as the dates of hearings, the *Review-Journal* later reported.

Janet was appointed Goodsprings' justice of the peace in 1987, and won every election, retiring in 1999. "She brought the justice of the peace station here to new levels," said a successor in the post, Dawn Haviland. "She was highly regarded. She strived very hard for excellence."

In her 1994 reelection campaign, a challenger attacked Janet as a "file clerk" who often got things wrong. But she declined to fight back. "I haven't got the time, energy, nor am I of the disposition to attack other people," she told the *Review-Journal*. Janet won the race with more than two-thirds of the vote.

She was born Janet Curtis on April 26, 1928, in Los Angeles, and moved with her family to Southern Nevada when she was ten. Her father, an ironworker, had worked on the construction of Boulder Dam, later renamed Hoover Dam.

She married Prince Smith after he served in the Navy during World War II. They had six children. Janet Smith joined the National Association for the Advancement of Colored People and marched in civil rights rallies in Las Vegas. The small town was just taking shape, and Janet helped form it.

In 1967 she was working as a legal secretary to District Judge Thomas O'Donnell. In 1971 she became the administrative assistant to Governor O'Callaghan. His son, deputy district attorney Michael Neil O'Callaghan, remembers Janet as his dad's right-hand person, running the governor's office in Southern Nevada. "She was crucial to carrying out my dad's vision," he said. "Janet Smith would have made a great frontierswoman because no one was tougher than her. She did not tolerate nonsense, yet she was genuine and loving."

Smith, a Democrat, was "absolutely fearless," according to her longtime friend Harriet Trudell. "She backed from nothing she believed in." Janet's son, *Review-Journal* columnist John L. Smith, said his mother spent her life as "a great fighter for common people's rights. ... For more than forty years, she devoted herself to helping people who really needed it."

Janet Curtis Smith died in April 2005.

Joan LeMere

Louise Aloys Smith

Aloys Smith's life and work in the city of Lovelock in Pershing County, Nevada, was, ultimately, the result of a chance meeting. Yet she came to serve the entire state through her role in politics.

Her father, Dr. Eugene Kneeland Smith, was living in San Francisco when Kathleen O'Sullivan and her family came to the city en route to a new life in Oceania. But they missed their boat to New Zealand, which allowed Kathleen to meet and marry Eugene. The couple then moved to Lovelock, Nevada, because the region—unlike most mining areas in the West—offered health insurance to miners, who with the local ranchers had built a hospital. Dr. Smith became medical superintendent of the Lovelock Hospital, and practiced medicine until his death in an automobile accident in 1954.

Aloys, who was born July 29, 1917, in Lovelock, pursued her education in California, where she also was trained in opera. This was a skill that enriched the rest of her life because, when she returned to Lovelock, she was much in demand for church and social functions, thanks to her lovely soprano voice. She also became active in Beta Sigma Phi, in activities of the Catholic Church, and in musical and theatrical projects.

During World War II, she was a sergeant in the United States Women's Army Corps, working in vocational guidance and education. Her father was a veteran of the Spanish-American War and World War II, while she received the World War II Victory Medal, the Good Conduct Medal, and the American Campaign Medal. After two and a half years as a WAC, she returned to Lovelock. There she acted on her interests in education and veterans' needs by serving as a Nevada assemblywoman.

Right after the war, she worked for the Lovelock Pharmacy. But in 1952, she began a career at the Sierra Pacific Power Company, which lasted three decades.

A company ad that appeared in the *Nevada State Journal* on June 8, 1969, focused on Aloys. "She's the kind of lady you like to have around," the ad read. "Aloys Smith is her name and she's been helping Lovelock people in just about every way imaginable." The ad concluded by noting, "Aloys is pretty special to the people of Lovelock. And to the people at Sierra Pacific Power Company."

1917–1999
MEMBER OF MILITARY,
STATE LEGISLATOR,
MEMBER OF CIVIC
GROUPS

Aside from her years of service with Beta Sigma Phi, Aloys also was a founding member of the Lovelock Soroptimists. She was a board trustee for the Pershing County Library, where she worked on adult literacy issues, volunteered for children's programs, and helped raise funds for a new library. She was a co-founder, actor, and sometimes director of the Desert Little Theater. And she was a member of the local hospital auxiliary.

But Aloys, who was a 1988 Nevada Woman of the Year, made her strongest mark in politics.

A Democrat, she served as a state assembly-woman representing Pershing County starting in 1949. In her first term, she was the only woman in the Assembly. Then after her reelection in 1951, she became the first woman elected as speaker pro tempore of the body. Also, she presided during the absence of Assembly Speaker Peter A. Burke.

Her successful second Assembly campaign was noteworthy because it helped soften the Republicans' sweep of seats. While in the Nevada Legislature, Aloys submitted an amendment to restore the Veterans' Service Commission. She served on standing committees that dealt with veteran's affairs, legislative functions, social welfare, the state library, and state publicity.

In 1951, the *Nevada State Journal* wrote about Aloys that, "Miss Smith is in her second session, specializes in welfare work and education. With plenty of charm, plus the fact the she was a WAC sergeant in the last war, she always has the situation well in hand."

Aloys, however, was prevented by the social mores of her era from one legislative duty to which she had aspired. She had been prohibited from serving on the Assembly committee that oversaw Nevada's mental institutions and prisons. Years after her time in the Legislature, Aloys explained, "The men wouldn't allow it. They said it wasn't a place for a lady."

Aloys was admired in all the spheres of her activity: the military, her community volunteerism, the Nevada Assembly and her workplace. Whether it was good or bad luck that made her mother miss the ship to New Zealand, Nevada reaped the benefit. Aloys Smith, who never married, died on May 19, 1999.

Fran Haraway

Mary Evelyn Stuckey

When Evelyn Stuckey in 1949 created the Rhythmettes, a female precision drill team that achieved national prominence, she expected from each team member what she had always demanded of herself—excellence.

Yet it was almost by accident that Evelyn came to the tiny spot of a town in the Nevada desert called Las Vegas, where she created her magic in the form of the Rhythmettes. If a friend had not pleaded with Evelyn to take her spot as a physical education teacher in the city's only high school, Las Vegas would never have known Evelyn.

Mary Evelyn Stuckey was born in Gordo, a poor town outside Tuscaloosa, Alabama, on September 10, 1921. Although Gordo was small, it still managed to ignite a voracious appetite for learning in Evelyn, which extended throughout her life. She easily mastered the sports of golf, tennis, and basketball. She also did well at dance, drama, and music. So varied were Evelyn's talents that she won several honors, including one for "best all around student." She also received a special honor for nine years of perfect school attendance.

Sports introduced Evelyn to the world. At age eighteen she toured the East Coast with a professional women's basketball team called the Pealers. She easily made enough money to pay for her college education.

In college she earned a bachelor's degree from Florida State College for Women—later Florida State University—where she studied human physiology as it relates to sports, dance, and health. She received an American Association of University Women Award in dance. Her graduate work, which continued her emphasis in health education, took her to Oregon and Oklahoma.

But after she finished her studies, Evelyn stayed in Florida, where in 1947 she became a health educator at the state Board of Health. The state awarded her a certificate of commendation for overseeing the Bureau of Tuberculosis Control.

However, health education was not Evelyn's first line of work. During high school she had worked at a Woolworth's store. At the beginning of World War II, she became the first woman to pump gasoline—which was the result of publicity stunt she did for the Firestone Tire Co. Later, she always said she enjoyed working on her own automobiles, doing maintenance and basic repairs.

1921–1980
TEACHER, FOUNDER AND
LEADER OF DRILL TEAM

178

Evelyn's mother said the girl had lost her mind when she left Florida in 1948 to replace her friend as a phys-ed teacher at Las Vegas High School. She created her drill troupe at the school in 1949, although the team's first name was the Pep Cats. It did not take the Rhythmettes name until 1950. Evelyn set several criteria for membership on the team. A 3.0 grade-point average was required. Members also had to maintain standards of modesty and etiquette.

The team was an instant success. As a measure of its popularity, in 1952 more than two hundred teen girls applied for six openings on the Rhythmettes, which had sixteen spots. For years, literally hundreds of young Las Vegans wore the Rhythmettes uniform and boots whenever they served as greeters for distinguished visitors or the general public at local fairs, rodeos, and events such as Helldorado Days.

Boosted by Evelyn's drive and skill, the Rhymettes toured as goodwill ambassadors of Las Vegas, which was emerging as the "entertainment capital of the world."

They performed on *The Ed Sullivan Show*, ABC's *Wide World of Sports*, and CBS' *Fabulous Las Vegas*. They were featured in magazine including *Colliers* and *Parents Magazine*. And they appeared in such films as Warner Brothers' *Howdy, Partner*, and *The World at Night*.

Although Evelyn disbanded the Rhythmettes in 1966 due to her poor health, in 1974 she revived the troupe for five more years.

Evelyn served on many local committees and boards. For example, she directed four Helldorado beauty pageants and directed two Elks Club memorial services. For years she served on the Miss Rodeo America committee and coordinated the Miss Nevada contests.

Her accolades included Las Vegas Woman of the Year in 1954, Honorary Queen of the Las Vegas Community Fair in 1955, honored teacher of the Las Vegas Rotary Club in 1963, recipient of the Las Vegas High School yearbook dedication in 1963, and Nevada's Outstanding Citizen of the Year in 1964.

Evelyn Stuckey continued to teach at Las Vegas High School until she passed away in 1980. She was single-handedly responsible for a wonderful burst of Las Vegas public relations called the Rhythmettes.

Susan Houston

Sheila Tarr-Smith

Sheila Tarr-Smith was a scholarship-winning and record-setting athlete who became one of the first professional female firefighters in Nevada. She worked for the safety of Southern Nevada residents, and led the way for women to take jobs in fields that traditionally were limited to men.

Born Sheila Tarr on June 14, 1964 in Bakersfield, California, she moved with her family to Las Vegas when she was two years old, and so considered herself a "native" Nevadan. Her parents were Jerry and Linda Tarr. She had one brother, Michael Tarr. Her grandparents included Dorothy Ann Rivers of Walnut Creek, California, and Sylvia R. Tarr of Bakersfield.

Sheila attended Clark County Schools: Tom Williams Elementary, Garside Junior High, and Bonanza High School. At Bonanza she earned awards in track and field, and basketball. She then attended the University of Nevada, Las Vegas on an athletic scholarship for women's track and field.

She broke many UNLV athletic records, including the indoor shot put, the indoor

1964–1998
ATHLETE, FIREFIGHTER, COMMUNITY VOLUNTEER

pentathlon, the outdoor shot put, the javelin, and the heptathlon—which is a competition of eight track and field events. Her marks in shot put and heptathlon also were conference records. In 1984 she became Pacific Coast Athletic Association Conference Champion, and was selected as the association's Athlete of the Year.

Also in 1984, she was named Nevada's first-ever National Collegiate Athletic Association Champion. She also was selected as an alternate to the United States Olympic team in the heptathlon. In 1985 she finished as runner-up in the NCAA heptathlon. Many think Sheila Tarr was one of the finest athletes the state of Nevada has ever produced. In 1997, she was inducted into UNLV's Athletic Hall of Fame. In 1988 she was inducted into the Southern Nevada Hall of Fame.

In 1989 Sheila joined the Clark County Fire Department and became a member of the International Association of Firefighters, Local 1908. She was one of the first female firefighters in Nevada. Beyond basic firefighting, she spoke at school career-day functions,

stressing the importance of a good education combined with fitness and a professional dream. She also served on the fire department's critical debriefing team, which assists firefighters who experience traumatic or life-threatening incidents in the course of their duties.

Sheila also was an avid volunteer. At Clark County's Child Haven, she worked with children who had suffered abuse or neglect. She shopped for gifts and food for the Helen J. Stewart Elementary School's Adopt-a-Family program. She also collected aluminum cans from local fire stations to help finance special projects at Child Haven's Howard Cottage.

But eventually the physical body that Sheila had trained, nourished, and relied upon rebelled against her. In September 1997 she was diagnosed with a form of multiple sclerosis called chronic inflammatory demyelinating polyneuropathy. Yet she maintained a positive attitude.

On April 3, 1998, UNLV unveiled two new athletic facilities, its Myron Partridge Stadium and the Sheila Tarr Smith Field.

On May 8, 1998 Sheila married her longtime love, Clark County Fire Department Battalion Chief Steve Smith, who cared for her until her death on August 15, 1998.

In her brief thirty-four years, Sheila inspired many people. Well over a thousand people attended her funeral service, which included a single bagpiper leading a parade of firefighters marching quietly behind a fire engine that transported her flag-draped casket along South Maryland Parkway for a half mile, up to the Artemus Ham Concert Hall at UNLV. The procession passed under an arch formed by crossed extension ladders of the county and city of Las Vegas fire departments. A gigantic American flag hung from the arch.

Inside Ham Hall, numerous individuals eulogized Sheila, including her brother Michael, her former personal coach Mike Strong, UNLV President Carol Harter and several of her closest firefighter friends.

The Clark County School District has made sure that Las Vegas youngsters will know her name, by unveiling Sheila R. Tarr Elementary School in the northwest Las Vegas Valley, in autumn 2000.

Denise Gerdes

Doris Higginson Troy

1937–2004
SINGER, STAGE
PERFORMER, RECORDING
ARTIST

In 1937, Franklin D. Roosevelt was sworn in for his second term as president; the Golden Gate Bridge in San Francisco opened; Batman made his comic-book debut; Amelia Earhart disappeared; *Snow White and the Seven Dwarfs* opened to adoring movie crowds; and Doris Higginson Troy was born, on January 6.

In 1984, her life saga was made into an award-winning off-Broadway play, *Mama I Want to Sing*, and in 2011, into a movie by the same name.

Doris' father, Randolph Higginson, was a Pentecostal minister in Harlem, the black community that had already become a vital, vibrant part of New York City. In this period, called the Harlem Renaissance, blacks were developing new art forms such as jazz dance and jazz poetry, which was a forerunner to today's rap.

Doris grew up singing in her father's church choir. As a teen she performed with local gospel groups and—much to her parents' chagrin—with secular rhythm and blues groups. She would sneak into the Apollo Theatre in Harlem to watch and listen to legendary performers Josephine Baker, Dinah Washington, Sarah Vaughan, and Pearl Bailey. Doris managed to get a job at the Apollo as an usherette and worked until her mother, Geraldine, made her quit.

Some accounts say that Doris even sang at the Apollo. Whether Doris was ushering or singing, James Brown, the "godfather" of soul, spotted her and encouraged her to perform.

In 1958 Doris formed a trio called the Halos. She also began writing her own material. A year later, the aspiring star decided to strike out on her own. She told her worried parents she *had* to sing. Later she was quoted as saying, "Don't let no one tell you, you can't do something. You just keep going. There's always light at the end of the tunnel."

Billboard magazine had coined the phrase rhythm and blues in 1948 as a marketing term. It replaced the phrase "race music," which originally came from the black community but was deemed offensive in post-war America. R&B was a catchall term for any music made by and for blacks, except for classical and religious.

R&B gained momentum in the late 1940s as "boogie woogie." In the early 1950s, some started calling it "rock and roll." By the time Doris formed her first group, the music was becoming popular with white teenagers, too. When

Elvis Presley tunes such as "Jailhouse Rock," "Treat Me Nice," and "All Shook Up" made the R&B lists, it marked the unprecedented acceptance of a non-black into a music category created and dominated by blacks.

After Doris left the Halos, she collaborated in the writing of "Just One Look," and performed it as well. The single made the top ten R&B hits of 1963; it was the first time she used "Doris Troy" as her stage name. The song was featured in the soundtrack of *Mermaids*, with Cher and Winona Rider. It also has been used in television commercials for Mazda cars and for Pepsi.

Doris went to England in 1969, where she became a sensation. Throughout the 1970s she was in high demand for backup singing. Her vivid voice can be heard in sessions with Carly Simon, Rolling Stones, Tom Jones, Eric Clapton, Joe Cocker, Pink Floyd, Dusty Springfield, Peter Frampton, and Elton John.

In 1979, Doris returned to the States to record in Los Angeles. But during a visit to Las Vegas, she fell in love with the city and decided to make it her home. She soon signed on as a backup singer for Lola Falana, who was appearing at the Aladdin. Lola encouraged Doris to solo, and often gave her a spot in the program. Doris worked with Falana until she became ill and could no longer perform.

In the early 1980s Doris performed in a jazz revue at the Tropicana Hotel called *Let Me Off Uptown*, in which she played the songstress Dinah Washington, whom she had seen at the Apollo. *Mama I Want to Sing* opened off-Broadway in 1984 and ran for many years.

Doris' impact on soul and pop music has been greater than her quantity of charts may suggest. Her rich voice on recordings by many stars extended her reach to a wide audience, particularly in Europe.

In 1996, she was recognized for her contribution when she received the Pioneer Rhythm & Blues Award. At the same time, she and eleven other R&B artists received funds from the Rhythm and Blues Foundation to compensate for the royalties they long had been denied by record companies.

The non-profit foundation—formed with the support of such industry giants as Bonnie Raitt, Ruth Brown, Isaac Hayes, Aretha Franklin, Bruce Springsteen, and Sam Moore—lobbies record companies to pay royalties to such ignored artists, and has had success with at least six labels.

Doris Higginson Troy died in her sleep in Las Vegas on February 16, 2004. But she lives on in every production of *Mama I Want to Sing*.
Barbara Riif Davis

Alice Bacon Turner

Alice Turner was born Alice Bacon on November 23, 1898, in Sanger, California, to John and Anna Swann Bacon. Her dad was a farmer and an operator of San Francisco cable cars. Alice was honored at age 101 when the Nevada Board of Regents—the state's governing board for higher education—named her a Distinguished Nevadan for her long-term volunteerism.

Alice grew up on a small farm with three younger brothers. As a child she loved riding in automobiles. At age thirteen, she learned to drive the family's Model T Ford, and got her driver's license three years later.

After high school, Alice moved to Denver to pursue a nursing degree at St. Joseph Hospital Training School. She received six dollars a month to attend, but had to use that to purchase her textbooks, uniforms, and shoes. Yet she still managed to treat herself once a month to a fifteen-cent scrambled egg sandwich. She graduated in 1920 and went to work. But she left the workplace early on, to marry Clesse Turner, a Standard Oil

1898–2002
NURSE, CIVIC GROUP
MEMBER, COMMUNITY
VOLUNTEER

Company executive, who went on to serve as a Clark County commissioner.

Alice's first child was a daughter, Mary Alice, born in 1924. Then in 1925, she gave birth to son Thomas.

The Turners moved to Nevada in 1937 when Clesse became the Southern Nevada manager for his company. He gave a youthful Harry Reid—who is now a U.S. senator and majority leader of the Senate—his first job as a truck driver. According to Alice, when they arrived in Las Vegas, the town had about six thousand residents, and did not offer many attractions. "For entertainment, they would walk up and down Fremont Street on Saturday nights," she recalled.

In 1970, when Alice was seventy-two, her husband of many decades died. She dedicated the rest of her life to helping others.

She volunteered at Child Haven, the county's emergency shelter for abused and neglected children, on a regular basis. She made birthday cakes for children living in Child Haven's several cottages, and also coordinated parties.

In 1980, when she was in her eighties, she became the first volunteer to help out in University Medical Center's unit for patients with AIDS, or Acquired Immune Deficiency Syndrome. "I didn't volunteer to be the first," she told the *Las Vegas Sun* in 1999. "I did it because people needed someone to talk to. They seemed to like talking to an outsider, especially those whose families had deserted them. I used to try to get them to talk about their good times, and that seemed to make them feel better."

Alice also was a member of the Las Vegas Child Welfare Board and the Clark County Children's Service Guild. She drove a car until she was ninety-eight, and decided to stop after causing her first fender-bender accident, which she attributed to slowing reflexes. But she stayed active, walking about two miles a day well in her nineties.

She also continued going to Child Haven every Tuesday, to make craft items for the Children's Service Guild to sell at fundraisers that defrayed the costs of running Child Haven. "I have a very strong feeling that when you are given so much in life, you should return something to the community, no matter how old you are," she told the *Las Vegas Sun*.

According to a longtime friend Ann Langebin, Alice was always an avid reader who liked to stay informed on current affairs by reading newspapers. When a *Sun* reporter asked her to name the saddest moment of the twentieth century, Alice said it was the assassination of President John F. Kennedy. When asked for the greatest accomplishment of the century, she named aviation. "It has brought the world together," Alice explained. Born five years before Orville and Wilbur Wright flew the first engine-driven plane at Kitty Hawk, North Carolina, Alice went on to become a world traveler.

In 2000 Alice received her Distinguished Nevadan Award, which is bestowed on individuals who have made significant achievements or contributed to the state's cultural, scientific, or social advancement.

Alice said the secret of her longevity was that she never smoked and enjoyed two glasses of wine each evening. She died at age 104 on December 7, 2002, of natural causes in her Las Vegas home. She left behind six grandchildren and thirteen great-grandchildren and her two children—Mary Alice Simpson and Thomas Turner—who both died in 2008.

Rekaya Gibson

Nora Bloom Ullom

Nora Bloom Ullom bloomed when she planted herself in Las Vegas, seeking a warm dry climate after spending time in a sanatorium for tuberculosis. She led the Mesquite Club for a term, but made her wider mark in the arts.

Nora Bloom was born in February 3, 1900, in Pierre, South Dakota. Her parents were Ole and Louise Bloom. Her mother—who was the first Caucasian child born in South Dakota after it became a state—was Ole's second wife, as his first wife had died. Nora's mom raised Ole's first five children and bore him eight more, including Nora.

The Blooms moved to Fox Island in Puget Sound in 1904, where they built a home. Four years later Ole moved his family to the Gig Harbor area, where he homesteaded 160 acres. Some descendants still live in the locale.

When Nora reached school age, she was sent to Tacoma, Washington, to live with an older sibling while she went to school. After graduating from Tacoma's Stadium High School, she attended Pacific Lutheran College. She received her teaching certificate after two years at Pacific Lutheran.

1900—1962
PHOTOGRAPHER, BUSINESS OWNER, MEMBER OF CIVIC GROUPS

She moved to the Dalles area of Oregon to teach, which she did for two years, and then married a Mr. Ozmore, who owned a photo studio. A year later, their daughter, Jean, was born. But her husband died shortly after. So Nora and baby Jean relocated to San Francisco, where she worked for the Schbaker and Fry studio, where she mixed chemicals, printed photos, and retouched negatives. She also mastered the artistic process of tinting black-and-white photographs, which was an art form in the 1920s and '30s.

Nora's interest in the arts extended to theater, as she performed in various musical productions in the San Francisco community.

But tragedy struck again, when Nora was diagnosed with tuberculosis and had to enter a sanatorium in Southern Arizona. For that period of time, her daughter had to stay with relatives in San Diego. Nora was treated for about two years, and then was able to leave the sanatorium. For her health she sought out the dry climate of Las Vegas.

In 1931 she began working for Larry Ullom, son of J.T. Ullom, an early Las Vegan who owned the Ullom Hardware Store. J.T. Ullom took Nora's

186

suggestion that he do a periodic inventory of his store's stock. She and Larry married in 1932, the same year that Nora's ten-year-old daughter Jean rejoined her mom. In 1933, Nora and Larry were blessed with their only child together: John Lawrence "Buzzy" Ullom.

The couple's first home in Las Vegas was a tent at the corner of Fifth Street and Bonneville Avenue. Around 1934, they acquired property at Sixth and Fremont streets. There they built living quarters and a commercial building. In 1935 it housed a new business, Ullom's Desert Arts Studio. The business sold photographs taken by Larry, postcards, Indian jewelry, blankets, and pottery that Nora purchased in California. The Ulloms also maintained a photography studio at the site. Their guard dog, Lucky, kept the property safe.

As the Boulder City population increased, the Ulloms expanded their business. They located another Ullom's Studio across the street from the Del Mar drugstore, but the Boulder City shop closed after three years.

From 1942 to 1943, she was president of the Mesquite Club, a ladies service and social group. During World War II, Nevada's U.S. Senator Berkeley Bunker appointed Nora to head a scrap metal collection drive. In the 1940s she also headed the parent-teacher association at the Fifth Street School.

In 1949, the Ulloms sold their property on Fremont Street to the JC Penney Company. Then Nora opened her own portrait photography studio, Nevada Studio, at 106 North Third Street. She took in oil paintings by local artists to sell on consignment, and also did some oil painting of her own. Husband Larry became a photographer for the Associated Press news service.

In 1952, when her son John, also known as Buzzy, was in college and daughter Jean had married, Nora hired helpers to run her studio so that she could continue her education. At age fifty-two she enrolled in the University of Arizona as a full-time student, and attended two terms.

After returning to Las Vegas, Nora did hand tinting of photographs. She also continued her community service. She served as a president of the Women's Eagles Organization. From 1946 to 1950 she headed the American Cancer Society in Nevada. The American Red Cross and the Business and Professional Women's Club also benefitted from her participation. Nora died on June 20, 1962.

Mary Gafford

Kay Novak Wallerstein

Before Kay Novak moved to Las Vegas in 1945, she had become adept at the art of persuasion. She used that art during the years she resided in Southern Nevada, to help develop organizations and activities within the local Jewish community. She worked hard raising funds to build the original Temple Beth Sholom on Oakey Boulevard, which recently relocated to Henderson.

Kay's father was Hyman Novak, a pioneer of yiddish-language radio in Chicago. He brought theater to Jewish listeners, many of whom were born overseas. The dramas highlighted American life and culture, thus providing education as well as entertainment to recent immigrants.

Kay, who was born March 24, 1908 was one of her father's radio performers. She acted in Chicago Yiddish theater, too. Kay's daughter, Dena Marienthal, told *Las Vegas Sun* reporter Ed Koch that, "because my mother was American born, she was cast as a *shiksa*," a Yiddish term for Gentile girl. "She was young, brilliant and could remember her lines—so that was the role they gave her."

Making people believe in her was valuable training, as the adult Kay Novak was able to induce people to donate money to support community causes and events. "When the casino owners saw her coming, they'd hide," her good friend, Barbara Greenspun—of the Greenspun publishing dynasty, which includes the *Las Vegas Sun*—once told Koch. "She was very persuasive."

The young Kay moved with her family from Chicago to Los Angeles. She moved in 1945 to Las Vegas, where evidence suggests she met her husband, Harry Wallerstein. Their wedding date is unclear.

Harry was co-owner of a furniture store. He and his partner, Max Goot, owned Tinch Furniture on South Main Street. The two were known for their attempts to organize a national gin rummy tournament, which was to be financed by ten casinos, to the tune of $25,000 each. Nine hotels agreed, but then the Riviera balked, which ended the enterprise.

When Harry died in 1977, Kay elected to move back in 1978 to Los Angeles, to be near her daughter and grandchildren.

One of Kay's enduring achievements in Las Vegas was the Temple Beth Sholom project. She and Harry were founding members of the congregation,

1908–2003
RADIO PERFORMER,
FOUNDING MEMBER OF
SYNAGOGUE, FUNDRAISER

> *Making people believe in her was valuable training, as the adult Kay Novak was able to induce people to donate money to support community causes.*

which is the oldest Jewish assemblage in Las Vegas. The body started from a core group of Jews who observed the high holy days in the home of Nate Mack, chairman of the Bank of Las Vegas. Mack spearheaded the building of a Jewish community center, and when the group outgrew that site, its members met temporarily for high holy days in the rectory of a Catholic church.

Both Kay and Harry supported efforts to raise money for bonds for the state of Israel. One of Kay's synagogue projects was the founding of the Temple Beth Sholom Players. Her childhood drama skills came in handy when she led the players. Her productions were known for cameo roles that were played by well-known Las Vegas citizens dressed in outlandish costumes.

Another of Kay's activities was serving as state chair of the United Jewish Appeal, a philanthropic alliance of Jewish charities. In Koch's article about Kay, he wrote that she somehow managed to get former President Harry S. Truman to come to Las Vegas for a United Jewish Appeal fundraiser she had organized. In return, she raised money for the Truman Presidential Library, and also donated memorabilia.

Harry Wallerstein served for a time as president of the Beth Sholom congregation. He, too, worked on behalf of the community at large. In 1971, Nevada Governor Mike O'Callaghan appointed Harry, who was semi-retired, to the state's Government Employee Management Relations Board. Harry served on the board until his death, at which time Kay briefly took over her husband's duties until a replacement was located.

The Wallersteins and Goot also got some press coverage for helping their friend, publisher Hank Greenspun whose wife was Barbara. The *Sun* publisher had been accused of blackmail and needed to post bail. Harry and Goot posted two $10,000 bonds to get Greenspun out of custody.

When the widowed Kay moved to California, she transferred her energy and skills to enhance Temple Beth Zion. Two months before her own death, her son, Robert, a retired judge, died in Palm Desert, California. Kay died on June 17, 2003, from the effects of a stroke, at age ninety-five. She is buried in Hillside Memorial Park in Los Angeles.

Daughter Marienthal summed up her mother as "really a star. Not in the entertainment sense, but as a 'star' personality. She had a lot of charisma."

Fran Haraway

Phyllis J. Walsh

1897–1985
MILITARY AMBULANCE
DRIVER, SPORTS
REPORTER, RANCHER,
COMMUNITY VOLUNTEER

A citizen of the world, Phyllis J. Walsh performed public service through her volunteerism. Her life began when she was born in 1897 into a Philadelphia family of wealth and privilege. Her life ended in 1985, at age eighty-seven in Reno, Nevada. She left a legacy of patriotic duty and charity.

Educated in private New England schools, Phyllis' independent spirit emerged early. World War I broke out when she was too young to enlist in the U.S. military. So, she joined the French Army, bringing with her the required small truck and a letter of credit. A family friend, an automobile manufacturer, provided the truck, which Phyllis drove from the port of Bordeaux to Paris, to deliver it to the Red Cross.

Phyllis went next to Alsace-Lorraine to train with the *Comité Américain pour les Francais Blessés*, or, the American Fund for the French Wounded. She enlisted in the French Army to drive trucks and ambulances, and survived many shellings.

After the war, Phyllis returned to the United States. A gifted tennis player, she achieved national amateur standing and was eligible to play at Wimbledon in 1929. Her father, Philip Jourdan Walsh, Jr., had been a huntsman and steeplechaser. Her interest in history likely arose from her mother's family, whose history could be traced to 1227 and the reign of England's Henry III.

With an insider's knowledge of sports and of high society, Phyllis found employment during the Great Depression as a sports reporter for the *New York Daily News*. She covered tennis, polo, baseball, skating, horse racing, fox hunting, and golf. After her stint in journalism, she worked as a representative for several brokerage firms in New York City. In this capacity, Phyllis met and became friends with the wife of the late George T. Marye, Jr., whose family had been active in the Nevada's silver boom, called the Comstock era.

This friendship was pivotal; it changed Phyllis from a quintessential East Coast dweller to an ardent Westerner.

After extensive travel to the Far East in the mid-1930s, Phyllis moved to Nevada, where she made her home for the rest of her life. With Helen Marye Thomas, the daughter of the Marye family, she settled onto the S Bar S Ranch, where she lived for more than thirty years. The S Bar S lay along the Truckee River, on 319 acres near the Pyramid Lake Indian Reservation.

During the ranch years, Phyllis helped run the daily livestock operation and made the ranch notable for its hospitality and social life. The two women entertained numerous famous visitors, including national and international leaders in the arts and society. Madame Chenault of China visited, as did such Hollywood celebrities as Sophie Tucker, Hedy Lamarr, and Tallulah Bankhead.

> *Phyllis' independent spirit emerged early. When World War I broke out she was too young to enlist in the U.S. military. So, she joined the French Army.*

A fire destroyed the main ranch house in 1946, and Phyllis took on the responsibility of rebuilding it. In 1969, Helen Thomas deeded the ranch to the University of Nevada, Reno. Phyllis lived there until Helen's death in 1970. Then Phyllis moved to Reno, where she lived until her own death in 1985.

In Phyllis' 1973 oral history, entitled *From Lorgnettes to Lariats,* she explained, "I love people, being gregarious."

Beginning with World War II, Phyllis Walsh's volunteerism expanded to military service organizations. As a longtime member of the American Women's Volunteer Service (AWVS), she was instrumental in setting up a blood bank, and entertainment, for personnel at a nearby veteran's hospital.

For members of the military on their way to or from the fighting in Asia, stopping in Nevada represented a chance to enjoy simple pleasures. Phyllis once explained, "Everywhere in the area, there was home entertainment for the serviceman [sic]. We had them out every available Sunday, and before the pool was put in, took them swimming in the river, or over at Pyramid Lake. Here the boys could do skinny-dipping around one cove, and the girls around another, out of sight of each other. It was not for years that we learned that we had been seen by all the Indians on the opposite shore!"

Phyllis also volunteered for the first USO (United Service Organizations) located in Nevada, the Red Cross, the First American Indian Voluntary Service, the National Society of the Daughters of the American Colonists, and the Daughters of the American Revolution. She also served on the Nevada Indian Affairs Commission.

"I think that the way the people here in Nevada respond to an emergency is just great!" she wrote in *Lorgnettes.* "I've seen it happen over and over again. Whether it's war, whether it's a typhoon, the response is 'all out.'"

Phyllis won the Clara Barton Award, the Service to Mankind Award, Outstanding Volunteer in 1968, and Reno Kiwanis Club Volunteer of the Year in 1976.

She once remarked that public service in Nevada is "perhaps made easier by the space and beauty around us. Here I have seen a majority of people go all out for the stricken and under-privileged. This is their concept of brotherhood and understanding." Truly, Phyllis Walsh was an exemplar of this spirit.

Jo Ann Parochetti

Emilie Norma Wanderer

E milie Wanderer challenged the odds when, in 1947, she became the first woman lawyer to open a solo practice in Las Vegas. She was a persistent advocate for juvenile justice and the family court system.

Emilie was born near Boston on April 8, 1902. She attended Fordham Law School in New York City, but did not finish due to the Great Depression. At the time, one did not need a law degree to take the New York bar exam. She did so, passed, and was admitted to the New York bar in 1933. She began her career in the United States Attorney's Office for the Southern District of New York.

After law school she had married Dr. Henry Wanderer, and they had three sons. While en route to Phoenix in 1946 to seek a healthier climate for one of the sons, the family stopped off in Las Vegas and decided to stay. Henry died sometime before 1957.

Emilie's legal career in Nevada soon unfolded. When she passed the state's bar exam she was one of three women to pass, but the only one to open her own law practice. From 1947 to 1949, she was the only woman practicing law in Nevada.

She also was the first woman to run for district judge in Nevada, but lost. Her involvement provided a platform for her to speak about the lack of female judges. "I decry the absence of women from our judicial system," she once said, "and the failure of officials to support qualified women to judicial vacancies in a community which thus far has not been enlightened enough to fulfill these positions at the polls."

With her son John, Emilie also formed the state's first mother-son law practice.

She moved away in 1957 when she married Illinois resident Erwin Mautner. She passed that state's bar and practiced law in Chicago for a number of years, but resumed her Las Vegas law practice in 1968.

At that point Emilie began to advocate for a family court. When the Nevada Legislature in 1971 passed the law to form a family court, Emilie ran again for judge, for a seat on the new family court.

1902–2005
LAWYER, ADVOCATE FOR FORMATION OF FAMILY COURT, CIVIL RIGHTS ACTIVIST

She lost the election, but continued to publicly criticize the lack of female judges in Southern Nevada courtrooms.

She litigated several important cases that resulted in state Supreme Court decisions. She advocated for the rights of children and minorities. She mentored women attorneys who were newly admitted to the state bar. As a member of the National Association of Women Lawyers, she served on several national committees concerned with family courts, juvenile justice, and probate.

Emilie also helped businesswoman Dorothy D. Brimacombe found Nike House, a non-profit residence in Las Vegas for abused girls.

Emile Wanderer is a legend in the history of Southern Nevada civil rights. Early in her career, she served as counsel for the Nevada chapter of the National Association for the Advancement of Colored People. She held meetings in her home despite harassment, threats, and intimidation.

Emilie was living in Henderson when she died in 2005. At the time of her death, she was the oldest member of the State Bar of Nevada. But her significance goes beyond her longevity.

Emilie Wanderer broke down barriers for herself and others. In an era that discouraged women from pursuing higher education and professional careers, she practiced law while raising her children. She worked to promote social justice by securing equal rights. She made social progress, and also exemplified social progress.

Vera Knox

Judith Mosier Warner

Judith Mosier Warner's life illustrates the principle of "once a teacher, always a teacher." She worked in Las Vegas schools until she was seventy-five years old. And when she passed away in January 1999, she was teaching senior citizens how to write about their life experiences.

Judith was born in Okema, Oklahoma, on February 4, 1918, to Henry and Ellen Mosier. During the Depression, the family struggled. While Henry worked as a barber, Ellen and the girls picked fruit and vegetables in Oregon.

Judith was always competing with her sisters, whom she considered prettier and smarter. But in junior high, Judith encountered a teacher, a Mr. Dalton, who changed her life. He taught her that each occupation requires a special sort of person. Till the day she died, Judith preached the same mantra, that there is a job for everyone.

In 1940, Judith earned degrees in business and education, then taught in Taft, Oregon. During World War II, she used her business skills in temporary duties at the Army camps where her husband, George, was stationed.

George loved mining. So Las Vegas was the perfect for the couple—close to mining sites, but large enough that each could find work. They moved there in 1945.

1918–1999
TEACHER, SCHOOL COUNSELOR, ADVOCATE FOR VOCATIONAL EDUCATION

After the birth of daughter Kitty, Judith was hired in 1946 to teach business at Basic High School in Henderson. She later became the chair of its business department.

In 1950, she gave birth to their second child, David. But during her pregnancy she could not tell anyone, as teachers in those days were not allowed to work when pregnant. But a great shift in society occurred. By the time Judith retired, the school district was operating several nurseries for the children of some students—so that students could study early childhood development and childcare.

Judith's Basic High business seniors undertook fundraising projects so they could celebrate graduation at a fancy restaurant, the Green Shack on Boulder Highway. One year, performer Liberace happened to be dining at the Green Shack the same evening as the Basic students. Although he couldn't play the piano for them, due to his contracts, he gave them autographs.

In 1957, Judith transferred to Rancho High, a new school, and became a counselor. Counselors needed a master's degree, so she spent several summers studying at the University of Nevada, Reno. She went on to crusade for UNR to establish a branch in the growing community of Las Vegas.

When the first building of higher education—to become the University of Nevada, Las Vegas—was built in Southern Nevada, many locals were horrified it was so far from downtown, out in the empty "desert" near present-day Maryland Parkway and Flamingo Avenue. Over the years, Judith lobbied the institution to add courses in hotel management and hospitality, to match the needs of the large Las Vegas employers.

At Rancho High, part of her job was to help students prepare for college and apply for scholarships. She also focused on preventing students from dropping out of school. Judith well understood that not all students were college material, but a high school could still prepare this group for the workplace. She also lobbied the school district to build a vocational high school, which it did in 1966 with the opening of Southern Nevada Vocational Technical Center, now known as the Southeast Career Technical Academy.

In 1964, the Clark County School District started a program for students called Manpower Development Training Authority, which coordinated with several local unions. Judith found that many students in the program had to learn more than academics. When a fellow teacher confided that some of the cooking students smelled bad, Judith took them into a special session to learn personal hygiene, such as regular bathing and daily use of deodorant.

When Judith wanted to return to teaching, Rancho had no openings, so she became a tenth-grade advisor at Western High School. Then in 1967, she returned to Rancho High as a counselor, where she stayed until retiring in 1993 at age seventy-five.

Judith belonged to numerous professional associations and received many awards. From 1964 to 1966 she earned letters of appreciation from the Clark County Manpower Board for outstanding service. Rancho High School named its Air Force Junior ROTC rifle team in her honor. In 1984, the local American Business Women's Association named her its woman of the year. In 1986, she was the Clark County Counselors Association's counselor of the year. That year she also received a certificate of appreciation from UNLV. Then in 1988, UNR honored her for donating historical mining equipment from the Labbe Mine in Johnnie, Nevada.

In 1989, Judith received a twenty-five-year award from the Alpha Delta Kappa Sorority. In 1997, the American Association of Retired Persons—now formally called AARP—gave her a certificate of recognition for the years she had represented the association at committee meetings of the Nevada Legislature. She also was honored by the Senior Citizens Advisory Board of the City of Las Vegas and by the KLAS television station.

Kitty Warner Umbraco, daughter of Judith Warner

Thelma Messick Weaver

Thelma Messick Weaver spent most of her life outside Nevada, but moved to Lamoille in Elko County in her mid-nineties. She joined the Lamoille Women's Club, became the Stampede Grand Marshal for the Elko rodeo one year, and remained active until her death at age 101.

Thelma was born in Indiana to Clara and Cephus Messick in 1900, their third child. Eighteen months later, Clara died of septicemia shortly after giving birth to a fourth child, who also died. Thelma's maternal grandparents raised Thelma and her siblings in Goshen, Indiana.

Thelma and her cousin, Fern Collins, grew up together and were close as sisters all their lives. They were among the first "flappers" in the conservative farming town, which has a large Amish population to this day. When Thelma cut her waist-length hair to a short "bob," her family was scandalized. She also loved clothes, and at a bridge party near the end of her life, joked that she had "come to be admired."

1900—2001
BANK WORKER, RADIO HOST, MARIONETTE-SHOW BUSINESS OWNER

Thelma went to Chicago after high school to study drama, and stayed until her money ran out. She then returned to Goshen and took a job as a bank teller. She didn't marry until she was twenty-four, and continued to work off and on in banks for many decades—which was unusual for women in that day.

After Thelma married O.B. "Buck" Weaver, they moved to LaPorte, Indiana. They had two children and stayed in LaPorte until Buck retired in the mid-1960s. One of Thelma's traits was her ability to take joy in the commonplace. During the Depression, she wrote in her diary that she was enjoying the family outhouse's new coat of pink paint.

She and several friends had a marionette company for several years. They made and strung large dolls, which they used to put on puppet shows in department stores like Fields in Chicago. To earn a little money, she also performed dramatic "book reviews" for women's groups. For example, when

196

she reviewed "Lilly Dache's Hats," she visited a millinery to obtain boxes and boxes of hats, which she donned one by one as she told the book's story.

Sometime in the late 1940s, she started and hosted a radio show in LaPorte, called *Cookbook of the Air*. Thelma loved to cook as much as she loved parties, so her show was successful. Before a studio audience, she cooked recipes that local housewives had submitted to radio station WLOI. Then after the show, everyone lunched. Later she and her friends published a cookbook.

That radio project led to another, in which she interviewed interesting people on the air. She worked for the WLOI station five days a week for about ten years. She also ran once—unsuccessfully—for township trustee.

When Buck retired in the 1960s, Thelma and Buck "hit the road" in a travel trailer, crisscrossing the United States for the next decade. The couple finally made a semi-permanent home in Sebring, Florida, where Buck died in 1973. Thelma stayed in Florida for most of that year, and then returned alone to Goshen.

After his death, she and her cousin Fern traveled both outside the country and, every winter, by car to a warm state such as Arizona or California. One time they were flying to Nevada but got off in Ely instead of Elko. Thelma charmed the Ely airport manager, who offered to fly the two women in his Cessna the several hundred miles to Elko. Thelma was thrilled to sit up front.

Thelma moved to Lamoille, Nevada, in 1995 to stay with her daughter, Mary Branscomb. Even in Thelma's later years, she had a flair for the dramatic. When she presided over the Elko rodeo parade, she sat in the stands, front and center, waving and cheering. After the rodeo, several young cowboys came over to sweep off their hats and shake her hand.

She loved playing bridge and, even at age 101, frequently emerged the winner. She died at home, not in a hospital, on October 27, 2001.

"Thelma, my mother, scattered joy wherever she went," Branscomb said. "She knew how to use the life God gave her."

Mary Branscomb, daughter of Thelma Weaver

Claudine Barbara Williams

Claudine Williams, who with her husband helped operate the Silver Slipper on the Las Vegas Strip in the 1960s, eventually rose to the top of the casino world. She sold her interest in the Holiday Casino to the hospitality group that eventually became Harrah's Entertainment, now known as Caesars Entertainment.

Claudine Barbara, whose maiden name is unclear, was born in Mansfield, Louisiana, in 1921. She grew up in the Shreveport area with her mother, sister, and grandmother. At age twelve, she took her first job. At age fifteen, she took a job in a local club that offered gambling. During the Great Depression, she learned every game of chance she could. She left school after the ninth grade to become her family's breadwinner.

Eventually she moved the household to Houston, where she worked in more clubs, learning all she could about the gambling business. Before the age of twenty, she and another young woman became business partners in their own "after-hours" club. She went on to deal cards in a hush-hush gambling joint, where she was noticed by one of the associates of Benny Binion—a Las Vegas casino owner who got his own start in Texas, too. From Binion, Claudine

**1921–2009
CARD DEALER, CASINO
OWNER AND OPERATOR,
PHILANTHROPIST**

soaked up knowledge of the intricacies of gambling, a complex and at times treacherous business. Even though the business was male-oriented, Claudine managed to break through gender barriers.

She then met and worked for several years with Shelby Williams, a sportswriter. In 1950, Williams and Williams married. During the 1950s, many states passed or tightened their anti-gambling laws. So in 1964, the Williamses decided to move to Nevada, where casino gambling was legal.

They operated and expanded the Silver Slipper on the Las Vegas Strip, and sold it in 1969 to Howard Hughes. The two then focused on building a new business. In 1973 they opened their Holiday Casino on the Strip, across from Caesars Palace.

Claudine credited her ability to rise within the male-dominated casino industry to her husband's desire for a true partner. They shared all aspects of the decision-making. Consequently, Claudine stepped into the office of president and general manager after Shelby died in 1977, after a long illness. She was the first substantial woman executive in Nevada gaming.

After two expansions of the Holiday Casino, Claudine sold her interest to the Holiday Inn Corp., which evolved into the Harrah's empire, but she

assumed the chairmanship of the hotel's board of directors.

In 1981 Claudine took on a new venture, working with others to establish the American Bank of Commerce. She was the first woman in Nevada to chair a bank's board of directors.

She also gave back to her community by serving on numerous government, business, and charity boards. She was the first woman president of the Las Vegas Chamber of Commerce. In 1992, her peers inducted Claudine into the Gaming Hall of Fame, its first female honoree. In 2008, she received the Dean's Medal of Distinction for her commitment to hospitality education from the William F. Harrah College of Hotel Administration at the University of Nevada, Las Vegas. She was in the small group of residents who launched the UNLV Foundation. She donated generously to funds that provided UNLV scholarships and created one of the UNLV residence halls.

"Claudine loved to participate in the activities of the hotel college," remembered Stuart Mann, a former dean of the of hotel college. He said she enjoyed the annual scholarship luncheons, "where she could see the eagerness and enthusiasm of our students."

Kitty Rodman, who was a good friend of Williams and a UNLV Foundation trustee, described Claudine as "truly one of a kind. From her status as a gaming and community leader, to the special friendship we shared over the years, she never let anyone down."

Claudine was a leading businesswoman, civic leader, and philanthropist, according to Peter Michele, director of the UNLV library's Special Collections, which documents the history of Las Vegas and its gaming industry. The library houses a body of photographs, awards, and personal documents donated by Claudine's family.

In 1997 and again in 2005, Claudine was interviewed by the UNLV's Women's Research Institute of Nevada for the Las Vegas Women Oral History Project. She died in 2009, a pioneer who made her mark in gaming, and through her support of higher education allowed many others to make their own marks, too.

Robyn Campbell-Ouchida

Helen Woolley Willis

Helen Woolley Willis was born in 1914. That year, World War I was beginning, but the Mexican Revolution was in full swing. It was also the year that the Ford Motor Company announced an eight-hour workday, and a minimum daily wage of five dollars.

Specifically, Helen was born on July 17 in Salt Lake City, Utah, to Paul and Frances Woolley. Growing up, she was always involved in the arts. She took roles in many high school plays, and went on to graduate from the University of Utah with degrees in art and drama. In 1936 she was teaching art at her alma mater, East High School. She then went to the University of California, Berkeley, to earn a master's degree.

Then in the 1950s, Helen hit Las Vegas with a bang. It was a small, dusty town open to ideas. Helen, who was full of ideas and energy, promptly became art director at *Magazine Las Vegas*, a local periodical. She also hosted two radio talk shows. And, she accepted

1914–2004
RADIO HOST, FOUNDER OF CIVIC GROUP, ARTIST, EDUCATOR

leading roles in small theater productions around the Las Vegas Valley.

During this busy time, she somehow managed to meet her future husband, Vernon Willis, who was a prominent business and community leader. Together they raised a son, Peter, and nurtured their community.

Helen gathered a group of Las Vegans who shared her visionary interest in the arts, and in 1950 they formed the Las Vegas Art League. Its purpose was to bring fine art to the city. The league moved into a portion of a ranch house at Lorenzi Park, which the city of Las Vegas had purchased in 1949. Then in 1974, the Arts League changed its name to the Las Vegas Art Museum. The organization held exhibits and offered classes.

The museum that Helen helped start went on in 1997 to occupy museum space at the Sahara Library. There it held exhibits and lectures and did art outreach. But in February 2009, the museum closed its doors due to a lack of financial support. It has, however,

kept its name in the hope of reopening when the economy improves.

Clark County Juvenile Court Services also benefitted from Helen's vision for her community. She created and directed a creative-arts program for the children who pass through juvenile court. At Spring Mountain Youth Camp—a secure site for delinquent young males—Helen provided counseling though arts and crafts programming.

In 1981, the *Las Vegas Review-Journal* selected Helen as one of the county's outstanding women. It was a tribute to her community involvement. But she kept honing her art skills, with her work displayed in homes, businesses, and galleries around the country.

Helen—who was a humanitarian as well as an artist—passed away peacefully on February 6, 2004, with her son and daughter-in-law at her side.

Joan LeMere

Pauline May Atterbury Wilson

In Nevada's mining heyday, an intrepid Pauline Atterbury Gage Wilson recovered from her engineering husband's poor mining investments by playing piano in such rough-and-tumble mining locales as Rhyolite and Tonopah.

Born on March 10, 1876 in Illinois, Pauline was the oldest child of Emily Millard and Joseph Barrett Atterbury. In 1884, the family moved within Illinois from Hillsboro to Springfield. Pauline's father was a commercial artist, who traded a piece of his art for six months of piano lessons for his daughter Pauline. Pauline, who already sang alto to her sister Ida's soprano, showed talent in her piano lessons. But the lessons ended when Joseph Atterbury's drinking problem started consuming the family's income.

But Pauline kept on learning on her own, by practicing on the pianos and organs of friendly neighbors. Soon neighbors began asking her to teach their children to play. So at age fifteen, she started charging twenty-five cents per lesson. At age nineteen, she had thirty pupils for whom she received thirty-five cents a lessons. With her savings, she eventually bought herself an old upright piano, which she cherished.

1876–UNKNOWN
PIANO TEACHER, PIANO PERFORMER

Although Pauline never could afford technical piano training she regularly attended recitals given by the music students at a nearby college, and would attempt to duplicate the techniques of these players. She was able to develop speed and finesse at the keyboard. When she started playing classical music, she gave the impression she had professional training.

One evening, while playing at her church in an entertainment program, Pauline met a young mining engineer, Charles Harvey Gage. The two married on June 30, 1897, and had two children. The first was a boy, born prematurely, who lived only five hours. The second was a daughter, whom they named Katherine.

Pauline traveled with Charles, who suffered repeated failures in his mining investments, which created embarrassing situations for the couple. However, at each location, she would perform musical programs for the local residents, on either piano or organ. Finally, her husband deposited her in Los Angeles, while he travelled on.

When Charles failed to send her money, Pauline declared the marriage over. Her mother and sister raised enough money for Pauline and

When a friend suggested the mining town of Rhyolite needed a good piano "dance player," Pauline decided to go.

daughter Katherine to return to Springfield, where she resumed teaching piano. By 1905, she had saved enough funds to return to Los Angeles, which she felt offered her more opportunities in the field of music. In Los Angeles she found work playing with a ten-piece band, of which she was the only female musician.

When a visiting friend suggested that the mining town of Rhyolite, Nevada, needed a good "dance player," Pauline decided to go. In Rhyolite, she played in many establishments. Although women of ill repute inhabited one street in the town, and the local lawman frequently had to quell fights, Pauline enjoyed her life. She once wrote, "Contrary to the belief that mining camps had only the roughest elements, there was considerable talent, spiritual culture, and refinement in Rhyolite." During this time, she got to know Tom Wilson, a widower, whom she married in 1909. In 1910, their son, Jim, was born.

In 1911 the family moved to Tonopah, where Pauline was the "dance player," and yet, she was still forced to join the musicians union before she was allowed to perform. She played not only for dances, but also for shows and meetings. At one time, she also taught a music class of about twenty pupils.

By April 1913, mining work had dwindled, so they moved to Los Angeles, where Tom found work in the shipyards. Pauline became the pianist for several fraternal lodges. She also played twice a week for a dance club in her neighborhood.

During World War I, she worked at the music counter of a store. At noon she would play the piano as service men from all branches gathered around to sing the popular tunes she played. But during this time, Tom's health declined, and in 1919 he died. In 1923, after daughter Katherine married, had a son, and went back to work, Pauline kept house for them. When the daughter and her family moved to a ranch outside of Los Angeles in 1941, Pauline went along. She helped with irrigation, milked cows, and did other chores. When word of her piano skills spread, she began giving lessons again.

When Pauline's daughter divorced, the ranch was sold. Pauline moved with Katherine to Quartz Hill, California, where Pauline played five years with the Quartz Hill Grange. And when Pauline was seventy-seven, she appeared on the television show, *You're Never Too Old*. At age eighty-one, she played at the Willow Springs Café on Mother's Day.

Details of Pauline Atterbury Gage Wilson's last years and the date of her death are not known.
Dorothy Bokelmann

Ethel Alice Bjornson Winternheimer

Educator Ethel Winternheimer moved to Las Vegas in 1950 with her husband, Walter, who had taken a job managing the La Rue Restaurant and Casino on the Strip. When his job ended, the couple stayed on.

As three decades passed, Ethel advanced from teacher to reading specialist in the local school district. She also worked for the University of Nevada, Las Vegas. Staton Elementary School bears her name.

Ethel Alice Bjornson was born on April 18, 1920, in Valley City, North Dakota. She was the sixth child of Norwegian immigrant Benjamin Bjornson, who worked in Pennsylvania coal mines at age fifteen, then became a dairy farmer in Valley City.

Ethel received her teaching credential from Valley City State University, and taught three years in Litchfield, North Dakota. During World War II, she took war-related work in California, where she met Walter Adam Winternheimer. They married on June 6, 1944, and settled in Baldwin Hills, where two sons—Darryl and Wayne—were born. Walt worked for the Bank of America.

1920—1999
TEACHER, READING CONSULTANT, UNIVERSITY MENTOR

Hollywood reporter William "Billy" Wilkerson, who had had built the Flamingo hotel with "Bugsy" Siegel, hired Walter when he opened La Rue, his own spot on the Strip. When it sold in 1952 to become the Sands Hotel, the new owners did not retain Walter. But the Winternheimers stayed put.

Ethel originally taught on a provisional certificate. But with a five-year contract at Stewart Elementary, she embarked on a four-year degree. She earned it from the University of Nevada, Reno in 1958 through correspondence courses plus summer and Saturday classes.

Ethel transferred to John S. Park Elementary. When it became a junior high, she moved to Crestwood Elementary. She taught the children of well known Las Vegans M.J. Christiansen, J.A. Tiberti, and Sam Boyd. On a recommendation from Tiberti, Judge John Mowbray requested a zone variance so his youngest son could be in Ethel's classroom. When the Clark County School District's school-naming committee considered Ethel's nomination, a grown Terrance Mowbray wrote that she "simply was the most effective mentor I ever had."

In April 1962 the National Council of Teachers of English congratulated Ethel for a sixty-two percent increase in membership—the highest in the nation—during the years she was president of the Nevada affiliate. She held posts in groups including the Nevada State Education Association, Nevada Department of Classroom Teachers, and the state panel for the National Right to Read.

Ethel received her master's degree in education from Northern Arizona University in Flagstaff in 1967, ending up with thirty-nine credits more than required.

In May 1968, Las Vegas school superintendent James Mason implemented a Reading Improvement Program (RIP) for struggling pupils. Ethel helped develop RIP, which targeted students who were not reading at grade level by the third grade, and served as one of its first teachers. In a May 25, 1972 evaluation, Ruth Watkins praised Ethel's methods and noted her "genuine concern for children, and makes each one feel of true worth."

Ethel's sons were both grown when Walter passed away. She filled her days with work.

From reading resource teacher, she was appointed a reading consultant to the district's reading management program. She trained teachers to use the program's diagnostic tools; she also developed a curriculum guide with sample lessons. She organized a reading council for grades kindergarten through twelfth, and served on it five years. From 1978 to 1980, she was the district's reading specialist.

Ethel lived many years alone in the pink house she and Walter had purchased in the late 1950s on Beverly Way near San Francisco Street, which is now Sahara Avenue. Through mutual church friends, she met John Staton, whom she married on October 14, 1978. Fulfilling one of their dreams, the two purchased a home on a fairway of Henderson's Black Mountain Golf Course.

After thirty years in education in Clark County, Ethel was feted at a retirement party at Sam's Town by former students, friends, and colleagues. However, retirement did not stick. Soon Ethel was supervising UNLV education students on their practicum requirements.

Always a leader, Ethel became president of the Clark County Museum Guild in 1990, serving two years. She drew in new members and increased meeting attendance, which led to successful projects such as Supper Under the Stars, addition of a patio, gazebo and memorial bench at the museum, and a cookbook fundraiser. Ethel also volunteered with the Nevada State Museum and Historical Society.

Ethel's Las Vegas doctors sent her to Scripps Memorial Hospital in LaJolla, California, to evaluate symptoms including weakness in her hands. The diagnosis was Lou Gehrig's disease. She took the news with her usual hope and courage.

Her husband John arranged a large support group to carry out Ethel's wish to remain at home. Hospital visits and stays at rehab became routine while she fought to be with family as long as possible. Ethel died on April 27, 1999, shortly after turning seventy-nine. She knew that a school would open in her name, though she never witnessed its dedication.

Joyce Winternheimer, daughter of Ethel Bjornson Winternheimer Staton

When the school district's school-naming committee considered Ethel's nomination, a grown student wrote that she "simply was the most effective mentor I ever had."

Bertha Rosanna Sanford Woodard

While growing up in Pasadena, California, Bertha Rosanna Sanford had no idea that one day she would be in the forefront of a national movement for justice.

Born on January 25, 1916, Bertha was the daughter of Samuel and Lillie Belle Sanford. Bertha met her husband, Ulysses Simpson "Woody" Woodard in Oakland, California, in 1946. He had operated a machine shop in Vallejo, but when he lost his lease, he moved to Oakland. He started working again for a former employer, Greyhound Lines, the inter-city bus company. Their wedding date is unknown.

After Bertha attended Pasadena City College, she left her parents' home to attend the Washoe Western School of Practical Nursing. She moved to Reno, and in the 1950s worked at Washoe Medical

1916–1999
NURSE, CIVIL RIGHTS ACTIVIST, CIVIC GROUP MEMBER

Center. She was the first black on the Nevada State Board of Nursing, and served from 1968 to 1975.

Bertha and Woody both worked for equal rights, particularly when members of the black community were charged with criminal offenses.

With every hair in place, Bertha was stylish but had a quiet demeanor. She led sit-ins and picket lines to protest racism in Northern Nevada. The Reno-Sparks chapter of the NAACP—then known as the National Association for the Advancement of Colored People—considers Bertha its matriarch. She served as its president from 1971 to 1976; her husband also led the chapter. She and Woody were pleased when Nevada recognized Martin Luther King Day, which removed one of the last vestiges of racism in the American West.

An example of Bertha's leadership occurred when she led a picket in Hawthorne to protest that the town's only restaurant was located inside a

> *Bertha organized a crusade to remove signs from Reno store windows that read, "No Indians, Negroes or dogs."*

casino that denied service to persons of color. Eventually the casino changed its policy.

Sammy Davis Jr. and Louis Armstrong were two of many black entertainers who were not allowed to lodge in the Nevada hotels where they performed. When either of the two came to Reno, Bertha made certain they had a place to stay, years before gambling magnate Bill Harrah invited them to stay at his ranch.

Likewise, there was a time when Reno's churches were not integrated. Bertha was grateful that the pastor and congregation of the United Methodist took her in after her arrival. She was the congregation's only black.

In her quiet way, Bertha moved things along so blacks could join the Reno fire department. She also organized a crusade to remove signs from Reno store windows that read, "No Indians, Negroes, or dogs." In 1959, before the Olympics were to be held in 1960 in nearby Squaw Valley, she petitioned the Reno City Council to lift its ban on minorities in local casinos for the event, but the ban stayed in place.

Bertha's diligence later bore fruit. In 1961, she was invited to attend Governor Grant Sawyer's signing of Nevada's first civil rights bill. It established the Nevada Commission on Equal Rights of Citizens, now known as the Nevada Equal Rights Commission. The bill declared that state policy is to "protect the welfare, prosperity, health and peace of all people of the state … without discrimination, distinction or restriction because of race, religious, creed, color, national origin or ancestry."

In 1981 the University of Nevada, Reno, honored Bertha with the Distinguished Nevadan Award, for outstanding service to the state. In May 1998, she was on hand when state Senator Joe Neal filed to be the first black candidate for Nevada governor, a race he did not win.

Shortly before her death on September 16, 1999, Bertha was planning a project with a group of students at the University of Nevada, Reno, to compile a comprehensive history of the civil-rights movement in Nevada. Her death reminded Nevadans of the truth of the African proverb, "Each time an elder passes, a library dies."

Members of the Nevada State Legislature conveyed their sympathies and condolences to Bertha's family. In the form of a resolution, they honored the legacy she left, acknowledging the breaking down of barriers and other dramatic changes in racial outlook that were the result of her strength and enthusiasm. The Woodard family deeded all Bertha's records to the NAACP in New York.

Nancy Sansone

Bibliography

ELLEN FINNERTY ALBRIGHT

Albright, Eileen. Personal notes of Eileen Albright. Special Collections, University of Nevada, Las Vegas libraries.

Junior League of Las Vegas, website at www.jllv.org/lv.

ELLA MARY MARQUAT ANDERSON

Tucker, Leola Anderson. Personal recollections of Tucker, who is subject's granddaughter.

KATHY ALFANO AUGUSTINE

Coolican, J. Patrick, "The late controller revealed a glimpse of her human side," *Las Vegas Sun*, July 13, 2006.

Entry, "Kathy August ine." Wikipedia, at http://en.wikipedia.org/wiki/Kathy_AUGUST INE.

Entry, "Ms. Kathy Marie Augustine." Zoominfo, at http://www.zoominfo.com/diretory/AUGUST INE_Kathy_548559227.htm, September 2010.

Haynes, Brian and David Kihara and Ed Vogel, "Augustine husband slits wrists," *Las Vegas Review-Journal*, July 15, 2006.

Puit, Glenn. *In Her Prime*. New York, the Berkley Publishing Group, 2009.

Ryan, Cy. "Guinn: August ine should resign." *Las Vegas Sun*, September 30, 2004.

Vogel, Ed. "August ine dies without regaining consciousness." *Las Vegas Review-Journal*, July 12, 2006.

Vogel, Ed. "State agency joins look into death of controller." *Las Vegas Review-Journal*, July 14, 2006.

DESSIE LOLA BASSETTE BAILEY

Harpster, Jack. *Helping Hands Helping Hearts: The Story of Opportunity Village*. Las Vegas: Stephens Press, 2007.

Obituary, Dessie Basset. *Bremerton Washington Sun*. No date supplied.

"Opportunity Village remembers one of its founders." *Las Vegas Sun*. April 17, 2000.

MARTHA GRUSS BARLOW

Entry, "Arthur Barlow." Historical records at ancestry.com/search.

Entry, "Martha Barlow." Historical records at ancestry.com/search.

Entry, "Martha Gruss." Historical records at ancestry.com/search.

Nevada: The Silver State. Carson City: Western States Historical Publishers, Inc. 1970.

Obituary, Arthur Barlow. *Mineral County Independent News*. September 12, 1984.

MARJORIE JACOBSON BARRICK

Las Vegas Review-Journal. May 6, 2007.

Las Vegas Sun. May 7, 2007.

Wikipedia.org.

ADALENE SPENCE BARTLETT

Pesek, Margo Bartlett. Oral interview by Mary Gafford of Pesek, who is subject's daughter. Date not supplied.

SELMA F. ABDALLAH BARTLETT

"Barlett Elementary dedicated Thursday." *Henderson Home News*, November 3, 1992.

Entry, "Mrs. Selma F. Bartlett." Clark County School District website, at www.ccsd.net.

"Henderson banker Barlett keeps the faith for 40 years." *Las Vegas Review-Journal*. April 19, 1994.

"Selma Bartlett." *Barlett Bighorn Newsletter*. October 29, 1992.

"Selma's Night." *Las Vegas Sun*. November 6, 1992.

BILLIE MITCHELL BATES

"Hoover Project helper retiring." *Las Vegas Review-Journal*. December 26, 1974.

"Billie Bates to moderate affirmative action panel." *Las Vegas Review-Journal*. September 4, 1975.

"Billie Bates will speak." *Las Vegas Sun*. November 12, 1976.

"Friendship Force executive named." *Las Vegas Review-Journal*. January 15, 1978.

"Teaching leadership natural for woman." *Las Vegas Review-Journal*. February 24, 1980.

"Parliamentarian honored." *Las Vegas Sun*. April 24, 1981

"Toastmistresses honor Boulder City resident." *Las Vegas Sun*. March 14, 1982.

"Area speakers attend Australia convention." *Las Vegas Sun*. July 9, 1982.

"Long-time resident turns 90." *Boulder City News*. January 10, 2002.

KATHY MACKLEY BATTERMAN

Bates, Kevin. "Medevac crash in Las Vegas kills Daughter-in-law of Topeka woman." *The Topeka Capital-Journal.* April 7, 1999.

Bowman, John M. "Victims in fatal crash were heroes." *Las Vegas Review-Journal.* April 28, 1999.

Entry, *Congressional Record.* April 25, 2006.

Entry, "Flight for Life." Wikipedia.org.

Entry, "Kathy L. Batterman," on Clark County School District website.

"Hospital board to discuss Flight memorial." *Pahrump Valley Times.* April 21, 1999.

Schoenmann, Joe.

Special report. "National EMS Memorial Service release names of 2009 honorees." *EMS Network News.* March 15, 2009.

FRANCES PUGH BEAUPEURT

Barritt family. Entry, "Frances Huntington Pugh." *Robert and Christina Barritt's Family History Pages,* at http://tree.barrittfamily.net/getperson.php?personID=I4177&tree=dyal_speckels.

Barritt family. Entry, "John Edward Beaupeurt." *Robert and Christina Barritt's Family History Pages,* at http://tree.barrittfamily.net/getperson.php?personID=I4177&tree=dyal_speckels.

Beaupeurt, Susan. Telephone interview of Beaupeurt by author Joyce O'Day, on September 29, 2011.

"Charter Day Luncheon Given by Century Club." *Nevada State Journal.* May 21, 1950.

Elder, Joan. "Good bye to winter clothes with 'Hello, Dolly' Styles." *Nevada State Journal.* February 28, 1965.

Entry. Daughters of the American Revolution, Nevada Sagebrush Chapter. DAR chapter website at http://darinnevada.org/sagebrush.htm.

Entry, "20th Century Club." National Park Service website, at http://www.nps.gov.

Entry, "About GFWC, History & Mission." General Federation of Women's Clubs website, at www.gwfc.org.

Entry. *Kansas City Star.* May 12, 1956.

Entry, online. *Nevada Observer: Nevada's Online State Journal.* June 21, 2007.

"Malone names his secretary: Edward F. Beaupeurt appointed to post." *Reno Evening Gazette.* December 20, 1946.

Melarky, Alice. "Mrs. Beaupeurt honored by Pythians." *Nevada State Journal.* August 14, 1958.

Melarky, Alice. "Mrs. J. E. Beaupeurt heads Reno Women's Civic Club." *Nevada State Journal.* April 13, 1958.

Melarky, Alice. "Women's Clubs receptions of awards." *Nevada State Journal.* April 13, 1958.

Mergen, Katharine N. "State officers are installed by Federation." *Reno Evening Gazette.* April 21, 1956.

Obituary. *Reno Gazette Journal.* January 23, 1990.

Thornton, Hale. Telephone interview of Thornton by Joyce O'Day. October 10, 2011.

ISABELLE SLAVIN BLACKMAN

Blackman, Isabelle Slavin Cuddy. Blackman notes, which are numbered pages 86, 87, 88. Author Fran Haraway presumes, but cannot verify, that pages come from *Past Presidents of the Mesquite Club, 1911–1967.*

Entry, "Alfred W. Blackman." Historical records at ancestry.com/search.

Entry, "George Bass Blackman." Historical records at ancestry.com/search.

Entry, "Charles Leo Slavin." Historical records at ancestry.com/search.

Entry, "Mesquite Club." *Online Nevada Encyclopedia,* at onlinenevada.org.

Entry, "Mesquite Club." *Las Vegas Review-Journal,* community links online.

Hammelrath, Catherin Slavin. "Remembering the Blackman Family." Las Vegas Centennial 1905–2005 website, at lasvegas2005.org.

EMMA LOU MONTGOMERY BRANDT

Brandt, Emma Lou. Oral interview of Brandt by Betty Middleton and Jean Spiller. Date not supplied.

Brandt, Bob and wife, Gayle. Emma's son Bob reviewed and approved the oral interview. Date not supplied.

HOPE GAUFIN BROADBENT

"Mining our richest veins: Eleven residents who are White Pine's true treasures." Ely Renaissance Society. 2000.

Obituary, "Hope Gaufin Broadbent." *Las Vegas Review Journal.* February 27, 2002.

Wikipedia.org.

JANE HOPKINS BROADFOOT

Jacque Cutler. Interview of Broadfoot's daughter, Cutler, by author Tish Campbell. Date not supplied.

Sandra Johnson. Interview by Campbell of Johnson, who was a friend of Broadbent. Date not supplied.

Nevada Athletic Commission.

EILEEN MILSTEIN BROOKMAN

Biography of Brookman. Women's Research Institute of Nevada.

Papers of Brookman. "Guide to the Eileen Brookman Collection." Collections EAD 1995–14. Special Collections, University of Nevada, Las Vegas Libraries.

Nevada Women's History Project.

LUCILLE KOENIG BROWN

Brown, Cecile. Written recollections by Brown, who is subject's daughter-in-law. Undated.

Merenthaler, John. Article in *Buenos Aires Herald*. Undated.

"Woman sheriff has 20 years of experience." *Sacramento Bee*. Date not supplied.

RUTH WESTON BROWN

BBC News. November 18, 2006.

Bernstein, Adam. *Washington Post*. November 18, 2006.

Brown, Ruth, and Andrew Yule. *Miss Rhythm, the Autobiography of Ruth Brown, Rhythm and Blues Legend*. New York: Donald Fine Books, 1996.

Entry, "Ruth Brown." Rock and Roll Hall of Fame Museum, at www.rockhall.com/inductee/ruth-brown.

Entry, "Ruth Brown." Wikipedia.org.

Goldberg, Marvin. *Marvin Goldberg's R&B Notebooks*. 2005.

Pareles, Jon. *New York Times*. November 18, 2006.

Press release. "Memorial evening to honor the legendary Ruth Brown." Rhythm and Blues Foundation. January18, 2007.

LUCILE SPIRE BRUNER

Bruner, Dr., January email from Bruner in Salona Beach, California, to author Lois Evora. Date not supplied.

Obituary, Lucile Bruner. *Las Vegas Review-Journal*. November 26, 1998.

Program. Lucile S. Bruner Elementary School's dedication and reception program. October 20. 1994.

Woods, Vivian. "Lucile Spire Bruner's monumental role in developing Southern Nevada's Culture." *Nevada Senior World*. November 1983.

Woods, Vivian. "Lucile Spire Bruner." Biography written for the Las Vegas Mesquite Club. Date not supplied.

LUCILE WHITEHEAD BUNKER

McKinnon, Sean. "Nevada public servant Bunker dies at age 92." *Las Vegas Review-Journal*. January 2, 1999.

Recollections of Bunker family members, gathered by author Loretta Derrick. Dates not supplied.

FLORENCE SANDFORD BURGE

Entry, "Florence Burge." Historical records at ancestry.com/search.

"Guide to the records of Florence Burge." Special Collections, University of Nevada, Reno.

Nevada State Journal. No date supplied.

Reno Evening Gazette. No date supplied.

HELEN CASE CANNON

Cannon, Helen. Interviews of Cannon by author Dorothy Bokelmann on June 19 and August 24, 2007.

Cox, Judith A. "Helen C. Cannon Middle School Tribute." May 10, 2007.

Healy, Rick. Article in *Nevadan*, Sunday magazine of *Las Vegas Review-Journal*. January 15, 1989.

Williams, B.J. "Women Airforce Service Pilots." Pamphlet created July 1991.

"Women Airforce Service Pilots, WWII." Sweetwater Chamber of Commerce and Visitors Bureau. No date supplied.

JUDY EDSALL CARLOS

"Longtime Sun reporter, columnist Carlos dies at 67." *Las Vegas Sun*. September 4, 2003.

MARGARET CASEY

Casey, Annie. Author Mary Gafford interviewed Annie, who is Margaret Casey's daughter. Date not specified.

Casey, Margaret. Subject of interview by Gafford. Date not specified.

MARILYN CHAMBERS

Entry, "Marilyn Chambers." Wikipedia.org.

Rogers, John. "X-Rated star Marilyn Chambers dies at 56." Associated Press. April 13, 2009.

Website titled Personalchoice.org. 2004.

LEONA GUDMUNDSON CLARK

Clark, Leona Gudmundson. Author Jeannette Oxborrow Clark interviewed and spoke informally with Leona, her mother-in-law, on numerous occasions. Dates not supplied.

Obituary. *Las Vegas Review-Journal.* December 6, 2000.

TONI GAGLIONESE CLARK

Dondero, Thalia. Author Carolyn Lake communicated with Dondero. Date not supplied.

Finuf, Larry. Author Carolyn Lake communicated with Finuf. Date not supplied.

Goodwin, Dr. Joanne L. Author Carolyn Lake communicated with Goodwin, director of the Las Vegas Oral History Project.

Koch, Ed. *Las Vegas Sun.* Author Carolyn Lake communicated with Koch. Date not supplied.

Las Vegas Sun website, at http://www.lasvegassun.com/history/implosions/

Las Vegas Sun website, at http://www.a2zlasvegas.com/hotels/history/h-di.html

Martin, Marydean. Author Carolyn Lake communicated with Martin. Date not supplied.

DR. ANGELA WEBB CLARKE

David, Marc. "Angela Clarke packs big punch in senior community." *S, The Magazine of Summerlin.* May 2004.

Obituary. *Las Vegas Review-Journal.* June 27, 2010.

MARGARET PHELAN COLEMAN

Coleman, Margaret. Autobiography obtained from the Mesquite Club.

Entry. Website of Chicago Cubs baseball team.

Flanagan, Tanya. "First woman on Planning Commission dies." *Las Vegas Review-Journal.* December 29, 1995.

Palm Mortuary Chapel at Jones Boulevard and Oakey Avenue, Las Vegas. Leaflet from Coleman funeral.

MARGARET JANE DAILEY COLTON

Funeral card from service held May 25, 2000.

Internet website, at http://www.quehoposse.org/duplex.html.

Meyer, Dale. Personal remembrances of Colton by author Meyer, who was the subject's sister.

Rogers, Ben. "General store owner dies at 83." *Las Vegas Review-Journal.* May 24, 2000.

MARY MELITA SMITH COOMBS

"Artists, They paint, study, exhibit." *Reno Evening Gazette.* February 22, 1975.

"Desert Wash." Nevada Watercolor Society. January 2009.

Obituary. *Las Vegas Review-Journal.* November 30, 2008.

ETHEL DOLORES "D.D." COTTON

Cotton, D.D. Oral interview of Cotton conducted by author Claytee White on February 14, 1997. Special Collections, University of Nevada, Las Vegas, Libraries.

MARCIA SMITH deBRAGA

"Friends, Family Remember Marcia deBraga's Devotion." Published on daylife.com, a website.

"Marcia deBraga authors dig no graves for us." *Reno Evening Gazette.* April 23, 1964.

Nevada Landsmen's Association Communique. May 8, 2000.

Ranson, Steve. "Friends remember Marcia deBraga's love for her state and Youth Rodeo." *Lahontan Valley News.* March 25, 2010.

Ranson, Steve. "SSIR: deBraga's desire led to creation of rodeo." *Lahontan Valley News.* July 6, 2010.

Wallace, Brooks. "Reid loses it." Nevada Journal. September 2010.

Zanjani, Sally Springmeyer. *Devils Will Reign: How Nevada Began.* Reno: University of Nevada Press. 2006.
"2001 Winners." Rutgers: Center for American Women and Politics.

CHERIE DeCASTRO
Entry, "Cherie DeCastro." Wikipedia.org.
Entry, "Peggy DeCastro." *New York Times.* April 21, 2004.
Grimes, William. Obituary of Cherie DeCastro. *New York Times.* March 24, 2010.
Las Vegas Sun. July 4, 2001.
Variety magazine. March 22, 2010.
Whitburn, Joel. *Billboard Book of Top 40 Hits,* seventh edition. *Los Angeles Times,* March 23, 2010.

JOANNE CUTTEN DE LONGCHAMPS
A Guide to the Papers of Joanne De Longchamps Collection No. 84–09. Matthewson-IGT Knowledge Center.
 University of Nevada, Reno.
Kloss, Pat. Biographical sketch of Cutten de Longchamps, revised by Nancy Oakley.

RUTHE GOLDSWORTHY DESKIN
Anderson, Tim. Interview at KNPR radio station. Nevada State Museum and Historical Society. February 5,
 1988.
Biography, Ruthe Deskin. Nevada Women's Archives, online at http://wrinunlv.org/research/our-history-
 profiles-of-nevada-women/ruthe-deskinm/
Entry, about Ruthe Deskin Elementary School. Clark County School District website.
Green, Michael. "Ruthe Deskin." *Online Nevada Encyclopedia,* at http://www.onlinenevada.org/ruthe_deskin.
Las Vegas Sun, online at
http://www.lasvegassun.com/news/2008/may/15/hank-greenspuns-lasting-legacy/
Nevada Women's Archives. Collection number 95–037. Special Collections, University of Nevada, Las Vegas,
 Libraries.
Obituary. *Las Vegas Sun.* February 16, 2004.

DOROTHY BUCHANAN DOROTHY
Andreeva, Tamara. "The women of Nevada—Dorothy Dorothy." Special Collections, University of Nevada, Las
 Vegas, Libraries.
Dorothy, Dorothy. Autobiographical sketch. Special Collections, University of Nevada, Las Vegas, Libraries.

GLADYS KEATE DULA
Blackman, Isabella Slavin. *Biographies of Past Presidents of Mesquite.* Unpublished book.

LILLY HING FONG
Fong, Lilly. "My Roots: The story of a 20th century Chinese American Family." *Gold Hill News.* Date not
 supplied.
Clark County School District. File titled "Naming of School Facilities." The file includes letters from Ken Fong,
 Jim Miller, and Vernon Burk, as well as a program for the Fong Elementary School's dedication and reception.
Patton, Natalie. "Fong, former member of Board of Regents, dies." *Las Vegas Review-Journal.* March 31, 2002.

LOUISE LORENZI FOUNTAIN
Entry, "Lorenzi Park Twin Lakes." Official website of Las Vegas city government.
"Lorenzi scion Fountain was link to LV past." *Las Vegas Review-Journal.* February 3, 2006.
"Lorenzi Park Collection," MS 026. Nevada State Museum and Historical Society.
"Louise Fountain. *Las Vegas Review-Journal.* January 31, 2006.

ESTELLE KELSEY GIVENS
Blackman, Isabelle Slavin. Personal papers.
Mesquite Club. Club records.

ALICE VIRGINIA WOOD GOFFSTEIN
Bingham, Bob. Telephone interview conducted by author Norma Jean Harris Price. Date not supplied.
Chung, Su Kim. Emails exchanged by author Price with Chung, who works in Special Collections at the

University of Nevada, Las Vegas, Libraries. Dates not supplied.

Feeney, Marie. Telephone interview and emails with Feeney conducted by author Price. Date not supplied.

Goffstein, Faith. Telephone interview and emails with Goffstein conducted by author Price. Date not supplied.

Obituary. *Las Vegas Review-Journal.* July 20, 2005.

Obituary. *Las Vegas Sun.* July 20, 2005.

Variety Clubs, Las Vegas Tent #39. In-person visit to view scrapbooks and telephone interview by author Price.

Wilson, Doris. Emails by author Price with Wilson, who was Goffstein's close friend, biographer, and spokeswoman for the Goffsteins.

POLLY GONZALEZ

Cesare, Cindy. Online material by Cesare, a KLAS-TV reporter, on station's *Las Vegas Now* website.

KLAS-TV station. Station website, titled *Las Vegas Now.*

3. Krull, Kathleen. *Harvesting Hope, the Story of Cesar Chavez.* San Diego, California: Harcourt Inc., 2003.

Latin Chamber of Commerce. Newsletters.

Mendoza, Rosa. Personal interview by Norma Price, the author, of Menedoza, a local schoolteacher.

Vicente Montoya.

Mondeau, Adrian Garcia. Personal interview by author Price of Mondeau, who was Gonzalez' piano teacher and vocal coach. Date not supplied.

Montoya, Vicente. Personal interview by author Price of Montoya, an immigration attorney who belongs to Si Se Puede Latino Democratic Club. Date not supplied.

Morales, Estella. Personal interview by author Price of Morales, who is with the Democratic Hispanic Caucus. Date not supplied.

Niemeyer, Erin. "Anchor of Hope." *Las Vegas Sun.* June 21, 1996.

Obituary. *Las Vegas Review-Journal.* March 29, 2005.

Price, Norma, author of profile. Personal observations of Polly Gonzalez Memorial Park.

Rodriguez, Thomas. Personal and telephone interviews by author Price of Rodriguez, who is an educator, author and executive manager of the Clark County School District's programs for diversity and affirmative action. Rodriguez is also recording secretary of the Latin Chamber of Commerce. Date not supplied.

VERA EVA WITTWER HARDY

Davenport, Effie. "Desert Echoes." *Valley Herald.* June 1984.

"Moapa Valley's Mother of the Year, Vera Hardy." *Moapa Valley Progress.* May 4, 1994.

Whipple, Elaine. Interview of subject's daughter by author Jean Spiller. Date not supplied.

BUNNY LONGBOTHAM HARRIS

Ballentine, Shannon. "Bunny Harris, Older Adult Interview." Midterm paper, unpublished. Date unknown.

Harris, Bunny. Resume. Date unknown.

"History of the Supreme Emblem." National Emblem Club. Online at www.emblemclub.com.

Koch, Ed. "Longtime business, civic leader Harris dies at 88." *Las Vegas Sun.* June 6, 2005.

Obituary. *Las Vegas Review-Journal.* No date supplied.

Shirkey, Pamela and Mona Vandever. "In memory of past Supreme President Bunny Harris." National publication of the Supreme Emblem Club of the United States.

EDITH CLAIRE POSENER HEAD

Fashion Designer Encyclopedia.

Wikipedia.org.

LOMIE GRAY HEARD

Obituary. *Las Vegas Review-Journal.* February 11, 2009.

HELEN KOLB HERR

Biography. Women's Research Institute of Nevada.

"Distinguished Alumnus Award Recipients." Valley City State University website.

"Media Gallery." *Online Nevada Encyclopedia,* at www.onlinenevada.org.

Puit, Glenn. "Helen Herr, first woman in the Nevada Senate, dies at age 91." *Las Vegas Review-Journal.* July 2, 1999.

"Women's Biographies." Nevada Women's History Project.

MABEL WELCH HOGGARD
Biography of Mabel Welch Hoggard. Women's Research Institute of Nevada.
LaCombe, Nancy, school counselor at Mabel Hoggard Elementary School. Provided historical information.

JEANNE WALSH HOOD
Adams, Ken. "Whatever will help! A woman's rise to the top in the gaming industry, as remembered by Jeanne Hood." Reno: University of Nevada, Oral History Program. 2006.

BARBARA JOANNE THOMAS HUNTER
Hunter, Barbara. "My personal biography," unpublished, left to Mesquite Club.
Obituary. *Las Vegas Review-Journal.* October 15, 2011.
Partridge, Carl. Personal interview of Partridge, an artist and fellow exhibitor, by author Mary Gafford. Date not supplied.

JUNE CALDER HUNTINGTON
Personal recollections of the author, Barbara Huntington White, about the subject, who was White's mother.

BILLIE JEAN HICKEY JAMES
Booth, Ursula Wilson on Facebook.
Bryant, Brenda on Facebook.
Cayot, Dr. Linda, of the Galapagos Conservancy.
Davis, Mary on Facebook.
Gaddis, Bernard and Charmaine Hunter, artistic directors of Las Vegas Contemporary Dance Theater.
Griffin, Shaun T., editor. *Desert Wood, An Anthology of Nevada Poets.* Reno: University of Nevada Press. September 1991.
Jourdan, Kristi. "Woman found dead amid clutter became compulsive." *Las Vegas Review-Journal.* September 5, 2010.
Miscellaneous interviews of subject's friends by author Norma Jean Harris-Price. Dates not supplied.
Roth, Kelly and Leslie, in dance department at College of Southern Nevada. Both are artistic directors of Dance in the Desert.
Saporito, Desiree, on Facebook.
Tomiyasu, Cisco, on Facebook.

VELMA BRONN JOHNSTON
Barendse, Michael. "Johnston, Velma B." Website of Learning to Give, at learningtogive.org/papers/paper344. html.
Cruise, David and Alison Griffiths. *Wild Horse Annie and the Last of the Mustangs.* New York: Scribner division of Simon & Schuster Inc. 2010.
Megles, Suzanne. "Betrayal of the Wild Horse Annie Act of 1971." Published online at OpEdNews.com.
"The Story of Wild Horse Annie." International Society for the Protection of Mustangs and Burros. Online at http://www.ispmb.org/AnniesStory.html.
"The Wild Horse Annie Act." American Wild Horse Preservation Campaign, online at http://www. wildhorsepreservation.org/resources/annie_act.html.

MARY KA'AIHUE KAYE
Brooks, Tim. "Mary Kaye." *Guitar Player.* September 2006.
Butcher, Len. "Popular trio of the '50s and '60s left its mark on entertainment industry." *Las Vegas Review-Journal.* January 10, 2002.
Kaye, John. "Stories of the Mary Kaye Trio." Las Vegas Historical Preservation Society: Heritage Makers. 2006.
"Mary Kaye." Celebrity Rock Star Guitars website. Online at http://www.celebrityrockstarguitars.com/rock/ kaye_mary.htm.
"Mary Kaye 1923–2007." *Fender News.* Online at fender.com.
Moseley, Willie G. "Mary Kaye: Beyond the Stratocaster connection." *Vintage Guitar Magazine.* March 29, 2006.
"Nightclubs: Natural-Seven Muzak." *Time* magazine. August 11, 1961.

Weatherford, Mike. *Cult Vegas*. Las Vegas: Huntington Press, 2001.

Weatherford, Mike. "Guitarist Mary Kaye dies at 83." *Las Vegas Review-Journal*. February 18, 2007.

Worth, Steven. "Mary Kay Trio: The birth of the Las Vegas lounge scene." On website of boingboing.net.

ANNA DEAN NOHL KEPPER

"A brief history of UNLV Special Collections." Special Collections. University of Nevada, Las Vegas, Libraries.

"Biographical Sketch." Anna Dean Nohl Kepper papers. Nevada Women's Archives. Special Collections. University of Nevada, Las Vegas, Libraries.

Biography. Women's Research Institute of Nevada.

Hopkins, A.D. "Anna Dean Kepper." *The First 100: Portraits of the Men and Women who Shaped Las Vegas*. Las Vegas: Huntington Press, 2000.

ALICE MARIE JULIET KEY

"Alice Key, Renaissance Woman." *Online Nevada Encyclopedia*, at www.onlinenevada.org.

Biography. Women's Research Institute of Nevada.

Obituary. *Las Vegas Review-Journal*. October 9, 2010.

Wikipedia.org.

MARTHA PIKE KING

Dedication. *The Aquila* yearbook. 1967.

Entry, "The Singletary-Dunham Family." RootsWeb, a website at www. rootsweb.ancestry.com.

"Martha P. King." Clark County School District website.

McBride, Dennis, "An oral history interview with Emory and Agnes Lockette." Boulder City Library Oral History Project. Boulder City, Nevada. 1996.

BRUNETTA MAE KELLS LENZ

Obituary. *Las Vegas Review-Journal*. July 10, 2010.

Obituary. "Modeling pioneer Bernie Lenz passes away." Website, at www.examiner.com. July 2, 2010.

Obituary. "Modeling pioneer thrived as teacher, entrepreneur." *Las Vegas Sun*. July 9, 2010.

DestinationVegas. Website of talent management firm, at www.destinationvegas.com.

CELESTA LISLE LOWE

Lowe, Celesta. Interview of subject conducted by author Mary Gafford.

Obituary. *Las Vegas Review-Journal*. December 13, 2004.

SISTER ROSEMARY LYNCH

Blasky, Mike. "Walking with God." *Las Vegas Review-Journal*. January 11, 2011.

Butigan, Ken. "Remembering Sr. Rosemary Lynch (1917–2011)." *Pace e Bene*, online at www.paceebene.org. January 14, 2011.

Sadowski, Dennis. "The nun who fought nuclear testing dies from injuries suffered in accident." *U.S. Catholic*. January 14, 2011.

Smith, John L. "For the late Sister Rosemary, peace was to be passed to all." *Las Vegas Review-Journal*. January 23, 2011.

Valley, Jackie. "Sister Rosemary Lynch, 93, founder of group against violence, dies after car hits her." *Las Vegas Sun*. January 11, 2011.

MABEL CLARA WHITNEY MACFARLANE

Author Joyce Cory relied on conversations with relatives of the subject, who also supplied some family history materials.

MARIE LOUISE HUNGERFORD MACKAY

Berlin, Ellin. *Silver Platter*. Garden City, New York: Doubleday & Co. 1957.

DeQuille, Dan (pen name of William Wright). *The Big Bonanza*, 1876. Reprint, Las Vegas: Nevada Publications. 1974.

Makley, Michael J. *John Mackay, Silver King in the Gilded Age*. Reno: University of Nevada Press. 2009.

Manter, Ethel. *Rocket of the Comstock*. Caldwell, Idaho: Carton Printers Ltd. 1950.

FLORENCE ELBERTA SCHILLING McCLURE

Distinguished Women and Men in Southern Nevada, a series. Carole Bellmyre, publisher. 2002.
McClure Dunn, Carolyn. Personal writings. 2010.

KARLA BOHAC McCOMB

Distinguished Women and Men in Southern Nevada, a series. Carole Bellmyre, publisher. Edition not supplied.
Obituary. *Las Vegas Review-Journal*. June 16, 2006.

ELIZABETH HAZEL PENROSE McKAY

Lucas, Elizabeth P. The author recalled her personal conversations and experiences with the subject, who was her grandmother.

ANN RITTENHOUSE McNAMEE

Entry, "John McNamee." *Nevada State Journal*. September 29, 1977.
Entry, "McNamee, Leo." Historical records online at www.ancestry.com/search.
Moehring, Eugene P. and Michael S. Green. *Las Vegas: A Centennial History*. Reno: University of Nevada Press, 2005.
Norman, Jean Reid. "McNamee, member of pioneer family of attorneys, dies at 68." *Las Vegas Sun*. December 10, 2003.
Obituary, "Franklin Rittenhouse." *Las Vegas Review-Journal*. March 7, 1999.
Obituary, "McNamee, Ann." *Las Vegas Review-Journal*. June 2, 2007.
Obituary. "Prominent Attorney Rittenhouse Dies." *Las Vegas Sun*. March 8, 1999.
"Waynesburg University Alumni and Friends." Waynesburg University website.
"Woodlawn Cemetery." Las Vegas official city website, at http://www.lasvegasnevada.gov/TextOnly/FactsStatistics/10662.htm.

EVE WICK MOSS

None supplied.

VIRGINIA MOREIRA MOURA

Historical records, online at www.ancestry.com/search.
Nevada: The Silver State. Carson City: Western States Historical Publishers Inc. 1970.

LEONA DAOUST MUNK

Entry, "Leona Munk." Historical records at www.ancestry.com/search.
Entry, "Niels Christian Munk." Historical records at www.ancestry.com/search.
Peek, Samuel Charter. *A Volume of Memoirs and Genealogy of Representative Citizens of Northern California*. 1901.
Pripps, Robert N. *John Deere Photographic History*. Osceola, Wisconsin. 1995.

COLANTHE FLORENCE JONES MURPHY

Obituary, "Florence Murphy." *Las Vegas Review-Journal*. January 27, 2006.
Hopkins, A.D. and K.J. Evans, editors. *The First 100: Portraits of Men and Women Who Shaped Las Vegas*. Las Vegas: Huntington Press. 2000.

DR. RENA MAGNO NORA

"Art of Recovery Auction and Charity Golf Tournament." Foundation for Recovery. July 13, 2001.
"Dr. Rena Magno Nora." Filipina Women's Network. July 13, 2011.
Obituary, "Demetrio Nora, M.D." *Las Vegas Review-Journal*. October 29, 2008.
Obituary, "Rena Nora, M.D." *Las Vegas Review-Journal*. November 11, 2008.
"Rena Nora, M.D." Nevada Council on Problem Gambling. July 13, 2011.

D'VORRE "DEE" OBER

Ober, Scott. Interview of Ober, the subject's son, by author Donna Gavac on May 4, 2011.
Obituary, "D'Vorre Ober." *Jewish News of Greater Phoenix*, online. May 23, 2008.
Obituary, "D'Vorre Ober." *Las Vegas Review-Journal*. May 20, 2008.
Online material. Clark County School District website, at http://schools.ccsd.net/ober/namesake.html.
Visit to D'Vorre and Harold Ober Elementary School by author Gavac on April 14, 2011.

This included interviews with members of the school staff.

ANNA ROBERTS PARKS

Jennings, Julie. Personal papers. September 13, 1999.

Gaffey, Patrick. *Las Vegas Life.* January 2002.

Whitely, Joan. *Las Vegas Review-Journal.* September 6, 2001.

EDNA BURKE PATTERSON

Branscomb, Mary. *Edna Patterson, Lamoille's distinguished Nevadan. Free Press* Extra. Elko, Nevada. July 17, 1990

"Dread disease appears in Salina. Children of Howard Burke have infantile paralysis." *The Salina Semi-Weekly Journal.* October 11, 1910.

Patterson, Edna B. *Home Means Nevada: The Autobiography of Edna B. Patterson and the History of the Patterson Family and their Life in Nevada.* Unpublished. Special Collections, University of Nevada, Reno, Libraries.

MINNE A. PETERS

Andress, Donna Jo Harvey. Personal recollections of author's experiences with the subject, who was the author's teacher.

Oral history of George Gordon Colton. Special Collections. University of Nevada, Las Vegas, Libraries.

Reid, Harry. *Searchlight, the Camp that Didn't Fail.* Reno: University of Nevada Press. 2007.

ANNABELLE PLUNKETT

Koch, Ed. *Las Vegas Sun.* January6, 2007.

Larsen, Lt. Dennis (staff historian who did research for author Norma Jean Harris Price). Las Vegas Metropolitan Police Department.

Las Vegas Metropolitan Police Department webiste, at www.lvmpd.com.

Luchs, Kelli (librarian). Women's Studies Archives, University of Nevada, Las Vegas.

BERTHA JANE MATTSON PURDY

Minutes of December 13, 1956 meeting. Board of Regents of University and Community College System in Nevada.

Purdy, Bertha. Personal writings and scrapbooks.

Watts, Carma Baker. The author used recollections of conversations and experiences with the subject, who was her grandmother.

Wikipedia.org.

BERTHA BERRY RAGLAND

Caruso, Monica. *Las Vegas Review-Journal.* September 2, 1997.

German, Jeff. *Las Vegas Sun.* September 30, 2005.

Jones, Chris. *Las Vegas Review-Journal.* September 28, 2005.

Koch, Ed. *Las Vegas Sun.* September 28, 2005.

Obituary. *Las Vegas Review-Journal.* September 28, 2005.

AGATHA PETTINGER ROBERTS

Bach, Lisa Kim. "Horticulturist Roberts dies at age 87." *Las Vegas Review-Journal.* May 19, 2006.

Hinton, Karen (dean and director). *Communique.* University of Nevada Cooperative Extension.

Levins, Pam Roberts. Interview by authors Fran Haraway and Nancy Sansone with Roberts, daughter of the subject. Date not supplied.

Mills, Linn. "Gardening: Aggie Roberts had a magic touch when it came to plants." *Las Vegas Review-Journal.* June 1, 2006.

Mrs. Green Thumb. "Goodbye, old friend." *Desert Gardener.* May 1, 2006.

Nevada Senate Concurrent Resolution 16: "Memorializes respected horticulturist and longtime Las Vegas resident Aggie Roberts." Nevada State Legislature. March 21, 2007.

Tucker, Laura. "A green thumb for life." *The View: Green Valley-Henderson.* June 6, 2006.

LUCIELL ROHLMAN

"Going Broke: A Special Report." AARP Bulletin. May 2011.

Las Vegas Perspective, page 23. 1998.

Obituary, "Luciell Rohlman." *Las Vegas Review-Journal.* August 17, 1999.

Speranza, Nicholas (Henderson resident who has never driven a car). Personal interview with author Donna Gavac about his patronage of the senior bus service. May 10, 2011.

"Western News" on volunteerism rates by state. AARP Bulletin. April 2011.

COLLEEN CARROLL SCHROEDER

Amon, Michael. "Philanthropist Schroeder dead of cancer at 71." *Las Vegas Review-Journal.* June 23, 1999.

Interview with Schroeder. Date not supplied.

ALICE LUCRETIA SMITH

Voices of Black Nevada. Bureau of Governmental Research. University of Nevada. 1971.

Who's Who Among Black Americans. Northbrook, Ill.: 1975–1976 edition.

Wikipedia.org.

JANET CURTIS SMITH

"Killer of girl in casino gets life term." *New York Times.* October 15, 1998.

Koch, Ed. "Smith, longtime resident, Goodsprings JP, dies." Las Vegas Sun. April 13, 2005.

Lake, Richard. *Las Vegas Review-Journal.* April 13, 2005.

Lichtblau, Eric and Nora Zamichow. "Guilty Plea in Casino Slaying." *Los Angeles Times.* September 9, 1998.

Puit, Glenn. "Gag order issued in slaying." *Las Vegas Review-Journal.* June 5, 1997

LOUISE ALOYS SMITH

Bennett, Dana R. *Women in the Nevada Legislature: 1818–2003.*

Entry, "Aloys Smith." Historical records at www.ancestry.com/search.

Entry, "Aloys Smith." *Nevada Statutes, Resolutions and Memorials.* File #50 AR 8.

Entry, "Aloys Smith." Special Collections, University of Nevada, Reno.

Nevada: The Silver State. Carson City: Western States Historical Publishers Inc. 1970.

Smith, Eugene Kneeland. *Journal of the American Medical Association.* Reprint 103/4/274-a.

MARY EVELYN STUCKEY

LaGrange, Joyce Ahern. Interview of LaGrange, a Rhythmette, by author Susan Houston. Las Vegas. 2008.

Las Vegas High School—Its People, Its Impact. Compilation of *Las Vegas Sun* articles. 1992.

Press release. Nevada Department of Cultural Affairs. 2007.

Smith, Dexter. "Miss Mary Evelyn Stuckey." Unpublished paper. Special Collections. University of Nevada, Las Vegas, Libraries. May 13, 1964.

Stuckey, Evelyn. Personal papers. Collection 86–056. Special Collections. University of Nevada, Las Vegas, Libraries.

SHEILA TARR-SMITH

"Fond Farewell." *Las Vegas Review-Journal.* August 22, 1998.

"Myron Patridge Stadium and Sheila Tarr-Smith Field." Official athletics website of the University of Nevada, Las Vegas, at www.unlvrebels.com.

Obituary, "Sheila Tarr-Smith." *Las Vegas Sun.* August 19, 1998.

"Sheila Tarr-Smith Inducted." Southern Nevada Sports Hall of Fame. 1998.

"Who was Sheila Tarr?" Article on Clark County School District website.

DORIS HIGGINSON TROY

"Harlem Renaissance." *Microsoft Encarta Online Encyclopedia.* 2008.

Jancik, Wayne. *Billboard Book of One-Hit Wonders.* Billboard Books. 1998.

Koch, Ed. "'Just One Look' singer finally gets her due." *Las Vegas Sun.* April 6, 1996.

Nadler, Art. "'Just One Look' singer, stage star Troy dies at 67." *Las Vegas Sun.* February 19, 2004.

Nathan, David. *Soulful Divas.* Billboard Books. 1998.

Rowan, Beth and Borgna Brunner. "Great Days in Harlem." Wikipedia.org.

Wikipedia.org. (Entries for: Doris Troy, Elton John, "Just One Look," Rev. Higginson, rhythm and blues, Simon Bell).

ALICE BACON TURNER

"Community volunteer turner dies at 104." *Las Vegas Sun*. December 10, 2002.

Obituary, "Alice Turner." *Las Vegas Review-Journal*. December 10, 2002.

Obituary, "Mary Alice Simpson." *Las Vegas Review-Journal*. October 19, 2008.

Obituary, "Thomas Turner." *Las Vegas Review-Journal*. May 14, 2008.

NORA BLOOM ULLOM

Ullom, John Lawrence "Buzzy." Ullom, the subject's son, gave multiple interviews to author Mary Gafford. Dates not supplied.

Entry, "J.T. Ullom Elementary School." Official website of the Clark County School District.

KAY NOVAK WALLERSTEIN

"Distinguished Residents of Hillside Memorial Park and Mortuary." Website of Hillside Memorial Park in Los Angeles.

Koch, Ed. "Former leader of LV Jewish community Wallerstein dies." *Las Vegas Sun*. July 2, 2003.

Marschall, John P. *Jews in Nevada: A History*. Reno: University of Nevada Press. 2008.

Oliver, Myrna. "Robert Wallerstein, 76: L.A. Judge has handled contracts of writers." *Los Angeles Times*. April 30, 2003.

"Temple Beth Sholom—Mission and History." Website of Temple Beth Sholom, online at templebethsholomlv. org.

PHYLLIS WALSH

"Longtime volunteer Phyllis Walsh dies." *Reno Gazette-Journal*. March 19, 1985.

"UNR students learn the ropes of ranching on a real ranch." *Las Vegas Review-Journal*. July 1, 1998.

Walsh, Phyllis J. *From Lorgnettes to Lariats: In Loving Recollection of the S Bar S Ranch, Where Hard Work Hardened our Hands while Visitors Lightened our Hearts*. Oral history conducted by Mary Ellen Glass. Oral History Program, University of Nevada, Reno. 1973.

EMILIE NORMA WANDERER

Biography. Women's Research Institute of Nevada.

Records. Project Vote Smart. 2002–2007.

Reid, U.S. Senator Harry. Tribute to Emilie Wanderer, delivered in Washington, D.C., April 30, 2003.

JUDITH MOSIER WARNER

Warner, Judith. Oral history, imparted to her daughter, author Kitty Warner Umbraco. Date not supplied.

THELMA MESSICK WEAVER

Branscomb, Mary. Author Branscomb's personal recollection of conversations and experiences with her mother, the subject.

CLAUDINE BARBARA WILLIAMS

"Claudine Williams, a Life in Gaming." Women's Research Institute of Nevada.

"Claudine Williams, an Appreciation." Classic Las Vegas, a history blog, online at classiclasvegas.squarespace. com.

Entry, "Claudine B. Williams." *Online Nevada Encyclopedia*, at www.onlinenevada.org.

Mann, Stuart. Interview of Stuart by author Robyn Campbell-Ouchida. Date not supplied.

Michele, Peter. Interview of Michele by author Campbell-Ouchida. Date not supplied.

Miller, Stephen. "From Dealing Cards in Louisiana, She Rose to Own Las Vegas Casinos." *Wall Street Journal*. May 23, 2009.

Rodman, Kitty. Interview by author Campbell-Ouchida with Rodman, a Las Vegas businesswoman in construction industry. Date not supplied.

HELEN WOOLLEY WILLIS

Desert News Publishing Co.

Obituary, *Las Vegas Review-Journal*. February 26, 2004.

Wikipedia.org.

ETHEL ALICE BJORNSON WINTERNHEIMER
No sources supplied.

PAULINE MAY ATTERBURY WILSON
Wilson, Pauline. Sixteen-page autobiography. Date not supplied.

Wilson's daughter, Katherine. Married name unknown. Two-page addendum by Katherine to her mother's autobiography

BERTHA ROSANNA SANFORD WOODARD
Nevada state Senators Mathews, Raggio, and Washington. Senate Concurrent Resolution No. 27 during session of Nevada State Legislature. April 3, 2001.

Sundstrand, Jaccquelyn, librarian of manuscripts and archives and public records officer. Special Collections. University of Nevada, Reno.

White, Claytee D., director of Oral History Program. Special Collections. University of Nevada, Las Vegas, Libraries.

Photography Sources

Ellen Finnerty Albright, no image

Ella Mary Marquat Anderson, unknown source

Kathy Alfano Augustine, courtesy of *Las Vegas Review-Journal*

Dessie Lola Bassette, courtesy of *Las Vegas Review-Journal*

Martha Gruss Barlow, unknown source

Marjorie Jacobson Barrick, courtesy of *Las Vegas Review-Journal*

Adalene Spence Bartlett, courtesy of *Las Vegas Review-Journal*

Selma F. Abdallah Bartlett, courtesy of WRIN

Billie Mitchell Bates, courtesy of *Las Vegas Review-Journal*

Kathy Mackley Batterman, courtesy of Clark County School District

Frances Pugh Beaupeurt, no image

Isabelle Slavin Blackman, unknown source

Emma Lou Montgomery Brandt, courtesy of Monty Brandt

Hope Gaufin Broadbent, courtesy of White Pine County Library

Jane Hopkins Broadfoot, courtesy of *Las Vegas Review-Journal*

Eileen Milstein Brookman, courtesy of *Las Vegas Review-Journal*

Lucille Koenig Brown, no image

Ruth Weston Brown, courtesy of *Las Vegas Review-Journal*

Lucile Spire Bruner, courtesy of *Las Vegas Review-Journal*

Lucile Whitehead Bunker, courtesy of *Las Vegas Review-Journal*

Florence Sandford Burge, courtesy of *Las Vegas Review-Journal ???*

Helen Case Cannon, courtesy of *Las Vegas Review-Journal*

Judy Edsall Carlos, no image

Margaret Casey, personal collection

Marilyn Chambers, courtesy of *Las Vegas Review-Journal*

Leona Gudmundson Clark, unknown source

Toni Gaglionese Clark, courtesy of WRIN

Dr. Angela Webb Clarke, courtesy of *Las Vegas Review-Journal*

Margaret Phelan Coleman, courtesy of *Las Vegas Review-Journal*

Margaret Jane Dailey Colton, personal collection

Mary Melita Smith Coombs, no image

Ethel Dolores "D.D." Cotton, courtesy of UNLV-Special Collections Library

Marcia Smith deBraga, courtesy of the Nevada State Assembly

Cherie DeCastro, no image

Joanne Cutten de Longchamps, unknown source

Ruthe Goldsworthy Deskin, courtesy of WRIN

Dorothy Buchanan Dorothy, unknown source

Gladys Keate Dula, courtesy of *Las Vegas Review-Journal*

Lilly Hing Fong, unknown source

Louise Lorenzi Fountain, courtesy of *Las Vegas Review-Journal*

Estelle Kelsey Givens, no image

Alice Virginia Wood Goffstein, unknown source

Polly Gonzalez, courtesy of KLAS TV, Channel 8 News Las Vegas

Vera Eva Wittwer Hardy, unknown source

Bunny Longbotham Harris, courtesy of *Las Vegas Review-Journal*

Edith Claire Posener Head, courtesy of *Las Vegas Review-Journal*

Lomie Gray Heard, unknown source

Helen Kolb Herr, courtesy of *Las Vegas Review-Journal*

Mabel Welch Hoggard, courtesy of UNLV-Special Collections Library

Jeanne Walsh Hood, courtesy of *Las Vegas Review-Journal*

Barbara Joanne Thomas Hunter, unknown source

June Calder Huntington, unknown source

Billie Jean Hickey James, courtesy of *Las Vegas Review-Journal*

Velma Bronn Johnston, no image

Mary Ka'aihue Kaye, courtesy of *Las Vegas Review-Journal*

Anna Dean Nohl Kepper, courtesy of *Las Vegas Review-Journal*

Alice Marie Juliet Key, courtesy of *Las Vegas Review-Journal*

Martha Pike King, courtesy of *Las Vegas Review-Journal*

Brunetta Mae Kells Lenz, courtesy of *Las Vegas Review-Journal*

Celesta Lisle Lowe, courtesy of *Las Vegas Review-Journal*

Sister Rosemary Lynch, courtesy of *Las Vegas Review-Journal*

Mabel Whitney Macfarlane, unknown source

Marie Louise Hungerford Mackay, unknown source

Florence Elberta Schilling McClure, courtesy of *Las Vegas Review-Journal*

Karla Bohac McComb, courtesy of *Las Vegas Review-Journal*

Elizabeth Hazel Penrose McKay, unknown source

Ann Rittenhouse McNamee, unknown source

Eve Wick Moss, no image

Virginia Moreira Moura, no image

Leona Daoust Munk, no image

Colanthe Florence Jones Murphy, courtesy of WRIN

Dr. Rena Magno Nora, no image

D'Vorre "Dee" Ober, no image

Anna Nuhfer Parks, unknown source

Edna Burke Patterson, unknown source

Minnie Peters, unknown source

Annabelle Plunkett, courtesy of UNLV-Special Collections Library

Bertha Jane Mattson Purdy, no image

Bertha Berry Ragland, courtesy of *Las Vegas Review-Journal*

Agatha Pettinger Roberts, no image

Luciell Rohlman, unknown source

Colleen Carroll Schroder, unknown source

Alice Lucretia Smith, unknown source

Janet Curtis Smith, courtesy of *Las Vegas Review-Journal*

Louise Aloys Smith, courtesy of *Las Vegas Review-Journal*

Mary Evelyn Stuckey, courtesy of Nevada State Museum

Sheila Tarr-Smith, courtesy of Linda Tarr

Doris Higginson Troy, courtesy of *Las Vegas Review-Journal*

Alice Bacon Turner, unknown source

Nora Bloom Ullom, unknown source

Kay Novak Wallerstein, no image

Phyllis Walsh, no image

Emilie Norma Wanderer, courtesy of *Las Vegas Review-Journal*

Judith Mosier Warner, courtesy of *Las Vegas Review-Journal*

Thelma Messick Weaver, unknown source

Claudine Barbara Williams Williams, courtesy of *Las Vegas Review-Journal*

Helen Woolley Willis, courtesy of *Las Vegas Review-Journal*

Pauline May Atterbury Wilson, no image

Ethel Alice Bjornson Winternheimer, no image

Bertha Rosanna Sanford Woodard, no image

Index by Occupation

AVIATION
Helen Case Cannon 50–51
Margaret Lehr Perkins Casey 54–55
Dorothy Buchanan Dorothy 80–81
Florence Colanthe Jones Murphy 148–149

BROADCASTING
Jane Hopkins Broadfoot 36–37
Marilyn Chambers 56–57
Ruthe Goldsworthy Deskin 78–79
Polly Gonzalez 92–93
Alice Marie Juliet Key 120–121
Agatha Lucy Pettinger Roberts 166-167
Thelma Messick Weaver 196–197
Helen Woolley Willis 200–201

BUSINESS
Selma Abdallah Bartlett 22–23
Emma Lou Montgomery Brandt 32–33
Hope Gaufin Broadbent 34–35
Margaret Jane Dailey Colton 66–67
Louise Lorenzi Fountain 86–87
Helen Kolb Herr 102–103
Jeanne Walsh Hood 106–107
June Calder Huntington 110–111
Brunetta Mae Kells Lenz 124–125
Mabel Clara Whitney McFarlane 130–131
Florence Colanthe Jones Murphy 148–149
Anna Parks 154–155
Bertha Berry Ragland 164–165
Nora Bloom Ullom 186–187
Claudine Williams 198–199

CASINO EXECUTIVE MANAGEMENT
Toni Gaglionese Clark 60–61
Alice Wood Goffstein 90–91
Jeanne Walsh Hood 106–107
Claudine Williams 198–197

CASINO OPERATIONS
Ethel Dolores "D.D." Cotton 70–71
Claudine Williams 198–199

CIVIC ORGANIZATIONS
Eileen Finnerty Albright 8–9
Adalene Spence Bartlett 20–21
Billie Mitchell Bates 24–25
Frances Pugh Beaupeurt 26–27
Isabelle Slavin Blackman 30–31
Emma Lou Montgomery Brandt 32–33
Gladys Keate Dula 82–83
Louise Lorenzi Fountain 86–87
Estelle Esther Givens 88–89
Bunny Longbotham Harris 96–97
Barbara Thomas Hunter 108–109
Florence Schilling McClure 134–135
Ann Rittenhouse McNamee 140–141
Eve Wick Moss 142–143
Virginia Moreira Moura 144–145
Leona Daoust Munk 146–147
Alice Lucretia Smith 172–173
Louise Aloys Smith 176–177
Alice Bacon Turner 184–185
Kay Novak Wallerstein 188–189
Phyllis J. Walsh 190–191
Thelma Messick Weaver 196–197

COMMUNITY ACTIVISM
Ella Mary Marquat Anderson 10–11
Dessie Lola Bailey 14–15
Billie Mitchell Bates 24–25
Frances Pugh Beaupeurt 28–29
Jane Hopkins Broadfoot 36–37
Eileen B. Brookman 38–39
Ethel Dolores "D.D." Cotton 70–71
Ruthe Goldsworthy Deskin 78–79
Dorothy Buchanan Dorothy 80–81
Gladys Keate Dula 82–83
Esther Givens 88–89
Polly Gonzalez 92–93
Helen Kolb Herr 102–103
Mabel Welch Hoggard 104–105
Velma Brian Johnston 114–115
Alice Marie Juliet Key 120–121
Sister Rosemary Lynch 128–129
Florence Schilling McClure 134–135
D'Vorre "Dee" Ober 152–153

Edna Burke Patterson 156–157
Minnie A. Peters 158–159
Luciell Rohlman 168–169
Alice Lucretia Smith 172–173
Emilie Norma Wanderer 192–193
Bertha Sanford Woodard 206–207

CULTURE
Marjorie Jacobson Barrick 18–19
Lucile Spire Bruner 44–45
Mary Melita Smith Coombs 68–69
Estelle Esther Kelsey Givens 88–89
Anna Dean Nohl Kepper 118–119
Kay Novak Wallerstein 188–189
Helen Woolley Willis 200–201

EDUCATION
Lucile Spire Bruner 44–45
Dr. Angela Webb Clark 58–59
Lomie Gray Heard 100–101
Brunetta Mae Kells Lenz 124–125
Karla Bohac McComb 136–137
Dr. Rena M. Nora 150–151
Agatha Lucy Pettinger Roberts 166–167
Ethel Bjornson Winternheimer 204
Judith Mosier Warner 194–195
Helen Woolley Willis 200–201

ENTERTAINMENT
Ruth Weston Brown 42–43
Marilyn Chambers 56–57
Margaret Phelan Coleman 64–65
Ethel Dolores "D.D." Cotton 70–71
Cherie DeCastro 74–75
Dorothy Buchanan Dorothy 80–81
Alice Wood Goffstein 90–91
Edith Posener Head 98–99
Mary Ka'aihue Kaye 116–117
Alice Marie Juliet Key 120–121
Doris Troy 182–183
Pauline May Atterbury Wilson 202–203

ENTREPRENEURSHIP

Florence Sandford Burge 48–49

Margaret Phelan Coleman 64–65

Louise Lorenzi Fountain 86–87

Jeanne Walsh Hood 106–107

June Calder Huntington 110–111

Brunetta Mae Kells Lenz 124–125

Mabel Clara Whitney Macfarlane 130–131

Leona Daoust Munk 146–147

Florence Colanthe Jones Murphy 148–149

Anna Roberts Parks 154–155

Bertha Berry Beggs Ragland 164–165

Colleen Carroll Schroeder 170–171

Claudine Williams 198–199

FUNERALS

Anna Roberts Parks 154–155

HISTORY

Anna Dean Nohl Kepper 118–119

Anna Roberts Parks 154–155

HORTICULTURE

Adalene Spence Bartlett 20–21

Agatha Lucy Pettinger Roberts 166–167

JOURNALISM

Adalene Spence Bartlett 20–21

Florence Sandford Burge 48–49

Judy Edsall Carlos 52–53

Marcia deBraga 72–73

Ruthe Goldsworthy Deskin 78–79

Dorothy Buchanan Dorothy 80–81

Gladys Keate Dula 82–83

Alice Marie Juliet Key 120–121

Celesta Lisle Lowe 126–127

Agatha Lucy Pettinger Roberts 166–167

Colleen Carroll Schroeder 170–171

Phyllis J. Walsh 190–191

Helen Woolley Willis 200–201

LAW

Janet Curtis Smith 174–175

Emilie Norma Wanderer 192–193

LIBRARIES

Anna Dean Nohl Kepper 118–119

Celesta Lisle Lowe 126–127

MEDICINE

Kathy Mackley Batterman 26–27

Jane Hopkins Broadfoot 36–37

Dr. Angela Webb Clark 60–61

Eve Wick Moss 142–143

Dr. Rena M. Nora 150–151

Bertha Sanford Woodard 206–207

MILITARY

Dr. Angela Webb Clark 58–59

Barbara Joanne Thomas Hunter 108–109

Eve Wick Moss 142–143

Dr. Rena M. Nora 150–151

Louise Aloys Smith 176–177

Phyllis J. Walsh 190–191

MINING

Margaret Jane Dailey Colton 66–67

Marie Louise Mackay 132–133

Anna Roberts Parks 154–155

Minnie A. Peters 158–159

Pauline May Atterbury Wilson 202–203

MODELING

Joanne Cutten de Longchamps 76–77

Brunetta Mae Kells Lenz 124–125

Colleen Carroll Schroeder 170–171

MUSEUMS

Anna Roberts Parks 154–155

Edna Burke Patterson 156–157

OFFICE WORK

Eileen Finnerty Albright 8–9

Billie Mitchell Bates 24–25

Margaret Phelan Coleman 64–65

Velma Bronn Johnston 114–115

Ann Rittenhouse McNamee 140–141

Louise Aloys Smith 176–177

PARLIAMENTARY PROCEDURE

Billie Mitchell Bates 24–25

Bunny Longbotham Harris 96–97

PHILANTHROPY

Marjorie Jacobson Barrick 18–19

Toni Gaglionese Clark 58–59

Joanne Cutten de Longchamps 76–77

Lilly Hing Fong 84–85

Alice Wood Goffstein 90–91

Bunny Longbotham Harris 96–97

Marie Louise Mackay 132–133

Claudine Williams 198–199

PHOTOGRAPHY

Nora Bloom Ullom 186–187

POETRY

Joanne Cutten de Longchamps 76–77

Billie Jean James 112–113

POLITICS

Kathy Alfano Augustine 12–13

Martha Gruss Barlow 16–17

Isabelle Slavin Blackman 30–31

Eileen B. Brookman 38–39

Lucille Koenig Brown 42–43

Helen Case Cannon 50–51

Marilyn Chambers 56–57

Marcia deBraga 72–73

Bunny Longbotham Harris 96–97

Helen Kolb Herr 102–103

Virginia Moreira Moura 144–145

Leona Daoust Munk 146–147

Louise Aloys Smith 176–177

PRIVATE INVESTIGATION

Margaret Jane Dailey Colton 66–67

PUBLIC SECTOR (PAID AND UNPAID)

Ella Mary Marquat Anderson 10–11

Martha Gruss Barlow 16–17

Adalene Spence Bartlett 20–21

Selma Abdallah Bartlett 22–23

Eileen B. Brookman 38–39

Lucile Whitehead Bunker 46–47

Lucile Koenig Brown 40–41
Margaret Phelan Coleman 64–65
Marcia Smith deBraga 72–73
Lilly Hing Fong 84–85
Bunny Longbotham Harris 96–97
Alice Marie Juliet Key 120–121
Brunetta Mae Kells Lenz 124–125
Virginia Moreira Moura 144–145
Leona Daoust Munk 146–147
Bertha Jane Mattson Purdy 162–163
Alice Lucretia Smith 172–173
Janet Curtis Smith 174–175

PUBLIC SAFETY
(POLICE AND FIRE)
Kathy Mackley Batterman 26–27
Lucille Koenig Brown 40–41
Annabelle Plunkett 160–161
Sheila Tarr-Smith 180–181

RANCHING
Ella Mary Marquat Anderson 10–11
Dorothy Buchanan Dorothy 80–81
Velma Bronn Johnston 114–115
Edna Burke Patterson 156–157
Phyllis J. Walsh 190–191
Pauline May Atterbury Wilson 202–203

RELIGIOUS LEADERSHIP
Lucile Whitehead Bunker 46–47
Margaret Jane Dailey Colton 66–67
Gladys Keate Dula 82–83
Sister Rosemary Lynch 128–129
Bertha Jane Mattson Purdy 162–163
Kay Novak Wallerstein 188–189

RESTAURANTS
Toni Gaglionese Clark 58–59
Mabel Clara Whitney McFarlane 130–131
Thelma Messick Weaver 196–197

SPORTS & RECREATION
Jane Hopkins Broadfoot 36–37
Florence Sandford Burge 48–49
Helen Case Cannon 50–51
Marcia deBraga 72–73
Mary Evelyn Stuckey 178–179

TEACHING (K-12)
Kathy Alfano Augustine 12–13
Martha Gruss Barlow 16–17
Isabelle Slavin Blackman 30–31
Hope Gaufin Broadbent 34–35
Lucile Whitehead Bunker 46–47
Helen Case Cannon 50–51
Leona Gudmundson Clark 60–61
Lilly Hing Fong 84–85
Vera Eva Wittwer Hardy 94–95
Lomie Gray Heard 100–101
Mabel Welch Hoggard 104–105
Billie Jean James 112–113
Martha Pike King 122–123
Karla Bohac McComb 136–137
Elizabeth Hazel Penrose McKay 132–133
D'Vorre "Dee" Ober 152–153
Minnie A. Peters 158–159
Ethel Bjornson Winternheimer 204
Mary Evelyn Stuckey 178–179
Nora Bloom Ullom 186–187
Judith Mosier Warner 194–195

VISUAL ARTS
Lucile Spire Bruner 44–45
Leona Gudmundson Clark 58–59
Mary Melita Smith Coombs 68–69
Joanne Cutten de Longchamps 76–77
Edith Posener Head 98–99
Barbara Thomas Hunter 108–109
D'Vorre "Dee" Ober 152–153

WRITING
Isabelle Slavin Blackman 30–31
Marilyn Chambers 56–57
Edith Posener Head 98–99
Brunetta Mae Kells Lenz 124–125
Karla Bohac McComb 136–137
Edna Burke Patterson 156–157